By the same author

Jasper Johns

Renderings: ESSAYS ON A CENTURY OF MODERN ART

Cubism/Futurism

Photography and Fascination

The Privileged Eye: ESSAYS ON PHOTOGRAPHY

Duane Michals: NOW BECOMING THEN

Lone Visions
Crowded Frames

Lone Visions

ESSAYS ON PHOTOGRAPHY

Crowded Frames

UNIVERSITY OF NEW MEXICO PRESS ALBUQUERQUE

Max Kozloff

Library of Congress Cataloging in Publication Data
Kozloff, Max.
Lone visions, crowded frames : essays on photography / Max Kozloff.—1st ed.
p. cm.
Includes bibliographical references.
ISBN 0–8263–1493–7.—ISBN 0–8263–1494–5 (pbk.)
1. Photography—Social aspects. 2. Photography—Philosophy.
3. Photography, Artistic. I. Title.
TR187.K69 1994
770—dc20 93-25588
 CIP

Contents

CONTENTS

List of Illustrations

Color Sections following pages 180 and 292

Introductory Note

I N T W O earlier books of essays on photography, I wrote inter-
mittently about human faces; in this one, they become main
subjects. The face continuously invites questions even when they
are unlikely to be answered. For we seek unique signs and
meanings there, vital to our own consciousness, available nowhere
else. Very little has been written on the aesthetics of portraiture as
compared with volumes on those who have been portrayed. A pho-
tograph certainly describes the features, but more specifically and
importantly, it conveys the momentary expression of a subject, an
elusive presence that is hard to paint in words. How had the camera
depicted it, in certain instances, and what role could this picture play
in viewers' imagination and memory? Over the last few years when
no book appeared on this topic, I addressed it in shorter writings,
interim reports on an enigma.

Doubtless, portrait photographs are artifacts, often with very specific
social programs. While acknowledging that at every turn, I wanted
to look into them more fully in terms of psychological perception.
For the portrait's tremor of aspect reflected something of human be-
havior that emerged despite, or regardless of, a social function, and
seemed to me worth talking about, all the more as it had been ne-
glected. There were reasons for this neglect. For one thing, such
concerns of portraitists as nuances of character and personal integrity
were disdained in the antiliberal criticism of our era. Instead of mobile
faces, our theorists perceived only masks, frozen into conventional
attitude by the media around us. For another, the whole problem of

individual subjectivity was depreciated by the writing on post-modernist culture. In portraiture, that problem comes to a head. When they weren't treated as irrelevant, feeling states and emotional truths—quite a large zone of our consciousness—embarrassed the prevailing intellectual skepticism.

No one method characterizes these essays on portraiture, for they were obliged to feel their way by means of empathetic response. The response could be assisted by a biographical approach, genre analysis, and moral concerns that were checked against the photographs themselves. On the basis of their visual evidence alone, one could see that a great deal of their content had been unnoticed or repressed. The same could be said for street photography (which receives much attention in this book), another idiom that in recent years has lost favor, though it is still energetically practiced. I believe, in fact, that a link exists between portrait and street photography, in the conditions of their regard.

The unpredictable conduct of one subject comprises the field of interest for the portraitist, just as the unforeseeable actions of many create the field of the street photographer. The incidents we think characteristic of both modes can be equally fugitive and subtle, though, of course, of different scale. Normally, we think of the street as the locale of figures, not faces; of "there," not "here." Yet, the closely observed human physiognomy is the site of as many uncontrollable moods and variables as the street. In these pages, the deliberate encounters of one genre and the roving spirit of the other unexpectedly join forces within an imaginative space.

Whatever their practice, the photographers singled out in these essays are viewed as risk-takers, reflective spirits, and significant artists, marginalized or misplaced by the media culture where they are often necessarily employed. In various degrees, many of them have resisted the neutralizing effect of the professional environment. Their portraits become more introspective and their photojournalism expressively darker than any of their original models had called for. An air of estrangement and solitude envelops their work, even as it seeks ever greater density of social contact. Considering their images, we're introduced to deepening stresses in our contemporary image output—and, of course, the pathos of the time. I write on doubts raised about photographic credibility by artists who use the medium for their own fictive agendas,

disturbances in the erotics of photography, as affected by the impact of AIDS, the depiction of "others" across class and ethnic barriers, the admonishing beauty of polluted landscapes, and finally, the gathered sense of misfortune and fatality which the image brings back to viewers at the end of our century.

I hope to be forgiven for introducing a hint of *fin-de-siècle* decadence in the title of the last piece in this collection, "The Digital Worm in the Photograph of the Apple." It was placed at the end, as a polemic about ongoing phenomena, but its assumptions are everywhere anticipated and reflected in comment throughout the preceding essays. Enthusiasts for the coming era of the digitized image would have us say goodbye to the legacy of sensitive witness that is discussed here. Suppose that instead of being historical determinists or vain prophets, they are realistic observers of an irreversible transformation in our commerce with visual images. Imagine that soon we will no longer be able to trust in the report pictures bring back to us from the world. In that event, these essays will testify to what was *once* at stake, and of special value, in our engagement with photographic culture.

M.K. 1994

The Aesthetics

of Portraiture

Opaque Disclosures

PORTRAIT PHOTOGRAPHS are invested with a routine deception. Normally, one thinks of them as the result of a moment that has been taken out of time to exhibit the face. In such images, all psychological slack has been pulled taut to assert the prepared, immobile display of the person or persons. The characterizing process should look stable, with details consistently presented throughout the frame. A subject may appear self-absorbed or unconcerned about a later audience, but this is only a device that masks the fact that he or she is primed and ready for inspection. Any resemblance between the behavior of the one portrayed and his or her unimpeded conduct is, in fact, coincidental. No one would deny that people present themselves through variable forms of personal theater. It's just that in sitting for their picture they project a very special, isolated, and artificial version of that theater. We think of it as concentrated, suspended in its impulses, weighted, wholly given over to us, the viewers.

Let there be any significant drop away from this concentrated bearing—any dilution into unself-conscious activity, any immersion within the subject's own time—and the idea of portraiture itself is correspondingly weakened. The subjects are shown to have had a purpose other than revealing themselves to us. They did not play the game; they did not allow their personhood to be appropriately congealed and legitimated. I might not think that such images are portraits, and I might very well be wrong.

Since its invention, photography has given us portraits, the majority of which have been vernacular, that is, images that served, and still serve, everyday, humdrum social functions. The moment of the pose certainly yields an aspect of an individual's appearance, but it also establishes a role into which many people, not just the one, could be fit. That typology also enables vernacular to be thought of as a long-term mnemonic form, a hopeful trade in permanent icons. I am encouraged to remember, not so much the way x looked when graduating, or y when running for mayor, but to come away with an ongoing impression that here was the proper graduate or the right mayor. The face is lit up with one of life's little promotions. Even the person in the passport photo would seem to belong to this genre, for it always tells of someone who expects to take a trip. To think of glamour or campaign portraiture, or that of book jackets, wedding, and school albums, is to notice continuous repertories of social advertisement. When the context is celebratory, the mood reads as "cheerful," and when the use is institutional, the face tends to be impassive. Viewers are here presented with little more than the general guise and decorous performance called for by the portrait stereotype. Moreover, viewers themselves are ideally characterized by the images, so that they more or less fall into apparent constituencies such as fans, parents, readers, consumers. Under these circumstances, any notion of the inwardness of the subjects remains moot. In vernacular portraiture, that state of being, even if it were expressible, would certainly be irrelevant.

As compared with the role that is determined, we're much more nagged and vexed by the "who" that is portrayed. How long has it been since it was imagined that people were integrated, homogeneous beings, or that their social placement regulated their personalities? These naïvetés about our fellow creatures, that they are fixed constellations of traits, have given way to the sense that we are eruptive and conflicted, in a ferment that is a mystery to consciousness itself. It is to ask too much of a still portrait photograph, a scanty object, to uncover any of this human process—or some flare from it. Yet this is what we do. For we've all encountered faces in the portrait archive that seem memorable apart from or in excess of a nominal social casting. The mold is broken and from that opening arise questions beyond the reach of answers supplied by genre analysis. The actual claims made for the person by accompanying text or established image use fall away

before a luminous intensity of the face. When that happens, the viewer is drawn into a problem, not of social history but of criticism.

Of course, sociologists who refine their typology of body gestures and their researches into the systems of image consumption do help us to understand the original portrait mission. And photo historians, who improve their descriptions, say, of lighting styles, viewing angles, or compositional preferences, have something to say about portrait aesthetics within traditional canons. One is grateful for such useful work. But it leaves off after deciphering the variant pictorial codes of the image, as if to acknowledge that beyond this lies something that defeats understanding. Here, though, is exactly where critical interpretation begins—in bewilderment.

The difficulty of interpreting portrait photographs stems from a contradiction in terms. The pictures earn their living, so to speak, from the work they do in providing intimate and pointed visual access to their subjects, in the interest of confirming them for future memory and appraisal. When sitters formally consented to be the objects of the portrait camera, their bodies became preoccupied with the thought of that appraisal, and what we view, as our own empathy tells us, is how they coped with that thought. It's as if they fancied that the photographer's attention could see *through* them. At the same time, each one of them, as a phenomenon, remains unknowable within the pictorial constraints—because character, identity, personal reflex, and history, utterance, and style, all those essential, unique groundings from which we sprout, quite obviously cannot be grasped from a visual icon. That image speaks of faces that have been knowingly composed for delayed transmission, one shot at a time. The look that issues from the portrait seems to address viewers, but it does not perceive any of us. It's a look that cannot be what it presumes—an interactive regard. It is walled up in its own pretense. In the end, we have to speak of something odd in portrait practice—of removed appeal, of opaque disclosure.

Serious portraiture in our century has tried to get around or to compensate for this necessary standoff. The photographers hit hard upon the theme of personal revelation, and they have done so in bodies of work that divide roughly into two traditions. These could be designated by the terms *formal* and *informal*, stressing pictorial effect, but

August Sander, *Dadaist Raoul Hausmann, Berlin*, 1929, from the series "Citizens of the Twentieth Century." Courtesy Philadelphia Museum of Art.

I prefer to emphasize what happens behind the camera, in the pulse of the moment, and to talk of attitudes in seeing: of intensive stares and impromptu scans.

Berenice Abbott, during the 1920s, and Gisèle Freund, during the 1930s, formally posed a lot of Parisian intellectuals, subjects who were professionally introspective. In a way that has not dated in Europe, a number of these people smoke or hold conspicuously lighted cigarettes to indicate a certain nervous reflectiveness, the keen life they lead in the mind. As the instrument is to the musician who poses, so, more vaguely, is the cigarette to the intellectual, an attribute of a mental process that cannot be visualized.

This fixed device to ascribe an almost poetic meaning contrasts with the methods of the German August Sander, whose stare was also very intensive, in the manner of the nineteenth-century artist, but whose detachment from his subjects was very chilly, in the mode of "objective research." Abbott and Freund clearly sympathized with their writer subjects and the Parisian intellectual milieu, of which they themselves were members. Sander's attitude toward his subjects was much more detached, and his peasants, bakers, lawyers, and soldiers, etc., were more explicitly the embodiment of social roles. What interested him was how the body proposed itself, with frontal poses, folded hands, and stiff spine, in guises that he thought had inevitable social implications.

The rhetoric of Sander's mammoth portrait program, "Citizens of the Twentieth Century," had a pre-Freudian scientific bias. Not only did it assume that personalities were determined by their place in the established community, but that people's appearance inescapably reflected their actual status and occupation. Still, Sander could not be accused of supporting that status, but only of studying it. The self-impersonation of the sitter had no more value for him than that of "evidence" in a half-baked scheme of extreme conceptual reductiveness. His camera might alter or miss an aspect of the sitter's display, or make it awkward, but Sander sought to bring out something archetypal in it. With that kind of priority, any sense of his rapport with sitters was beside the point and even detrimental to his project. Their humanity was left to fend for itself under an impassive gaze that emphasized what was peculiar and idiosyncratic in their organisms. In many other respects old-fashioned, Sander's work, with its analytic

thrust, strikes us as very modern. For it discovered that script and player, contrary to his own expectations, did not necessarily fuse and that personal display was much more volatile in action than in principle. Nineteenth-century portraiture had shown little interest in or even awareness of this disjunctive possibility because subjects and photographers unreflectively shared the same value systems. By refusing the traditional collusive gesture toward his subjects, Sander took a decisive step in unmasking them.

Following Sander in his objectification of role and his description of physical peculiarity, Diane Arbus went further, into a rhetoric of *ex-posure*. Not only did she see the posing stance as essentially uncomfortable, but also as unequal or vulnerable to the inspective stare. In her view, people were marked by the transparency of their self-delusions and branded by their (often marginal) social status.

Such portraiture gains in vibrancy the more it effectuates a sense of the mutual alienation of the sitter and the photographer. We see this effect in Bill Brandt, Richard Avedon, and Chauncey Hare. Deprived of the trust that had been customarily expected on the portrait occasion, Arbus's subjects give off an air of being unduly isolated, sometimes even of being cornered. With no place to hide, and stripped of imposture (seen as flawed defense), they become the objects of what purports to be an extremely honest scrutiny, but is in fact a merciless one.

Quite frequently, Arbus's figure is starched with an odd, iconic rigidity, as in certain nineteenth-century portraits, but without the stable context and technical limitations that underlie the original, archaic effect. It's as if the sitter, a transvestite, say, or a dwarf, had been pathetically immobilized by the prurience of the photographer, a morose impresario, whose startling modes of access, or blunt realism, or theatrical mood draws attention to itself. When Bill Brandt, for his part, portrayed Nicol Williamson, it was the photographer's dramaturgy of angst that came through, not the actor's. Improbably enough, all Brandt's people are cousins in despair.

There can be no question of documentary intent or real candor in such an approach. And forget there was ever such a consideration as "natural" behavior. Nothing, in fact, is natural anymore except the unease that shows the harrowing quality of the portrait ritual itself. And yet the viewer is asked to judge another state of being entirely,

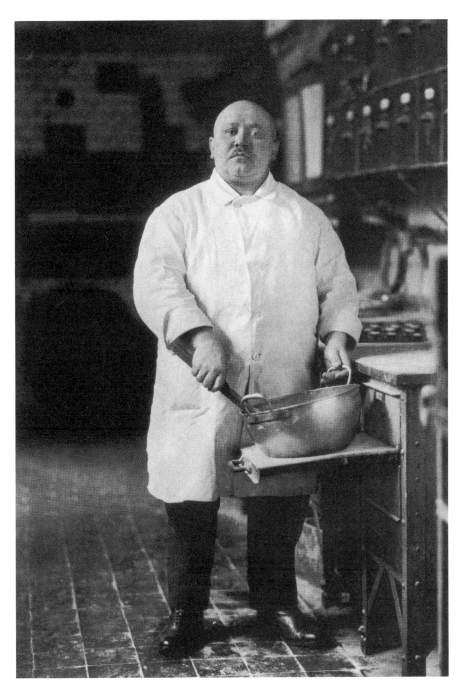

August Sander, *Pastry Cook,* 1928, Cologne. Courtesy Philadelphia Museum of Art.

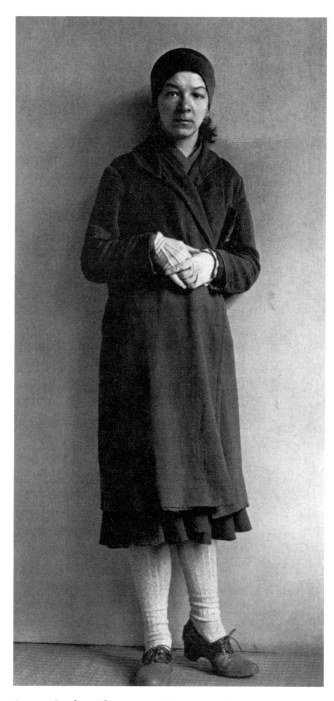

August Sander, *Charwoman,* Cologne, 1928.
Courtesy Philadelphia Museum of Art.

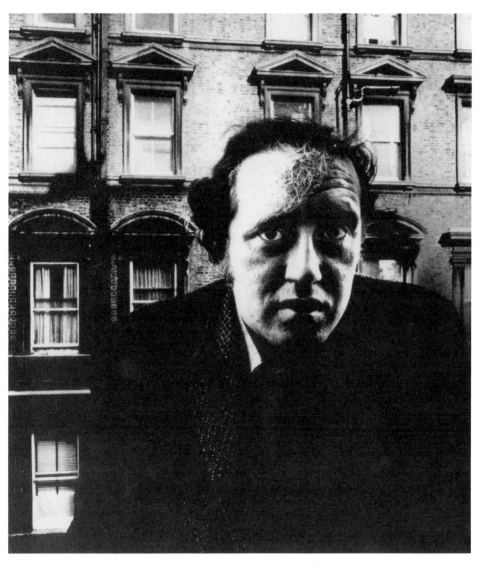

Bill Brandt, *Nicol Williamson,* Kensington, London, 1965. Courtesy Da Capo Press.

for post-Sander portraiture depends upon a metaphor of our fellows who have been appropriated into an imaginative world, a distinct, separate form of stressed existence. Collectively, they represent the imprint, at nearer or farther remove, of that stress, so that their life histories are made to appear the homogeneous product of one insightful mind. All variables of expression are absorbed by, or bear up under, an obscure adversity, more vital, poignant, or alarming in its effects than the real flesh would ever suggest. At an Avedon opening, a critic was disappointed to meet one of the photographer's portrait subjects, who exhibited only normal traits and an annoying sanity.

It's implied that an Avedon person actually doesn't have or belong in a home, but is, in fact, obliged to hang out in front of a sheet of white seamless paper. Nineteenth-century sitters were equally marooned in the photographer's studio, but that environment at least pretended to a symbolic decorum, situating or ennobling the sitter with shopworn props. The modernity of the work I am describing, on the other hand, consists in the feeling it gives of emphatic limbo. Even when Brandt's sitters are viewed in a cluttered apartment, they may be resident but they are not accommodated or naturalized by their theatrically darkened scene. The slop of articles and furnishings in a Chauncey Hare working-class interior is, on the contrary, only too domestically banal. The objects derive power from his up-front aim to make wretched accoutrements symptomatic of deprived lives. If people and things look inseparable from each other in Hare's photographs, it may be because the people themselves have been transformed into objects, which makes them pretty far gone in their estrangement—from their possessions and from us.

One further point of all this work is that such "homelessness" affects us viewers, too—we no longer know where we are positioned socially and morally. There's a clandestine pleasure to our witness, alerted by photographers who make us accomplices to their intrusive acts. Consent had been given by the sitters, with the likely thought that self-esteem would be flattered, or at least attention paid. But the picture pays the "wrong" sort of attention. For the expressive purpose is to invade the subject's privacy while he or she is attending to something else—to being portrayed. Not only does the photograph underline the effect of a body caught out in the open, but of an unsheltered ego as well.

During this period, however, we've had another portrait genre—I hesitate to call it a tradition—a relaxed one, which never aimed to be as conclusive as the formal mode. Instead of typecasting individuals as representatives of unhappy mental states or material conditions, the photographer looks at people case by case, without wanting to foretell the expressive result. The last thing that would occur to portraitists of this sort would be to assign any permanent social role or psychic label to their subjects. In this genre, the work may risk being porous and unincisive. But it also tends to be generous, even spacious, for the photographer is part of the social moment, visualizing that moment as one in which human personalities burgeon within the interactions they themselves create. Even when the subject poses, that activity appears as kinetic motion which the picture stops only provisionally. We always seem to get a rough draft of a temperament and rarely a consciously distilled presence. Where formal portraits would be synthetic but stilted, these decidedly incidental ones are necessarily more spontaneous. They have a strong realistic premise, based on their maker's modesty, recessiveness, and tact. The photographer imposes as little control as possible on the actual swim of events.

Informal portraiture features people viewed at ease on their own ground, or in an environment to which they relate. The material world in which they move locates them socially for the time being and gives some account of their action. It also reflects the interest of observers who report on milieus. In fact, a number of informal portraitists unsurprisingly come from journalism. The media context of their work is reportage, but its personal model derives from the snapshot. In the fusion of these two genres, history has Erich Salomon to thank for having shown the way. André Kertész, Brassai, and Robert Doisneau traveled farther along that route, into private documentary, of which the surreptitious subway portraits of Walker Evans are an American instance. Recently, three sizable albums that exemplify the informal approach have been published on Henri Cartier-Bresson, Lee Friedlander, and Inge Morath.[1] Their work shows the casual mode to have taken more artistic liberties, though of a subtle kind, than had been imagined.

The complication is that "spontaneity," when the sitter is in the company of an agent with a transcribing tool becomes almost as much a pose as a pose. I was about to say that the word *sitter* no longer

applies to circumstances where the point is to depict people relatively off guard, disarmed, or in action. Yet it is inconceivable that the subjects of an informal portrait would be unaffected by what the photographer was up to. Their responsiveness to the observer makes a difference, but is not overtly acknowledged. Lee Friedlander pictures a number of fathers introspectively dandling their children, as if he were nondirective at quite close range. The same must be said for Cartier-Bresson's men of letters, who seem to ignore him as they ebulliently speak to someone outside the frame. Compare this familiar social behavior with the artistic charade that appears in a movie—where the camera grinds away without ever being avowed—a true perversity which we nevertheless accept very well for the convention it is. In contrast, the informal portrait subject abides an outsider's near presence with a certain nonchalance, a grace, really—and *it's that grace that wants to convince us that things were as we see them.*

Suppose you are involved with an activity while allowing a photographer to make pictures. Or the reverse: you're a portraitist, there to do a job, but you encourage your subject to carry on with whatever business. Though both of you ostensibly ignore the other's interest, you also slyly relinquish some self-investment to the other. This kind of equitable exchange protects the portrait from the alienation effect of the formal mode, which subsides for all parties, and vanishes from the picture. I can speculate about the many possible interactions of the seen people with the unseen observer. But I don't sense in these portraits that anyone has been reduced to an object by the photographer, and I don't miss that sense, or the photographer's belligerent, chafing attitude.

But other problems arise in its place: chiefly, what are we looking at, or where should we look? We should certainly entertain the idea that in some of Cartier-Bresson's most famous "portraits," with their scatter of appointments, the figure is only one circumstantial element among many. For example, think of the shot of Marcel Duchamp with cigar and bicycle wheel, or of Breton in semiprofile amid a collection of African masks. Several of these pictures have appeared earlier in published surveys of his work, where they blend with photography of very different import. Let's imagine that the man facing us while talking to Mahatma Gandhi (the latter is seen only from the back) was a key actor in a political episode—let's imagine that, and admit

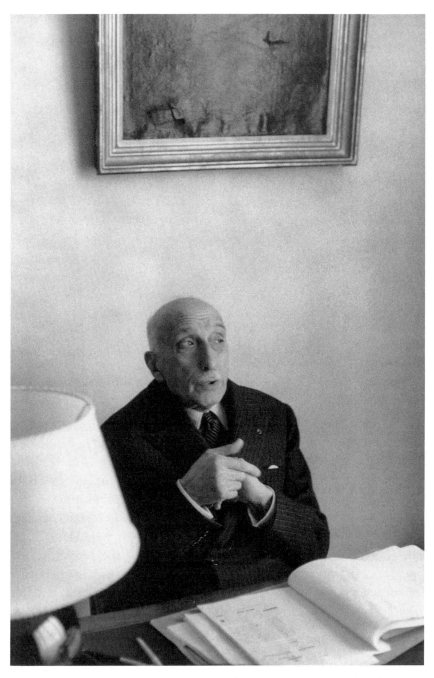

Henri Cartier-Bresson, *François Mauriac*, 1964. Courtesy Museum of Modern Art, New York.

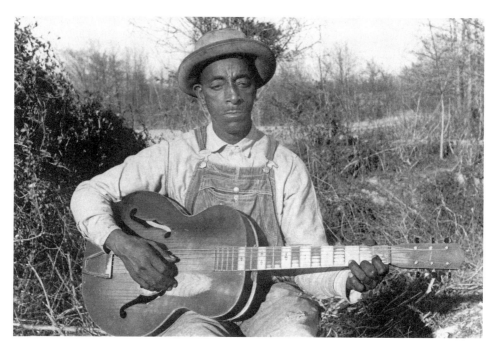

Lee Friedlander, *Fred MacDowell*, Senatobia, Mississippi, 1960. Courtesy New York Graphic Society.

that it doesn't matter. In this last image of Cartier-Bresson's recent book, the critical passage is the gesticulating hand of the Indian leader, its fingers and palm sunlit against the dark.

Here as elsewhere in the street-photo mode, the picture may have had one or more immediate objectives other than portraiture, which could have been an afterthought. Among a number of competing accents, the articulate gesture or a raised eyebrow is singled out. This emphasis never presumes to judge the mask nor the person behind the mask. It works upon us through an opposite thesis, namely that the most revealing human comportment is the most unreflective. To have insisted upon this principle, however, would have meant to undermine it. The photographic reflex must be as instinctive as the gesture it seeks to capture. Those who work on this level know generally what they are doing, but not always what they are seeing. At every moment they're confronted with a sea of trivialities, into which they unhesitatingly plunge. But if that is their occupational hazard, they avoid a more serious one—the picture of a subject who has thought too much, has become sluggish and is rigidified by thought.

Lee Friedlander, *Wade Ward's Granddaughters,* Galax, Virginia, 1962. Courtesy New York Graphic Society.

When Inge Morath did a number of photographs of her friends posing with their faces concealed under brown paper bags decorated with grimacing Saul Steinberg masks, she had fine satiric fun with this idea. (The reference to what brown paper bags are sometimes used to conceal—booze, porno—is particularly delightful.) This criticism of the hold-your-breath and paint-your-smile school of portraiture is directed toward vernacular snapshot imagery, which sets up, rather than discovers, the amiable subject.

Lee Friedlander happens upon subjects of reasonable cheer while operating very close to the snapshot mode. He is, at the same time, a most self-conscious practitioner of the impromptu scan. Equipped with the omnivorous regard of Garry Winogrand, to whose memory he dedicates his recent portraits, Friedlander is also imbued with the plainspeak style of Walker Evans. He snapped his often tentative characters, complaisant in a homely way, as he zeroed in at intimate range. Edited from extended wanderings through small U.S. towns and from calls on friends, his portraits give the impression of dawdling, of having endless time in an uneventful world, and yet of his having

struck so fast that subjects couldn't know how amusingly at odds they were with the objects that surround them, or just how obstreperous and fussy the environment could be when its inhabitants are described. A cutout poster of white sandwich bread ridiculously abuts a woman who posed in Galax, Virginia, in 1962.

Certainly Friedlander likes to view people amid ill-assorted bric-a-brac in a bristling clutter that never quite overwhelms the portrait moment. Only gradually do the faces declare themselves against the squared-off triteness of things. (So much of Friedlander's work depends on the unhurried way the faces take the light.) The more acclimated we become to this gallery of unstated types, the more we feel ourselves to be companions on a benign visitation through that large thing, American culture itself. As he moves through it, Friedlander encounters subjects who either accept him very well, or who gather themselves up more self-consciously before the lens. Among the latter, the blacks that he shows—jazz musicians, blues singers—are rather elegiac in their portrait performance, as if Friedlander could actually manifest their sorrowful relation to their culture.

Cartier-Bresson, for his part, catching people always in midstroke, pictures them as relentlessly animated, piquant, with their radar humming, eyes and fingertips pointed. Such perkiness is, perhaps, a specialty of the French. Do they not have a whole tradition, the Rococo, that insisted on the mobile face, and certain well-bred words—*esprit, sensible*—to back themselves up? But there's such a mob of witty people in Cartier-Bresson's album that they blur into each other, their charm tires you out and their esprit fizzles away. Fluent as they are, their thought seems to pass through them without gaining depth. It's only with some trait that looks stubbornly inbred—the pinched hyper-sobriety of the Joliot-Curies, for instance—that the picture comes alive, despite the sparkle of the photographer's work overall.

Don't ask such images to clinch anything, that is, to give more than the limited evidence of character they can actually show. What they assume, on the other hand, is revealed by Cartier-Bresson's entry into the lives of people accustomed to disport themselves in the lime-light, or who invent themselves for large publics: politicians, writers, entertainers, and some people of fashion. The list is distinguished. One is brought right along with him into their confidence. (If Morath's 1961 picture of Cartier-Bresson is any indication, the man had some-

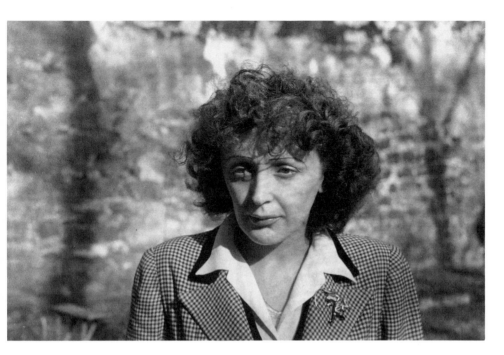

Henri Cartier-Bresson, *Edith Piaf*, 1946. Courtesy Magnum.

thing feral and expensive about him.) With more irony and conscious-
ness of form, Cartier-Bresson's work deploys the same transgressive
strategies as Erich Salomon's. But it has this further difference: Cartier-
Bresson's voyeurism is more flattering for the viewer because of an
implied peerage with his subjects. I would have called this motif
French once again, high French, but for the sense that Cartier-Bresson's
images, as they accrete, deal less with one culture than they treat an
entire, mid-century, international epoch. Collectively, the faces func-
tion as seismic, sporadic traces of that epoch.

On rare occasions, it was possible for him to discover in a single
face an individual's entire epoch—when the phenomena were right,
or as he would say, when the moment was decisive. Cartier-Bresson
took a close, head-and-shoulders shot of Edith Piaf, a small woman
with a copious expression. Drawn with clean lines, her face brims over
almost uncontainably with its experience, and the luminosity of its
disclosure is profound. The same sun that casts a shadow from her
tousled hair across her right eye, making it appear to blink, produces
a vaguer, shimmering light and softened, feathery grays on the out-

of-focus stone wall behind. Issuing from her features is a look that shades indescribably from subtle well-being into imminent sorrow— and holds them both in tremulous suspension. It surprises as a bubble would that has been touched and still survives. No durable knowledge of Piaf has been transmitted through this image, which blends so many delicacies together. But I nevertheless come away from the picture, having it still in my mind, convinced that this is, above all, the way I want to remember her.

Notes

1. Many of the portrait photos discussed in this essay have appeared in these recently published books: *Henri Cartier-Bresson: Photoportraits,* preface by André Pieyre de Mandiargues (London: Thames and Hudson, 1985); *Lee Friedlander Portraits,* foreword by R. B. Kitaj (Boston: New York Graphic Society, Little, Brown, 1986); *Portraits: Photographs and Afterword by Inge Morath,* introduction by Arthur Miller (New York: Aperture, 1986).

This essay appeared in *Art in America* (October 1987).

Variations on a Theme of Portraiture

WITHOUT REFLECTING, people seem to think they know what a portrait is, even if they're not always able to define the term or distinguish a portrait conceptually from other pictures that have similar appearances. Familiar images of sitters, recollected from history, the media, and from the family crowd into mind: what else could they be but portraits? Before the camera of Walker Evans, Mrs. Gudger was perfectly assured she was posing for her portrait . . . and so are we.

What did the participants hope would result from their share in this common ritual? At the least, they knew themselves to be partnered in an open-ended but definite transaction. They both performed gestures, from physically opposed viewpoints, imagining that a kind of *representation* would be made available. Such a visual product would stand for the "person," much as a verbal statement may be understood to propose a thought. Something from its own level of organic and psychic existence is reduced to a sequence of signs (an individual's appearance, immobilized from one vantage point, at a particular moment), and those signs are said to indicate or represent that "something" we don't see. In this view, the record of physical details allows us to speculate about the interior consciousness of an Other. While a portrait is recognized as a memorial record, it's also acknowledged as a penetrative device. However, if a portrait can be likened to a special form of text or book, we might also consider Georg Christoph Lichtenberg's remark: "A book is like a mirror; if an ass looks in, an angel can't look out." It would certainly be asinine, for example, to suppose

that every photograph that features or highlights an individual as the center of regard is a portrait.

One can think of many photographs that lack any portrait intent even though someone's head had top billing—beauty parlor pictures, for example. Similarly, some pictures of people in hot action (Edward Weston's photograph of General Galvan shooting, or many images of public figures in midstroke) are portraitlike in effect but not in fact. Their signs lead away from depiction of the other. If one is to approach this portrait topic, one has to think of more than the ritual that ordinarily identifies it.

The ritual, indeed, may alter, the focus change, various rhetorics may suggest discordant meanings, and still the face smiles on. If it's agreed that portraits represent or make statements about people, then one way of describing portraits is in terms of their function: the significance of the image is fixed by the social origin and identity of its public or audience. A functional approach concentrates on signals determined by the interests of media presentation and receiver context. The image has no value other than as a vehicle to program messages. As it's tagged by the social work it does, however, it is also nuanced by the mood of its subject, loaded with contrary signals. If one wants to follow their cross-currents and undertows, then the approach to portraiture, the one I explore here, will be generic, that is, a theory of genres and their distinguishing traits. Such a perspective is first drawn to those representational forms which portraiture shares with other types of figural depiction, and then studies how its syntheses are developed from opposing strains. Clearly overlapping in some concerns, these two points of view also diverge, the one emphasizing class and material factors, and the other, the pictorial character and psychological resonance of images. Yes, but resonance for whom? Not for a member of a defined group but an unspecified creature, a viewer . . . someone who compares experiences in order better to grasp variations on a theme of portraiture.

Here is a comparison. Robert Doisneau made two photographs, the first showing a country wedding group having its picture taken, and the other depicting the same scene but with just the camera and an empty bleacher. In the populated frame, people were clustered together not for us the present viewers, but for the man there, under the cape. These sitters might be thought of as parts of a whole, or as protagonists

of a scene. Their involvement defines what is going on, but it's not essential to know at this distance who they are. Doisneau's picture describes an activity staffed by virtually interchangeable figures. Faces or gestures may catch the viewer's attention, but they serve as no more than accents within a tableau.

Certainly this is not at all how the sitters imagined themselves, how they regarded their status. They had a right to think they were up front, enjoying the privilege of being *subjects,* but here they come across as only the motifs of Doisneau's picture. Motifs are perceived in a kind of neutral zone that is set up between the "there," where the figures hold forth, and the "here," where the viewing is done. Across that ground travels an interest of the photographer's, but it is not psychologically based, nor does it individuate anyone. More to the point, Doisneau makes of it a social comedy, to which he gives a twist of sadness when he depicts the setting without the actors. The first photograph derives its piquancy from the fact that he stood back, much farther from the spectacle than his hired counterpart, who was working to order. From that simple choice, in which he compares his own stance with that of another photographer, we can gather something of the relations between space and expressive intent in photography. When things are *not* seen at the distance we consider appropriate, they discourage one kind of genre acceptance and take on another. What this suggests, as far as portraiture is concerned, is that there must be some implicitly recognized but still easily violated idea of the proper distance from which to make a portrait.

Well, why not check our attitudes toward this notion by talking of real distance, and of literal measure? Does anyone suppose that a portrait can be made from sixty feet? From fifty? Even at forty feet, it's hard to conceive of a portrait shaping up. The space of the photograph must not appear to upstage or dwarf the figure; a viewer has to feel at least in hailing range of someone if a portrait potential is to be recognized. The proportion of figure relative to frame should be . . . personable. (Of course, cropping and telephoto lenses can mislead us about viewing distance, but these exceptions actually protest their intimacy.) Most portraits can be said to do their business within the zone of hypothetical conversation, from twenty to three feet. Closer than that, the picture becomes transgressive in effect, uncomfortable, destabilized; it tends to warp the idea of the *individual* as the subject

of prime regard. Viewers seem to have an instinctive reflex about this matter. Their empathies with the sitter are initially conditioned by their own self-esteem and sense of presence, an equivalent of which they wish to see accorded to the portrait subject. One doesn't need the whole figure; not by a long shot. But one requires it to have a certain recognition value. In order for viewers to understand that the picture is a portrait, it must set apart this person or that from all others as a proper subject for viewing.

Faces visualized unceremoniously up close, or obscurely, are hard to read. Of course information is always withheld or excluded by the one-shot frame, an obvious feature of still photographs. For this reason, the clear exposition of the face depends upon its seeming accessibility in real space. Unquestionably we impose social criteria upon this phenomenon, so that while sitters may seem approachable, and their proximity is often appreciated, their personal territory has to be respected. When a photographer penetrates too deeply within that territory, the sociality we associate with the portrait is nullified. Whatever else they may be, Helmar Lerski's closeups of faces, taken from a few inches away, do not qualify as portraits. At such abrupt quarters, deprived of context and social orientation, the "psychic existence" of the person has no chance of asserting itself over the topography of the flesh. All signifying features are marginalized by dermal peculiarities, papules, macules, or squamous sections stretched over the escarpment of a chin or cheek. This is as true of Bill Brandt's radical details of eyes as of Jacques-André Boiffard's Surrealist studies of face fragments. If we attribute shock value to such pictures, it may be because something precious has been lost—not just the human scale of the face— but the discreet social and psychological relationship between the subject and the viewer . . . as was no doubt intended. We can never draw back far enough to assess the person depicted, since we're stifled by material surfaces or textures that verge on the abstract.

Here, literally speaking, the human being is perceived as an *object*. It's not just that the face has been transformed into a kind of landscape, but that the photographer's stare has undisputed sway over it. The individual posing has submitted drastically to this stare, all defenses down: any other human initiatives on his or her part are rendered moot in the wake of this act of utter submission. In an obvious sense, any figure depicted in a photograph is made into an object, that is,

a helpless target of our gaze. The medium does that, no matter what the genre or the consciousness of the ones who are seen. The term *objectified* has been used to suggest that human beings in photographs have been demoted to objectlike status, and that, by virtue of being looked at in a way that assumes nothing more about them, they have been victimized, deprived of their human integrity and dignity. Within North American or European cultures which consider staring to be indecorous and demeaning to those who are the object of it, the politics of sightlines are worried over. And with good reason. Richard Avedon, for instance, has been candid about the erotic advantage which the camera has furthered for him: "You look in a way you're not allowed to look in life. Is there any situation in life where you can look at the Duchess of Alba for half an hour without ending up dead at the hands of the Duke?" Did I say "worried"? Evidently, this is not anxiety at all, but gloating over the imposition of a power for which photography is an excellent pretext.

Still, it's hard to deny that most often the objectifying stare is innocent or neutral in its disregard for the sensibilities of the sitter (who is now better designated as a model). The man is there, for example, simply to demonstrate new winter underwear, or the woman, to display the art of that particular hairdresser. In another picture it's the refrigerator that counts, not the housewife who opens it. As for the photograph of the deformed bone structure of the patient who is a mere appendage of his ailment, human priorities are reversed, but we can see its point. In each of these cases, the figure may be closely examined, but not for itself, there being another expositional purpose which the person serves. The ones depicted are thought of as specimens or demonstrators, with no moral depreciation of them as individuals intended by the photographer. Especially is this true in purely artistic contexts, such as that which infuses a picture by Ralph Gibson, where the closely viewed sitter, hand on forehead, is simply an alibi for a study in architecturally disposed forms.

For all practical purposes, the objectified figure has no "self," and no reflexes relevant to the consciousness of being scrutinized. The institutional or commercial or propaganda or aesthetic texts to which a model submits demand a prescribed demeanor, into which the individual subsides and quite vanishes. Whatever the message conveyed, whatever the elaboration of the role, both are detached from the actor,

Cindy Sherman, *Untitled Film Still*, 1979. Courtesy Metro Pictures.

a merely expedient presence. In turn, he or she betrays a noninvolve-
ment and characteristic inertness of the ego, noticeably at odds with
the keen presentability of portraits.

What motivates a role, and for whose sake is it performed before
the camera? This inevitable question brings us to the crux of perfor-
mance, upon which much of our understanding of portraiture rests.
For example, how is it that we're reluctant to call any number of
photographs taken by Cindy Sherman between 1979 and 1983 self-
portraits? They seem to fulfill the nominal requirements of the genre,
and they can be animal enough. The sitter, the artist herself, dominates
all visual concerns, and apparently enacts a scenario about herself whose
introspection is granted all expressive headroom. But the player is
absorbed or even consumed by the role, and appears to have no in-
dependent existence outside it. By contrast, in portraits the self's
ongoing effort at impersonation stops somewhere along the line and
is modified, undone, or enriched by the self that doesn't know how
to be impersonated. In a Sherman photograph, though, the fictive
character of the display is so overtly stressed that it cannot have been
intended to offer any personal revelation into its subject. There's a
working disjunction between the woman as she may be in actual life,
and the character she enacts in the photograph. Her theatrics seal off
these two creatures into two different compartments. If anything dis-

tinguishes Sherman's work from the illustrations and film stills that were her source (she calls *these* pictures "film stills"), it must be a rhetorical transformation. Inescapably, given her procedures, she had to treat herself as an object in order to achieve the illusion that she was a subject. She sacrifices the real Sherman to a metaphor that would have her stand-in as the victim of an erotic gaze.

How does this kind of behavior before the camera differ from professional acting? Acting is manifested as an open form of misdirection, premised on the supposed erasure of anything pertinent to the actor. I do not hesitate to regard it as a mode of self-objectification. As sitters, the material with which we work—our own flesh—has to be configured as if consciousness were at some remove and the material could thus be visualized from outside. An object like a human body is something that can be operated upon in a palpable way and externally changed for worse or better. Not for nothing is the archetypal look that comes to us from the portrait one of anticipation: "This is my best face which I hope meets with your approval." In similar quarters, we would smooth down our organic ruffle more or less on the same impulse as hair is slicked, to project a homogeneous external view of our persons. Fortunately for the amateurs that most of us are, that charade is rarely perfected. Nothing adds more liveliness to portraits than when the mold of narcissism cracks open, something that occurs most frequently in informal genres. Contrarily, after she embedded herself as a pseudo-subject, Sherman melodramatized her performance, suspending it in some puzzling and ambiguous place: a debased thriller or romance. Her images lack the naïveté of the anticipatory look, but have not been taken over by the practiced confidence of trained acting. (The ideal audience for such an indeterminate spectacle is an art crowd.)

When it comes to real theater, we have to reckon with the crafting of a psyche that seems to be enveloped in its own aura. In such instances, it's relevant to speak of the persona, a masklike presence that has appropriated the person, who is supposed to be incarnated in the performance. Portraits of actors being themselves—Hurrell's of Franchot Tone or Tyrone Power—are contradictions in terms. These people were hostages of their own myths, from which it was perilous to lapse. Except for a studied memorial of their image on the silver screen, they had nothing to offer. As the actor gains artistic control, through discipline and restraint—and repeated exposure—the identity

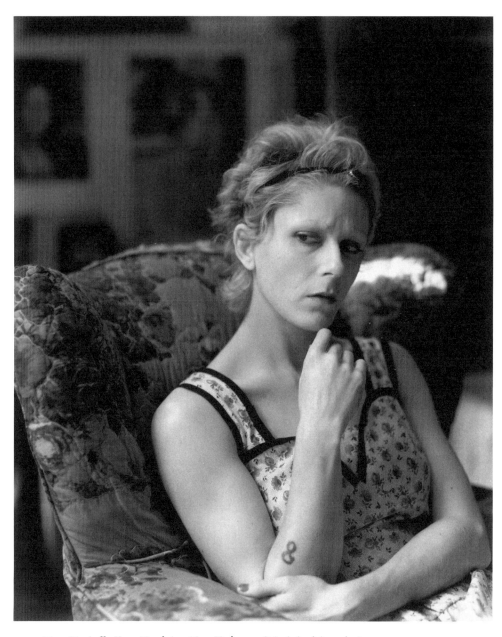

Max Kozloff, *Kate Manheim, New York,* 1978 (original in color).

of the person exerting the control becomes correspondingly glazed over, opaque, and inaccessible. The act of self-creation turns into something like its opposite, as some larger than life or glamorous illusion of the sitter is advanced upon its public. Paradoxically, the outright and apparently most unabashed expression of ego is realized through a form of self-disinvestment. The star *bestows* his or her presence upon the viewers, but the thing dispensed is openly treated as a property, of which the supply lasts only as long as the public demand.

If I study the way the avant-garde theater actress Kate Manheim composed herself, and remember her gestures during our portrait session, it would be to consider performance on quite another level, as mystery. Here was a sitter who wore a chintzy frock, plucked her eyebrows, sported a tattoo on her arm, and painted her lips purple. Her deportment managed to be simultaneously muscular, pensive, and a little suspicious, as if these ill-assorted moods could be synthesized in the poise of one moment's representation. This and other moments, equally weighted and oddly deliberated, she created as we went along. Obviously, the fact that some of the details and dispositions did not accord with each other was foreseen in the performance, and equally obviously, that performance was wrought to achieve narrative suspense, as in the clues it gave of an intriguing instability. So the vaguely discordant display had been arranged to be enjoyed for itself—not as an expression of the sitter, but only as it demonstrated what Manheim's skill and cunning could do. Visualizing a paradigmatic statement in the manner of actors, she had given over—staged—the representation, but she had not drawn it forth. It had not come from a place within her, where portrait viewers would have recognized something of themselves. I couldn't determine if there was any "backing" to the content of the moment or any reference whatsoever to a core—where she came from, where she was going—and the tease of such a question lingers on as the rationale of the image the actress constructed.

Of course, these remarks depend on the idea that people hold something in reserve for us and for themselves, in excess of what their representations allow or claim. This idea has been disputed by those who have concluded that our willful and ephemeral pretenses are, in their own right, a social reality. According to this argument, it's impossible to isolate what is not artifice in the ways we conduct ourselves, and, as a result, we can have no valid criteria of what

constitutes "natural" behavior. Hadn't Kurt Vonnegut said, "We are what we pretend to be; so we must be careful about what we pretend to be"? Thus, it's not a matter of playing or refusing to play a role, but only of selecting the one that best fashions us for the circumstances, or is aligned with desire and need. Role-playing itself remains inescapable, the name of the game. How, then, can a distinction be made between being, and wanting to be taken for, something, even though in a portrait these states are emphatically bound up with each other? One wants to ask: is there no escape from illusion in the communicating stance, and is there no level or dimension of reality in culture other than the endless charades of social reality?

But these questions have to be rephrased once one applies them to pictorial experience. Pictures evoke their own alternate to whatever reality we know or think we know. The assertion that manner triumphs over and absorbs matter is a metaphysical topic, uselessly open-ended as far as portraits are concerned. We simply note their usage as a device to visually isolate what the individual *exhibits*. To exhibit oneself is to imply that one has taken time out from social interaction and process, the continuum in which we are normally perceived. Inevitably, the picture that frames that exhibition reduces, fragments, and therefore short-circuits our understanding of human personality. Sitters for portraits appear as people auditioning for parts in their own lives. And the picture alone tells us how their script performance goes. As the shutter clicks, a gap opens up between obtainable knowledge and the frozen style of the one portrayed, which the picture itself formulates. So, portraits characteristically induce doubts about manner more often than they assuage them.

Such misgivings, I think, are implicitly recognized in the photo-booth strip, whose sitters traditionally ham and mug a little play about themselves through a suite of three or four images, as if to re-enact process. The mood may be playful in the photobooths, but at the same time it hints of a serious human drive, which is to suggest depth and create impact by multiplying physiognomic display. (Of course, these are private self-portraits, which can get a little hectic.) Ordinary consented portraits, whatever their approach, rarely allow sitters to relax in their process, that is, their habitual reflexes, their on-call deployment of related personal traits and idiosyncratic gestures. We have to assume that all practitioners are conscious of these draw-

backs. As a counter-measure, the pose tends to bear down upon us as a peculiar, tensile mode of engagement, suspending the viewer's perception in a compensatory scenario involving the subject. The impression is very forthcoming, with a tone often verging on the hyper. It's something we may glimpse in actual behavior, but it is never as concentrated there, never as literary.

Viewers keep asking who it is they see on the portrait dais. In response, portrait discussion has typically centered on the historical identity of the sitters whose biographies are encapsulated without any reference to the pictures themselves. Evidently so and so's appearance, at age whatever, photographed by what's-his-name, acts merely as a pretext—literally—for the main text. For all practical purposes, that which is externally supplied usurps that which is given, words over image, and the picture is left to mope about, apparently drained of further meaning. But suppose now that, instead of historical, the reading was intended to be symbolical, beyond the range of anyone's mere curriculum vitae.

It's worth taking as an example Robert Mapplethorpe's photo-diptych of himself as leather-clad rough trade and as topless androgyne, an image pair symmetrical in frontality and lighting. The artist yields his own presence to a sexual fantasy, of which he's both the object and the subject. I've spoken elsewhere of posing as a corrupted form of momentum, a state of limbo, neither active nor inactive. Here the corruption is meant to embody certain polarized states—active and passive, profane and sacred, male and female—as projected by the same person. So as to ensure his point absolutely, Mapplethorpe, in these pictures, as in most of his portraits, visualizes the figure iconically. One is not invited to ask who it is but, as with Hollywood glamour shots, to bask in its glow and finally to be seduced by it. Desire is fixated by physical perfection, an academic idea that is also close to fashion appeal. But at least when Mapplethorpe uses himself, in a palpable sense it really is himself: the diptych pertains to him even if "him" becomes a rather questionable entity. Cindy Sherman and Kate Manheim, more sophisticated artists, are also more elliptical and dissociated ones. They have only lent themselves, whereas Mapplethorpe is centered in the proceedings. For all the generality of his statement, it furnishes distinct reference points to the artist's mental life, an aspect of which is acted out in his charade.

Robert Mapplethorpe, *Self-Portrait*, 1980. Copyright c 1980 by the Estate of Robert Mapplethorpe.

In the abstract scheme of Mapplethorpe's self-exhibition, one can see that the "male" portrait, caught up with the myth of the alluring dominator, is lifeless. It fails to exert any effect because the artist's attitude to power is throughout only one of conventional flattery. But Mapplethorpe "female" tells another story. It, too, is involved with a cliché—of feminine vulnerability—and since this requires the outright transfer of viewing power to the unknown spectator, Mapplethorpe can no longer be iconically self-contained as he confronts the lens. It's sufficient to compare the squinting, armored gaze of the one personage with the open, liquid stare of the other to see Mapplethorpe discovering

Robert Mapplethorpe, *Self-Portrait*, 1980. Copyright c 1980 by the Estate of
Robert Mapplethorpe.

the look that yearns for, but is unsure of, approval. It is as if, in terms
of the portrait ritual, he had truly placed himself in the position of a
female sitter, won through to it, and the guise in which he thereby
presents himself has a certain poignance, despite his scheme.

Hopefulness, in fact, is a sign of normal posing. Psychologically,
it animates the portrait presence by suggesting that there is indeed
an impression to be earned, with the sitter flexed and on the mark.
One steps out from the everyday into a portrait and is put on one's
mettle. I aspire, therefore I am; such is the automatic motto of most
sitters. But there remains the question of how that "I" is to be identified

in a picture. The answer to this can mostly be found in the selection of a feature or salience that is recommended because it appears to condense information about the sitter. It could be a liability of the flesh, a stage of life, a hierarchically prescribed status, prominence on a specific occasion, ethnic affiliation or membership in a group, material accoutrements and lifestyle, a genetic or morphic distinctness, erotic tone, familial role, an ideological stance, reaction to the photographer. The list of such defining marks is clearly endless. Portraits will be seen to have depended on one or more of these tags, the more insistently the "identifying" element had visual potentials. Emmet Gowin's wife Edith is very spherically, and thus convincingly, pregnant. A few of August Sander's child subjects are sensationally blind. Bachrach has given us thousands of . . . just grooms.

A problem arises, though, when a viewer asks to what degree the observed attributes belong to the individual, or the individual to the attributes, in which latter case he or she is not very much of an individual. Was it only a certain condition that people wanted to have commemorated in the pose—or with which they thought they had to settle? A condition is a state of being, permanent or temporary, and it may affect deeply or slightly the one who is in it. (Fame, for instance, is certainly a condition one can be in, but so is unedifying fatigue.) For pictorial purposes, however, once the condition is declared it tends to be symbolically decisive. We're encouraged to forget everything else about the sitter, and to let aspiration and condition fuse in whatever way to give meaning to the figurative outcome.

In the event, we're sensitized to the forces that specifically play upon the sitter's features during the portrait ritual. The face is illuminated by a rhetoric that has two seemingly contrary impulses: one which would imbue the picture with an active story content, and the other which would treat the person as an object in a certain static condition. With the first, a link is suggested between the individual's image and his or her everyday life, or at least an affinity between the two. With the second, the sitter appears to have been completed but also isolated in a special cameo role, which admits of no further prospect of change. His or her body has been deputized to incarnate a lasting persona, whether functional or symbolic.

But oddly enough, in portrait practice, these apparently opposing appearances are not only compatible, they tend to inflect each other.

It could well be that the subject forte of portraiture is necessarily a blend of narrative motif and object colorations, and that portraiture is a genre operating to draw them in from the outlying districts of other genres, where, as they mingle, an additional chromatic possibility, a subject, is realized.

Indeed, there's no supply of a quality called "subjecthood" floating around on its own. Most portraits fall short as probes of character and identity, regardless of how assured we remain that such things genuinely reveal our fellow creatures or ourselves, and that we are to be known consistently through them. But I've stated the problem too broadly. A perception of the depth, complexity, and uniqueness of a human being need not be articulated in words or pictures, but if it is, it has to be rendered in terms permitted by words and pictures and must be negotiated by their rules. This will not do justice to the perception, exactly, but it might amplify it. Photographic portraits are framing devices that amplify a certain relationship between the viewed and the viewer. In these matters, we want to be afforded the sense of "seeing in." Hence the word *subject,* which here implies an image of a person to be appraised, yet one who is also perceived to be capable of looking or "feeling" back, unlike a neutral "motif" or "object." We tend to think of portraits as pictures where this reciprocity is specifically acknowledged and kept alive, even if it is not always resolved. If the representation favors the ephemeral glimpse, the sitters may look merely unconcerned, while if they are weighed down by symbolic intent, they may appear only deadened. In from these polarities, toward the center of the portrait spectrum, sitters begin to emerge as kindled beings, almost as if vitalized at photographic contact.

Who would deny that the man called Robert Capa, shown in Ruth Orkin's photograph, is one of their number? By his gesture of head leaning against supporting palm, and his condition, particularly his crinkled, pouched eyes, he allows that he is wearied at the moment, and has been seasoned overmuch by experience. Glasses on the restaurant table suggest there has been drinking. Meanwhile, he smiles kitty-corner toward the camera, or more precisely at a woman with a camera, seated with him at the table. And now, of course, he smiles at the viewer. By the look of things, the portrait was taken during a pause in conversation. Capa the person and Capa the sitter would seem closely related, and yet the performance in the portrait has overtones

that look studied, or at least practiced. Here is someone who would agree with Kirk Douglas's remark that "the actor never gets lost in the character he's playing; the audience does." Capa's is not so much a face whose geniality has been prepared specifically for the camera, as one that accepts its gaze while in the process assuming full knowledge of the portrait act. I stare at him and there comes back to me his canniness about what it means to be looked at. The slight smile tells of his amusement at being in that scene, at another's visual disposal, but the eyes look out shrewdly, as if to say that on other occasions he is capable of using others less gently than he is being used now.

On one level, the text of this picture could read: here is a person who has decided to be nice about the superior consciousness he has. But on another level, it doesn't work that way at all, because the overall persona expresses a charm that is involved—I was about to say compromised—with rue. The naïvetés of aspiration fail to perk up this man's spirit—he's past that—but, at the same time, there's no substitute for them. How does one "be" oneself in a circumstance like this? A conflict arises in which the desire *not* "to be what one pretends to be" is defeated by the prerequisites of posing. And the irony of this dilemma, reflected and yet created in Capa's demeanor, is extraordinarily moving.

It could be said that Capa's was an exceptional case. At the date of this picture, 1951, he was, after all, the most famous war photographer of the twentieth century. So take, instead, the case of a sitter who demonstrates no such virtuosity as a performer, and who appears unaccustomed to receiving the camera's attention. I refer to "Mrs. Gudger," photographed by Walker Evans in 1936. This young woman is well absorbed by the portrait moment, an interval which definitely excludes the other cares in her life. The physical portrayal comprises only her head and shoulders flat up against a pineboard wall. There's no hint whatsoever of an impulse on her part to outflank the camera's stare. She takes it on directly, as the point of what has been asked of her—to hold still. In its calm, simple, and pinched way, the face says "I am having my picture taken," and that's it.

Of course, the face and the wall go together remarkably well; they're both unpainted and penurious. And then one notices that the information furnished through the lens is insistently tactile—for example,

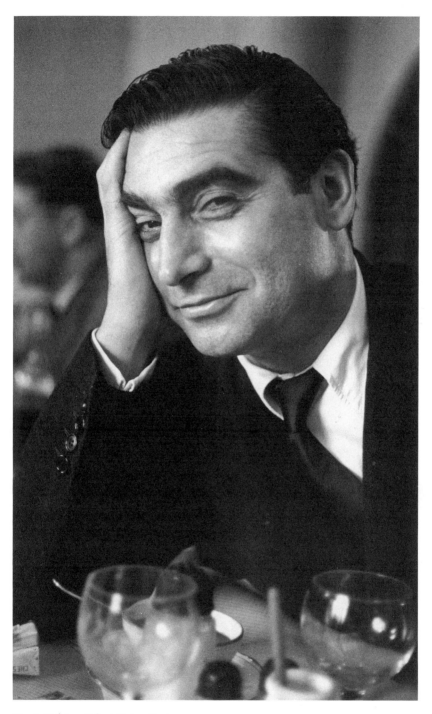

Ruth Orkin, *Robert Capa, Paris,* 1951.

the woodgrain and the dress pattern, which complement each other and frame Mrs. Gudger's drylooking, scrubbed skin pulled tight. Evans describes her as he would a plain but eloquent *object*. So it's proper to speak of the priority he gives to her condition, quite pronounced in this instance if only because the sitter offers little else for visual record. To be sure, she proposes herself as a subject, and wants to live up to the small occasion with ordinary understanding. Of three shots taken by the photographer, this one is most furrowed about the mouth, whose thin lips are tightly compressed to keep them from the real—and banal—possibility of smiling.

However little she can muster of power, pretense, or grace, Mrs. Gudger makes herself presentable. This is precisely what the picture would have us regard as being of high intensity and worth. That is, her pose is treated with just as much respect as the other humble but radiant physical details, and, like them, reinforces the immediacy of overall contact. All this is compatible with the title that most often accompanies this picture, *Alabama Tenant Farmer's Wife,* a specific, even evocative, label. She fits that caption visibly enough, but more than that, she illuminates it. She comes right out of the type that is said to represent her. Every physical detail is "backed up" and warranted in the final *self*-possession of the subject. At first I imagine this is because photographer and sitter are leveled in a working equity each has established with the other. Later, I revise this impression with the feeling that the photographer had considered it a privilege to be accepted by his sitter. If that is so, the transparent life of the portrait is the best index of its moral beauty.

Any general commentary about portraits should include some idea about their psychological reach and affective power. Clearly that power is linked to the centrality of *subject* in portrait experience. To put it crudely, subjects are made and not born. But just the same, who would enjoy the thought that such a constructed subject is *not* founded on any psychological reality? Portrait performance springs up and through the personal organism depicted, and energizes the picture in ways that are uniquely characteristic of the actor. To deny this point is to question the obvious difference between artifice and deceit; that is, between a representation of content, and a statement that is meant to lie. We do not believe that portraiture projects a sitter whose concealment of real motive is appropriate and expected, but rather that, at its best,

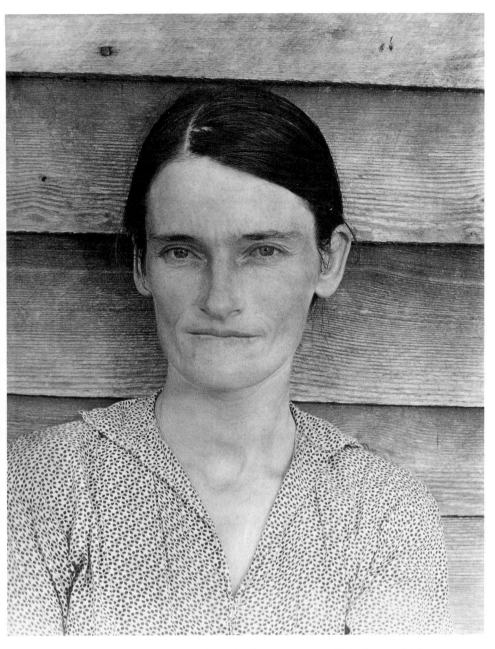

Walker Evans, *Allie Mae Burroughs, wife of a cotton cropper, Hale County, Alabama,* 1936. Courtesy Library of Congress.

the genre intends to open us up to the human interior. The problem faced by sitters, however, is to convince others that their appearances are "like" themselves, their deep selves, and they must convey that impression by a form of exhibit that usually provides the viewer no model of comparison—nothing unlike or "less" like who they are.

So, one could ask how it might be possible to decide whether any sitter is or isn't represented adequately by a pose. But this issue of adequate resemblance is thoroughly misleading, even if the critique of portraiture has to fasten on some scheme of a *truth* to self as the chief allusion to content in the genre. And, as if this weren't difficult enough, the abstract phrase "truth to self" is practically useless, because no one can agree about what either a truth or a self might actually mean in this pictorial context, let alone in volatile states of individual consciousness. It might seem advisable to drop the whole argument, but for the fact that portrait aesthetics are strongly influenced by a realist premise. It was because they successfully projected a sense of personal disclosure that I discussed the pictures of Robert Capa and Mrs. Gudger. Realism, in their cases, means a form and an attitude that would convey the feeling of those inner states induced in the sitter when examined by a camera. So, the "truth to self" becomes the truth to *that* curious moment of the self's perception. Such a palpable degree of autoreflexiveness is how I would account for the very different candid effects that work their way out of the Orkin and Evans photographs.

But of course they still leave a great deal unsaid, including perhaps the greater part of what we want to know. Elias Canetti wrote, "The outer bearing of people is so ambiguous that you only have to present yourself as you are to live fully unrecognized and concealed." It is strange that "Robert Capa" and "Mrs. Gudger" were only pseudonyms of the sitters in those photographs. (Real names: André Friedman and Allie Mae Burroughs.) But perhaps that shouldn't be surprising, and the pseudonyms are symptomatic of an ongoing dilemma. Instead of depths that are deliberately withheld, portraits more often offer us mysteries that can't help themselves. In studying photographic portraits, we focus, I think, on this seductive impenetrability. And it's the face that conjures it up . . . that in fact embodies it. All other points, the clothes or gestures or contexts, are of secondary interest. They amount to so much socially coded information, and the face

can't be counted on to obey any social program. In certain portraits, just when everything seems to have been settled and the picture is home free, into meaning, the face demurs. For me, the most affecting portraits are those that accept, even seek out the unintended enigma of the face, or that have glimpsed it while concerned with something else.

Clearly any exploration of the *affective* tones will be at some angle to the *functional* and *generic* notions of portraiture. But then, other photographic genres are not crucially involved, as is this one, with the articulateness of the face. Given its endless fertility of expression, the face can insinuate random meanings distinct from the signs which conventionally narrate or objectify the personality.

This is difficult to think about because we routinely use our faces to implement just those signs, and are certainly reminded of them when our pictures are taken. The face is always larger and freer in its emotional possibilities than genre guidelines admit. It can interfere with their decorum if it is not composed with sufficient blandness. Or worse, its humanity can pose a serious threat to the corporate message network, a point demonstrated by the practice of fashion photographers, who, when dealing with faces, never fail to make a beeline to the vapid.

The influence of media norms upon the representation of the human face is suppressive. It standardizes the face's repertoire, and rules out of order all kinds of spontaneities and shocks. They have nowhere to go anymore, except in portraiture. Though it, too, has its regulations, as we know, portraiture remains the primary showcase for a face *released* to play within a much more realistic, that is, infinitely shaded, gamut of its expressions. Out of these finely gradated physiognomic tones which photographs discriminate, there is suggested a world of consciousness with which we cast our lot.

This essay originally appeared in *Aperture* 114 (Spring 1989).

A Double Portrait of Cecil Beaton

DEGAS ONCE chafed Whistler who wore a cape and sported a monocle, by saying, "My dear friend, you dress as if you had no talent." Cecil Beaton adopted a similar pose during a career that enabled him to photograph Lillie Langtry in the beginning and Mick Jagger at the end. Unquestionably an artist of special refinement, he posed almost fatally as one who was "artistic." The pose has kept his name alive as a character who played various hothouse scenes in Mayfair and Hollywood and among the Manhattan and Palm Springs hoi polloi of the depression thirties. The summer's immense Beaton retrospective at the Barbican Art Gallery, in the Barbican Centre, London, reconstructed this sense of his foppish theatrics, and yet, with much unpublished material and new comment, it proposed a thoroughly new vision of them. As a photographer, Beaton emerged as an intricate strategist, whose work has strange depths and a bright future. I came away thinking I was in the presence of another legend and that Beaton could be the Scarlet Pimpernel of photography.

To be sure, Beaton's fleecy society sketches, illustrations, costumes, and interior decors betray the stamp of the froufrou, which is not so much the genuinely lighthearted as the sententiously arch and casual. He penned these things often at the last minute and feverishly, as if they were annoying distractions from the real business of life's party. They have an artistic merit on the nether side of inkings by, say, Ludwig Bemelmans or Marcel Vertès, two forgettable illustrators of the period 1935–55. As for his photographs, he disingenuously an-

nounced that they were just as offhanded, which did much to hinder their recognition. This sometime playwright and constant poseur insisted that he held his photography in low esteem because it came too easily to him. Behind his denial of professional expertise, however, lay the implication of a natural vision, which has to be considered against the grain of his public legend.

In Beaton's view one did not admit that one worked hard to realize images, even those that became famous. But this disdain for manual input—the activity of a tradesman—was just one more item in the effortful calculations of his pose. When Condé Nast demanded that he give up his old folding snapshot Kodak for a huge and strenuous camera, and that he study lighting—get sharp—Beaton tended to lose his touch. The distance in time from which he emulated the great genteel amateurs of British nineteenth-century photography only emphasized the deliberately throwback character of his position in the twentieth century. He skirted perilously close to the border between the amateur in the earlier, aristocratic sense of the word and the dilettante, in ours. But he had a spontaneous need to enjoy himself, which was of the moment.

Unlike his drawings, photography demanded that his enjoyment be filtered through a machine, which tempered the results at a certain remove from his immediate desire. The characteristically good Beaton photograph visualizes people and situations much more delicately in the flesh than if he had drawn them from observation. Elegance one would have expected, but delicacy—not just in the early soft pictorial manner but in his response to human beings: this feature freshened the show. Whether consciously or not the sitters function as performers in a scenario constructed by the photographer. Often there's a contrast between foolish trappings or silly circumstance and the reflectiveness of his subjects—but it's not as if Beaton himself draws the distinction. He rarely elaborates his ideas at the expense of the subjects' inwardness, an atmospheric zone into which they are allowed—or encouraged—to retreat. The image does its work as a composite of garrulous surrounding and laconic presence. Each exists side by side but also as a reserve of the other. The poise, even the gravity of the figure is never so extreme as to foreclose the possibility of personal collaboration between performer and director. Edith Sitwell appears as an alabaster figurine dwarfed with her black maid serving breakfast under the

looming canopy of her eighteenth-century four-poster bed. As was intended, this 1930 scene is reminiscent of a genre piece by Johan Zoffany: one of Beaton's preferred minor masters. But this rococo fantasy also behaves as a document of a very particular milieu. Not only was this Sitwell's home and those her furnishings, but the picture formally displays her idea of class (and race) relationships animated by her vitreous little smile that shared in Beaton's game.

The Sitwells were Beaton's earliest important patrons and his pictures of their family catapulted him from the wings of fashion and media to the center stage of British and then American *Vogue*. He needed no lessons in effeteness and preciosity from the Sitwells: Baron Adolf de Meyer was his pictorial mentor, and young men often painted and powdered their faces at Cambridge, from which Beaton had recently emerged. But he did gain the Sitwells' connections as well as their support at his debut exhibition. That event in 1927 launched a very curious photographic career in which a revivalist sensibility intersected with Modernism, the whole alibied and supported by the main-line fashion work. Beaton had a genuine temperament as "a couturier, a historical revivalist, and a social observer with a too-particular sense of both past and present," as Ian Jeffrey and David Mellor, the show's curator, observe in the Barbican catalogue.[1] But if extravagant artifice was Beaton's occupational specialty, he would nevertheless overplay it or catch it out, as if to expose it. In the same way, the contextual froth of the Barbican installation, plastic flowers and phony obelisks, though festive, was deliberately chintzy and not entirely celebrational. Matter-of-fact photography made it possible for Beaton to let show the slip of representation as supposedly part of what was there, what was merely given. Sometimes this could be subtly qualified, as in the glimpse, among older things, of a twenties baroque screen in the Sitwell bedroom. More often, the saving glitch appears in the person of the photographer or of the photographer's assistant, agents of production actually within the scene produced.

One such scene from 1949 contains a man on the left who kneels holding a metal surface that reflects sunlight on the vertical figure of nineteen-year-old Princess Margaret, on the right. They are separated by a corridor which plunges deep into the pictorial space, but are functionally associated in a joint activity. In that it accentuates what

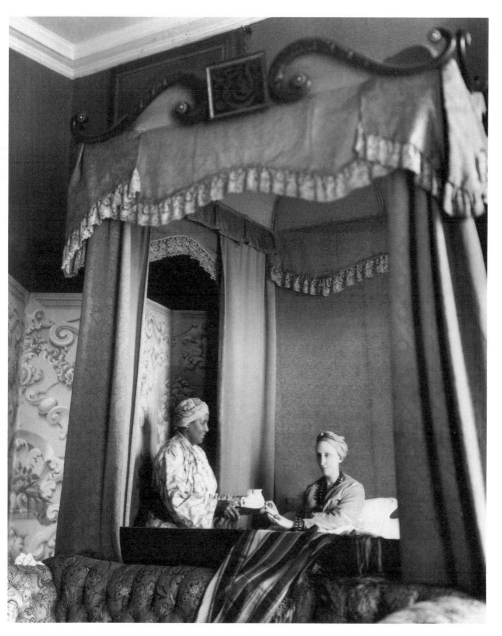

Cecil Beaton, *Edith Sitwell receiving breakfast in bed at Renishaw*, 1930. Courtesy
Sotheby's London.

has been staged, this photograph might be thought improper for an official royal portrait. But the deference of the man who simultaneously aids the picture and cleverly helps nature illuminate the princess restores the image to its task. Take away the extra and the poetry would quite frankly go with the wind. Beaton, by his "indiscreet" framing, achieves a witty homage that also acknowledges his own role in the charade.

An aesthetic principle of the Modernist was to unmask or otherwise denature representational modes, apparently in the name of truth-telling. As part of its shifting equivocal strategy, some Modernist work ironically compares representational modes, as in collage. Timorously in this spirit and despite his vegetal historicism, Beaton appears as a Modernist without portfolio. Practically on his own he questioned the theatrical solitude of the fashion and portrait styles. He often personally intervened within the dramatic metaphor of the pictorial space. By the logic of the scene he could have been relied on to be near Picasso when the great artist posed, but he shows himself actually with him in the mirror. The conceit is not only that the Englishman collaborates with Picasso, but also that his presence can't literally be removed from the picture—which is now liquidly a composite, a double portrait. Yet for all that he gets into the act with Picasso, Beaton is strangely enough not intrusive. (He's out of focus and in small scale.) The photographer reveals himself seriously regarding (an active process) not only the (nominal) subject but himself posing passively. The desire to participate in both psychological ways is hardly surprising in an artist who perceived himself to have a chronic lifelong problem. For he premised his life on certain tense basic denials: of his middle-class social origin, always, and of his homosexuality, intermittently.

As everywhere noticed by good friends, Beaton was possessed by a continuous diffidence within his extroverted persona. At the same time, though a conservative man who desperately sought the respect-able, he was compelled to flaunt what, for society, was a pronounced deviance. Exhibitionism was central to his identity, and he made a spectacle of himself both in the social whirl and in self-portraits realized by timers or mirrors. Anyone who talks about his photography must at some point discuss its taste for masquerade. This man, who designed ballet, theater, and film costumes for others, was frequently in costume himself, and available for the camera. In youth, aside from the clothes

of kings or princes, the outfit of choice was that of the opposite sex. British popular entertainment has long stressed female impersonation, a staple that is considered very funny. The falsetto screeches of the Monty Python troupe and Benny Hill are late examples of the idiom. Women, imitated negligently by these fellows, usually appear as pea-brained, lowbrow, frumpish creatures. Since the "real" gender orientation of the players has been established in other skits, such male vaudeville can be called heterosexual female depiction. Beaton depicts an instance of it himself when, in 1932, he shows those notorious skirt-chasers the Marx brothers as a chorus lifting its pants legs to expose absurd bony shanks. But there is another kind of drag masque taking place in many of his scenes, those that express sexual cross-dressing as a true social ritual in which homosexual signals are meant to be exchanged from like to like.

Beaton's early portraits of himself and his upper-class bohemian friends depict so many pseudo-females that they perhaps outnumber the real ones. Both pictorial types, in any event, are generally dressed in pearlescent ballroom getups and have a would-be sexual fragrance that is also naive, as if kids were trying out mummie's gowns of yesteryear. The ideal female personage in Beaton's early photography is virginal, the Madonna, a role in which he cast his mother and then, later, Lady Diana Cooper. Mellor is surely right to stress the centrality in Beaton's adult mind of his infant adoration of a postcard photograph of Lily Elsie, an Edwardian actress, which he encountered once when his mother was opening mail in her bed. This episode Beaton used as the founding myth of his vision. The first task of his photography was to present his mother as a distinguished society woman or, rather, as an actress in that guise. Outside their cliques and raunchy parties and their performances at the Amateur Dramatic Company, sometimes attended by "dirty old men" come down from London, the Cambridge group was at risk in the everyday homophobic pressure around it. Beaton was sensitive to this pressure, and even, in part, sympathetic to it. In 1923, he wrote in his diary,

> I've never been in love with women and I don't think I ever shall in the way that I have been in love with men. I'm really a terrible terrible homosexualist and try so hard not to be. I try so terribly hard to be good and not cheap and horrid.[2]

Seven years later he resumed wearily,

> if any pretence was necessary it needed as much and more to pretend
> one was a gay and coy young girl than to be a strapping and healthy
> young dog. I told Charles [James] that I have always hated fairies
> collectively . . . they frighten and nauseate me and I see so vividly
> myself shadowed in so many of them.[3]

The conviction that one's behavior within a group is self-incriminating
when seen by outsiders releases anger toward the group, but the group,
nevertheless, is the only milieu that feels hospitable.

In the thirties, Beaton seems to have felt professionally trapped in
his escapist routines. Paradoxically some of the trouble that brewed
between him and American *Vogue* later in the decade revolved around
his notions of Edwardian revival as à la mode, and the staff's sense
that this was literally old hat. He associated the Edwardian moment
by this time with monarchy, and his portraits of the Queen Mother
(then the queen of George VI) as a belle époque matron achieved
fabulous postcard currency in the British Empire during World War
II. The Americans liked royals very well as celebrities but were cer-
tainly not in awe of their fashion consciousness. So the dissension
between the editors and the photographer was part a dispute about
fashion style and part a cultural conflict, a small Anglo-American spat.
For Beaton, however, the affair could have had other, internal mean-
ings, in which the professional stakes merged with ethnic loyalty and
a sexual confusion summoned by the word and role of "queen." Like
mother, as she could have been fancied, the nonsexual queen was good,
but to him "queens" were the contrary. Here was his personal antithesis
between the sacred and the profane, in which the memory of the
former was counterfeited by the infamous mimicry of the latter.

The rhetoric of the fashion trade required Beaton to show women
reduced to objects and emblems, devoid of human character. But at
the same time it was possible for him to view such objectification for
what it was. As his remark about his difficulties in pretending to be
either "a coy young girl" or a "strapping young dog" indicate, Beaton
could perceive acting—his own no less than anyone else's—as a sad
ruse. In a photograph called Mock Puppet Theater, 1936, showing

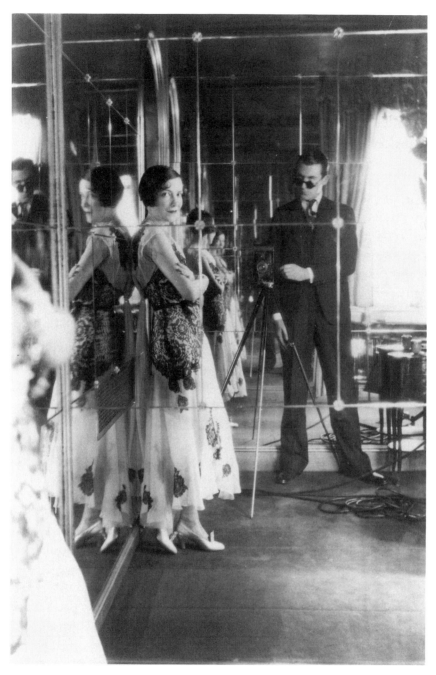

Cecil Beaton, *Adèle Astaire and Cecil Beaton*, 1931. Courtesy Sotheby's London.

two pretty models on a small proscenium, their arms, heads, and even pigtails weakly pulled by strings, these feelings are allegorized. It is a very strange picture to have appeared in *Vogue* because it can obviously be read as antifashion. The subjects are literally acting out their status as only mannequins. Once again, Beaton uncovers by masquerade, that is by overt subterfuge intending to fool no one but still to drive home a point.

He was often keen to photograph strong women in socially exposed positions, personalities who had, as the cliché goes, some "male' decisive manner to them, like Tallulah Bankhead, Marlene Dietrich, Greta Garbo, and Wallis Simpson. It was as if they represented an attractive composite of masterful and yielding behavior, the perfect subtext for his particular invocation of the media portrait. The mirrors in many Beaton photographs work as a kind of advertisement, I think, of the split he sensed in himself and in several of his sitters. The mirrors operate as devices used to consult his own demeanor and to make visual the dualities to which he was attuned in human character. Sometimes he could achieve such an effect by literal cutting and pasting as in a ca. 1936 photomontage of Katharine Hepburn. The more one looks at this twin portrayal with Hepburn frowning on one side, cheerful on the other, the more its initial coquettishness fades into an anxious mien. The poised, rippling fingers and the lines around the mouth are repeated on left and right, acting as apparent mirror reflections, but they don't come out even. In fact the accent on symmetry is a transparent miscue. The photograph is still a play on the mirror, however, and the mirror is central to Beaton's outlook, conceptually as well as physically. Its obvious Cubist and Surrealist implications have their way in his scenarios, though they need not be dwelt on, and, in any event, are put to other uses. Rather the mirror motif time and again invites the question of where to look and of how to look at the face. In a totally mirrored room in 1931 Adèle Astaire poses with her photographer among infinite versions of herself, all of which convey her one pose, but from more angles than she could prepare for. This kind of multiplicity adds nuance to selfhood because it offers a spectrum of different moods to the same face. (There are many actual multiple exposures of heads in Beaton's portraiture as well.)

Such effects climax in a remarkable picture entitled Mirror, Bed and Camera: Self-Portrait with Admiral Lord Louis Mountbatten, Faridkot

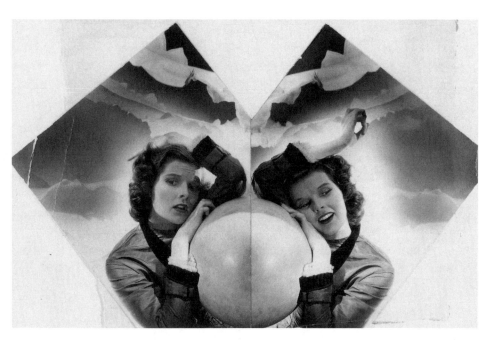

Cecil Beaton, *Katherine Hepburn,* ca. 1936. Courtesy Sotheby's London.

House, Delhi, 1944. The caption has a seductive, not to say baccha-
nalian, tone, belied by the sedate though confusing appearance of four
figures, all of them reflections, floating below, as if seen from a height.
The lower and more legible gentlemen, separated decorously on their
bed by a bolster, are relaxed and affable as they look up at themselves
in the mirrored ceiling. Not so the upside-down gentlemen reflected
in the mirrored wall. Its glass panels cross through them, blur their
bodies, give Beaton four hands, and produce on Mountbatten's face
and figure a stiff and sullen bearing. What starts off as a kind of in
joke about offbeat familiarity turns into a darker, more questionable
scene altered in the twinkle of a mirror. László Moholy-Nagy, during
his Bauhaus years, could not have produced a more surprising formal
invention, and yet it mustn't be forgotten that Beaton's picture shows
the Supreme Commander of allied forces in Southeast Asia—that his
image belongs, of all things, to the category of war photography.

The thousands of pictures this master of fashion produced while
working for the British Ministry of Information and the Royal Air
Force are finally like those of no other war photographer and yet are
startlingly right and true for the English, or, rather, the English Tories

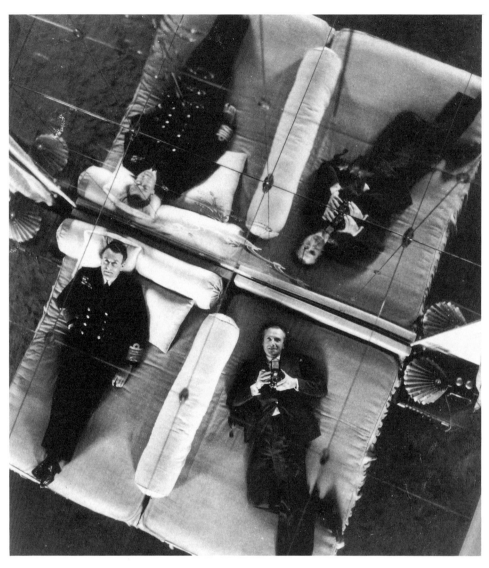

Cecil Beaton, *Self-Portrait with Admiral Lord Louis Mountbatten, Faridkot House, Delhi,* 1944. Courtesy Sotheby's London.

of the time. He had been told to stress "might," "force," and he gave the MOI trouble by rendering instead the smartness of the soldiers, or, more often, the officers and their masculine charm. In photographs taken throughout the various theaters to which he was sent, after documenting the blitz, evacuated children, and airfields at home, the atmosphere sparkles softly and the touch is incredibly light. He is

Cecil Beaton, from the series "Fashion Is Indestructible (Digby Morton Suit),"
1941. Courtesy Sotheby's London.

resolutely undramatic, unforced, in the African desert and the Middle
East, and he adopts the attitude of the privileged visitor (which he
was) in India and China, where his Rolleiflex focused on genre details
in hospitals, viceregal life, the natives and their condition, training,
and the relations between men and their machines (the latter braced
by fragile struts and cranked by hand). In comparison with these
works, those of the Edward Steichen team and W. Eugene Smith in
the Pacific stand out all the more as pictures of operatic juggernaut
and sweaty inferno. Theirs was grandiose John Ford or Life magazine
propaganda—the sweep of matériel and everywhere determined fight-
ing men with high-precision and dangerous jobs to do. Beaton's mil-
itary, on the other hand, have misadventures, but there's nothing
tragic in their lot, and actual violence is peripheral to the moment in
which they're photographed, a sensory moment in the lives of dis-
placed, unflappable, insular men who seem to belong together, or get
on with each other, as in a club. In fact, Beaton did land in one old-
boy network after another, as he went from post to post along a circuit
of former collegemates and acquaintances. On one level, these are

modest pictures, seemingly tentative glimpses only of an unimpressive war effort. But on another, they are quite presumptuous because they operate through pleasure, one man's epicurean savoring of the phenomena of place and the animation of human features, regardless of the charnel magnitude of the events in which everyone was immersed.

By his own account and that of many others, the war drastically changed Beaton: that is, sobered him. But this was true only up to a point. The look of his war photographs is provisional and fragmentary, but this was also the mode of the street photography that he'd been practicing for the last ten years. These street pictures were taken for his own benefit during his annual business trips to the States and on his European jaunts. They were jeux d'esprit holidays from the serious frivolity of his fashion work and the lettuce of the socialite and royal portraiture. As soon as one came upon the street work in the Barbican Centre, it felt as if a window had been opened to let in some of the air of the times. Like many other fine street images of the thirties, they have much type in them, signage, and they deal with media, parades, the selling of newspapers, headlines, advertisements. Walking the streets of the metropolis, the photographer takes in the blazoning of sports, murders, politics, and his accent is that of one attentive to the visual noise it makes. Such, too, is the import of a self-portrait from 1937, in which he shows himself in a hotel bed, swamped by strewn pages of the Sunday New York Times—the idea being that here is a person avid to keep tabs on the world. The newsprint becomes not only bedclothes but costume in a cascade so farcically excessive as to deny any possibility that Beaton was a serious reader. In fact, his personal indifference to the events of journalism and of history, or to the lives of anyone outside his camarillas, was so marked as to make this image one of his most willful masquerades.

When it came to personalities Beaton was impressionable; but when it came to any moral consciousness of the public issues around him he had little. In pursuit of amour he thought nothing of traveling in fascist Italy and Nazi Germany during the time those regimes were rounding up their Jews and helping Franco to annihilate the Spanish Loyalists. He no more perceived the despair of the Jazz Age than the anxiety of the French Popular Front. Instead of swimming among the most glittering and gilded youth of his era, as he thought, he identified with the most pampered, selfish, and reactionary in their political

values. The depression hardly figures in Beaton's diaries, but racist epithets do. He was surprised that anti-Semitic phrases he penned into a *Vogue* illustration in 1938 created a violent tumult and that he was sacked because of it. But he was truly shocked that some of his friends rallied to his "cause," as if it had been political conviction that motivated him instead of arriviste snobbery. Vivid as are many of the personal observations in his diaries, we get the idea of someone with deficient social radar. In terms of career strategy, his celebration of the defecting Windsors, though profitable, ought not to have put him in good odor with the royal family, but he was in fact shortly thereafter, in 1939, placed at the summit of his career by the patronage of the queen. This was certainly the great arrival, which brought with it major dividends of power, in Mellor's words, "as a writer of history, a manufacturer of popular memory."[4] Mellor goes on to say that "the advent of the twentieth century, of mechanization, of total war, of all the kinds of ways in which that invades the structures of everyday life is a great threat to Beaton, and what he can throw against that is the memory of what came before. The memory of the idyllic childhood, specifically of a childhood . . . composed out of society ladies and actresses."[5] Such was the personality, repute, and outlook of a man thrust into a virile world of killing, a man who would make the major photographic statement about the way the English waged World War II.

Of course it was a uniformed, hierarchical world, like the English class system, where people know their place. But the place had changed. RAF trainees jog past a sphinx on the grounds of one of the great houses. A 1941 fighter pilot reads a Penguin paperback, Henry Williamson's Tarka the Otter, in a wicker chair in what looks like the hall of a resort pavilion, its far windows taped against bomb blasts in a pattern that reminds one of the Union Jack. City children, taken to the country out of the path of bombers, have a pathetically disoriented look, to which Beaton clearly responded—it mirrored his current life. In one 1940 photograph, a German explosive has severed the head of a shop-window mannequin of the old-fashioned, rose-bud, angelic sort, which rests upside down amid shattered ruins. The amalgam of the city's destruction and that of the painted plaster flesh symbolizes the threat to the old order, and is figured here through Beaton's earlier technique of laconic presence with busy environment.

But in this altered context the effect is grotesque. What makes it so is not just the visual pandemonium of the scene but its synecdochic concision. Passersby thought there was something indecent in the spectacle of a man arranging a broken doll's head in blitz-torn London. Sensibly, they grasped neither the childishness of his fixation nor the guile of his metaphor. Of the things that had gone, this object meant little, yet he made it signify much. In fact, to continue as he had in these prickly circumstances suggests flagrant innocence or subtle irony— perhaps a combination of both. Certainly, one is struck by the perpetually small psychological scale of Beaton's vignettes when compared with or as representative of cataclysm. Here was someone at the center of it and he kept on thinking of the margins. At first this tactic appears to misfire as fatal disproportion, until one takes away one's American lens and sees British understatement.

Beaton was close enough to the French to be at home with their indication of a street environment as a "decor." But decor with Beaton means something artificial, an inanimate support (or perhaps contradiction) to a narrative idea. In Hollywood, he had included props, scaffolds, and lights as attributes of the stars' work and as antidotes to their aura, which was the rationale for shooting them in the first place. Yet prosaic setting did not diminish his subjects, since Beaton was so obviously susceptible to them as animal beings. Princess Natasha Paley could pose before upended bedsprings and neither lose her dignity nor suppress a clear, unforgettable disjunction. On that score, no one has ever equaled the bad taste displayed by Beaton in 1941, when he made a fashion model pose against a bombed-out arcade. The war— just then going very badly for England—was reduced to a mere backdrop for a gesture of insufferable chic (or rather the backdrop made the chic insufferable). Of course, the *Vogue* photograph was meant to say something else, for its caption states, "Her poise unshaken, she reads about the other fire of London in which the earlier Temple was destroyed."[6] News pictures of government leaders visiting the ruins were part of the media context of the image. So this immaculate woman, in the Digby Morton suit, was taking their place on behalf of the patriotism of the fashion world.

The odd thing about the Beaton war photographs is not their self-conscious private artistry—the MOI held this royal photographer on a relatively loose tether—but that such war images were realized with

a feminine sensibility. Beaton represented that point of view una-
bashedly in a totally male-oriented environment. An outrageous figure
of war photography develops: one who deliberately fails in news ini-
tiative, who is averse to seeing action, and who would anyway faint
at the sight of blood. But I will not call this man timid. Robert Capa
was a brave combat photographer, but even he would never have dared
to invite Dwight Eisenhower to join him on a bed to have their picture
taken. The complaisant Mountbatten belonged to the highest strain
of English ruling-class culture, a strain in which Beaton had found a
place. The photographer expressed a self-image of that culture when
he depicted the military caste and colonial elites—though locked in
a desperate historical struggle which they were eventually, after the
war, to lose—as if in no crisis, or, better still, impervious to challenge.
If the sangfroid seems a little exaggerated it's because Beaton himself
doesn't believe in this deluded prophylactic situation. As he put it
ironically in a letter, "everything looked so idyllic, like a wonderful
picnic party with mules and jeeps bringing up the tea things and if
someone's head got in the way of a bit of shrapnel, well it was just
too bad. But accidents do happen at picnics."[7]

What Beaton left out reinforced the propaganda message of his war
photographs, just as his fashion images were undermined by certain
of his inclusions. Friedrich Nietzsche said, "Women would not have
had such a genius for decoration if they were not resigned to playing
a subordinate role." The themes of decoration, power, art, fashion,
and history are entwined in Beaton's career with more twists than a
pretzel. Nothing could have been more out of date, after the war,
with America's political ascent, than for Beaton to insist as he did on
reviving his revivals—the Edwardian fictions that had made him orig-
inal in the thirties. Fashion photographers had often looked for ideas
to cultural models not only of high social prestige but ones known
for forcing the pace of visual and perceptual change—the Modernist
avant-gardes. But most often fashion can only accommodate such
modernisms when they are thought to be "safe," and that is generally
at a time when the conceptual heat in art has moved on to something
else. From cultural perspectives, art-conscious fashion is decidedly
arrière garde, and the kiss of fashion is the goodbye kiss to the "ism"
in question. A prominent sector of fashion photography, on one level,
is a hyperbolic, after-the-fact, and obtuse version of twentieth-century

art movements, and fashion photographers, despite their pretensions to high aristocratic style, are defensive and compensatory in their relation to art. Behind all of fashion photography, there was once, wrote Alexander Liberman of *Vogue*, "an ideal of decency, an ideal of furthering the civilizing influence of culture and taste."[8] When fashion photography is arresting, however, it's not because of its dead "civilizing" (read imperious) mission, as Liberman imagined, but because of its living vulgarity. This had once been Beaton's forte, with his youthful burlesque turned skeptical around its edges. On the other hand, his postwar fashion moves with straight decorative coquetry, and despite the grand pop victory of two Oscars (color costume design and color art direction) for the 1964 film version of My Fair Lady, led only to farce.

Beaton's life was ridden with farce, as so often when he drove himself to arrive in fields where he had been long accepted, had little competence, or was not welcome. This ensured a youthful vigor but did not guarantee any peace of mind. The two great love affairs of his life reveal him as a victim who needed to be toyed with by uncommitted partners. But his photographs of the second of these, Garbo, grace the one field where he was truly luminous: portraiture. In all his other enterprises, the payoff was in getting attention; in portraiture, the pleasure was in yielding it. There's a difference between necessarily paying attention, as in much of his commercial portraiture, and giving attention, a voluntary and generous observance of the ones he cared for, or who excited, amused, or touched him. These included his young sisters and Buster Keaton, Walter Sickert, and Marilyn Monroe, Mrs. Mosscockle, Cole Porter, Garbo, and, of course, himself.

The Garbo portraiture is interesting because here was a woman who refused to confirm Nietzsche's remark about her subordinate role and who yet entered history as an indefinable object of display. Beaton's slack pictures of the dreamy Garbo do little visual justice to her, even as their intimacy stressed his involvement with her. But the episode is revealing of the demands of the portrait mode. Though a portrait depicts, a picture with a person prominently in it is not necessarily a portrait. And a portrait may not be much of a picture.

For much of his career, the photographer thought to resolve the simultaneous demands of pictures and portraits by active visual fields that would keep the eye engaged right up to their edges. If the activity

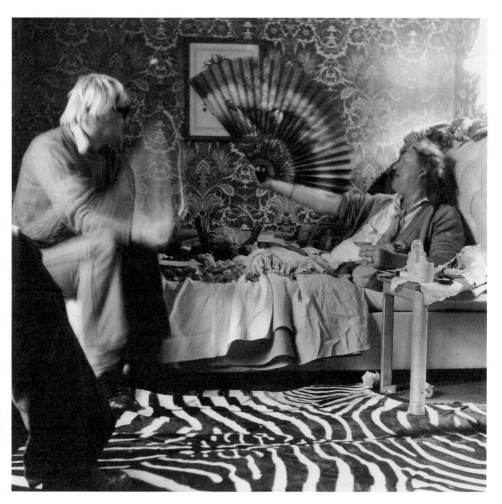

Cecil Beaton, *David Hockney with the Hon. Stephen Tennant,* 1971. Courtesy Sotheby's London.

told of the sitter's history, so much the better. With the Garbo portraits, there is no decorativeness of dress or ambience, and not even much of a figure to speculate about. There is only a face. Great portraits act unforgettably as carriers of temperament, such that the picture seems absorbed by that temperament, or selflessly given over to it whatever the rhetoric of the pose or weight and duration of the scrutiny. This memorableness isn't to be confused with familiarity, and it's a measure of Beaton's achievement here that some of the faces of his celebrities are as memorable as those of his unknowns.

In Beaton's diaries, the most acute wordplay evokes the look and manner of people through their organismic display and odd accents in fugitive moments. The Duke of Windsor's face

> now begins to show the emptiness of life. It is too impertinent to be tragic. . . . The eyes do not correspond. He looks like a mad terrier, haunted one moment and then with a flick of the head he is laughing fecklessly.[9]

An aperçu of this kind, in which the spirit of the diary takes chilling visual form, is the previously unexhibited A Pair of Photographs of the Hon. Stephen Tennant, 1971, noted in the catalogue as "taken on a visit to Wilsford with David Hockney." Seen close in his vulgarly overdecorated boudoir, propped up in his chaise longue, a cocktail glass in the left hand, an outsized dark fan flipped open like a turkey flutter by the right, Tennant is blurrily pictured amid the hoopla of the aged poseur. He appears in profile as a bohemian Mussolini, with long, stringy hair, and cuddling a monkey doll. Seated next to him on our left, all but his blond head lost in shadow and movement, is the young David Hockney. Tennant was a high-born relic of the exquisite Cambridge days, and a lifelong respected friend of Beaton's; Hockney was the photographer's heir apparent in the same fields. It's as if Beaton was lingering in the memory of his past by virtue of this mad, festive sorrow, while the future attended as cipher. The scenario recapitulates the binary structure of many of his portraits. Hockney plays the servant to Tennant's Edith Sitwell—and so it goes: the assistant shedding light on the princess, the war correspondent on the bed with the Supreme Commander. Long before he had any contact with *My Fair Lady,* the relationship of Eliza Doolittle and Professor Henry Higgins foretold the archetypes of Cecil Beaton's life, and of his life in art. Certainly he had reason to identify with both of the subjects in this double portrait. Certainly too in this late, ultramannered photograph, a masquerade that is yet unnervingly frank, he embodied the knowledge of a lifetime.

Notes

1. Ian Jeffrey and David Mellor, "The Tyranny of the Eye: The Theatrical Imagination of Cecil Beaton," in Cecil Beaton (London: Barbican Art Gallery, 1980), p. 101. A catalogue of the exhibition.

2. Quoted in Hugh Vickers, Cecil Beaton: A Biography (Boston and Toronto: Little, Brown and Co., 1986), p. 40.

3. Ibid., p. 134.

4. Susan Butler, "Beaton at the Barbican: An Interview with David Mellor," Creative Camera 5 (London, 1986): 30.

5. Ibid., p. 31.

6. Cecil Beaton, Barbican Art Gallery catalogue, p. 202.

7. Quoted in Vickers, Cecil Beaton: A Biography, p. 277.

8. Polly Devlin, ed., The Vogue Book of Fashion Photography, 1919–79 (New York: Simon and Schuster, 1979), p. 8.

9. Quoted in Vickers, Cecil Beaton: A Biography, p. 340.

This essay originally appeared in *Artforum* (October 1986).

Through Eastern Eyes:
Richard Avedon's *In the American West*

NO ONE HAS smiled in an Avedon portrait for a long time. If there was pleasure in their lives it left them in the act of posing, or rather, confronting his lens. One sitter, de Kooning, told Harold Rosenberg that Avedon "snapped the picture. Then he asked 'Why don't you smile?' So I smiled but the picture was done already. . . ." The photograph of de Kooning and the quote appeared in Avedon's *Portraits* (1976), an image-gallery of famous people in the arts and media. A disproportionate number of them look either snappish or torpid and tired . . . oh so tired . . . unto death. At the end of that book, in a suite of shots that record the progress of his father's cancer, the subject is described as literally wasting away. But this is a progressive account not so much of the flesh dying off, but more of his father's terrified knowledge of his decomposition—a conclusive rush of dismay that gives *Portraits* its unstated theme.

Avedon's most recent portrait effort, *In the American West,* published by Abrams in 1985, furthers that theme, once again by a characteristic emphasis at the end of the book. There, in studies of slaughtered sheep and steer, he insists upon such details as glazed and sightless eyes, blood-matted wool, and gore languidly dripping from snouts. As his father was the only unprominent person in the first campaign, so the animals are the only nonhuman subjects in the second. It's as if Avedon were each time underlining his philosophy by breaking his category. Adjoining the guignol presences of the animals are ghoulish

images of miners and oil-field workers, as befouled by the earth as the animals by their spilled entrails.

Avedon's portraiture of "ordinary" westerners is on the whole darker and more cutting than his earlier work. It's essential to the effect of the current subjects that they be presented as unaware of his designs on them. For Avedon's program is supraindividual. He wants to portray the whole American West as a blighted culture that spews out casualties by the bucket: misfits, drifters, degenerates, crackups, and prisoners— entrapped, either literally or by debasing work. Pawns in his indict- ment of their society, his subjects must have thought they were only standing very still for the camera. Even those few in polyester suits who appear to have gotten on more easily in life are visualized with Avedon's relentless frontality and are pinched in the confined zone of the mug shot. In photography, this is the adversarial framework par excellence. He could rely on knowledge of this genre to drive home the idea of a coercive approach (which he frankly admits), and of incriminated content. But why should he have imitated a lineup? And why, since this is his personal vision, should he refer to an institutional mode?

The answer to these questions should probably be sought in the politics of Avedon's career, or rather, his career in the politics of culture. With him, style has always been understood as political ex- pression, and the will to style but a reflection of the will to power. Translated into photographic terms, this becomes a matter of visually phrasing the relations between the subjects and the photographer. For example, either the sitter can be depicted as apparently possessing the means to act freely, or the photographer can be perceived as free in the exercise of control over others. In his fashion work for over thirty- five years, Avedon configured the myth of the hyper-good life of the ultramonied in the bright expressions and the buoyant gestures of expensively outfitted women who flounce through a blank or glittering ambience where there is always enough room for them to open their wings, even in close quarters. No one had more success in vectoring the physical ease with which splurge maneuvers. No one could fake a more lacquered spontaneity. Unquestionably Avedon called the shots in the studio, but his was the kind of work in which mastery nev- ertheless had to disguise itself, hold itself in check.

Though they were literally his creatures behind the scenes and in the throes of picture production, the fashion models were imaged to have a magnetic, even commanding effect. The conceit of the genre asserts that subjects are constant narcissists and photographers are professional adorers. Fabricated through the collective resources of a large and nervous industry, the final spectacle, a self-centered object of regard, was something that existed only to lift up and draw in the gaze of the viewer. The high-fashion photograph mimics a situation in which the viewer is supposed to be captivated by styles of material display. Of course its commercial message was thoroughly bonded to the psychic lure and social symbolism of the picture. All those with craft input into the fashion image were contributing to a mercantile semblance of a court art in a democratic society.

In the late forties and early fifties, there developed an American market for an idiom of literal swank and sniffishness. Avedon led the way in adapting this largely continental mode more appropriately to our manners. He made his figures approachable, innocently overjoyed by their advantages, as if they were no more than perpetual young winners in life's lottery. It was Avedon, too, who set the pace for contemporary *narrative* scenarios of fashion display. Into the sixties he managed to waft via the faces of his mannequins the sense that their good fortune had hit very recently—say the second before he opened the shutter. When unisex became chic, and fetishism permissible, he filtered some of their nuances into his design. He could also suggest that the glamour of his models drew the attention of sports and news photographers, whose styles he sometimes laminated onto his own. (This was a snap for someone who grew up on Steichen and Munkacsi, and knew about Weegee.)

Insights into the crossover of genres and the convergence of modern media gave Avedon's work its extra combustive push. He got fame as someone who projected accents of notoriety and even scandal within a decorous field. By not going too far in exceeding known limits, he attained the highest rank at *Vogue*. In American popular culture, this was where Avedon mattered, and mattered a lot. But it was not enough.

In fact, Avedon's increasingly parodistic magazine work often left— or maybe fed—an impression that its author was living beneath his creative means. In the more permanent form of his books, of which

there have been five so far, he has visualized another career that would rise above fashion. Here Avedon demonstrates a link between what he hopes is social insight and artistic depth, choosing as a vehicle the straight portrait. Supremacy as a fashion photographer did not grant him status in his enterprise—quite the contrary—but it did provide him access to notable sitters. Their presence before his camera confirmed the mutual attraction of the well-connected.

Unlike the mannequins, most of the sitters had certified personalities, and this perked up Avedon's interpretations with extra dividends of meaning. The early portraits worked like visual equivalents of topics in the "People are talking about . . ." section in *Vogue;* they fluttered with cultural timeliness. When he showed Marilyn Monroe and Arthur Miller lovingly together, it was as if each of them took manna from the other in a fusion of popular and highbrow icons. The first book, *Observations* (1959) with gossipy comment by Truman Capote, spritzes its subjects with an almost manic expressiveness. They are engaged at full throttle with their characteristic work, so that the contralto Marian Anderson, for instance, has a most acrobatic mouth. These pictures were engendered well within the fashion mold (publicity section), but they led gradually to a break into a new, anxious politics of the image.

Avedon's second book, *Nothing Personal* (1964), tries to evoke something of its historical moment, although it would seem hard to suggest the duress of the sixties through portraits alone, even when arranged in narrative sections. It opens with foldout tableaux of wedding groups, in which a number of ordinary people rehearse their festiveness, as if they were models. Thereafter, we get sitters known for ideological heaviness, positive or negative depending on the readership: the Louisianian politician Leander Perez, George Lincoln Rockwell, Julian Bond, and so on. They scowl, salute, or look clean-cut; that is, they are made to impersonate their media image with breathtaking simplicity and effrontery. One symbol is assigned per person, and one thought is applied per image. Almost at the end, Avedon treats us to a group of harrowing, grainy action closeups of inmates in madhouses, and he concludes the book with happy beach scenes.

These wild technical and mood swings are worked up in a jabbing, graphic magazinelike layout, as if Avedon thought that a book audience had as short an attention span as a fashion-mag public. One gets the

strange feeling that while the illustrations are present, the feature articles are absent. In their place is an essay by James Baldwin, at his most self-indulgently alienated and bitter. Not only does his prose fail to mention the pictorials, it has nothing to do with them, regardless of the occasional avowed racists Avedon depicts. There is something half-baked about the way the book seeks to move visually from the emphatic trifles of the fashion media to the "relevance"—a word then in great currency—of political statement.

Baldwin lashes out at the unmitigated nastiness of the American scene, but Avedon does no such thing. This impresario of haute couture at *Vogue* and *Harper's Bazaar* lacked the credentials to offer any sort of critique from below. Even when it would seem to be suggested by a tendentious icon, there was no moral energy in his outlook. We're in a world only of angles, not of values. The book offers an uneasy sequence of sentimental, tart, sycophantish, and pitiless images. A group portrait of D.A.R. officials comes on simultaneously as a takeoff from Irving Penn's *Twelve Most Photographed Models* (1947) and as a satire on genealogical arrogance, but is too respectful to succeed on either count.

One of the most vivid faces in the history of portraiture is also here, that of William Casby, an ex-slave. One of the most significantly disturbed personalities in our post-World War II history, Major Claude Etherly, bombardier of the *Enola Gay* at Hiroshima, makes an appearance, though he does not create an impression. *Nothing Personal* certainly grabs one's attention, but it doesn't add up. It's so busy figuring out its strategies that it gives the reader the idea that Avedon had no time to respond to anyone. Much of the album assumes a clarity of purpose that is not realized in a design chopped up by willful and unexplained thematic jumps.

Like crossed wires, the messages in this curious album seem to have shorted out. Thereafter, we no longer see a rhetoric infused through the junction of image-sets or portrait scenarios. Strangely enough, such a liberation does not appear to have refreshed his sitters. A pall now generally falls over them, and their body language is constrained to a few rudimentary gestures. Avedon, in fact, would take the portrait mode into a new, antitheatrical territory. Visualized from familiar rituals of self-consciousness and self-scrutiny, portraits offer specific moments of human presentation, enacted during an unstable contin-

uum. Whatever their apprehensions, sitters hope to be depicted in the fullness of their selfhood, which is never less than or anything contrary to what they would be taken for (considering the given, flawed circumstances). What ensues in a portrait is usually based on a social understanding between sitter and photographer, a kind of contract within whose established constraints their interests are supposed to be settled. In his fashion work, Avedon dealt with models whose selfhood had been professionally replaced by aura. His career was a function of that aura. Presently, engaged with sitters, he found that their selfhood could become a function of his aura.

Avedon did nothing so crass as to intimidate his subjects since it was much simpler and more effective to put forth his *indifference* to the portrait contract itself. While depicting people, his portraits carry on as if they were describing objects of more or less interesting condition and surface. Though this deflates his subjects, such a radical procedure is just as evidently not hostile . . . not, at least, consciously hostile. *Nothing Personal* anticipates the route Avedon was to follow, and is already aptly named. *Portraits,* a much later book (1976), gets very close to its subjects in terms of physical space and is now decisively removed from them in emotional space. The noncommittal titles of these projects are ideological clues intended to suggest the absence of individual bias.

Many of the details in these newer portraits are very articulate socially and culturally, but the visualizing instinct behind them is certainly opaque. The photographer wants to do justice to the presence of the sitter, at that particular moment, though only insofar as he can make a certain kind of Avedon picture, or cause a sensation. (Ideally, the two would go together.) Avedon demonstrates such a long-term superiority in the contest of wills in portraiture that even the occasional assertiveness of a subject does not compromise the unconcernedly abusive look he had begun, in the sixties, to achieve and be known for. For all that they are sentient and experienced people, his subjects consented to exposure since it was still hard to imagine anyone like him taking their feelings so little into account. The contrast between what is presented and how it is processed generates the unsettling effect of the Avedon portrait. Let there be no mistake, that effect is here the equivalent of intended content.

Harold Rosenberg spoke of Avedon's "objective cruelty" (when pho-

tographing Warhol's scars), and then went on to write of the photographer as a difficult, reductionist artist, like Newman or Still. This is spectacularly wrong, since it implies that Avedon wanted to practice an ideal, difficult truthfulness, whereas he's a most equivocal, advantage-taking realist, and knows it. As he himself says about the western portraits: "Assumptions are reached and acted upon that could seldom be made with impunity in ordinary life." The big 8-by-10-inch camera is, then, an alibi for a most transgressive stare. Such a stare doesn't come from painting, of course, but it does stem from a knowledge of the German August Sander, whose catalogue of social types Avedon makes much harder edged, and of Diane Arbus, whose ecstatic, guilty transgressions Avedon routinely refrigerates.

An assumption of extreme, hard-headed realism is brandished through Avedon's portrait work. There is, for instance, the highly specific dating of these pictures, as if the day as well as the year of exposure mattered. This is extra, inessential information—and quite typical of a realist attitude. Then, too, one notices the clinical approach, the pronounced, unshaded clarity of sight and the emphasis on physical data. Further still, if Avedon's glamour imagery was known to be highly fictive, then his realist portraiture, through an altogether mechanical turn, would have to stand for everything unglamorous. In his recoil from the sentimental, Avedon hardly stops anywhere along the line until he gets to the unsparing and pugnacious. Even his young westerners seem to have a meanness knocked into their faces and only a bleak life in the future. Realists are thought to look the world unflinchingly in the face, and their credibility is supposedly increased the more imperfections they record.

In realist territory, Avedon had to compensate for his well-earned reputation for smart, commercial stagecraft, and he protests, accordingly, in the hands-off direction of these "dumb," do-nothing poses. The subjects are understood to be engaged with (or are caught in) nothing more than an unschooled or archaic attempt to comport themselves, which they more or less fumble, thus revealing their actual character.

But the question remains: what is convincingly revealed in these images? I, for one, am persuaded of the grumpiness of most of the sitters at the moment they were photographed. One sees this expression often in photographic culture, when people aren't getting help from

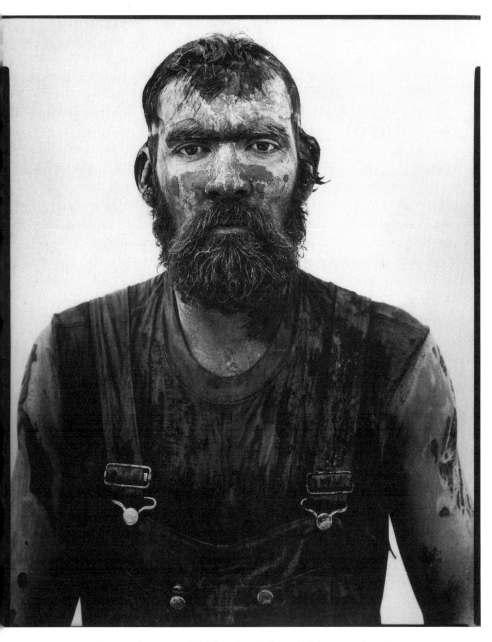

Richard Avedon, *Red Owens, oil field worker, Velma, Oklahoma,* 1980. Courtesy
Pace Gallery, New York.

the stranger behind the camera, and don't know why he should be trusted. It's a kind of squint, and it hardens them. In a book containing 106 pictures of westerners, this arid psychological atmosphere prevails so completely that it rules out the freshness of any open, one-to-one human contact. The subjects are individuated according to their varied circumstances and histories, but not by their moods. Whatever public foreknowledge might have made it difficult for Avedon to obtain his results in his own social circles during the first half of our decade, they could be brought off more easily among any group unaware of his national reputation, such as these somewhat defensive but unsuspecting westerners. Their need to plead their case went deeply, he says, but "the control is with me." If his insistence upon this control is necessary to legitimate himself as a realist artist, no matter at whose expense, he nevertheless fails to accomplish realist art.

Again, his sophistication about photographic pictures prepares him to encompass and accept this judgment. As he introduces the western gallery, Avedon writes, "The moment [a] fact is transformed into a photograph it is no longer a fact but an opinion. There is no such thing as inaccuracy in a photograph. All photographs are accurate. None of them is the truth." How remarkable that his critics have not thought to quote him a little further on in this statement, where the deep, internal conflict of Avedon's portraiture asserts itself. On one hand, he arranges it so that the sitter can hardly shift weight or move at all, supposedly because the camera's focus won't allow it. The hapless subject has to learn to accept Avedon's uncompromising discipline (as if the lens and the photographer were the same). On the other hand, "I can heighten through instruction what he does naturally, how he is." In the end, "these strategies . . . attempt to achieve an illusion: that everything . . . in the photograph simply happened, that the person . . . was never told to stand there, and . . . was not even in the presence of a photographer."

One either remains speechless upon reading this total denial of his working program in the American West, or one sees that it applies covertly to fashion photography. Such stridently mixed signals and elemental confusion about self-process have something to say to us about the derisive qualities of the work itself. I think not only of the fact that voyeurism is the chic metaphor in fashion (none of the models are supposed to be aware of the photographer), but also that fashion

Richard Avedon, *Juan Patricio Lobato, carney, Rocky Ford, Colorado*, 1980. Courtesy
Pace Gallery, New York.

has always been an imagery of material display—and that's what Avedon's western portraiture consciously amounts to. The blank, seamless background thrusts the figures forward as islands of textures—of flesh, certainly, but also of cloth. Nothing competes with the presentation of their poor threads, nothing of the personal environment, nothing that might situate, inform, and support a person in the real world, or even in a photograph. At the same time, the viewer is left in no doubt about the miserableness and tawdriness of their lives— for their dispiriting jobs or various forms of unemployed existence are duly noted. An ugly comparison is invited between all these have-nots and Avedon's previous and much better defended "haves." It is one thing to portray high-status and resourceful celebrities as picture fodder: it is quite another to mete out the same punishment to waitresses, ex-prizefighters, and day laborers.

Where is the moral intelligence in this work that recognizes what it means to come down heavy on the weak? Even the thought that such hard luck cases might arouse class prejudice does not surface in the book's text. All that would be required for "polite" society to imagine these subjects as felons would be the presence of number plates within the frames. In the mug shot, the sitter's selfhood is replaced by an incriminating identity in a bureaucratic system. Avedon has gained a cheap, enduring dominion over his sitters by reference to this mode, but executes his pictorial versions of it very expensively, and therefore, innovatively. He not only used a view camera of much greater optical potency than needed and exposed around 17,000 sheets of film in "pursuit of 752 individual subjects";[1] he also enlarged his photographs to over life-size and had them metal-backed for exhibition in art galleries and museums. The disproportion, technical overkill, and sheer obsessional freakishness of this campaign work as factors of stylistic insistence. And without question, he succeeded, for one can definitely recognize any of these pictures as an Avedon at sixty paces.

For fashion photographers, the problem of "saying" something, of having any conceptual obligation to picture a world, is solved before any film is exposed; they know who the client is. The action and the enjoyment of fashion photography is bound up entirely with distinctions of craft, flair, and setting—the equivalents in their commercial context of imaginative vision in an artistic one. For all their harshness,

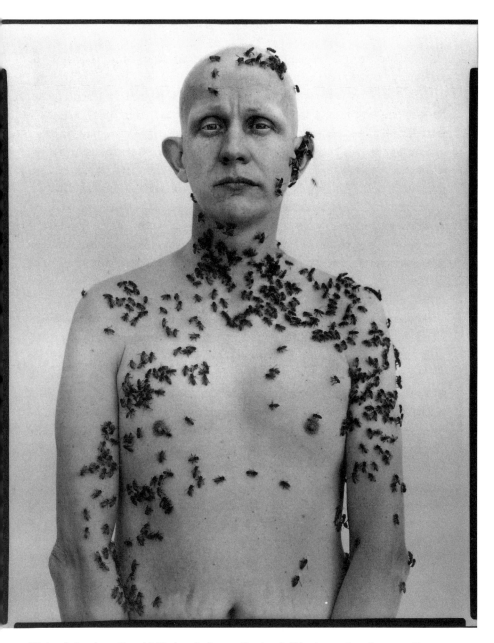

Richard Avedon, *Ronald Fischer, beekeeper, Davis, California*, 1981. Courtesy Pace Gallery, New York.

Avedon's portraits belong to the commercial order of seeing, not the artistic.

Just the same, the western album is his most arresting book. I am thoroughly downcast by his terrible perspective on the West (in a background text Laura Wilson, his assistant, more or less implies Avedon's special receptivity to damaged subjects), but that is his right. Obviously, whole spheres of western culture—the sun-belt retirement communities, the new wealth grown up through oil and computer development, the suburban middle class—are ignored in Avedon's gallery. He is definitely obsessed by a myth based on geographical desolation, rather than engagement with any real society. Just the same, those who complain about his unfair visual sampling are quite off the mark; let them tell us what sampling *is* fair. But if I ask what is the principle of this sampling—for example, personal animus, political critique of western culture and conditions, or humanist compassion for social casualties—I don't get any legible reading at all, and suspect that there isn't one. It's not that the subjects don't incite judgment or sympathy—they do that automatically because they're human and we're human. Rather, Avedon counts on their shock value, on this level, to get us absorbed by the way they look.

It's certainly true that the picture of the blond boy exhibiting the snake with the guts hanging down is a sensational image. Likewise, the hairless man literally covered with bees. And who can forget the Hispanic factory worker with the crisp dollars cascading down her blouse, or the unemployed blackjack dealer, with a face made of dried leather and bristle, whose sport jacket is a tantrum of chevrons? Nothing seems to come out right in these faces, and so many others, that have a breathtaking oddness. They make terrific pictures. In 1960, Avedon did a real mug shot of the Kansas murderer Dick Hickock, protagonist of Capote's *In Cold Blood*. He printed it next to a larger one of Hickock's father (taken the same day), in the *Portraits* book. Here is some evidence of an avid look at the genetics of American faces for whatever might be reckoned as pathological in them. In the current gallery, that pathology seems to have come home to roost, at such close graphic quarters that it's a relief to know that these are only pictures, and the subjects won't bite.

Pictures may be only their mute selves, but for Avedon they are everything, a totality. The photographer thinks that you ultimately

get to know people in pictures, as if there is some arcane, yet clinching knowledge to be gleaned from the image. Strangely enough, it had been the inadvertent resemblance of his earlier western portraits to nineteenth-century ones that led the Amon Carter Museum of Fort Worth to commission Avedon to do this series. If any such work is recalled to me, it would be medical photography of the last century. Doctors had sick people photographed to exhibit the awesome hand of nature upon them. Later, the subject might be lesions.

Avedon photographs whole people in the "lesion" spirit. In the *New York Times* of December 21, 1985, he asked, "Do photographic portraits have different responsibilities to the sitter than portraits in paint or prose, and if they seem to, is this a fact or misunderstanding about the nature of photography?" Well, if he had to ask, the question certainly indicates his misunderstanding of the medium. But more than that, the question symptomizes a failure of decency that no amount of vivid portrayal will ever redeem, because the portrayal and the failure are bound together in the malignant life of the photograph, each a reflection of the other.

> *"Sometimes I think all my pictures are just pictures of me. My concern is . . . the human predicament; only what I consider the human predicament may simply be my own."*
>
> —RICHARD AVEDON

Notes

1. Stephen Frailey, "Richard Avedon: 'In the American West,'" *Print Collectors' Newsletter* (May–June 1988).

This essay originally appeared in *Art in America* (January 1987).

Real Faces

STILL PORTRAITURE is one cultural index of how people are schooled to regard themselves, and this is a good reason to ask what is currently happening in that index. Let's say that a portrait photograph is designed to indicate something particular about a person or persons. Visual details would operate as clues to what could be said—or plausibly guessed—about the situation of the subject. The people who posed could be enacting certain social types, or playing work roles, so that their performance broadly overlaid a deeper sense of who they were. Until recently, such performance, when it showed, was understood to be a form of status assertion, engagement with the portraitist, or a psychic overture, perceived as an aspect of conduct to which the photograph gave priority. In whatever way the sitter appeared as a member of a social group, one knew that he or she had behavioral singularities and emotional reserves that the picture type itself had not called upon. There was no conflict between what was displayed for the portrait occasion and what little could be intuited beyond the display. The two existed side by side as stated and unstated complements of each other. Viewers could grasp the whole of the characterization without being troubled by the awareness that it would only be partial. "We never touch," says Emerson, "but at points." Nowadays, however, the most publicized portraiture shocks us out of that stable acceptance of the way part relates to implied whole and performance to being.

As many portraits have lately shown, playacting has gained such dominance, at the expense of the player, that it seems utterly quaint

and useless to wonder about who the person portrayed was or is. For the sitter's pictorial guise has absorbed into itself all of the merely idiosyncratic possibilities of a character—has sucked them away into a bright or a sullen grimace. If the viewer is led to anything, it could only be to that which has replaced personality.

Criticism has insisted that the media are to be held responsible for this eerie state of affairs, and criticism, here, is right. "To imagine ourselves in fiction, recent portraits argue, is no longer to imagine ourselves in literary but in visual culture." This is Ben Lifson, from his catalogue essay for a show called "Faces Photographed, Contemporary Camera Images, which took place at the Grey Art Gallery of New York University in 1982. Some of the artists included were Peter Hujar, Robert Mapplethorpe, Cindy Sherman, and Bruce Weber. Lifson had been talking about the degree to which the photographic portrait studio had ceased being understood as a metaphor for a stage and was now grasped as a setting emergent from magazines, television, films. He implied that the creatures depicted in the flattened space of these media could maneuver there only as shallow images; there were no backs to them, and they had no bottoms. In a literary zone, though this would take time to perceive, there would be room for psychological development and the acknowledgment of certain individual causes for the effects of character. The photographs, in contrast, were caught up in their instant visual styles and conventions, givens that imposed a depersonalized volatility on the portrait display.

In 1987, introducing an exhibition called "Portrayals," at the International Center of Photography, New York, Carol Squiers professed to be agog at the hero of the hour: Max Headroom—a fictive TV reporter who had been brought back from a moribund state, via computer-generated image, to function as a sparkling, manically disjointed talk show host. Squiers took this personage to be emblematic of our uneasiness about human authenticity—its public failure to maintain itself during the era of Reagan: "in this intriguing, otherworldly and frightening lack of full personhood Max affirms the contemporary plight—that the wholly manufactured persona, even if it is truncated, is the only one that is interesting, noteworthy, attractive, amusing. . . . All else slips into random categories of sloppy imperfection and human foible, the gray areas of . . . individual psychology." The more contemporary audiences sense their own grayness in contact

with the semihuman media image of the person, the more these audiences can't help depreciating and diminishing themselves. If it were to be in the slightest degree questioned, that image might appear grotesque.

On TV, for instance, we daily watch an actor called an "anchorperson" conversing with an interviewee on a second screen who appears twice life-size, so irrationally magnified that it baffles us why the one never acknowledges the monstrosity of the other. In such scenes, we suspect that the reflexes of the cast are entirely managed affairs, maintained by lip sync, headphone, and teleprompter, or dialed in by unseen agents. Almost as if in response to such ventriloquism, the "Portrayals" show at ICP was, in fact, an antiportrait exhibition. Squiers writes that "the portrait itself has disappeared, giving way to effigies, icons, clones and simulations that are rooted in . . . fear and social control." Insofar as they locate that control in the malignant smiles of the media, the photographers recoil from them and are phobic about any hint of cheer. Let Clegg and Guttmann, who were represented in "Portrayals," typify the newer work. They set forth images of inert, sour, robotic figures, well-clothed, lost in the obscurity of ill-described rooms. One came away from the show feeling that as far as its one-time ideal to probe into the psychology of its sitters is concerned, artistic portrait photography had recently suffered a blow to the head and was now a pitiable amnesiac.

As for the portraiture that makes its way outside the gallery system and the art world, when we hear of its authors in the big media, it purveys the usual celebrities—arrestingly, expensively replete with pseudojudgments meant to titillate the mass public. The older generation of portrait moguls—Irving Penn, Arnold Newman, and Richard Avedon—has left its mark on a newer one, which pursues more promiscuous goals. Since the photographic impulse, in both cases, stems mostly from the fashion industry, it has an expositional problem to solve when it deals with full-fledged notables in their own world. Fashion photography naturally places any regard for people far lower on its illustrative agenda than the highlighting of objects and the graphic design of the pictorial field. Often, then, in celebrity portraiture one senses a conflict between subject and photographer over the psychological trademark of the scenario. With a genial violence, both parties conspire to outflank each other in a sensationalistic en-

vironment. The sitter, however, must yield to the directive photographer in the construction of a fantasy meant to provide dividends for the continuance of both their careers in fame. With the portrait campaigns of Annie Leibovitz and Helmut Newton, above all, this symbiotic compact has demonstrated its market value by introducing a voyeuristic note into the portrait genre. One has one's choice of a lifestyle of the rich and famous—made insouciant by Leibovitz, or lubricious and kinky by Newton.

The images in the present show are just as contemporary, and are more challenging, but they reflect none of these developments. The alternatives they present could only have been realized without guidance from the successful portrait modes, and through a modesty of tone. "Real Faces," in this case, means human faces that are looked at and attended to in a frank attempt to take their measure. As they express a psychological curiosity, it does not occur to the photographers to place themselves above or beneath the social status of their subjects— and this absence of presumption makes for freshness of contact and transparency of effect. The distancing of the formal or informal pose is acknowledged and quite often minimized. The ethnic or racial or material "otherness" of the scene, relative to the photographer, is taken note of, and then the portrait business is transacted forthwith. Portrait photographers enter, or find themselves in, distinct milieus, and carry on there with no more authority than their credentials as people. But that is precisely how they consider their subjects, so that there's a kind of unpremeditated peerage between the seer and the seen. For the moment, the success of the portrait hangs on the thread of that understanding.

Judith Ross, who lives in Bethlehem, Pennsylvania, came to public notice quite recently in a small group show at the Museum of Modern Art. Her section of it consisted of visitors and mourners at the Vietnam Veterans Memorial in Washington, D.C., 1983–84. Such a locale is quite obviously public ground. People from many walks of life go there in observance of a historic and national trauma, signified by an inventory of the engraved names of thousands of killed soldiers. What we see in Ross's photographs is the product of time taken out from that visit, and yet the gravity of the event still resonates in faces. The young man with the crew cut and the hooded boy, his mouth open,

Judith Joy Ross, *Untitled,* from the series "Portraits at the Vietnam Veterans Memorial, Washington, D.C.," 1983–84.

know themselves to be portrayed, a knowledge reflected in their stance before the tripod camera, but their minds are not altogether centered and alerted to the fact—and Ross slips into their reflection. She had asked them to hold still for a little bit. What they could not have known was the way the camera lens makes everything about them go out of focus and how the light pastorally modulates their faces and figures in space. Ross's rendering in that light acts as a landscape vision of human physiognomies. Above all, the immersion of these physiognomies in limpid tonalities is what counts, expressively. Their exposure to the open air becomes them no less than the elegiac circumstance that has taken hold of them. Each picture makes us sensitive to the effect these things have upon each other . . . as a created moment of perception.

The same applies to Ross's portraits of young campers at Eurana Park, Weatherly, Pennsylvania, a series from 1982. Once again, human figures are asserted as the only solid presences in melted surroundings. That they stand out but are not pictorially detached from their moist, wooded setting is due to the hazy light, which bathes them in its dapples. On first glance, the terms of encounter look as unstressed as in family snapshots, an impression furthered by the simplest of framing and the most straightforward, perfunctory poses. Yet Ross's gold-toned studio proofs are anything but casual. All knobby knees and legs, these vernacular, pubescent American kids, some with a little baby fat, are curiously sober and prepossessing. They had been approached in off moments during structured, rural, summertime playfulness, but it is actually the ambiguous stage in their lives, when they are still unformed and partly self-conscious, yet also shrewd, that is held in the mind. They had been invited to pause in their leisure, and it is as if sometime during that pause an older person buds forth from the child. Both the scene at the monument and the episodes at camp, while they are well frequented, are also porous and diffuse, made of a shifting populace. These are gathering places, but not real communities, or at least not permanent ones, and so these faces cannot be said to have grown with or to belong to the places where they were found. Ross seems to work at a slant from the situation of her subjects, with an awareness of their only transient occasion and rare presence in her viewfinder. The visitors will go home and resume their lives. As for the campers, it is as if Atget had been there, on Parents' Day.

Judith Joy Ross, *Untitled*, from the series "Eurana Park, Weatherly, PA," 1982.

Birney Imes, on the contrary, has taken his camera right into certain baptisms, gospel meetings, country bars, general stores, roadhouses, and rap sessions among long-standing black communities in such places as Lowndes County, Mississippi. The people there seem to know each other well, are often cronylike, and are rounded off by chat that one can almost imagine hearing. Imes's presence is implicitly thrust in; he sinks down, level to seated knees, or somehow zigzags amid social pockets, half contained or cut by the picture frame, evidently in the hope of touching his subjects at many points. A few of the people pay him no mind, but others are on to his game, live coals in rough interiors. This young white man, from Columbia, Mississippi, has been allowed in at very close social quarters to his subjects, where he behaves energetically, ruffling some of the proceedings as he moves, "misfiring," as someone laughs or dances blurrily past the figures on which he's zeroing in. But it is the whole of what he shows at any one time that is intended, and if partial commotion disturbs the view, it also deepens the self-containment and introspection of the nominal sitters. Imes's farmhands, parishioners, or families are on their own ground, but this inwardness, which veers away from things, keeps these photos from being anecdotal or reportorial. Be it a burial or a pool game, the photographer wedges the circumstances open and discovers that there are ripened, characterful people there, as well as a narrative. The effort has been to maintain both of these descriptive possibilities, and in that unresolved process discover a community sense of springiness, hilarity, and sorrow.

There can be few modern portraits where a stomach seems to bespeak the person so fully as it does in Imes's *Deacon Robertson, Lowndes County, Mississippi,* 1982, but Bill Burke's *Reverend William Beegle, Bellaire, Ohio,* 1979, is one of them. It's impossible to decide whether the memorable hauteur of the man is enhanced or subsumed by his great, flaunted, T-shirted belly, hanging low. Many of Burke's portraits appear to be the products of an unlikely chemistry. "I wanted to make pictures in a place where I didn't know the rules, where I'd be off balance." He was speaking of Southeast Asia—Thailand and Cambodia, where he'd been a few years ago and where he wants to return— but it could have been of backwoods Kentucky, the site of many of the Polaroids included here (a survey officially sponsored by the Kentucky Bicentennial Documentary Photography Project). One can de-

Birney Imes, *Deacon Robertson, Lowndes County, Mississippi,* 1982. Courtesy Birney Imes.

code Burke's statement as follows: too much ease in the portrait protocol means too much acceptance of the psychological moment, which therefore leads to a blandness of picturing. How often does one feel, by contrast, the tension and the strange edge in this work, where the parties to the image are implied as at some kind of social angle to each other, freely acknowledged as such. Because he was off-limits, in a manner of speaking, and outnumbered, this Bostonian needed to be ultra alert. But he found that his hesitancy in soliciting posing time from flawed or ground-down people turned out to be more his

problem than theirs. Having no choice but to yield the territorial advantage, the outsider Burke learned that something like the equivalent of it was returned to him in his subjects' sense of the attention he was paying them. Andy Grundberg has written: "Burke's subjects look at the camera differently than urbanites, more naively and more expectantly"; if so, it is a naïveté that equalizes them both in the precariousness of their exchange. Unlike Diane Arbus, Burke is never on top of what he sees—battered and abrupt as are the faces there— and he never jabs at the reflexes of his audience. Somewhere, midway between him and his subjects, a luminous copyright is jointly established.

If his sitters speak volumes for unkind experience, they do so not only as individuals, but in the context of a historical era. Drawn to areas of agrarian poverty and unemployment where violence brews, Burke depicts the penalties of all these conditions, marked in faces. He does it in a way that lacks rhetoric but has an awkward precision. Material tawdriness is concisely noted as an accompaniment of social stagnation, the collapse of American promise deep within the recesses of its own Third World. But this physical lowering has a past, extending backward into the depression when, for example, the booth pictured in the Koffee Kup Restaurant (Carrollton, Kentucky) might have originally been built.

It is remarkable how few eighties artifacts crop up, not only in Burke's but in Imes's and Ross's pictures as well: not much more than a Budweiser snaptop, or a Timex with Speidel band, and for the rest, remnants with which the folks in Walker Evans's FSA photographs of the thirties would feel at home. These current portraitists, in fact, are of Evans's line. They look back and have been tempered by him, as were Nicholas Nixon, Lee Friedlander, and Robert Frank. He schooled them all by the discretion with which he examined those who had been stranded or cast away or deeply misused by hegemonic progress. By "discretion" is meant the explicit insight that people are not defined by role-playing or material circumstances, and that the portrait attitude must stop well short of pretending that they are—so as to let personality breathe beyond the visual limits of the frame and the diplomacy of the moment. As we perceive that Evans's subjects are not meant to be completed by his description, they gain in psychic fullness.

The crucial fact that such breadth was underscored by pathos was

Bill Burke, *Koffee Kup Restaurant*, Carrollton, Kentucky. Courtesy Bill Burke.

not lost upon Evans's successors, for it showed them a way out of the rhetorical impasses, either those criticizing or typifying the media, that have deadened contemporary portraiture. Being alive to the mood of the country now, the photographers could only have sensed in it a moral loss and civil decline, and they have given us a range of unsorted

Bill Burke, *Reverend William Beegle, Bellaire, Ohio,* 1979. Courtesy Bill Burke.

faces that are variously afflicted by, and seem to meditate on, this state of affairs. In a curious way, this is portraiture as lament. Burke, who confesses to having failed his draft physical (during the Vietnam War) "with some effort," is haunted by the need to return on his own to the desolate aftermath of U.S. intervention in Asia, and to record its power imprint on individuals removed from us in space and experience. And what is the implied effect of Ross's foray at the Veterans Memorial if not of another such attempt to circle back to that unhealed wound of the national consciousness?

The work of Nan Goldin also leads off from a retrospective vision, though this time into personal bereavement. While her New York subjects are among her most intimate friends, she shows them as carriers of woe and as casualties of desire. They are mostly opened out, abandoned with a sad, heated euphoria, matrixed in the nomadic life they share with the photographer. The subject of *Colette with fan, Provincetown, Mass.,* 1979, is a transsexual, "now dead, killed in her apartment in Boston by people who broke in." Bobby A. on a Pool Table, Tin Pan Alley, N.Y.C. (1981) "slept with his eyes open, moved to Kansas City later on, killed in a shoot-out in a parking lot of a club where he was the bouncer" (from notes Goldin supplied to the author).

Although much of this reads like a memoir of the undone and defeated, culled from her ongoing "Ballad of Sexual Dependency" (several hundred diaristic slides dating from the mid-seventies on), the photographer herself sees it as a positive record. The lives therein are dedicated to freedom, no matter how expensive. From a purely genre point of view, the extremely close psychic range of the pictures is a correlate of that freedom, for it often demonstrates a fluidity of raw contact before any hint of performance rises up to intervene in and conclude the portrait. *Suzanne Crying,* 1986, writes Goldin, "is the friend who once said being photographed by me is as much an aspect of living as drinking coffee or any other daily action together." A social compact has been signed far earlier than the flash is set off, and the fact of it makes even the looser canons of photographic portraiture, such as that of Goldin's one-time teacher Bill Burke, seem more constrained than they are taken to be.

At the same time, Goldin's are narrative portraits, soaked with verbal text and personal reminiscence. It is a paradox that these dar-

Nan Goldin, *Colette with fan, Provincetown, Mass.*, 1979. Courtesy Pace/MacGill Gallery, New York.

ingly unprocessed (and sometimes offhand) visualizations are among the most literary of recent practice. They testify to a thoroughgoing impatience with the bourgeois idea of privacy, and they therefore bear down upon us with a pronounced indiscretion, unlike the other portraits here. Even so, this is only to say that Goldin has proceeded further, toward intimacy of disclosure and penetration, on a road that the other artists have traveled too. For surely, the aim has been to get closer to people, and to see, in an always limited fashion, how it is with them. It is an aim profoundly indifferent to the dissociated glitter of the publicity portrait and its mockery in the art galleries. In the ground gained by the exploration of "real faces," subjects are shown and viewers are enabled to maneuver with an enlarged view of the American historical experience, one whose depth both can recognize.

This essay appeared in the catalogue to the exhibit "Real Faces," curated by the author at the Whitney Museum of American Art at Philip Morris, May 6–July 7, 1988.

Hujar

He went into the woods with a light and he took pictures of animals.
FRAN LEIBOWITZ

SURPRISED BY his pictures of animals, you can almost gather how Peter Hujar, a curiously neglected but also legendary photographer, who died in 1987, would portray people, and that he would have a memorable feeling for them. His dogs, horses, goats are individuated and affecting characters. They have sniffed in his presence. Some of them pause while others seem almost to display themselves. John Berger has written, "No animal confirms man, either positively or negatively. . . . But always its lack of common language, its silence, guarantees its distance, its distinctness, its exclusion, from and of man. . . . Just because of this distinctness . . . an animal's life . . . can be seen to run parallel to his. Only in death do the two parallel lines converge. . . . With their parallel lives, animals offer . . . a companionship . . . to the loneliness of man as a species."[1] Hujar appears to have grasped this without thinking about it. And as if that weren't remarkable enough, his animals come on to us like people.

I don't mean that he anthropomorphizes them or somehow endows them with our traits. Nor are they depicted as prize specimens of their class. The photography of pet books or stock shows satisfies that unctuous taste. Rather, Hujar accords animals the same kind of attention he lavishes on people, letting import take its course after that. It seems that each kind of being can claim from him an equally intense regard, that they compare in their knowability—that is, they're both mysterious—and that he can identify with each, indiscriminately, as

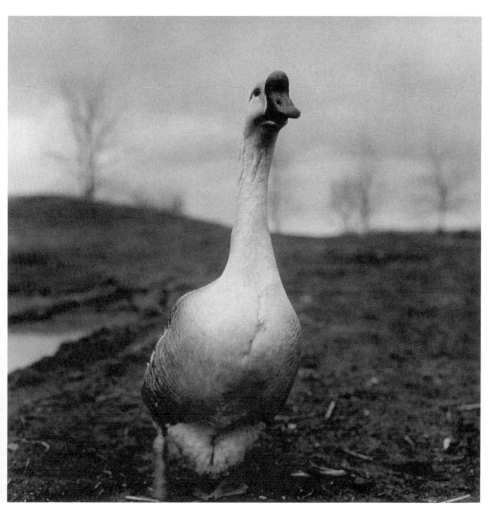

Peter Hujar, *Goose, Germantown,* 1984. All Hujar photographs courtesy of the
Peter Hujar estate.

organisms. This approach is all the more marked when it's a case of
an animal we don't empathize with very much . . . a goose.

The "parallel life" that interested Berger can be ascribed not only
to animals but similarly to the human subjects of photographs, since
they are speechless, too, behind their paper divide. Compensating for
this, Hujar appreciates creaturely muteness as being vibrant in its own
right. Of course the vibrancy inheres finally in the images alone, which
have already survived many of their subjects, and that now survive
their author.

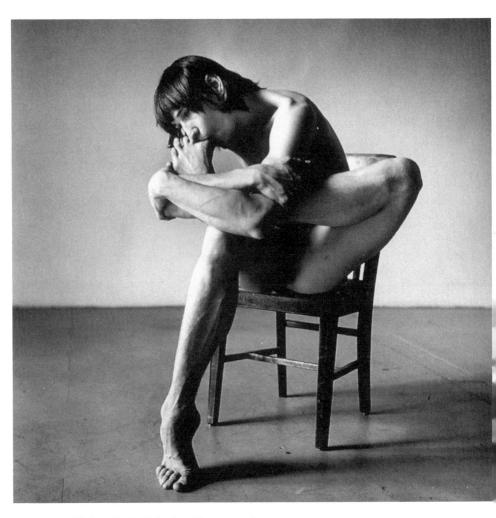

Peter Hujar, *Daniel Schook sucking toe*, 1980.

It's tempting to speak of the impulse behind Hujar's project as animist, that is, as catching the whisper of some extra gift of life and sentience in the inanimate—in this instance, the pictorial object. If so, he fulfills that impulse not by vivacious narrative so much as by a reflection on the carnal. As they show themselves for us, his nudes of both sexes also give themselves over to this introspective activity. The men sometimes express it by fondling their cocks, as if to distill the self-regard of posing into its primal gesture. They have come to know themselves in the biblical sense, and their knowledge of the erotic use of their bodies is offered to us as a natural form of seduction.

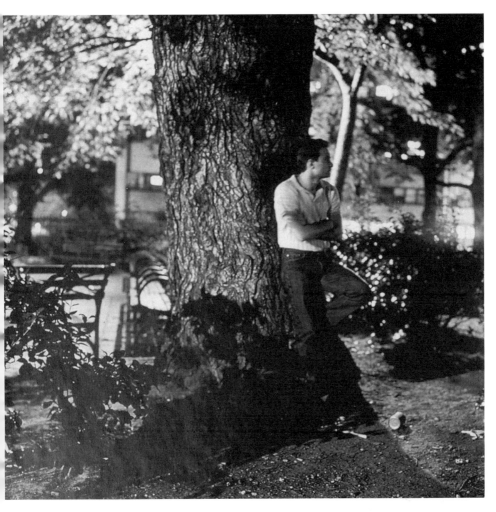

Peter Hujar, *Park at night*, 1983.

At the same time, the photograph insists on the full person, in the manner of a portrait—and a formal one at that.

A naked man, seated on a chair, puts his foot (his big toe) in his mouth—not your usual pose. It has some of the same quality of unconcerned oddness as Hujar's cow chewing on barbed wire. This sitter has composed himself in a Rodin-like attitude at once infantile, mute, contorted, and narcissistic, and because none of these are re-solved, it is enigmatic as well. Has he somehow been stunted as an adult human being, or is he having the next best thing to oral sex with himself?

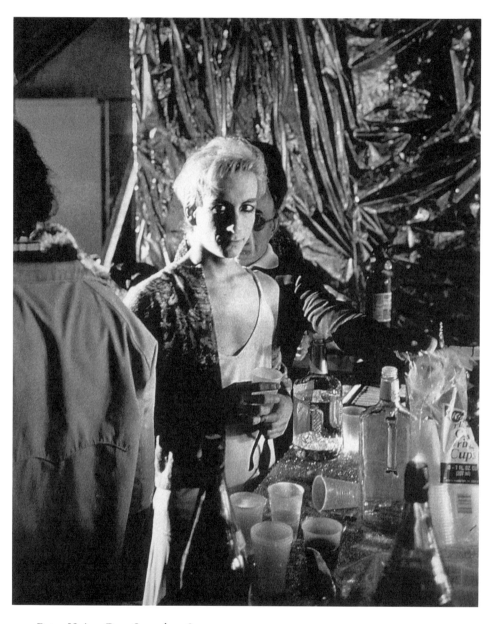

Peter Hujar, *Dean Savard*, 1984.

"He went into the woods with a light and he took pictures of animals." . . . Among the moving portraits of Hujar's show last winter at the Grey Art Gallery of New York University, some landscapes reveal a pastoral vision. With their dappled sunshine or earthiness, they contrast with the artifice of the lighting in his bare-walled studio, the urban site of many figure studies that one thinks, for some reason, were taken at night. But if these modes are distinct, Hujar has nevertheless introduced an openness to phenomenal states, characteristic of the pastoral, into his renderings of his city subjects. We can say of the majority of them that they're seen *au naturel,* even when clothed. On a warm evening, a man relaxes against a tree, a neutral enough act, but within the context of Hujar's overall work, one suggestive of male cruising. Both subject and photographer are on the lookout for their necessary kinds of action, outside and within the viewfinder. Hujar's people are endowed with a quality of being at large, they're approachable, and they look unspent. Meeting Dean Savard's smile at a heavy-drinking party, one knows what this would have meant in close quarters. Restless in their effect, the objects in the scene fail to compete with the steady flirt of the young man's eyes. His acute come-on is, in its way, as magnificent as that of Brassai's famous hooker at the billiard table. I am reminded of Albert Camus' remark, too, that "charm is a way of getting the answer yes without asking a clear question." That opens us to an understanding of the "tough" charm of Hujar's photographs.

They are poised by an awareness that conceives social reflex—even elaborate artifice—as a natural phenomenon. This can mean at least two things: that the exhibitionistic gestures of the gay culture—his scene—were obvious givens to the photographer, and that he came to feel at home in his own pictorial style. But how short a fall to leave it at that without noticing something else, which would bring us closer to the actual grasp of his work. For he depicted a world that was natural above all because it was mortal. A consciousness of the moment is necessary to frame any camera image, but the consciousness of a life is what often suffuses Hujar's particular kind of image. He was there to photograph quite unhesitatingly in the hospital room when the life of one of his subjects, Candy Darling, neared its end, and her most beautiful denial of that fact he touchingly encouraged for what it was. Here was something more poignant than a temporary

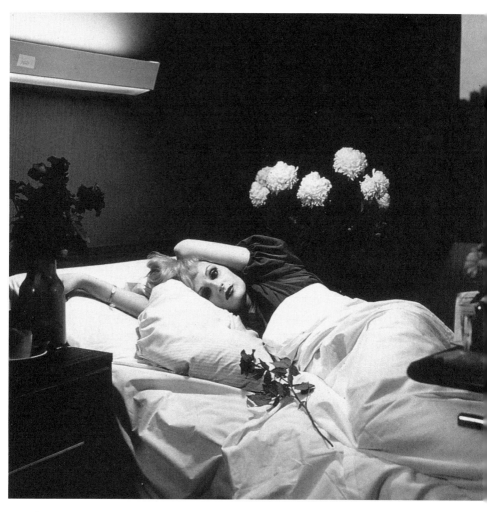

Peter Hujar, *Candy Darling on her deathbed,* 1974.

remission, for in collaborating with each other, both subject and photographer affirmed that a cosmetic surface can have an undeniable depth. The eerie bloom of the face in this portrait has nothing to do with ravaging nature, yet stems from the profoundest instinct.

Hujar's outlook is certainly attuned to the extravagance of some subjects who emphasize masquerade and makeup. Their forte is the mimicry of cross-gender behavior, as provocation to the public, and as ritual for themselves. The circus and Halloween in Greenwich Village make their appearance in his work. Transvestites strut about,

Peter Hujar, *Divine,* 1975.

and actors are sometimes seen costumed, but in off moments. Still, the vaudeville of all these people did not interest Hujar just as display. Rather, he alerted himself to the more active signals for which such theater prepared. Then, as he put his pictorial "make" upon them, another mood would come over his gays, for the camera has a power of isolating consciousness from its surroundings. You can see it slightly in the few street scenes, or street portraits, and more definitely in the set pieces with the face in the studio. Stephen Koch, a close friend of the photographer and now executor of his estate, has written about

them as having a terrible solitude. Certainly Hujar must have foreseen that state and used his charm to guide people into themselves (just as he had gotten animals to stay still).

The large number of Hujar's reclining portraits was well worth notice by writers on his work. His studies of the mummies in the Palermo catacombs are involuntarily stiffened in this pose, but to many of the photographer's living models it seems to have been congenial. It relaxed them, with their weight easily responding to gravity. It also let him come in close, and affords us the subtly unfamiliar pleasure of seeing the face more or less horizontally. Further, the pose establishes an intimacy with the viewer that seems vaguely privileged and conversationally offhand, even though the image is composed very surely. Divine, that fat, lewd man, looks down toward the lower left corner of the square, toward which his great belly sags. But more important, this is a ghostly Divine, all in white denim, whose maleness can't quite be placed. Sometimes the recumbent sitter, while merely at ease, also seems voluptuous, lost, and implicitly vulnerable before the camera.

Was Hujar more interested in the everyday guise of his sitters or in their personas, their masks? I said before that he tended to see people *au naturel,* specifically within the resonance of their courtship practices, and clearly as one who was engaged in these practices as well. In fact he used the camera as a traditional form of seduction that was also highly adapted to the society in which he circulated. For all his insider status, however, he was detached from the rococo culture of his group by his spare, almost classicist photographic style and his existential vision. Though his work was keenly prized by colleagues, it was also professionally marginalized because of this unlikely mix of qualities that didn't fit any category. Of course this also made him distinctive. He took the known features of a camp sensibility, its delight in "bad" taste, its penchant for an illusion that is not perfect, its indifference to conventional morality that acts as a protest within the self-righteousness of the host culture—he took all of these in their deliberate lightness, enjoying them for their own sake, and he darkened them. This characteristic effect he achieved through a stripping process that was not unkind. So often he closes with an individual who would want to be known in a certain guise but who is mysteriously persuaded of a hidden, deeper, and more sorrowful personal core. This is fatal to the celebrity he or she has enjoyed in a small cult world, and even

in a larger zone such as Peggy Lee's or Jerome Robbins's. Whatever their off-frame theatrical personae, people now seem more menschlike without it, that is, in their new *pictorial* role. But rather than emphasizing the mundane over the idealized aspects of the sitters, as if to plug his realism, Hujar sought an introspective element, still dependent upon them but less familiar because it was a product he himself invented. In the end, visualizing that product, he either disregarded or saw through worldly style.

In the beginning, though, Hujar was heavily disadvantaged by success as a sixties and seventies fashion photographer for *Harper's Bazaar.* To bring off acceptance there, he had developed a tricky studio lighting that could be overstudied, and that he never purged. Worse than that, a manikin is "there" for a fashion photographer so as to sell clothes, whereas Hujar needed a person to be there, so that he could foster an act of revelation. Nevertheless, fashion might have sensitized him to style as personal display, whose fragility he could evoke. How different he was in his moral purpose, and his subsequent downward mobility, from Robert Mapplethorpe, who also maintained open lines between fashion, celebrity, frank eroticism, and portraiture.

In the light of the controversy Mapplethorpe has posthumously stirred up over an NEA grant for his retrospective, it is ironic that his work should epitomize so much of the ruling-class antiliberalism of the Reagan years. There was no secret in his identification with the ultrarich and no subtlety in his worship of overly developed musculature, historically a staple in the visual propaganda of the repressive state. Yet the scandal of his work did not lie in its engagement with taboo, roughtrade subject matter—socially provocative as that is— nor in its flirtation with authoritarian power values. Rather it lay in the shallowness of its artistic form, designy, iconic, and flat. Appropriate as it may have been for its hard-edged content, Mapplethorpe's form could never extend itself to the human subjecthood of its figures. He treats them decoratively, that is, as no more than fleshy embodiments of that same studied bloom that he repeated in his flower pictures. In fact, his hyperestheticized manner, reflecting only upon itself in just-so arrangements, is more loyal to its own process than to the sexual content of his pictures. As for his subjects, they remain perfected and therefore frozen objects in an erotic fantasy that merely titillates. This list of drawbacks could be continued, but why go on?

Peter Hujar, *Trees,* ca. 1963.

The position of Mapplethorpe and Hujar in American photography is the reverse of what it should be.

When he rejected the material rewards of fashion, condemning himself to poverty, Hujar did not automatically come into his own. For practically from the start, he had been sensitive to the deprivation of "parallel lives," already evident in a harrowing 1963 study of retarded children in an asylum. What makes it harrowing is the freshness with which their space communicates with "ours." He does not minimize their deficit, nor does he sensationalize it. This photographer, whose one published book, from 1976, is called *Portraits in Life and*

Death (with a text by Susan Sontag), was drawn to illness and repeatedly visited mental institutions and hospitals to take pictures of people and friends who languished there. At first I tended to think of this motive in his work as morbid, but now I see it as the psychological crux of an art in which we are all perceived, in or out of the sickroom, as unprotected from our fate. That motive gives the spark of life to his portraiture, and a shock of recognition to us. At the same time, he was interested in many possibilities of our condition besides the desire and pain to which he so often returned. During the last several years, too many years, photographers have documented the lives of those stricken with AIDS, sometimes eloquently. Hujar does not seem to have consciously engaged with that illness as subject, and would not have considered his subjects to have been defined by affliction. But he was on insider terms with it. His connection with the theme was too viscerally yet imaginatively involved to be documentary, so much so that, as it was incandesced by his art, they shall have no choice in the future but to speak of him as the poet of the age.

Notes

1. John Berger, *About Looking* (New York: Pantheon Books, 1980), pp. 3–4.

This essay appeared in *Artforum* (October 1990).

The Family of Nan

MUCH OF the photography exhibited in art galleries these days depends upon a familiar paradox. A typical image will announce its artifice in such loud terms, it will so exaggerate its staged departures from the depiction of any "natural" conduct (as most new narrative work demonstrates) that its very fraudulence becomes an act of disclosure. As compared to the media off which it feeds, such photography explicitly *demands* to be disbelieved. It would deprogram and reinform all of us who are targeted by the media by isolating the media's rhetoric and detaching it from its context and audience. Such a photographic genre is understood to be "critical" in stance, and it has become so familiar as to be unexceptional when it appears.

A minority photographic report has now emerged, dealing with some of the same issues that "critical" photography has explored—the myth of the American family, with its erotic tumults; the deficits of various life-styles; and the violence of cultural forms themselves. This report is even more narrative than the media-critique work, but it gains its force by reducing artifice. Much of its credibility stems from the way it jumps right into the swim of behavior that appears to be happening spontaneously. If the people in these photographs are acting out their own neuroses, we're persuaded that the action was a real event, and that the photographer was somehow involved as a participant. This *self-critical* stance offers a powerful moral seduction.

I refer to Nan Goldin's *The Ballad of Sexual Dependency.* This ongoing project has a twofold identity: it exists, first, as a huge body of work

in the form of 35mm color slides, which are continually re-edited in shows with musical sound track and presented by Goldin to audiences around the country; second, an extensive selection from the series has recently been published as a book (New York, Aperture, 1986). Since I have only seen a videotape of one of the slide shows, I will here address the work in its book format. Shot over the last ten years, mostly with flash and in bedrooms, the pictures are primarily of young, punkish people engaged with one another in scenes of desire and frustration. Goldin herself appears in many of the pictures, and many of the subjects are clearly her companions and friends. As a sign that her subjects have allowed her to share the intimacy of their disheveled quarters, and, it appears, their messy lives, the bed acts as the ideal prop in Goldin's narrative. Her subjects sprawl on mattresses. Sometimes naked men are shown sleeping. Couples or singles have sex without being in the least bothered by the camera. When her friends are seen shaving or showering, bathroom scenes vie with the candor of the bedroom ones. We are given immediate access to what are usually off-limits episodes and embarrassing rows. *The Ballad* depends on an openness of personal territory where the setting, even when it's a hotel room, belongs to photographer and subjects alike—as their common pleasure site and private hell.

What stands out particularly, amid the exhibitionism of a few and the abstractedness or lonely mien of other subjects, is the depressive state of some of Goldin's women. It is as though the photographer came naturally upon them in such moods. *The Ballad* has the character of a tawdry story, carried by thematic momentum, as distinct from linear plot or expositional plan. Goldin's announced topic is the incompatibility of the sexes, or alternatively, their ferocious liaison, and her pictures offer a visual brief for that state of affairs. The smirky weddings, raunchy dances, and parties she shows are overwhelmed by scenes of estrangement, tension, dubious coupling, different kinds of sulks, and regrets. It appears that at any moment matters could quite easily get out of hand. In one unbearable shot Goldin portrays herself with facial trauma, the result of being viciously sloughed by a lover (it's titled *Nan After Being Battered*). Pairings don't work out in her circle, and yet couples keep on reconstituting themselves in new combinations.

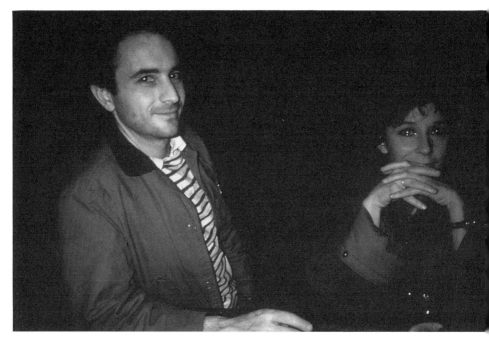

Nan Goldin, *David and Butch at Tin Pan Alley, New York City,* 1982, from the series "The Ballad of Sexual Dependency," 1986 (original in color). Courtesy Marvin Heiferman.

There can be no doubt that the work has been realized as a "family" snapshot album—this is her extended family—and that it is a sad album. Like snapshots, the pictures here are historical in aim, with the hope of remembering close ones as they were. But Goldin reverses the family album's typical wholesomeness, where power plays are often covered up as jokes (though the latent psychodynamics of the family album, usually ignored, are another question). Goldin may assume a familial tone when she shoots, but her work lacks the cheeriness and official naiveté of the snapshot model. Her subjects are in complicity with the bluntness of her project, since they have let their most private behavior be exposed on her film. Even when they overtly relate to the camera (as they occasionally do), the photographic act is incorporated as an authentic episode in their lives. Here, the fact that those who cavort or break down before our view can expect and perhaps *need* to have their activity recorded means that they can never be spied on, nor can they disavow the photographer as witness. Having set up the

tableau for a timer, Goldin herself often joins in as one of the objects under surveillance. What emerges is a family album like no other, one that takes part in the domestic bad news as it happens, and also the lechery.

So, for example, the photographer's sleeping men are objectified in their naked, defenseless flesh and often almost gloated over. Streisand never looked more fondly on Redford sleeping in *The Way We Were* than Goldin looks on male bedmates in *The Ballad*. The camera is used to appraise these hunks, libidinously, possessively. One such tattooed fellow, loosely tied up on a bed, next to his indifferent dogs, gets smooched by a clothed woman (who may be Goldin herself). This scene has a particularly wonderful glitter. Yet the countervailing, brazen force of the men is felt everywhere, often as partners who wield the upper hand. In one photo, David smiles for the camera while Butch, the woman with him at the bar, struggles through her tears to do the same. What a dissonant moment, in which a couple demonstrates obvious good will toward Nan, though the woman is wretched. Direct as it is, the photo pivots on a mystery that results from the camera's intervention: is David merely polite on this portrait occasion, or is he smug about his role in the immediate, conflicted past?

The photographer herself states that she found it difficult to "understand the feeling systems of men; I didn't believe they were vulnerable and I empowered them in a way that didn't acknowledge their fears and feelings." At the same time, she goes on, "People cling together. It's a biochemical reaction, it stimulates that part of your brain that is only satisfied by love, heroin, or chocolate." All amorous gambits, in other words, are motivated by the same addictive needs, and the point about people who are so hooked is that they have no sense of emotional moderation. When they come on to each other they're the ideal characters in a clichéd structure that has been used in popular culture, say, from Jules Feiffer's cartoons to Franky and Johnny (a real ballad), and why not even to Tasso's Rinaldo and Armida? In her manner of generating pictures, Goldin herself lacks any restraint (she's *addicted* to photodocumentation of her life), but she achieves a certain balance of expressive possibilities. The distinctiveness of these images lies in the contrast between their author's would-be romanticism and her realist position and style. The vulnerable man is a figure of romantic culture; the brutal man is a protagonist

of realist art. Human interactions, she seems to say, are shaped, above all, by physiological cravings. Such single-minded desires take hold in scenes served up as raw as possible.

Because *The Ballad* issues directly from an insider's perspective, J. Hoberman (*Village Voice*) was quite right to say that it is a diary, but thoroughly wrong to call it a soap opera. One has to insist on the difference between real access to the intimate lives of people and media representation of them. Soap operas are such elaborately text-ridden, opinionated forms that they smother all visual life under a blanket of judgments about character, style, and even gesture. No one can possibly breathe the same atmosphere as the members of the cast. Goldin, in contrast, lets in the air, through the nervous and impulsive rendering of her pictures, which enhances their confessional tone. Actually, she distinguishes (in her preface to the book) between her uninhibited written diaries, which are private, and this visual one, which she makes public. She allows that her undisclosed writing is more personally judgmental than her pictures—inappropriate, therefore, for general consumption. For her, the value of the snaps is that they are free of her opinions yet remain embedded in her experience—she considers her images to be as everyday, unstudied, and idiosyncratic as "talking or eating or sex."

Goldin's documentary keenness is rooted in high-energy traditions in recent American photography. She was kindled by the lessons of Garry Winogrand, Lisette Model, and, above all, the legacy of Larry Clark, whose *Tulsa* (1972) was serious photography's original family album. In fact, *The Ballad* particularly recognizes and extends the promise of Clark's book. In both autobiographical campaigns, the diffuse history of socially marginal or outcast figures is substituted for that of the photographer's relatives. Lacking blood ties, the solidarity among these figures becomes all the more poignant because it is compensatory and ingrown. Clark's junkies were actually at a dead end, a fact underlined by his projection of *Tulsa* as a memento mori. For their part, Goldin's friends are urban members of underground bohemias—East Village filmmakers, rock musicians, and drug-doers.

The presence of such fringe beings has led at least one critic, Andy Grundberg, to imagine Goldin's chief precursor to have been the Robert Frank of over thirty years ago, not in his role as the perennial outsider but in his admonishing vision. Still, the characters depicted

in *The Ballad of Sexual Dependency* don't really come across as alienated, however sullen or woebegone some of them might be. For that to have been felt, there needed to be implied a hostile outlook on America, a sense of the country as very unhealthy for the featured group—and this sense *The Ballad* rather clearly lacks. In contrast, the slide shows of *The Ballad*, with their rock, heavy metal, and country-and-western sound tracks, point to the experience of these young people as something shared with countless others, everywhere, tuned into the same musical stimuli. As long as her principals are heated up or upset, come what may, they're alive to their moment. The tone of the picture may be lurid, yet also warm. But when Goldin's camera visits bourgeois interiors (some party scenes and pictures of children), she notes a decrease in such warmth and, with that, a failure of even ordinary human connection. Here, her mood turns harsh, and displays a certain kind of antagonism toward the undemonstrative body, the immobile face.

Goldin's *Ballad* opens with a shot of the artist fleshily hugging her man, whose doleful expression bodes poorly for their future. This tableau is immediately contrasted with a portrait of the photographer's natty, pinch-lipped parents at a French restaurant. To drive home the point of the emotional chill (from which her subsequent imagery departs), the parents are juxtaposed with a picture of effigies of the Duke and Duchess of Windsor at the Coney Island Wax Museum. The self-protective reserve of the older generation, and of the well-off middle class from which Goldin is a refugee, is assumed to be corrupted behavior, taken over by a hateful lifelessness. Of course, this kind of presence has been fastened upon by new narrative photography all around, and has in fact become a recurring motif. Yet one glimpse of the current gallery scene is enough to see how Goldin stands apart from the trend of narrative in photography that refrigerates the formal voyeurism of commercial media. Her volatility challenges this wasteland of stiff or frozen depiction. From Goldin's view artists who do that are hopelessly distanced from their subject matter, locked up in bloodless strategies that obscure desire.

A more interesting counterweight to *The Ballad*, because of its clear erotic focus, is Bruce Weber's *O Rio de Janeiro*, which purports to be a quasi-narrative photojournal of sexual preludes or languorous after-

maths down by the Rio beaches. With an expensive team and paid models, shooting on location in the exotic, indigent Third World, Weber, an ultra-successful fashion photographer, naively constructs a "personal" diary, filled with handsome frowns and moues. Here, the bodies all look glossy, spruce, voluptuous, and fine; the sex, he suggests, is really tops, and the tints are plummy. There's no question about this market illustration being a sincere fake, for it lacks consciousness to be anything else. Weber's sexual high jinks are conceived as a charade reduced to a tourist fantasy with imperialist overtones.

I don't know if Goldin's album acts as a challenging entry into the feminist politics of our visual culture. But it certainly urges us to think that it is a strong, front-line report on women who are in primal engagement with men, and who apparently lose ground in the process. The work has been criticized by some feminist writers for visualizing only a stereotypical female victim, or for being overly heterosexual. But these complaints miss the actual fluidity of the album and seem not to grasp that the erotic themes are fused with social description.

The regulars in Goldin's milieu, for instance, are economically hard up. One look at the fleabag they stayed at in Merida almost suggests that they were on the lam rather than on vacation. Though not outlaws for whom time is running out, like Clark's friends, Goldin's evidently drift just as much and are just as restless. If they are centered by any productive work, she doesn't show it. They turn up among skinheads in London or at discos in Berlin, on trams or in cars, without giving the impression that they're getting anywhere. In terms of social class, the women are of undetermined origin, while the men display emphatic proletarian style mixed with rock and motorcycle regalia. A fair percentage of the women appear to have been hardened to this company, but Goldin gets closer to those who are uncomfortable with it. She's a virtuoso at charging the atmosphere with a kind of opulently glowing sleaze in which characters glance suspiciously at one another. They may have been caught at loose ends or in tentative moments, but the effect is of too much having been left unspoken. In this suspicious environment, one takes one's pick, either of callow dalliance or of baffled solitude.

Actually, Nan Goldin is not alone in placing herself in the thick of all these emotional ricochets and shortfalls. Hundreds of students in photography departments across the country have found in variations

Nan Goldin, *Nan on Brian's lap, Nan's birthday, New York City,* 1981, from the series "The Ballad of Sexual Dependency," 1986 (original in color). Courtesy Marvin Heiferman.

of her confidential mode a way of pictorially exploring their own sexual identities and psychic interactions. But Goldin's downbeat photographs examine real conditions, in the midst of which her young subjects torment themselves, without insight into their own self-destructiveness. This work does pose problems: what sort of awareness are we to attribute to women who need to cling to men readily capable of brutalizing them? And to the men who do the beating? Is there no way of growing up free of the more repressive aspects of social conformity without arresting one's emotional development and fixating on bad vibes? Finally, how admirable is the act of coarse self-exploitation, which devalues privacy and personal dignity in the name of artistic license?

Yet the exceptional interest of Goldin's project depends on the candor that invites such damaging questions. With so much riding on the honesty and unsparingness of her pictorial statement, one has to take seriously the neuroses to which it alludes. *The Ballad* is involved

in a politics of the body, whose language is intrinsically visual. Early in her life history, Goldin, rejecting the cerebral but inexpressive male authority figure, embraced the physically demonstrative but menacing male lover. Her images are weighted toward the second of these polarities. The very toughness to which Goldin's characters are generally drawn becomes the source of their undoing. In recognizing and caring about what happens to them, the photographer acts out her own dilemmas.

As *The Ballad* finally appeared in published form, it was overtaken by public events that infuse it with unexpected overtones of alarm. These events were not likely to have been on Nan Goldin's mind, nor do I believe she would have heeded them even if they were. During an era in which some people feel compelled to test themselves negative for the AIDS virus before they even kiss, and in which the press hounds political candidates into the private recesses of their sex life, the sensational aspects of *The Ballad* are retroactively boosted. What kind of moral sense can be made of them at this point?

The appearance or projection of new social restraints is one symptom of Americans' public anxiety about sex. Where organized religion sometimes proscribes it, the media wallow in it, and officials of all sorts counsel abstinence from it, eros is urged to turn in upon itself. Within this increasingly loveless public atmosphere, the punishing attractions of *The Ballad* contribute a demonic twist of their own. We seem to be looking at an earlier promiscuity that no one can afford anymore, and therefore at a spectacle with penalties for anyone who would play a role in it now. An ordinary viewer is unsure whether to consider *The Ballad* an unwitting object lesson in destructive self-indulgence, or an exemplary call to arms for erotic spontaneity. Goldin's best photographs raise these conflicting issues, which have accrued through our current predicament.

Though very present-tense in feeling (some of her rock-musician and filmmaker subjects are right now achieving fame), the album looks backward, illustrating behavioral codes to which less and less of middle-class bohemia think it prudent to subscribe. The bringer of a more up-to-date message may indeed be Bruce Weber, who tells us that bodies are only there to be looked at. His photographs retail a collection of fleshy still points, arranged for the appraising eye. With far fewer

perks and less-good physiques, the family of Nan simply moves me more because the people in it are far more dramatically themselves, gripped by their limitations even as they seek release. They want everything, fail in their knowledge of how it can be obtained—and they lash out at one another. They're located where we see them because that's where their flawed lives are, and we viewers are secondary. A world in which access to objects of desire is by implication permitted only to those with an excess of cash is in the end a world debased, exhibitionistic, and shallow. How much more authentic is *The Ballad,* where it is painfully learned that desire can't be satisfied without affection, and affection can't be bought, only earned.

This essay appeared in *Art in America* (November 1987).

*T*he Social Landscape

INSIDER VIEWS AND ESTRANGED REGARDS

Looking Backward on the U.S.S.R. in Construction

SOVIET PHOTOGRAPHS between the world wars often reveal more than a kinship with the Russian silent cinema: they seem like extracts from it, actual pieces of a saga we can hold in our hands. Both media obviously have in common their survival from a defeated grandeur, devastating in its illusions. But the renowned cinema has been degraded by the passage of time and mostly exists for us now as blurred shadow on poor stock. Contrarily, the far less known photographs present themselves as vignettes from that same spectacle, immobilized, with contrasts sharpened and details retained. Whether film or photography, though, the historical value of the picture consists in its special, period denial of the very history it pretended to record, the unspeakable present of Stalinism. Here, the cultural ability to disguise a nightmare as a utopian dream fascinates a world continuing to adjust to the death of the Cold War. Wherever else totalitarian state propaganda may have imposed itself, in Russia such bombastic imagery was nevertheless visualized by art often on a serious level, (ignited by libertarian modernism), that speaks to us with an unintended pathos. For even the formal discoveries of the Soviet picture carried with them strange closures, moral as well as psychological.

The film was presented as a continuum that sweeps around key images, sometimes recurrent motifs conceived beforehand in terms of a design guyed within a frame. Turbulent narrative activity burgeoned through space, and while developed or interrupted by cuts, was blocked out always in relation to the authoritative containment of that frame.

Instead of the frame being psychologically dissolved in the absorbent flow of events, one feels that the action was brought to the frame and knowingly configured to stamp an indelible—frequently a symbolic—impact in the memory. In the same way the camera dwelled on faces, reiterated within a compressive space, leaving no question of the director's investment in an iconic sensibility.

For their part, Russian photographers started out from the iconic—a locked-in reserve of which they make us very conscious. All the more did they seem to yearn for an egress from the frame, which was expressed by pressure against its margins. That is, objects, people, and vistas poked beyond the edges with such insistence as to suggest a new uncontainability of the phenomenal world. In western Europe, a comparable pressure existed about the same time, the late twenties. But there, unexpected photographic cropping came about spontaneously or it echoed devices of modernist painting, such as the Bauhaus's. A machine esthetic and therefore an ideal of efficiency dominated European vanguard art, inspired by redeveloped economies. Lacking any such infrastructure, the Russians discounted the rational tone but emphasized the dynamic spirit, and specially the insurgent, rampaging vectors of such a prewar vanguard as Futurism. Never had photography been as kinesthetic, as metaphorically caught up with those traversals of space in evident time we associate with cinema. One has only to compare Moholy-Nagy with Rodchenko to see how much further the Russian took still photography along such apparently fluid and dizzy vantages, forecasting endless others, so that the frame seems as open and omnivorous a fitting as a movie screen, exploding with presences.

Of course the photographic frame acted as a permanent field of fixed imagery while the movie screen worked as a staging area for fugitive impressions. The fact that the two photographic media emulated each other suggests more than the impact of arts fusion theories in contemporary thinking. A synthesis of the arts and crafts, in a nonhierarchical, industrial setting, was a feature of left bourgeois as well as Russian revolutionary aesthetics. But the convergence of film and photography had a very different import in Russian agitprop and prolecult activities than in European modernism.

The latter was antirealist and ahistorical. It was intended to address itself to cultivated audiences rather than mass, illiterate publics, as in

Alexander Rodchenko, *Gathering for the demonstration*, 1928. Courtesy Laurence Miller Gallery.

Russia. There, the requirement to report the progress of a new society led to an early accent on the documentary, as in the filmmaker Dziga Vertov's *Kino-Pravda* (cinema-truth), a sort of avant-garde newsreel. And even Dovshenko's lyrical film *Earth* was said to have been originally suggested by a newspaper account of a peasant murder in the Ukraine. Apparently reportorial and transcriptual techniques were part of a breakout impetus: the artists extricating themselves from the sentimental artifices of salon painting, the genteel stage, and romantic fiction. In their place were installed values associated with rapidity of eye and first-hand witness, and if life were let into the visual field kicking or bumbling, and not a little chaotic, so much the better.

On the other hand, given the scantiness of communications and the regime's illegitimacy for the majority of the populace, particularly from Lenin's death in 1924 through Stalin's definitive seizure of power, by 1929, photographic media were assigned a didactic, coercive mission the very opposite of documentary. And this conflict of aims was articulated in the tension between the attributes of film and photography as they were brought into play with each other. It now seemed as if film, cinema, and still were to use up all their reserve for light in the task of *structuring* the fugitive moment. By its momentum, contrasts, and gestures, the visual field constantly demonstrated how it, along with the productive environment itself, could be assembled before one's very eyes . . . into an artifact that existed outside real time. In photography, this constructive process was expressed as a kinetic emblem; in film, as an emblematic continuity. Rather than being digested through the subjectivity of people, in their individual circumstance, the visual moment had to bear the supposedly public weight of a "collective"—everyone's and no singular—consciousness.

While they survive in many random sizes, the photos were often deliberately worked up as large exhibition prints, almost posteresque in effect. They were meant to capture the eye before they described any condition. One picture, actually just a snapshot, reveals how the stage management of an exemplary thirties Soviet image was put together—behind the scenes. El Lissitzky, once a prime vanguard figure, and Georgi Zelma are shown as they posed and lighted a model impersonating an October revolutionist, who was to be featured in a spread on the military, for the monthly *U.S.S.R. in Construction*. Their evidently deadened, academic rehearsal of it in the studio confirms

the ferocious vacuity of the image as it was printed in the magazine. Most likely the snap is complicit with the mock-up, even as it reveals it. By any reckoning, this must be a rare tableau. With its freedom of design and sparkle of witness, it exposes a dulled practice of the late thirties by means of the enterprising style of a decade earlier.

Some memorabilia of the photographers have posthumously trickled out from the homes of their families, and give us an idea of how these men regarded themselves. Their formal work appeared in *Pravda, Ogonyok,* and, above all, the awesome *U.S.S.R. in Construction,* the main clearing house of Soviet imagery for foreign consumption. A few of them were employed by the Soyuzfoto agency. One operated out of the Information Department of the Magnitogorsk steelworks. Now, in the field, we see Georgi Zelma, profile, in the charade of a conqueror, one foot upon a stone chimney, as if it were a body. Arkady Shaikhet poses on a balcony of some building, as if to take one of those tilted, familiar bird's-eye shots of the city street below. Georgi Petrosov raises his Leica way above his head, conceivably in the act of photographing over some impediment—a crowd?—at eye level. As they smile good-humoredly, with their apparatus at the ready, these men are positioned for an overview, hardly the horizon of an average worker. Their desired vantage is quite bluntly the panoramic, by which they assert their optical power.

At short range, this power demanded an unusual sufferance from its human subjects. They had to submit to being inspected, say, from under their chin or from behind an ear lobe. Yet they were not the targets of merely voyeuristic gazes. A commanding energy of design subordinated any erotic nuance or individual interest. Rather, the camera was squinched into the unlikeliest places in order to exalt its own, transgressive but utterly detached act of looking. As in the cinema, so in these photographs, heads pretend to be ignorant of surveillance at excruciatingly close quarters. Rodchenko attacked the conventionalized camera viewpoint "from the navel" as authoritarian, since it allowed only for a single alignment, not the degravitized and liberating perspectives that excited him. He had collaborated with Dziga-Vertov in the early "newsreels" and was a virtuoso of montage. It was natural for this highly esthetic Constructivist to depreciate "photo-pictures" and proclaim his own "photo-moments that have a value as documents and not artistic objects." Certainly these moments,

Boris Ignatovich, *By the entrance to the Hermitage,* 1930. Courtesy Laurence Miller Gallery.

instead of being momentary, were meant to endure by virtue of their contrast with any conceivable psychological viewpoint. They do not accord with the perspectives of social human beings but rather with creatures that fly or crawl. The actual sizes of things, and their scale, relative to each other, were constantly aggrandized or diminished. Even as he eulogized them for their scientific spirit, the photographs of Rodchenko and his talented followers kept on knocking rational effects out of plumb. Near and far, up and down, were juxtaposed raw with a deliberate excision of any gradients between them. Viewers were invisibly levered off any ledge or base from which to locate their engagement with a scene. A whole middle distance of street contact dropped out of sight. Banished, too, was any introspection or reflectiveness on the part of the image-maker. In a powerful photograph, Boris Ignatovich's seemingly leviathan (close up) sculptured foot could crush the ant-like citizens who walk in the background at the Hermitage. The urban world was charged as an arena in which people and things are in some kind of exhilarating, but also sinister and

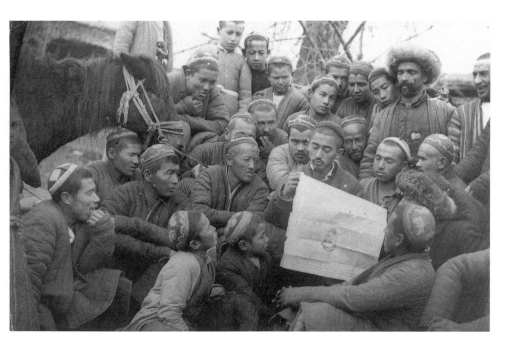

Georgi Zelma, *Peasants discussing news on land reform, Uzbekistan,* 1927. Courtesy Laurence Miller Gallery, New York.

adversarial relationship to each other. There ensues a weird tension whose defiance of gravity and logic reinvests old power symbols, just as much as new ones, with a dynamic they could never have had before 1917.

When the camera was trained on events in the country, these internally jagged, hyper-modern formats added zing to anachronistic subject matter, out of phase with its time. The news that the twentieth century even exists, in its characteristic technology, only now percolates to the supposedly dazzled peasants in the endless fields and outlying steppes. Many Soviet photographers are concerned with an iconography of "arrivals." A village waif grins at the movie camera. The Tatars delightedly hear their first phonograph recording or radio broadcast. One of their number with a knowledge of Russian reads or translates for the crowd from *Pravda,* which miraculously wreathes everyone in smiles. From the distant center come benevolent tidings and new materiel which they are presumed to have longed for as a sign that will redeem them from their archaic ways. "Is it coming?", "It has come!", repeatedly shout the poor moujhiks in Dovshenko's

Earth, as a rickety tractor finally lumbers across the meadow. Here is the moment in which a thing implacably material and profane is raised into a spiritual presence, ecstatically received.

In the first years after the revolution, agit-trains and steamers, kiosks, buses, and trains, festooned with news photographs, were sent out to remote districts. Now, photography was directed to record a later stage in the process of news reception, under the generic heading of "progress." But if so, it was a progress that echoes the industrial revolution of a hundred years before, in the West, as well as the techno-conquests that accompanied it, when the European camera colonized preindustrial peoples over vast territories.

The time-warp that runs through Soviet photography has not received as much comment as it should. When the Russian camera celebrates the building of railroads and canals, Arctic exploration, or the schooling of backward farmers, and when it remarks upon the ethnographic diversity of tribes, all of which it does between the world wars, the view tells of a center wishing to have understood that its will has been communicated to enthusiastic peripheries. The early Western versions of these scenes are familiar to us. They imply the ruthless displacement of natives and the ravaging of nature, none of which were even perceived as costs by the acquisitive audiences back home. In contrast, the Soviet rerun of this old outreach to "autonomous" frontiers was stylized by a completely disjunctive modernism. And this is very unfamiliar because the clichés of primitive development and the rhythms of Futurist utopianism, quite in a limbo of their own, are in conflict without being acknowledged. A viewer is irreconcilably placed in two time zones at once: not the confidence of the present as it studies the living past, but the spectacle of the past awakened to a future that does not exist.

Even stranger, the collision of two cultures, be it great Russian with Uzbek or Kazakh etc., fails to signify. In the nineteenth century, at least, the image *didn't* imply that alien and sullen natives looked upon the advent of the European with the thought that their lot would be instantly bettered. But this is especially what Social Realism assumes, against all historical evidence, and with such frequency of protest that we can make out the fear that motivated it. Underlying this massive propaganda drive is the dread that the improvised center will not hold and that the new will not triumph over the old. Such

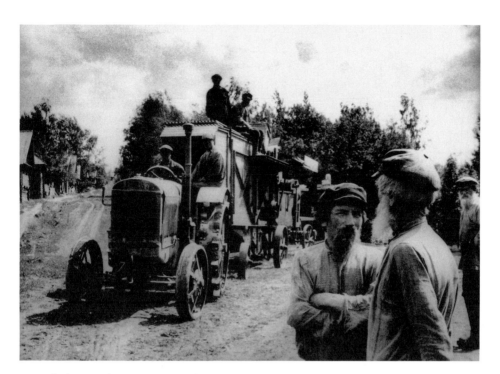

Arkady Shishkin, *Now we can live!*, 1935. Courtesy Laurence Miller Gallery.

was the insecurity of a system gripped by time that slipped through its hands and isolated in a space too vast to overcome. In the countryside, Bolshevik perspectives of time and space converged traumatically. For the cities, and with them the proletariat responsible for the advancement of the state's industrial base, were only to be fed by leeching all foodstuffs from the peasantry, a class so gouged, set out to famine, and murdered, that, as much as it could, it fought back.

Intended for city readership, photographs depicted peasants of whatever race in the most positive light, hospitable to the camera, tamed, enthusiastic in the work they freely do for the modern Socialist state. Where the peasants ferociously resisted the kolkhoz (the new farm collective), they are shown unanimously—though stiffly—voting in its favor at village council. So, too, we are to believe that Muslim women gladly tore off their veils in denial of their ancient culture. As for Asiatics overall, they're characterized as vigorous heroes of folklore, lovely or weatherbitten, according to gender.

In one of the really great, and certainly most operatic images of the period, Max Alpert's *Construction of the Fergana Canal,* 1939, immense

native trumpets and drums encourage the sweeping mass of Uzbek laborers on to their work. As a pictorial moment, this could well have been influenced by the passages in Eisenstein's *Alexander Nevsky* that describe the surge of medieval peasants who join under the prince's banner. The photo gives the same sense as the film of a whole, irresistible people underway, united in a common purpose, and massed in picturesque columns. Eisenstein himself, who might have seen Alpert's image, planned to do an epic on the building of the canal, as if to cycle back into his new film a "documentary" treatment of a contemporary subject that reflected his earlier grandiose vision of Russian history. At the last moment before filming, Stalin, who called the shots everywhere in Soviet culture, canceled the entire project.

One begins to understand how photographic imaging systems were hostage to the strain between party line and personal rule in the ideology that monitored them. Cultural diversity, an obvious fact of life in the Soviet Union, could not be celebrated as a source of strength in a national effort at the same time as its tribalism implied resistance to economic diktat. The more a certain Oriental and exotic flavor was packaged in photography, the greater its suggestion of integral social groups that could compete with and remain outside the state's control. Even the somewhat "liberal" Russian ethnographic photographs, that have a vaguely tourist air about them, though far less racist than Nazi ideas about non-Aryans. are particularly hollow in effect. It is true that the Bolsheviks in November 1917 immediately proclaimed the right of non-Russian peoples to sovereignty and succession. Native languages were encouraged and for a while in the twenties, anti-Semitism was made a crime. But in the Stalinist thirties, from which date many photos of happy ethnics, these rights had long been rescinded, and all dissent from massive Russification had been hounded underground. Similarly, the peasants had once been granted some independent ownership of land, along with profit farming, during the New Economic Plan. But under the second Five-Year Plan, their holdings had been seized and collectivized by the state, which "disappeared" resisters into the gulags and deported untold numbers into industry as slave labor. Given these facts, the objective of photographers was to attribute a mythic vigor to the action of a people who had in truth been broken in spirit.

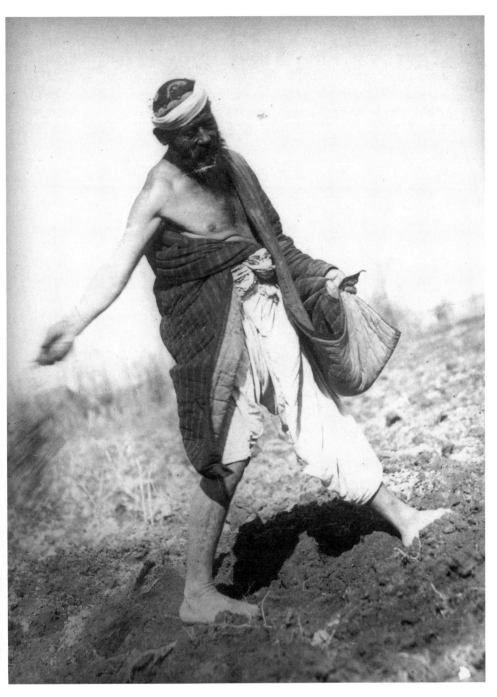

Georgi Zelma, *Scatterer, Uzbekistan*, 1924. Courtesy Laurence Miller Gallery,
New York.

In the central theme of Soviet photography—the performance and meaning of work—all this disinformation is brought to a head. The building of the White Sea canal was a Pharaonic labor that witnessed the deaths of several thousand souls, and then in the end the canal was too shallow to be used. In the December 1933 issue of *U.S.S.R. in Construction,* devoted to this project, we read: "In the course of 20 months about 20,000 skilled workmen were trained in 40 trades. They were all ex-thieves, bandits, kulaks, wreckers, murderers. For the first time they became conscious of the poetry of labour, the romance of construction work. They worked to the music of their own orchestras." Running through this journal and many other Soviet media was the idea that human personalities had be to reconstructed along with the backward industry of the country. Among the negative images in Soviet cinema were those of drunks and priests; now photography was said to have pictured all sorts of onetime reprobates and misfits, whom the state was reprocessing as useful citizens. This kind of work was also carried on within the intelligentsia itself, striving for ever greater orthodoxy as Stalin took the country into purges and all-out terror.

Rodchenko and his friends in the October group, for example, were scourged by Alpert, Shaikhet and Fridland of the Russian Association of Proletarian Photographers (ROPF) precisely on the issue of how the industrial order, henceforth, from 1931, was to be represented. The predilections of the old vanguard were at stake, and inevitably they lost. Accusing their colleagues of a "fetishistic attachment to technology and the machine," the ROPF people, in fact, had a point. After all, how could workers be exhorted to ever more strenuous production—to meet their hopped up quotas—on the basis of very lonely views of the workplace? As pictured by the October photographers, this was an environment where surfaces dominated the field but gave very little idea of how anything got done. The picture may have been rousing as a visual stimulus, though only at the same time as it made moot the relationship of the fabricator to the thing fabricated.

Workers, therefore, needed to be reintroduced into the picture zone as effective and human agents, engaged in unison with their own kind. Even better would it be to single out one or two of them, a Victor Kalmykov, a comrade Filippov, as exemplary of the doubtless humble but also wholesome and fulfilling lives led by so many of the proletariat.

Such figures were put through certain paces, the first in an evolutionary route that took him from the status of landless, shabby, illiterate peasant to become a skilled worker, member of the party and carrier of the Order of the Red Banner, at the Magnitogorsk steelyard, and the second through the round of his daily activities, as a metalworker at the Red Proletarian factory in Moscow, and with family at home. As magazine features, these were among the earlier photo-essays in twentieth-century propaganda journalism. They are informed by homely touches and raw particulars. Kalmykov's feet are clothed in burlap, for instance, and he is shown being given the first (and spotlessly clean) bed sheet of his life. Transmitted by the foreign language editions of *U.S.S.R. in Construction*, January 1932, to the depression-era West, which had little sense of Russia's actual crisis, the sentimental genre scenes of Kalmykov and Filippov played well. Of course, instead of "fetishing" technology, they did the same to the state, an entity whose abstractness was supposed to be humanized by its material provisions for deserving workers.

At this point, one can see that the contrast between the imagery of things and that of social relations reflected complementary rather than antithetical approaches to the problem of depicting work. The October (or "Left") mode of photography tautened formal relations; its opponent, lacking the other's visual intelligence, pictorially inventoried objects (including the workers, because they, too, for propaganda purposes, were classed as objects) in a narrative context. Soviet film offers more than a glimpse of how both these tropes were adrenalized by sheer cinematic values. In Dziga Vertov's *Enthusiasm* and a great deal of early Eisenstein, the action of work cuts through space, much as harvest machines scythe through grain. Here, the culture of production as a relentless build of physical input takes shape in crude tracking shots, arpeggiated by parallel and cross cutting, paced with ever greater rapidity, until it reaches a shattering crescendo. Men and machines are bonded in some unstoppable, mesmeric frenzy. And it finally looks as if the film itself is in a great hurry, under an imminent deadline in which too much visual material needs to be compressed in too little time.

Such a feeling tone accords with the historical reality of a state that knew itself to be behind, and desperately tried to catch up with more industrialized nations (let alone to establish its own plant), by means

of impromptu policies, stop-gap programs, and unreal schedules . . . executed at no matter what human price. Because it in no way took account of the bodily and psychic costs people would pay, the state, in fact, conceived "progress" as an inhuman development.

Elsewhere, in the German filmmaker Fritz Lang's *Metropolis* (1927), though couched as sci-fi or fantasy, this vision was expressed as the quintessentially infernal product of modern times themselves. The proletariat is a class of wretched underground moles, propelled in regimented columns within a screeching environment governed by a remote management of plutocrats accompanied by decadent high-lifes. As a critique of capitalism, such imagery (if not the film's actual plot), was more forceful than Diego Rivera's frescos of modern industry at the Ford plant in Detroit. But the fact that that painter was an expelled Communist party member working for a capitalist patron did much to complicate his evocation of modern labor. With great poise, Rivera sees the assembly line simultaneously as a depersonalizing force and as a technological marvel. It is serviced by workers who are half robots and half heroic. The finished product of their labors can be utilized by a system which has as much potential for evil as for good.

Needless to say, any such ambiguity of outcome would never have entered the programs of Russian filmmakers and photographers depicting working conditions, in the "workers' state" that exceeded the worst infamies of capitalism. As far as the rhetoric of their images is concerned, the long-term necessity of the cause which demanded such immediate sacrifice simply existed as an article of faith in the society to come. Magnitogorsk was relatively up to date for its time, being in part furthered by Western expertise. But the Soviet imagery that described that stupendous place belongs to an earlier mind set, in which it makes no difference if work is made to look—subjectively— noble or rough, dangerous, even alienating. For it was the momentum of it all that counted, an almost dynastic impetus that transfigured the horizon of the once empty plain. Just as the modernizing despot Peter the Great begat his new capital, raised from the marsh, so Stalin caused there to be heavy industry, without an adequate material base. The traction and tactility that came out of reportage on Magnitogorsk stand apart from the much smoother rendering of similar subjects in the West. We celebrated our modernity by references to geometric ideals that were ultimately Platonic in origin. In Russia, since the

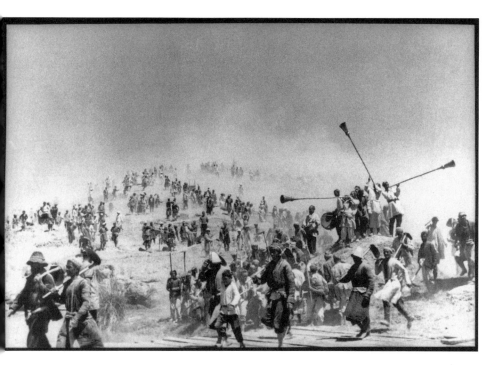

Max Alpert, *Construction of the Fergana Grand Canal,* 1939. Courtesy Laurence Miller Gallery.

only conceivable viewpoint was one that extolled the constructive state, photographers could wonderfully describe the filth and the violence of that construction, and think themselves on good terms with the powers that be. For us, this is a pictorial dividend and an irony that at the time, no one would have savored.

Soviet photography was given its apotheosis in *U.S.S.R. in Construction.* For the first half of its tenure in the thirties, this giant publication—twenty-two and a half by thirty-two inches, double spread—broadcast the good news of socialist development throughout the Western world. One has to see the magazine, to hold it in one's hands, to fully appreciate the magnitude of one of the great pictorial campaigns of the century. In lay-out alone, it included monochrome printing in four different colors, montage, foldouts in surprising sections, shaped photos, diagrams, charts, pictures juxtaposed flush or running into each other, combination photographs in single frame, overlaps and skewed designs that leapt off the page—not always co-

herently, not always effectively, but with a graphic zeal matched by no other journal of its day. The changes of weight and viewpoint, of thought and sequence, are often disconcerting . . . and delightful. It was as if the shock designers of the magazine could accomplish instantly for the page what filmmakers do over time on the screen. Many, if not all the known names in Soviet photography had their day in the great publication, with pictures that have appeared elsewhere in calmer, more settled circumstances.

But by degrees, this volatility became a thing of the past. Later in the decade, very few pictures escaped an inexplicable retouching. Unpredictable outdoor shots tended to be replaced by more controlled interior scenarios. Compositions lost their push and design plodded on, through routine picture stories, such as on an OGPU commune, a kind of boys' reformatory run by the secret service, or a feature on the Maxim Gorky Central Park in Moscow. The latter contained a remarkable caption: "Here and there in the park are 'glee parties,' in costumes and masks. Their duty is to turn up in any place where people are getting bored and begin to make them merry." We can well appreciate the lack of merriment in a society where spontaneous public utterance was definitely frowned upon. Already, in 1917, Lenin anathematized "spontaneity," by which he meant the spontaneous demands of the proletariat for better wages and working conditions, demands that had no place in his agenda. But the centrifugal and incongruent energies of whole peoples did not cease through being indiscriminately repressed. The tendency of huge masses to spring out and galvanize the moment, in an amazing gyre, was symptomized sporadically in Russian film and photography. It was to be released, and pictured, in an explosively new form with the coming of the Second World War.

This essay appeared in the exhibit catalogue *The Utopian Dream: Photography in Soviet Russia 1918–1939,* which accompanied a show at the Laurence Miller Gallery, January 3–February 15, 1992.

Signs of Light: Walker Evans's American Photographs

TOWARD THE end of our century, Walker Evans's images, though long canonized, jumpstart our moral imagination. In many of its liabilities his America has not changed fundamentally, for all that the look of it has altered since the publication of his *American Photographs* by the Museum of Modern Art, New York, in 1938, slightly over fifty years ago.[1] Nothing dates a photograph more specifically, aside from the lettering that it may frame, than the cars that it depicts. Evans's are inevitably of their bygone period. But we are still a chauvinist society, still a violent and a wasteful one, and still hopelessly racist. On the other hand, we have lost any resistant temper, any unified drive that would combat these social pathologies, so that our emotional horizon has been transformed. Today's affluence would be unknown in Evans's images, but so, too, would be our listless sense of the national future and our ethical fatigue.

American Photographs, now reissued with an accompanying exhibition at the Modern, calmly examines the wide spectrum of our possibilities, our past, and our defeats. Even though he recognizes inequities for what they are, in a hard and dry way, Evans does not complain of them, and still less does he wallow in them. His detached attitude impresses us as fearsomely principled. We are a more bellicose place than he knew then, but morally speaking a less potent one. "Here," wrote Lincoln Kirstein in his afterword to the 1938 book, "are the records of an age before an imminent collapse." The writer was conceivably anticipating a proverbial fall, brought on by the debacle of the thirties, and the terror of imminent war. Fifty years into that "fall"

have made a difference. Objective conditions are presently not so bad that a failure of will can't make them worse, and to the extent that we surmise that failure in ourselves, Evans's panorama, with its refusal to be alienated by what Kirstein called "an open insanity and pitiful grandeur," strikes us as audacious . . . even farfetched. Had he been outraged, we could have understood him better and perhaps dismissed him a little. But he was circumspect.

With their varied inventories of homely facts, Evans's photographs are pleasurable to read, but the tactful stringency of his approach makes him difficult to discuss. Ever ready to illuminate the concreteness of deprivation, as if a thing of beauty, he puzzles us about his "engagement." His peculiar mixture of pessimism, aroused by some of the things he saw, and optimism, openly expressed for the prospects of photography such that he thought they might even drive him mad,[2] has provoked ideologists from the right and from the left. They have treated him either as a figure wrongly politicized by liberals or one to be condemned as a self-involved mandarin. So, for example, Hilton Kramer comments:

> The cultural ethos of [the 1930s], with its emphasis on social consciousness and political commitment, did much to determine the way Evans' work would be perceived for several decades, and . . . still determines the way many of his admirers look upon his achievement. . . . This mistaken emphasis has blinded a great many to the fact that the human chronicle so dear to political sentimentalists of rural poverty and urban low-life plays a relatively minor role in this photographer's total oeuvre.[3]

It's odd to hear that the decisive period in Evans's career, 1935–38, during which he established his greatest impact upon his colleagues of the Farm Security Administration (Historical Section) played only a "minor role." It's even stranger to read that a social concern for oppressed subjects—during the depression!—was not a relevant basis for serious art, nor even apparently a worthy human instinct: to imagine that Evans was involved on any such level is to be "blinded," "mistaken," and sentimental. On the other hand, a neo-Marxist theoretician, John Tagg, has recently castigated all the FSA photographers as lackeys of a Rooseveltian paternalism, *except* Evans, who is judged

Walker Evans, *Main Street faces*, 1935. Courtesy Museum of Modern Art, New York.

an especially odious character because he diverged from them into an elitist esthetic favored by Alfred Stieglitz and the American ruling class.[4] Aside from being ignorant of the fact that Evans had no use for Stieglitz, this statement amounts to censuring an artist because he had esthetic tendencies. Still, one would like to know how these estimates, so utterly opposed to each other, could have been elicited by the historical evidence.

In many respects, Evans had a conservative outlook. The photographers with whom he felt most in step, Mathew Brady and Eugene Atget, were either historically remote or looked to the past, this at the time when *Life* and the big press agencies were racing breathlessly upon the scene. Apart from them his chief artistic allegiance, as is well known, was claimed by writers, Flaubert and Baudelaire, once again nineteenth-century creators. It's a sign of an intricate sensibility that the photographer wanted to keep the dispassionate method of the one and the corrosive spirit of the other equally in mind. Certainly he expressed just as much scorn for bourgeois norms as they did (though he had far greater respect for a democratic society's vernacular culture).

Evans is often thought of as a classicist, but it's truer to say that he was antiromantic, an attitude that emerges in his emphasis on the disappearance of the author into the work, and the thought that the picture should selflessly describe states of affairs. When this inclination is contrasted with those of his fellow workers who managed to affirm themselves, or to heroicize their subjects, in the service of a good cause, Evans turns out to be quite aristocratic. Yet this son of a well-off Chicago North Shore family withdrew into a craft that enjoyed little artistic standing and less social prestige. He behaved thereafter as an impecunious New York bohemian, who lived on the air and dressed as a dandy. When on assignment to illustrate Carleton Beals's radical book *The Crime of Cuba,* 1933 (an exposé of U.S. business collusion with the Machado dictatorship), he went off on his own to photograph Havana stevedores and neglected to read Beals's text.

Some of these blackened dockworkers appear in *American Photographs,* inserted easily with native material and hard-times Anglo faces. Before any sequential or narrative idea emerges in the book, disjunctions such as this make the pictures appear to be shown off as if by a collector who implies that the subjects are replete with meaning by virtue of their bare presence. The work comes upon us as a motley assortment of images with minimal titles banished to the ends of its two sections. In the far more concentrated group of photographs included in *Let Us Now Praise Famous Men,* the famous study of Alabama tenant farmers that Evans coauthored with James Agee, the ostentatiously untitled pictures are fed in before the text even commences. "Parallel play" might be better than "mutual support" as a way of describing this relationship of images and words—though their themes are deeply entwined. One can't help noticing, and is intended to notice, Evans's balkiness in the matter of being encompassed by discourse. The downward behavioral mobility, the accent on work as an accumulation of images, the insistence on the sufficiency of photographic content as visual statement on its own terms: these mark Evans as a highly self-conscious artist.

In line with that perspective, he never claimed that he made documents, but that he worked in a "documentary style." "An example of a literal document," he remarked in a 1971 interview,

would be a police photograph of a murder scene. . . . A document

has use, whereas art is really useless. . . . I'm sometimes called a "documentary photographer," but . . . a man operating under that definition could take a certain sly pleasure in the disguise. Very often I'm doing one thing when I'm thought to be doing another.[5]

Since Evans was praised everywhere for his straightforwardness, it is reassuring to hear him confess to being devious. But he certainly did not take pleasure in the supposed inutility of his images in order to titillate himself. It would likely have been with the thought of Evans's work that Agee wrote, "The artist's task is not to alter the world as the eye sees it into a world of aesthetic reality, but to perceive the aesthetic reality within the actual world, and to make an undisturbed and faithful record of the instant."[6] A police photographer obviously has no regard for the esthetic—his or her unaltered view is meant to confirm a temporary and random position of things, to record only their latest moment together. In contrast, Evans's undisturbed view affirms their representative, that is, their symbolic, alignment with each other. In *American Photographs,* material conditions are understood as predetermined and deep rooted. He has a lively sense of the fatality of ordinary arrangements, which he observes in fresh morning light or bright sun.

The bureaucratic photograph must be dissociated and affectless in order to do its job. Its vantage is neutralized, subordinated to the purpose of relaying information, such that it can be said to portray anyone's or no one's encounter with the subject. Evans, though, stoutly testifies to "being there." His esthetic issues from a sense of place, and that sense is fulfilled only to the degree that the camera gaze can accommodate the viewer to the particularities of what is seen. The articles depicted within the frame are not treated as suggestive chaff but are understood as things that have intelligibly taken into themselves, have been imprinted with, their users' lives. People and their artifacts are mutually possessed by each other. Evans's "useless" imagery, in fact, is a study of user and used things, and therefore of the plain work that has affected each. That the work itself has a cultural value, as it does in *African Negro Art* (the pictures commissioned from him for a show of that title at the Museum of Modern Art, New York, in 1934), there can be no doubt. Evans has a dualistic concept of function. The purpose of labor is to fabricate, to which he bears witness

with fellow feeling. But labor also reveals an interrelatedness between people and their environment over time—and to note the depletions that have worn them both down is a political act.

In the homes of miners in West Virginia or of tenant farmers in Alabama, Evans's arrays of domestic objects open us to questions far beyond the reach of any merely beautiful still life. Without being reordered by the photographer, things take their place in a narrative— or is it that the regard for them is storied? The thirties were a decade when the indigenous textures and folkways of small-town and rural America were being studied in WPA handbooks and evoked in fiction. (One Georgia filling-station attendant had his background data typed out for the benefit of passing anthropologists.) Evans, who once described himself as a failed writer, approached American gas pumps, movie posters, civic statues, rocking chairs, wood-burning stoves, barbershops, and the faces that went with them all as typical features in a vast *sign* landscape. Contrary to the eeriness that the Surrealists had seen in Atget, Evans took from him a systematic, if never categorical, respect for the primacy of signs and their varied sets as carriers of photographic meaning. Literal signs denote locales and services, allude to popular fantasies, and announce goods at specific prices. Less discursively, worn-away topsoil is a sign of erosion, and the freshly mounded grave of a child is a sign of a premature death. Whenever possible, such indications are featured so as to work as internal titles.

As it comes to the fore, this semiotic of the American scene crowds out the reportorial or anecdotal latencies of the documentary style. Compared to the images of other FSA photographers such as Russell Lee, Arthur Rothstein, and Ben Shahn, which he influenced, Evans's has more nouns. Occasionally their images scrutinize certain telling details—gnarled, arthritic hands, thin, sagging, mattresses and bedsprings; but Evans visibly concentrates on things like these. He never really shows anyone at work, but only the physical toll of work on flesh and material. He does not reveal people at prayer, but he will illuminate their faith by displaying the kind of wooden churches they built in forest clearings. By observing that newness and energy have been taken out of things which nevertheless are still maintained, *American Photographs* presents itself as a gallery of moral effects. When subjects posed for Evans, the interest is in the effect of the permission he gave them to construct their own, ordinary performance. What

Walker Evans, *Washroom in the dog room of Floyd Burroughs's house*, 1936. Courtesy
Library of Congress.

had preceded him or was offstage but in every sense had contributed to the present sighting is included by implication in the experience of the current moment. Absence and presence are continually juxtaposed with each other. Evans's record of sign language fuses with his historical consciousness, freighting his pictures with their characteristic density.

Speaking of the Gudgers and the Ricketts, the farmer families in *Let Us Now Praise Famous Men,* William Stott remarks, "These are not simple people if we mean by 'simple' having just one significance and that readily apparent. . . . Yet in another sense, these people *are* simple. . . . What one sees, looking in at them, . . . is an incapacity to dissemble."[7] In a greater measure, the population of the rural America Evans depicted had no capacity to dissemble. The subjects inhabiting this ruined pastoral were unaware of the condescension of urban purposes or big media, and therefore were undefended against them. A consciousness of this was loudly publicized by Agee and certainly shared by Evans, together operating in Alabama on assignment for the Luce press (*Fortune*). The purposes of their in-depth study demanded that they gain access and trust in a damaged area; at the same time, the openness or transparency of conduct that they found everywhere furthered their penetration. In fact, it was positively magnetic. Agee wrote about such vulnerability with a kind of ornate, late-romantic, transfiguring guilt, as if he might be redeemed by confessing his privilege in the face of poverty. But Evans, here and throughout his career, seized upon the idea that the most "strict" observation provided the most apt commentary. And he had a natural advantage over the writer because he could claim, with justice, that surfaces spoke for themselves . . . that is, they spoke, without dissembling, of their history.

It is time to say that this forthright artist was also very elliptical. In his remaking of the documentary style, cause was continually displaced by effect. This put him at odds with Roy Stryker, his section chief at the FSA, whose socioanthropological approach was particularly illustrated by the "shooting scripts" he sent to photographers in the field: he wanted them to show how tasks were performed, large and small, and social affairs conducted. This practical-minded boss thought that no improvement could be realized in the lot of the dispossessed except by tooting the horn of American know-how . . . and the

affirmation of our traditional values. There may have been much to recommend that wholesome attitude, overall, but not in Evans's book. A great deal has been made of the conflict between the two men as a bureaucrat's inevitable misunderstanding of an artist. But a larger difference separated them. For Stryker, society was a network bent on remaking itself; though it had been seriously injured, pictures could show the process of repair at local levels. But Evans's outlook was retrospective, as befitted one who had a regard for lingering effects rather than for new inputs. The subject of his work was primarily what had happened to America, or what America had been, as opposed to what it might become. He took it for granted that everything observed through his large 8-by-10-inch view camera was in the process of survival.

This distinguished him from such powerful colleagues as Dorothea Lange and Margaret Bourke-White, who had emphasized the bitterness of the present, a condition in which they were fully immersed but that they sought to repudiate and overcome. Pictorially speaking, their work was embroiled in a psychology of struggle, sculpted and personalized in the bodies of resistant victims. The function of the picture was to dramatize either the need for new legislation (as in Paul Taylor's text for Lange's *An American Exodus*) or the pain of beaten-down hopes within anonymous lives (as in Erskine Caldwell's captions with Bourke-White for *You Have Seen Their Faces*). Viewers of these illustrated books knew at least preliminarily how they stood: as the ones who were exhorted. In contrast, the Kirstein essay in *American Photographs*, published by a museum, was about the pictures, not the conditions they recorded. The book failed to exhort anyone, and could have left its viewers somewhat at a loss.

Certainly all these photographers, of such high caliber, who covered analogous turfs and found similar, even interchangeable outlets, worked with immediacy and with connection to their reality. But Evans's comparatively muted, quietist, and deliberate view of it seems to address itself to the margins or the shards of the national dilemma. For all that they make an affecting appearance, individuals do not play a central role in his vision. He often appears to care more about weathered articles or effects than about the personal fortunes of their owners. Just the same, the rightness of this tone gradually sinks in on the viewer, who grasps that Evans aims to describe a broader

spectacle, the diffusions of a culture in its material expression. As for the culture itself, he perceives it as something that endures only with hardship and that is comprised mostly of relics, Victorian and clapboard. One has to say that Evans's notion of his present is of an aftermath, that the sheer scantiness of people's belongings—poverty here is distinguished by neatness rather than clutter—is all that remains of an experience itself not visually expounded.[8] In some respects, Evans's act of memory reflects the bleakest temper in the FSA archive, and throughout thirties American photography as a whole, because he was heretically resigned to what he shows: a world irremediable in its appearance.

Yet *American Photographs* refuses to declare any one view of that world. When Evans spoke about the disguise he wore in the depression, it was with the pride of an artist who had flimflammed government and corporate patronage to accomplish his own—deeper and more ambiguous—ends. Consistently in the book, brief runs of one kind of subject are interrupted by others, so that the viewer is kept off balance. Sour urban faces are replaced by eye-rolling movie posters; cars on Main Street give way to histrionic war statues, which are in turn succeeded by a Havana policeman, American Legion types, a coal-begrimed longshoreman, and a racist minstrel-show bill. In this fashion, disparate vignettes and mean flashes are likened to each other for reasons of poetic comparison rather than documentary coverage. Throughout, dirgelike elements are interspersed: abandoned antebellum plantation houses, an auto junkyard, the shacks and hovels of blacks, and the famous view of the graveyard in Bethlehem, Pennsylvania. (The whole second part of the book is like an elegy on the naive architecture it shows.) Aside from this recurrent motif, any single theme contends with others in a seemingly offhanded design. Suddenly we realize that we have to *work* to get at the thought that underlies this proposal about America.

Evans allows emotional shades to animate and flicker through his sequences, but he never settles into any of them, never identifies any of them as his own attitudes. But in this rhetorical inconclusiveness is located his politics of seeing. What there was to indict in the social system and what there was to admire in those meshed within it are found as resonances of often static visual phenomena. Invited to supply an ideological text to these provocative images, we discover it only

Walker Evans, *Negro barber shop*, 1936. Courtesy Library of Congress.

in the light that etches in scene after scene. Our basis of looking at *American Photographs* continually shifts, in fact, not only because its short takes are disruptive of each other, but because the pragmatism and scruple of Evans's historical method were energized by a search for revelation. The phenomena he photographed are crystallized in his images, as he hoped, in some *transcendent* moment of encounter. Instead of imposing his "superior" way of seeing upon the humbleness of the thing seen, he wished to fuse them at equal strength. When the moment came, it was as the reward of his patience and to be served by his craft. "Only I," he said, "can do it at this moment, only this moment and only me. That's a hell of a thing to believe, but I believe it or I couldn't act."[9] How attuned is Evans here to Emerson's remark, "The eye was placed where one ray should fall, that it might testify of that particular ray"?[10] Howsoever the light gifted the scene, Evans's self-effacing but also specially elected role was to offer unique witness

to it. And this may account for the odd—and compelling—sense of gratitude that informs even his pictures of extreme want and wretchedness, and of the extraordinary faces that bear up under them. It comes home to us that this is a dissonant experience just before we realize that in such dissonance the man consummates his art.

The ethical stance of *American Photographs* was hardly lost on contemporaries or successors, but its poise—certainly its range—was elusive to sustain. Shahn and Helen Levitt further developed the urban side of his vision, while Wright Morris lyricized the rural one. By the time of the Swiss Robert Frank, who gladly confessed his debt to Evans, the militarist economy that had finally eliminated the depression, had puffed us up mighty vulgar. In loathing fifties culture as passionately as he did, Frank lost sight of, or didn't care about, Evans's historical mission. *The Americans* is definitely Evansesque, but Evans's exemplary status is undone in Frank's work. For one thing, the whole structure of the later book is metaphoric rather than semiotic. "In Frank's transforming vision of America," says Tod Papageorge, "a car is a casket, a trolley a prison . . . a flag a shroud."[11] The outer environment exists for this photographer only to confirm the dejectedness and estrangement he himself feels, and the gauche, anomic, or desolated scenes he discovers derive their power from being already, as it were, *within* him. Even when signs appear, to denote other purposes (as they would in Evans), they exist here only to incriminate the makeup of the culture and people's dismal acceptance of it. Doubtless the U.S. was a most blameworthy place, but Frank, instead of giving an account, provides only notes, glimpses, and impressions of it.

While this fragmentary view was a reflex of the fifties Expressionist style to which Frank was highly sensitive, it more importantly announced his failure of connection with this adopted world. He intervened in it as if to say that he could never be of it, nor reconciled to it. In that one, almost unending plaint of homelessness, the younger figure decisively reverses the mentor who had actually sponsored and encouraged him. For a chief thing gleaned from *American Photographs,* their very stamina as imagery, is that their author worked as someone centered by a society that he could call, for better and, perhaps more often, for worse, his homeland. Because he had stakes in that place, which gave him spine and push, Walker Evans, if he chose, could be

more critical of it—and more deeply grained in his criticism—than the unforgiving alien who was Robert Frank. The latter strikes the inflammatory note of Baudelaire, but lacks the chilly eye of Flaubert. Such critical potential is more conspicuous for its absence in Garry Winogrand and Lee Friedlander, native Americans who hardly deny the influence of Evans, but who denature and attenuate it. Frank vilified the American surround, memorably. By contrast, Friedlander, in the sixties and seventies, knew only how to itemize sterile phenomena. Though he was surely caught up with its vernacular and indigenous furnishings, he had utterly no idea of American society, and became a specialist in casual unrelatedness and visual miscellany. The mordant weight of its photographic heritage goes out of this work and is replaced by a cheerfully numbed and dissociated regard for . . . come what may.

Indeed, most of the photographers who have since traveled about the land with some kind of residue of Evans behind their work—William Eggleston, Lewis Baltz, Stephen Shore—have been almost programmatically unwilling to make any sense of what they look at, and so virtually approach it as strangers, alert but unknowing. Prolix with detail, their pictures are empty of purpose. They present an antiseptic, unintelligible, leveled-out, vacant, embryonic, and finally picked-over land or townscape, all at once, with a blandness of description that is really dispiriting. It could be argued that latter-day America physically resembles the picture of it given in their photographs. Even worse than the visual accuracy of their observation, however, is the neutered quality of their mood . . . which might reflect, all too convincingly, the unresilient culture in which we now find ourselves.

Into this atmosphere, *American Photographs* is put forth once again, and it has a melancholy sparkle. Its tally of necessary losses, so near and yet so far, is balanced by its commitment to what endures, accompanied by the teaching that the past is inherently valuable, for it tells us whence we came. The pictures are information rich, but comprehension of the messages secreted within them depends altogether on an understanding of how Evans's style discloses them. His framing instinct is the first clue to his content, and he made sure that content was planted where he looked. Memory comes back to us in such a gaze, which reaches beyond the capacity of neo-Marxist or

neoconservative viewpoints to assess the substance of Evans' imagery. For these are among the dogmas of an age that needs to be awakened to the worth of a liberal consciousness.

Notes

1. *American Photographs* was accompanied at the museum by a show of the same title. This was not the first time Evans has been associated with the Modern, nor would it be the last: in 1933, the museum had mounted his "Photographs of Nineteenth-Century Houses," and in 1934 he was commissioned to photograph the objects in the "African Negro Art" exhibition. MoMA also excerpted pictures from *American Photographs* for a show in 1962, followed by "Walker Evans's Subway," in 1966, and a retrospective in 1971. Now, to celebrate the original publication, the museum has reissued as attentive and close a copy of the 1938 book as possible, with an array of mostly vintage prints on exhibit. Though Evans's repute has broadened past the reach of any one sponsor, such a history is worth citing because it demonstrates the museum's strong attachment to him. From Lincoln Kirstein, Evans's first patron, through John Szarkowski to Peter Galassi, the current curator, this attachment, it seems fair to say, affirms the Modern's understanding of Evans's central place in the continuum of twentieth-century photography.

2. See John Szarkowski, Introduction, in *Walker Evans,* exhibition catalogue (New York: Museum of Modern Art, 1971), p. 13.

3. Hilton Kramer, quoted in *Walker Evans First and Last* (New York: Harper and Row, 1978), front flap.

4. John Tagg, *The Burden of Representation: Essays on Photographies and Histories* (Amherst: University of Massachusetts Press, 1988), pp. 12–13.

5. Quoted in Leslie Katz, "An Interview with Walker Evans," in *Photography in Print,* edited by Vicki Goldberg (Albuquerque: University of New Mexico Press, 1988), pp. 364–65.

6. James Agee, *Photographs by Helen Levitt: A Way of Seeing* (New York: Horizon Press, 1981), p. vi.

7. William Stott, *Documentary Expression and Thirties America* (New York: Oxford University Press, 1973), p. 274.

8. Nor could it have been, Here, for instance, is one historian's summary: "These were the tragic years of American agriculture. The long slow slide downhill of the twenties had ended devastatingly in the Depression, like a disease suddenly entering its terminal phase. The high tariffs of the twenties

and the effectiveness of foreign competitiveness had cut the farmers off from their traditional foreign markets. . . . The Depression destroyed the domestic market. Purchasing power in the cities collapsed, and the effects worked back through the chain of textile factories, meat-processors and vegetable-canners to the primary producers . . . dozens of small country banks broke, and with them fell both their debtors and their creditors. The remaining banks . . .foreclosed their mortgages on farms as soon as payments ceased . . . nowhere was the Depression more of a calamity than in rural America." Hugh Brogan, *The Pelican History of the United States of America* (New York: Penguin, 1985), pp. 551–52.

9. Quoted in Katz, "An Interview with Walker Evans," p. 365.

10. Ralph Waldo Emerson, "Self-Reliance," in *The Portable Emerson* (New York: Penguin, 1985), p. 139.

11. Tod Papageorge, *Walker Evans and Robert Frank: An Essay on Influence*, exhibition catalogue (New Haven: Yale University Art Gallery, 1981), p. 8.

This essay appeared in *Artforum* (April 1989).

Koudelka's Theater of Exile

Charity is always help that is offered too late,
just as revolution is help that is offered too soon.
—JOHN KRICH, *Music in Every Room*

THERE WAS very little, in fact nothing material, that Mendel Grossman could have done to help his fellow Jews in the Lodz ghetto. Powerless, and at great risk from the Nazis, he chose to photograph the extremity of his people. Those few of his negatives and prints that have survived stand as an appeal to a future he was not to know. In serving to recall past events, photographs with this urgency also admonish us. It is as if we were being told that historical hardships and cruelties have been visualized so as not to be repeated—and, of course, they always are. When photographs show horrible suffering, we are often inclined to think the picture-taking impulse itself was ineffectual. As human dignity is threatened and life is lost, it seems a pathetic, sometimes a callous thing, or worse, to raise a camera to one's eye instead of intervening. Under those bad circumstances when conscious intervention is possible, we should be more impelled to act than to record. But how few are those circumstances! Most often the need to stand back, if only mentally, in order to make the picture is compensatory. Photographic culture is here a human undertaking that is resigned to secondary action, and that implies the marginal status of everyone who has taken a picture, relative to whatever is pictured. Between the magnitude of the event, of which some aspect is described, and the reportorial vantage, there is always a disproportion.

Verbal reportage, of course, occurs after the fact, and is an account as often based on sources as on actual experience. But a photographer has to be on the scene—either in the midst of events that unfold at

the moment of the camera exposure, or at their physical aftermath. Physical presence enhances the possibilities of involvement. When the situation is extreme, the pictorial motivation will likely compare with it, urged on by a passion for justice or vengeance. (I am speaking of the partisan rather than the bureaucratic photodocument.) Here, the photographic act has a rhetorical charge: it is understood to confirm, protest, indict, or mourn, sometimes all at once. An operator uses the camera as a tool with which to sublimate or symbolically perform these gestures, undeniable in their import.

Yet the whole stance of the picture is reactive, even when the timing and accuracy of the photographer are split-second. The photograph partakes of its moment in an intimate way, but happens too "late" for anyone to have prevented what it records. Though they sometimes contribute to a change of social or political attitude toward their subjects, photographs seal off their contents in a strange temporal limbo. By virtue of having frozen a process, they seem to have transformed it into something permanent and fatal, the opposite of process. When they move us, it is not so much that we are swayed by the activism of photographs as overwhelmed by their poignance.

I'm not sure I subscribe to John Krich's remark about charity being help that is offered too late, or revolution help offered too soon. There is something too schematic and symmetrical about that. But I see what he means. Our good intentions have a tendency to be mistimed; and altruistic measures frequently have goals of their own, not necessarily relevant to those affected by them. Krich's observation occurs in a description of Mother Teresa's Calcutta Home for the Dying Destitute, in a book whose subtitle is *Around the World in a Bad Mood.*[1] That phrase puts me in mind of the Czech (now naturalized French) photographer Josef Koudelka, whose acute talent for scenting out wretched places and oppressed people should lower our spirits. But he visualizes them with such tang and euphoric bitterness that his work is positively exhilarating.

It's shocking to think of how much in current Western experience is ruled out by Koudelka, and nullified as if it never existed. One could search practically in vain for the historical Europe or the tourist scene, the life of the middle classes, plastics, the consumer market, signs, cars, modern diversions, blue-collar existence, productive systems of any kind, in short the characteristic jamboree of the late

twentieth century. It takes a certain exclusionary genius to have re-
jected such a sights while still asserting one's ties to people. A great
deal has been made of the solitary spirit of Koudelka's work, but that
spirit protests too much. Because of his rhetorical estrangement, his
world may be as inhospitable as it is unfamiliar, but it remains a
world of minority cultures, whose religious and funerary rituals it
intimately discloses. The question of how long these cultures will
continue to exist in recognizable form is held in suspense by his
imagery. Preindustrial and mostly unrelated to any sizable economy,
they seem to be holding on, in atrophied, ingrown states, a dwindling
that has spurred him to make his late records. Europe had no place
for the Eastern Slovakian gypsies Koudelka photographed in the sixties,
and the Spanish peasantry of his more recent images would not seem
to have the brightest prospects either. At first glance, it looks as if
he's declared his theme to be rural, Third World poverty, but the
faces, though gnarled like those in undeveloped countries, are Cau-
casian. What happens in his pictures seems to have taken place a long
time ago, under archaic conditions, hard to remember . . . so that
their actual contemporaneity appears misplaced.

The first plate of Koudelka's most recent book, *Exiles,* which ac-
companied his show at the International Center of Photography this
summer in New York (it had traveled there from Paris), shows the
photographer's left forearm stretched from a balcony over an empty
Prague boulevard. The year is fateful, 1968, and the gesture is un-
mistakably that of someone who consults his watch. It's twelve o'clock,
a noon hour here momentous because of its silence and emptiness, as
if to mark a large strike. The photographer engages us with a symbolic
interval of his resistance as a fighter on behalf of the aborted Dubcek
liberalization. His subsequent flight from the Brezhnev armed clamp-
down, along with numerous other Czech intellectuals, artists, and
filmmakers, was an escape to a freedom in the West whose embryo
promise they had lost at home. (In this era of glasnost, the persistence
of the Czech regime in its singularly reactionary unbending course
indicates all the more glaringly what they were up against.)

In the case of Koudelka, however, welcome into Western creative
circles did not lead him to an endorsement of the materialism, much
less the capitalist ethic, that surrounded him there. The only pictures
really impacted with *things* in his entire career are of Soviet tanks in

Czechoslovakia, swarmed over by defiant but impotent crowds during the time of national humiliation and trauma. Events like that have the capacity to mark an artist's vision. Though befriended in the West (particularly at the photo agency of Paris Magnum, which took him as a member), and clearly grateful for it, Koudelka was never consoled. It can be argued that this diffident man, who lives and travels as lightly as possible, is by temperament an uprooted character. In the early sixties, as a young man, an aeronautical engineer and theater photographer, he had already been taking pictures of the outcast gypsies, a foretaste of his experience as one expatriated in his own turn. Still, there had once been a homeland for his alienation, and now he was forced to reproduce and project it by the sheer strength of his nomadic will. So, the pictorial introduction of his book is also really a closing down, a climax from which there could only follow an anticlimax. But from that ensues his meaning, as it's realized that "our" Western Europe has been suffused by Koudelka's downcast view of Eastern Europe.

The history of photography is heavily populated with exiles and émigrés. Of course travel has always been a professional need of practitioners, and the visual character of photographic work has enabled it to move fluently across cultural and language barriers. Communications networks have been a dense growth industry in the Western democracies, and after World War I they drew all sorts of photographers from the East, notably Hungary (Robert and Cornell Capa, László Moholy-Nagy, Brassaï, André Kertész, Martin Munkacsi, etc.). When World War II threatened their survival—many of them were Jews—the exodus concentrated in the United States. It was only well into the cold war that any of these migrations resulted in disaffected comment upon the host culture: the work of Robert Frank, a Swiss Jew, in *The American*.[2]

Frank was correctly taken to say that there was no spiritual coming to rest in a place that mistook affluence and acquisitiveness for culture, that brutalized its minorities, and that threatened the world with its militarism. As for the joyless Americans themselves, they were imprisoned or dissociated by meaningless drudge work, or else they were uncentered roamers, like gypsies moving over a space incomprehensibly large to a European eye. As Frank saw them, they enjoyed a pointless mobility. And he saw "freedom" itself, the slogan of American

cold warriors as a concept made hollow and feckless by politicos who clarioned it as a transcendent American virtue utterly denied those in the totalitarian Eastern bloc. ("People," wrote Elias Canetti in 1942, "always want to get away, and if the place they want to get to has no name, if it is uncertain and they can't see any borders in it, they call it freedom."[3]) Now, thirty years later, but at a jingo moment dismally reminiscent of the fifties, we're shown the art of Josef Koudelka, an exile from that Eastern bloc, and an artist whose body of images joins Frank's in its revulsion from the complacent mood of his adopted environment. But his apparent similarity of outlook with Frank's is treacherous.

What Frank saw as targets are the equivalents of things toward which the Czech photographer feels an affinity. Dispossession and disenfranchisement, Koudelka's photographs insist, are states in the natural order of life . . . life lived beneath the notice of the social majority. Precisely through that reckoning, his subjects hold together and derive their energy. No matter that ghetto status stunts and hardens so many of them. They expect little from the outside world, and they subsist on not much. Koudelka would have us believe the same of himself, when, in a photograph from 1976, he shows us lunch: a few triangles of processed cheese, a glass of milk, perhaps some yogurt, the remains of an apple, and bread, with a pocket knife as silverware. As a placemat for this half-eaten snack we have the front page of the *International Herald Tribune,* where one article is headed "Middle-Class Youths Swell Ranks of Argentine Terrorists." (The contrast of near and distant accentuates the pride of Koudelka's indigence.) Seen from above, the lunch is proposed to the viewer as something valuable to share, and even if the meal is spartan the light is voluptuous, as vibrant as when Koudelka pictures the life of abandoned objects and the plight of lone animals.

By contrast to this empathetic vision, in a store in Lincoln, Nebraska, Frank saw some styrofoam crosses and plastic wreaths with a sign: ". . . REMEMBER YOUR LOVED ONES 69¢ . . . , a little text so impressively obtuse that the photograph itself could be bland and recessive. When they treat death, both these diaristic reporters observe its rituals—how in America (outside the society of rural blacks, where the deceased are prayed for) one is anonymously picked off in a road accident and lies under a tarpaulin, or how, in Eastern Europe, one's

tribe lays one to rest amid lamentations. The sacramental, a continuing theme of Koudelka's, illuminates not only the pilgrimages he follows, but many of the still lifes he chances upon. It is evoked when, within deep shadow, the light in a photograph appears to have *elected* humble figures or objects for display. Frank's America is occasionally lit with that possibility, but is on the whole a place crass, uncaring, and profane, far removed from that redemptive zone where Koudelka wanders. But of course he's not a pious photographer, any more than his predecessor. He views religion, I think, in the way Peter Sloterdijk phrases it, in his *Critique of Cynical Reason,* as

> not primarily the opiate of the people but the reminder that there is more life in us than this life lives. The function of faith is an achievement of devitalized bodies that cannot be completely robbed of the memory that in them much deeper sources of vitality, strength, pleasure, and of the enigma and intoxication of being-there must lie hidden than can be seen in everyday life.[4]

The earlier photographer saw his new ground as bereft of comfort or hope—truly devitalized—and out of a sense of impasse he converted his disenchantment into poetry. The later one, Koudelka, preemptively steels himself against the main environment. It is made to act as background for the observation of festivals, pilgrimages, and rocky scenarios, sought out by the promptings of memory. As material prosperity encroached, these were harder to come upon, and Koudelka was obliged to rely on his faith in rapturous powers of perception. They were at the ready, for instance, when he saw a man transfigured by smoke from the flight of a small rocket at a celebration in Spain.

Frank loosened up stylistically at the daunting challenge of photographing this country. For his part, Koudelka tightened his procedures when he came to the West. But like so many others, he embraces a proposition worked out by Frank: that photography can encompass an indefinite spread of often small incident, revealed as the consistent moral illumination of a community by an outsider. What makes both men's photographs expressive, past the entirely personal aesthetics, is the troubled consciousness of their makers.

In *The Americans* Frank engaged in a great deal of uneasy mimicry of togetherness, a kind of pseudoparticipation with his subjects. Not

Joseph Koudelka, *Festival in Andalusia, Spain,* 1971. Courtesy Magnum.

for a minute do we believe that he was a caucus member at a national party convention, or a gambler in Elko, Nevada, despite the chummy space. These episodes work as false intimacies; the closeness in them is spatial only, and not social, as we might initially assume. At every point where he would draw nearer, the photographer dramatizes his foreignness, sometimes making it blatant in the unfriendly gazes of subjects he has surprised. Failing to share the lives of the people he shoots, he multiplies his transgressive roles, an act that leads him to explore a range of unpredictable visual gestures and framing. Koudelka, on the other hand, everywhere characterizes himself as the same meditative viewer studying the perennial corrosions of existence. It is as if he were playing through headphones some kind of philosophical tape that spooled to a harsh ending, upon which he had to invent infinite variations. One comes away with the feeling that, while never staged, his tableaux existed only for him, that he was sole witness of transient events that could not be helped . . . because they reflected his inner state. It would not have been a Koudelka picture had he righted a turtle wriggling helplessly on its back before photographing

the creature. Any grotesque detail he instantly charges with a general significance, of a kind to which his expatriation lends a dramatic tone. Frank kept on catching glimpses of a heartless future; Koudelka lives his life in the stoic past. Encouraged by Henri Cartier-Bresson, he studies old masters of the museums and tautens his compositions. If his work betokens new knowledge, it does so the better to conserve its original impulses.

The Polish writer Czeslaw Milosz contributes an essay, "On Exile," to Koudelka's new book. In that text he writes of a subject that has obviously tempered his own life: "Exile destroys, but if it fails to destroy you, it makes you stronger."[5] He speaks of the immigrant's "loss of harmony with the surrounding space, the inability to feel at home in the world," as an experience that "paradoxically integrates him in contemporary society and makes him, if he is an artist, understood by all." If many moderns dwell on a rupture of historical consciousness, for a writer like Milosz or an artist like Koudelka it becomes acute, a scab at which they are always picking in their mind. It is not at all that they become mere rhapsodists of homesickness and the passage of time. Though not overjoyed to arrive, they remember that they were compelled to escape. Koudelka has condemned himself to a hyperalertness toward a few viscerally selected motifs, of a certain scarcity, which he repeats, or which repeat themselves, year after year. Out of his own rituals there seems to have developed a trade-off in which he uses the social deficits of the stranger to irritate or prick his visual sense, so that it constantly seeks a perfection of display, of expressiveness, and, above all, of chiaroscuro. In its jagged organization, with its depths, the shock of this light-dark consummates in his images what is not completed in his life.

We can guess at the influences that were absorbed into this art at its formative stage. The gypsy photographs Koudelka made while he still lived in Czechoslovakia show a kinship with the knotted spareness of Giacometti's figures and his weighted emptiness of space. It's also reasonable to suppose that during his stateless period in England, 1970–79, Koudelka was affected by Francis Bacon's paintings and Bill Brandt's photography. Finally, one should add his likely sympathy for Samuel Beckett. But to continue to modulate their kind of dramaturgy through the seventies and well into the eighties was, for an artist, to be seriously out of phase, even provincial in relation to current

style. A provincial artist is one who works with an outward-looking attitude, adapting from models at some distance in time and place, in the art capital; a regional artist is involved with his or her marginal scene and its idioms, and is or chooses to be oblivious to the rest of the world. Koudelka represents a particularly complex variation of both types. In Prague, he defected from his technocratic class and capital city (which was itself a cultural outpost) in order to document the social and ethnic groups at still more outlying districts. When he left his country and entered mainstream modern culture, he was attracted to agonistic strains of it that dated from an earlier time. Unquestionably, factors in his *provincial* upbringing predisposed him to certain choices of Western European models, but it was his loyalty to the mental universe of his self-appointed *region* that empowered his work with continued vividness and presence in new circumstances. As for another, highly conditioning factor, his personal history, everyone notes his love of the theater which comes out in Baroque rhythms and in deeply marked graphic and narrative contrasts.

One of his admirers, Romeo Martinez, observes that "Koudelka has recognized in the theater a form and a metaphor of life."[6] This idea is seconded by Robert Delpire, who not only originally organized Koudelka's recent show, in France, but was the first to publish Frank's *Americans* in the fifties. Delpire says that Koudelka's work is "marked by a sort of theatrical organization of reality."[7] In such a view, the subjects of the photographs function as players on a stage, and it is true that some of them perform obvious roles, such as a little boy with angel wings and sneakers on a bicycle, or a young gypsy man cuffed and condemned on the edge of a village. Interestingly, both these individuals are removed from their nominal audiences but are close to the camera. Imaginative or real as were their onetime scripts, they now perform unknowingly in dramas devised on the spot by the spectator's eye of the itinerant photographer. He is an expert in showing us two or more scenarios adjacent to each other in the frame, not merely keeping track of them but welding them together freshly in a new production. A one-armed bather seems resentful of a squalling baby on a Portuguese beach—as far as Koudelka will go in depicting vacation. Some kids horse around in a Spanish alley while just around the corner, in the foreground and out of their sight, a baggily dressed fellow seems to play uninvited hide-and-seek. Four Irishmen piss against

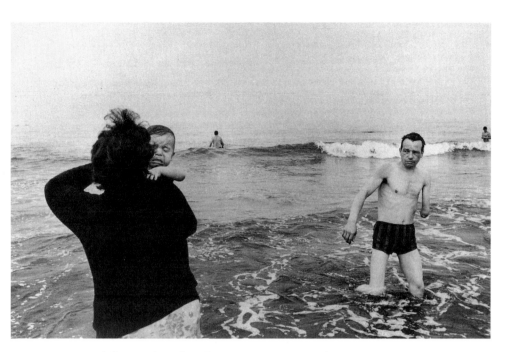

Joseph Koudelka, *Bathers along the Portuguese Coast,* 1976. Courtesy Magnum.

the wall of a concrete trench, and though they avoid noticing each other, as men typically do in such quarters, Koudelka, behind them, makes a dramatic synthesis of their isolation.

While the town or village offers Koudelka's theatrical flair such glints of reduced sociality (which are humorous and a little sinister), what of the country? He almost seems to thrill to the depressing vacancy of open reaches and plains. He's a vagrant explorer of unpopulated places where every now and then he finds like-minded passersby, animal or human. He insists on the freedom to be without direction, to be derelict, to be attracted to the unlovely and unploughed field or heath, where there is no refuge from the feeling of loss. Here is nature, spoiled not by industry—but by the viewer's own malaise. Koudelka's pictures of this type never make it to the status of landscape. The weather is bad. Someone throws up a ball, in poetic ennui, and a horse lounges in the distance. Later in his work, we realize that this desolate mode overmasters the ecstatic one of the denser groupings. The impression grows that an admirable independence of spirit can have its morbid side: instead of going his own way, the photographer shuns people out of reclusive need, weariness per-

haps, or suspicion. If the smallest incident or modest object—a glance, graceful debris—becomes an event, it may be because of a disheartened vitality that has to disguise itself.

An emphasis through much of the later work is the use of the wide-angle lens (25 mm) in a way that can be described as literary. Although the space it plots is tight, the device enables him to show that no one connects. In fact, space either seems to push or keep people away from each other, or to cramp them together when their purposes and sometimes scales are very different, so that obviously gratuitous relationships, invented stories, are at issue. The effect of wide angle is to slope perspectives and to inject an unexpected pointedness into things. A strange dynamism is imposed upon the pictorial surroundings, and Koudelka makes it look portentous. The dizziness sometimes produced looks as if he had gone wrong in the inner ear and couldn't take the curves. Abruptly, the ground sinks away or down from our viewpoint. By means of the wide-angle view, yoked to his strong lighting, the photographer orchestrates mood, just as the music track underwrites our emotions in response to film.

In the great earlier work that brought him fame, *Gypsies,* published here in 1975,[8] Koudelka carried on more or less as a portraitist. His subjects posed for him, or they accepted his presence in good enough humor as they went about their bleak lives. Considering this retrospective, which includes images from the thirteen years since then, one noticed the great incidence of pictures in which the photographer is invisible to his subjects. The wide-angle lens permits him to get quite close to people while extending the view; he also uses a telephoto lens, which allows him to shoot at a distance, narrowing the field, without being noticed. Yet it's remarkable how few of the post-*Gypsies* faces in the ICP show react to him, whichever lens he employs. The documentary aims of the gypsy project—to study the mores of self-contained social enclaves so intensely as to become a part of them—have been transformed into a kind of artistic itinerancy, where lives barely touch each other. Almost as if he recognized this weakening, or at least denaturing, of his original intent, the photographer hyperactivates his formal sense. Eventually he himself becomes the center of regard, insofar as he dominates everything that is seen by the very fact that it is he who sees it. The introspective tone grows almost fanatical, and increases correspondingly as the subject's social import

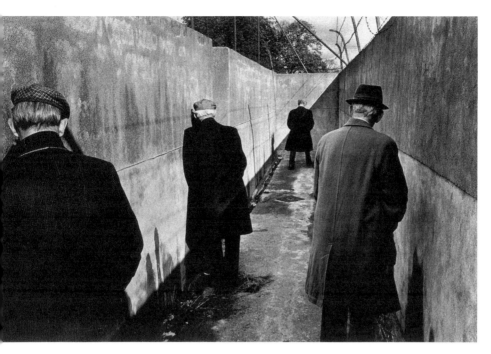

Joseph Koudelka, *Exiles,* Ireland, 1976. Courtesy Magnum.

declines. Most of the pictures he shows from after 1980 work as still lifes, even when they're shot in the streets. Though their vigorous shadow play had been anticipated in earlier work, they transmit far less passion, if only because he no longer fuses his predicament with that of others, no longer confirms a privation of spirit but rather indulges in it. Mendel Grossman sought to preserve a record of his people as they were all engulfed in the crisis of the Lodz ghetto. Artless, grainy, and crude, his photographs lack visual strength, but they convey the horror of "being-there." Much more complexly, Koudelka, failing to achieve that horror, compensates by memorable artistry.

Still, if Koudelka's aesthetic now outruns his openness toward the world (which is his right, in every sense), it's necessary to recall that he had initially put his imagination to the service of memorializing the lot of the gypsies, a quarter of a million of whom had been exterminated by the Nazis. He photographed them during a period in which the Czech government had sought social control by registering and resettling them, often against the will of their neighbors. Many of the gypsies are shown out in the cold Slovakian wastes, but

others are depicted as inadequately urbanized, in raw interiors. It was a transitional and deeply uncertain moment, in which many of Koudelka's subjects chose to present themselves with photo mementos of their dead ancestors and relatives. First, then, in his aim, and then in his motifs, Koudelka's photography was recuperative. So his subject is legitimately viewed as historical, but there is something about his style, considered in the United States now, that looks old-fashioned as well.

I wonder if that might be because of the way he stands out at the end of a decade much of whose effect has been to uncoil and numb any tension of personal feeling on the part of its artists.

In his *Wanderjahre,* which apparently continues, Koudelka seems never to have heard of our cynical vogues of art that have appropriated commercial media. His own work is steeped in the innocence of its depth. The historical mission of that work is blended with a theatrical impulse, the two finally gathering into metaphors of the artist's own vulnerability in exile. For he is aware of how little photography can help, how late it is, and yet how necessary it was to persist in bearing witness. Under the circumstances, such an effort can only be described as gallant.

Notes

1. John Krich, *Music in Every Room* (New York: Atlantic Monthly Press, 1984), p. 153.

2. Robert Frank, *The Americans,* (New York: Grove Press, 1959. Reprint ed. New York: Pantheon Books, 1986).

3. Elias Canetti, *The Human Province* (1973, reprint ed. New York: Farrar, Straus and Giroux, 1986), p. 1.

4. Peter Sloterdijk, *Critique of Cynical Reason* (Minneapolis: University of Minnesota Press, 1987), p. 277.

5. Czeslaw Milosz, "On Exile," in *Josef Koudelka: Exiles* (New York: Aperture, 1988), n.p.

6. Romeo Martinez. *"Immagine del teatro, teatro della immagine,"* in *Josef Koudelka: I grandi fotografi* (Milan: Gruppo Editoriale Fabbri, 1983), p. 4.

7. Robert Delpire, in *Exils: Photographies de Josef Koudelka* (Paris: Centre Nationale de la Photographie, 1988), n.p. The French edition of *Josef Kou-*

delka: Exiles, this book substitutes a discussion of Koudelka among Delpire, Alain Finkielkraut, and Daniele Sallenave for the essay by Milosz.

 8. *Koudelka: Gypsies* (Millerton, N.Y.: Aperture, 1975).

This essay appeared in *Artforum* (September 1988).

Photojournalism and Malaise

I F A S K E D to reflect on it, anyone can develop a list of melancholy sights. They are affairs that have become progressively easier to see or hear of in a world where human misfortune is brought about by malign fate or bad behavior, and are circulated as never before by avid media. I have in mind only a modest idea of a sad sight, but one that I think is really touching. It is a tableau in which one or more people display themselves or offer themselves and what they do for attention, to no avail. It may be a street musician without a crowd, or a pianist in an indifferent bar. The host is speaking at a party and they're not listening. I don't like seeing small businesses doing poorly either. Something about these scenes does strike me as natural, for there are after all only so many messages we will want to attend or be willing to receive. Just the same, a performance that does not find its audience—fewer and fewer pennies dropping into its hat— is a doleful occasion.

What about the opposite? Private activity never meant to be exposed on any public stage and that is now spotlighted there? Let me be more specific, for purposes of a certain argument. Imagine such private activity is of some disadvantaged or victim group, persons to whom an injustice is done. Their lot in life has been reduced in its possibilities, and it is precisely this fact that is brought to notice and becomes the chief thing that distinguishes them. Whatever else might be said about their being in the world, the fact of their doing badly is the only one that ignites attention. The first kind of tableau, where it is noticed that solicitous people aren't noticed, is a poetic vignette;

the second, much more widespread scene, where defeated ones or strugglers, in their pain, are examined, is an informational setting. It is, in fact, the domain of journalism, or, if pictures are the bearers of such "data," of photojournalism.

Any exhibition of photojournalism today will already have a long tradition behind it, and will reflect some of that tradition. If the work is critical, as is true of the present show—it will have to deal with social costs as the consequence of a certain kind of energy deformation. On one hand, the pictures speak of (or are testimony of) the unavailability of energy to make adequate redress for the trouble they depict. On the other, the pictures themselves are transgressive, that is, they could only have been gotten through the remarkable energy of their makers. The plight of individuals does not, in and of itself, spontaneously declare itself to others. It has to be broadcast, it has to go through certain channels, underwritten by the profits usually accrued by news media through advertising revenue. In the nature of things, there will be more supply than demand for such photographic images, so that the majority of them, too, will become the victims of misfortune: frustrated in their search for outlet. Whether their authors find this particular obstacle poetic or not—I imagine they know it to be an occupational hazard—is another matter.

There is a point of soft speculation in each hard assignment, and fierce competition among workers for the very little space that is furnished them in the print media. The contents of this particular show might be thought constrained—at least in theory—by the demands of editors who, themselves, are obliged to highlight situations that are usually at the extremes of human fortune. But that, as I say, is in theory.

This exhibition reveals a different reality of practice, or rather, a practice that an exhibition of this sort can make visible. For the photographers offer to a public their own, unedited, or auto-edited decisions about the substance of their work, i.e., the way they hope it reflects the reality of the lives of their subjects. There may be a correspondence between the private recognitions of the photographer and the editor, working for a public readership. Among many other agents, they are uneasy allies in a common enterprise. But here, the initiative of the photographers is the transparent point at issue. They are much more at liberty to choose their own shots and arrange their

own expositions than they would be for magazines. If it is significant that they choose not to accompany their work by text, that might reveal something about their attitude toward a verbal control and a subsidiary position that is normally imposed upon them by outside supervisors as a matter of course. Naturally, in accepting the greater latitude they have here, they accept also a public disproportionately small when compared to the one that sees their work in the mass media. Not that the present show is a terminus, in any sense, of the images we see here. It is, rather, one specific point of distribution along a chain that may include appearances in books published by foundations or commercial houses and publication in a potentially great variety of journals, all from a large pool.

What has to be understood from the track records of the photographers as well as the work they continue to do, is that they are combatant image makers, active in close proximity to danger and disease, often under conditions of duress and hardship. Claudia Andujar, in her testimony of the Yanomami Indians, whose Amazonian culture is being destroyed, Wendy Watriss, illustrating the agony of the U.S. Vietnam veterans afflicted by Agent Orange, and Mary Ellen Mark, portraying the wasted patients in Mother Teresa's hospital in Calcutta, all belong to a photographic mode that indicates wrongs that need to be righted, and perhaps points—though not without text—to measures that should be taken to correct those wrongs.

Photographs of this sort work on at least two levels. They solicit compassion by dramatizing the fact that our fellow human beings, made of only too mortal flesh and blood, are in the throes of a tragedy. Furthermore, the impression is given that the tragedy was avoidable, had there been greater justice, foresight, or resources (often, these three have to go together). Such work, therefore, is unhesitatingly polemical. It ranges itself against the fact and the potential for needless human injury, and it will record the efforts of those who extend themselves to help or who fight, against daunting odds, for restitution for the group.

In the case of the hospital, for instance, there is illustrated a famous embodiment of Christian succor to the helplessly sick, and with the veterans, a dawning consciousness of solidarity and resistance to official stonewalling and whitewashing. "I got killed in Vietnam and didn't know it," said one of the poisoned and expiring veterans, cautioning

his similarly damaged buddies to pursue their cause. As for Susan Meiselas, her photographs of El Salvador have followed from her earlier indictment of the Somoza regime and its National Guard in Nicaragua. Now there ensues another brutality, even more bitter for being repeated, as a Latin American populace endures oppression at the hands of a U.S.-supported regime. Unquestionably on the side of those who resist, Meiselas joins to the "concerned" modes I've just described, the particular stringencies of the war correspondent. Finally, Eugene Richards portrays much more diffused phenomena, since he pokes about the casualty wards and the urban ghettos of the nation, evoking through single figures, the anomie, the derangement, and the loneliness that stifles the human perspective in all these unremembered places.

The particular techniques of such photojournalism—and the five people shown here are very lettered in such techniques—have to do with the presentation of the "affecting" individual. Since the graphic power of the photograph consists in its prodigious capacity for the storage of visual facts, the working assumption here is the increasingly harrowing, case-by-case study of debility. Let generalizations be the task of the sociologists, and the study of cause and effect be the concern of the historians (though in Watriss and Andujar, these roles are fused in an activist temper). Quite often, pathological anatomical details are to be seen in these images, and sorrowful, angry, or worried expressions. By confronting the viewer with outrageous facts, the photographers want to convey an anxious, dire mood.

Since the famous Farm Security Administration photographs of the American depression, such intimate scrutinies have been the trademark of the liberal, reformist movement in photographic aesthetics. It is no secret that they have become toughened and are more indicting now. As the flagrancy of the social abuse has increased, so has the stridency of the photographic act of witness. Still photographs cannot compete with network television in massiveness of audience, but they can be more concentrated and dramatic in their revelations. Fifty years after the FSA photographs, into the chancred world experience of the late twentieth century, a pessimistic consciousness has supercharged the photographic journalism of our day. Vietnam itself, and with it the tide of guilt and denial that brought so much twistedness into the portrayal of our national character, so much awareness of bureaucratic juggernaut and human frailty, did much to change the face of

our serious photography. The toxic brilliance in the style of Diane Arbus was a product of that era, and it has left a crucial mark in the work that has come after it.

I would say that our photographers have gradually ceased to remember anymore how to flinch. What bothered James Agee when he wrote *Let Us Now Praise Famous Men,* a remarkable textual and visual study of Southern sharecroppers during the thirties, was that he and Walker Evans were documenting helpless and undefended people. Because of the enormity of the chasm between his class and that of his subjects, Agee felt that his own viewpoint was exploitive. Today, on the contrary, such an attitude would most likely be considered self-indulgent and irrelevant. The helplessness and defenselessness of the subject is read as a symptom of criminal technology backed up by authoritarian politics. It is not seen, or there is no time for seeing, that subjects are also vulnerable to the photographer. The very pointedness of the fleshy detail in these pictures leads me, though, to ask not only about the political conditions that have brought these subjects to their wretched pass, but also what happened between the subjects and the photographer. . . .

"Nowadays I often get up very close to people. I don't take their reactions into consideration much. Maybe that is contempt. Every picture is disrespectful, a manipulation. It is also a desire to make contact." We do not know whether these remarks, attributed to a Belgian photojournalist, François Hers, really illustrate his attitude or are representative of his American colleagues. But what can be inferred from their photographic production—always a social phenomenon—is that a strange moral paradox is involved in journalistic work. The subjects are treated as objects of compassion, but their deeper feelings about being photographed are hardly ever consulted, and their dignity is not at a premium under the circumstances. What prepared for or succeeded the photographic act may have been as empathic as its author knew how to be. But the behavior was generally, in the short or long term, instrumental, a means for getting pictures. There is obviously a great deal of ethical latitude in the photographic transaction. It would be reasonable to suppose, however, that a definite professionalism takes over in these scenes, obtaining consent from subjects not always aware, or not usually aware, of the purposes which their images will serve. I find it hard to shake off an impression of

the innocence of the subjects as compared to the knowingness of the photographers. The latter had in mind any number of rhetorical possibilities which could only be realized through the special, trusting pliancy of the ones they photographed.

Imagine, for example, the wrong note that would have been struck had the Yanomami shielded their faces, or the Agent Orange veterans scowled in the direction of the photographer! Any suggestion that the photographic act was in itself intrusive (which, in the beginning, it was most likely to be) is banned from the resultant picture. One can easily see why. For the polemical character of "concerned" photojournalism would be instantly spoiled if the photographer was sensed as the adversary of the subjects. The effect sought on all these occasions was rather one of intimacy that does not declare itself, as if the outsider with the camera was either very much accepted or invisible. That kind of metaphorical access was necessary in the transmission of a grim situation. The patients in the clean Calcutta hospital, for a future duration that could not be calculated, are hostages of the goodwill of Mary Ellen Mark. It could be said that all the photographers had the interests of their subjects at stake, but not necessarily at the moment of the photograph!

Part of the difficulty on these occasions is that the photographers tend to look over their shoulders, previsioning images they think would most likely weigh heaviest in the social reconsideration of their topic. They anticipate an ordinary audience of average decency, most certainly a little dulled by exposure to similar images in the past. It's necessary that the photographers have in reserve a psychic predisposition that identifies with the audience, a feeling, if nothing else, that those photographed are indeed "others." (Egocentrism does play a role in our sympathies, since it either urges them on in extension to the disenfranchised, or outrages and galvanizes them when the victim is one of our own.) The victim figures are used for the cause of their own eventual betterment—whether it be a guaranteed preserve in a native jungle or recompense in a lawsuit. Of her work at Mother Teresa's Home for Dying Destitutes, its founder has said "We have absolutely nothing to do but allow ourselves to be used." By that standard, photojournalists could not be said to have gone noticeably far in the application of Christian dedicatedness and charity.

Nevertheless, a longer look at the relations between subjects, jour-

nalist photographers, and image distribution shows a pattern in which the mutual use of the parties by each other can be a definite feature. An awareness of the utility of the image in documenting their disease is a subtext in the self-portrayal of the Agent Orange veterans. Andujar and Meiselas plan that their efforts feed into and fuel a larger thesis about the incursion of "civilized" diseases, physical and mental, into traditional cultures. These photographers permit their work to be used by a system in one of its branches, the publishing and communications networks, while clearly indicting other branches of that system, for example, the military-industrial complex. In that sense, we could also argue that the image-maker uses the system, injecting into it a peculiar political tension which it has to tolerate for the sake of keeping itself going.

No doubt I've indicated a series of interconnected functions by means of language that is rather impersonal. Nothing said so far responds to the actual emotional moods of these images, or rather, the mesh of mood and fact which is the distillate of each frame. As soon as one engages with their pictorial descriptions, narrative intent and psychic point of view differentiate each photographer's vision in a series of overlapping concerns.

Watriss's veterans, for instance, tell a story. While more or less failing to lead normal, American working-class lives, these returned soldiers, whites, Hispanics, and blacks alike, are shown in various stages of sinister physical deterioration. They receive treatment, go to meetings, and display photographs of themselves in better, prouder days (as if to show what they had done to merit our regard). Into their domestic interiors a malign presence, legacy of an earlier violence, asserts itself on a delayed schedule. Meanwhile, they still display the trappings of patriotic fervor, recalling their days in a service that had held their lives cheap.

These Americans are described as in a shock caused by their own culture. The Yanomami are shown at some kind of mysterious loss under the impact of an unseen presence. Like the consciousness of the Americans, the identity of the Indians is under duress, which may be one reason the close portrait, rather than the scene, is Andujar's preferred vehicle. In the pictures she displays here, a physiognomic searching is emphasized over invocation of setting. The expressions are querulous or dreamily indrawn—impossible to say what they mean—

and the light is dramatic and sometimes invasive with flash. These people do not exactly collaborate or even seem to know what posing means, and so there is far less of a "story" here than in the more textual Watriss series.

The same applies to Mark's vignettes from the Calcutta hospital, which have a photographic heritage that traces back to Gene Smith on Albert Schweitzer (for old *Life*). She depicts the fatality of such a place by means of burning eyes and reaching arms, and the extremity of deprivation in withered, desiccated flesh. But these are finally not harsh pictures, if only because the theme is active convalescence. The community in which these patients have a place is an ordered one and apparently strict. Their needs, those of them that can be met, have social priority. One also feels that their weakened state and their confinement within close quarters made for an inherently rich pictorial opportunity.

Eugene Richards, in his *American People/Portraits Made Across the U.S.*, also deals with malaise as an ongoing strain of consciousness but wants to find ways to personify it, so that malaise becomes a transgressive presence in its own right. By means of abrupt framing, disjunctive shadows, spaces that imprison or open forlornly, away from the foreground subject, the photographer finds metaphors that would externalize a cultural sickness. There is very little here of what could be called straight documentation. As Claudia Andujar relates to a strong current of Latin American photographic interest in ethnic cultures, Richards, it seems to me, has taken and then amplified certain cues from Robert Frank. He has Frank's lack of ceremoniousness about introducing subjects, but he is at the same time more point-blank and romantic. He studies disconnection, makes it happen. The access he gains looks almost like a forced entry into the private horrors of his subjects. For they seem to have no cognizance of an outside, more rational order, or even of the interloper with the camera.

Though not so overwrought, Susan Meiselas has strangely more in common with her Magnum Agency colleague, Eugene Richards, than the other exhibitors in this show. I say "strangely" because inner states appear to have as much importance for her as for Richards, while her nominal objective, war reportage, would seem to take her very far from such a concern. But I take this tension as a sign of brisk comprehensiveness, the fact that Meiselas moves across combat lines and

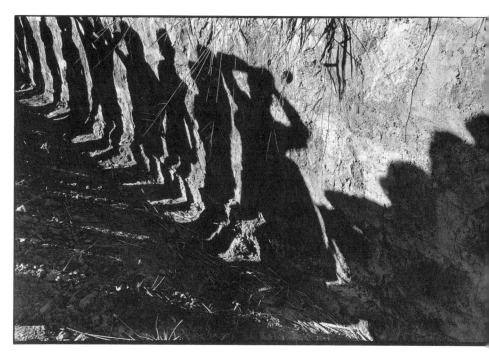

Susan Meiselas, *Road to Aguilares*, 1983. Courtesy Magnum.

that her aim is to show the contention of forces, with particular account given of the human cost, the brutal suffering, endured by the peasantry of El Salvador. They grow up and live side by side with a violence against which they have no protection, and that is perpetrated upon them by their own government. In other words, their tragedy has a direct and specific historical framework, but it is realized and projected as a shadow play of roundups, the identification of bodies, and burials. With many of these pictures, it's obvious that no one posed—so that the intent to give a symbolic weight to this agrarian struggle, without intervening in the action, without staging behavior, is a mark of high seriousness.

Yet in all five of these photographers, the "desire to make contact" cannot be fulfilled except through a selecting or sampling process that wants to obscure its own fictions. I have speculated about the transactions between photographer and subject so as to better gauge the relations between photographic image and viewer. The pictures, on this occasion, are essentially all that we have. They are the results of certain confrontations that inevitably enter into the final content. The

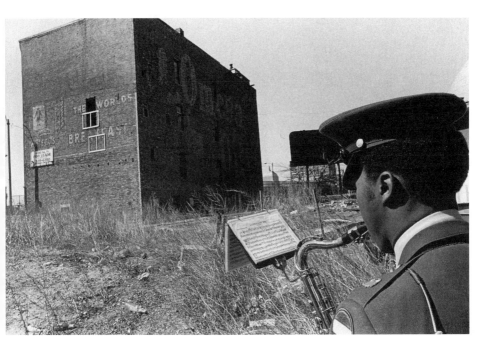

Eugene Richards, *St. Patrick's Day, South Boston,* 1978.

best of this work is uncivil and problematic because it does manipulate at the same time as it cares for its subject. When that conflict becomes vital, it carries with it an extra dimension of consciousness as we face our own malaise.

This essay appeared in the catalogue to the exhibit *Photojournalism in the Eighties* at the Hillwood Art Gallery, Long Island University, C. W. Post Campus, October 1985.

Gilles Peress and the Politics of Space

WHERE OTHERS can only quote from them, Gilles Peress actually studied under Michel Foucault and Edouard Balibar in Paris, fifteen years before those theoreticians became demigods in art discourse. Learning from such teachers convinced him that words were indeed increasingly dissociated from any correspondence with reality. But this was a cultural malaise, he thought, that the professors themselves illustrated. Peress, a young social activist from the days of 1968, recoiled from the academy. Eventually he considered that the camera might be a means of coming to terms with the textures, events, and import of the world. One can imagine such a person being impressed by photography's specific power as a material witness (though it then had few serious publishing outlets). By a fluke, as he supposes, he was accepted into the ranks of the Magnum agency, in 1972, despite his lack of professional photojournalistic experience. Years passed and knowledge was gained. Among so many others, Peress was sent, or took himself to the usual international hot spots and murder zones at times of crisis. Recently concluding a term as president of Magnum, he looked forward to full-time action in the field, only to be brought back to doubts he's long had about the word *photojournalism*, how to define it, and how it may, but most likely doesn't, apply to the kind of work he does.

Hardly any of the responses to Peress's famous book *Telex Iran* (1983) have signaled its textual singularity as a clue to such doubts. The editors themselves point to their use of captions of telexes between

the photographer in Iran and agents in Paris and New York as data that indicate the "distortions . . . the incomprehension, the venality of the process of collecting and diffusing information." We have no reason to doubt the existence of such things, but the telexes don't spell them out, not any more than Peress's images "explain" the American hostage crisis during the Khomeini takeover. Instead, we learn that negotiations to feature some of these pictures fell through at *Life,* or that the photographer worried that right-wing editors would use the wrong captions. What normally goes on only behind the scenes and is part of media market competition is blended into the overt program of the book. Occasionally a photographer's account of his or her personal experience accompanies the pictorials in articles or books. But works of photojournalism had not previously used documentary scraps of their own material and commercial difficulties to distract from pictorial content as this one seems to have done.

The Iran photographs themselves are perhaps too moody, disjunctive, and artful to have appealed to picture editors known for their taste for banal exposition. Peress's angles are often tipped. Shadows reach out with ominous extravagance. Imbalances between trivial and significant detail confuse the narrative sense. Rather than outright news, the pictures convey what it feels like to be tossed about in a revolutionary environment within alien crowds. Gradually there comes through a disgust with the regime of the mullahs, whose icons reflect the scowls of pallbearers and armed men—the tense, lumpen masses of the new theocracy. All of this has the air of a story that found no buyers and didn't get out. The captions evoke a certain helplessness vis-à-vis the photographer's own system, while the pictures register his vulnerability in the Iranian moment. *Telex Iran* finally appeared on our horizon as an oversized, modestly priced art book dripping with historical information that exposes its own inutility.

In current jargon, the project was "self-deconstructed," though a historical development contributed as much as a conscious strategy to this outcome. As suppliers of media visual products, photojournalists had seen the standards for their work publicly leveled as the qualifications—and private awareness—of a few of them increased. Since the upwardly mobile Eugene Smith in the fifties, editors and distributors have resisted the idea that photojournalism had any higher calling than reportage. They bristle particularly at the essay form, or any

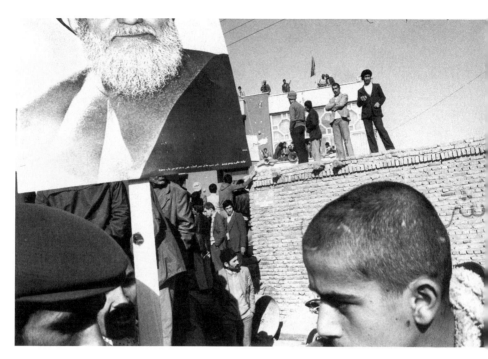

Gilles Peress, *Demonstration Pro-Sharist Madari, Tabriz*, 1980. Courtesy Magnum.

equivalent of it, which allows for extended comment and subtle truths. It must nevertheless have bothered some of the photographers that such truths could only be founded on the basis of egocentric observation—which violates the credo of journalistic objectivity. They had not been given a mandate to express their opinions, but to gather certain "facts," according to institutional criteria.

The Magnum agency has bred more dissenters from this state of affairs than other photo co-ops or collectives. But even in the Magnum files, one will not find any heading for Peress or Richards or Branco. To discover their work, one has to look under, say, Iran, hospitals, or Brazil. The Magnum outfit does business by selling illustrations to topics, of which it must have extensive coverage. Many pictures are made; few are chosen. However they may inform us, it's important to realize that most news photographs are understood to reflect no one's experience in particular. Such images are inserted into texts nominally as guides or corollaries to written material, though more often as necessary breaks in it, to refresh the winded reader. It can easily be seen what an affront to this practice is presented by photog-

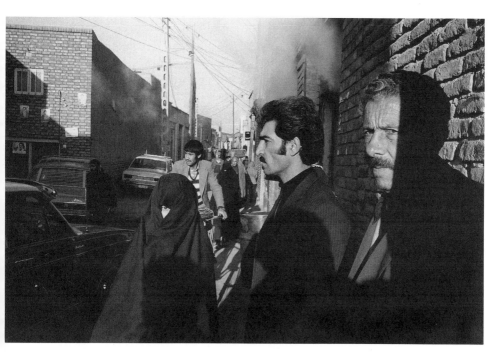

Gilles Peress, *Street scene, Azerbaijan,* 1980. Courtesy Magnum.

raphers who insist that they have the stories in their heads, or even worse, that until it is visualized there is no story.

They generate work that presses home its advantages of tactility and immediacy of local encounter—so much so that words seem inadequate to deal with the atomized narrative structure that is implied. The randomness of the photographic presence—everywhere and nowhere—is at odds with the inevitably linear sequence of news copy. Compared to standard texts, the photographs of people like Peress have no defined entrances or exits. They act only as frames for ongoing developments, seen by one individual with his or her arbitrary set of reflexes. Magnum photographers often, in fact, show themselves as wayward optical egos who appear to diverge from the corporate rule all the more as they become monsters of investigation.

The two outstanding theaters of Peress's career have been Teheran, with other Iranian locales (briefly), and Belfast, the site of his first serious assignment, to which he's returned ten times in sixteen years. A viewer is impressed, in the choice of these two places, by their kinship in violence, and the way lines are drawn irrevocably between

an "us" and a "them," determined through physical vantage. Peress freely crosses over these lines, identifying temporarily with one group's perception or another's, but without pleading anyone's case. He's continually observant of the degrees to which religious indoctrination and political propaganda fuse in the consciousness of besieged groups. *The photographs are made to witness the toll upon a community of exactly that kind of consciousness—minds under siege.*

But in Iran, the social space is entirely transformed by mass rituals and demonstrations, so that the life of the people is understood as a kind of thrust or surge. This transgressive possibility produces an environment which quickly seems to fill any public space with figures gathered up in their cause. There is no vacancy in Teheran that is not also a staging area. In contrast, life goes on quite placidly and some-times with drollery behind and between the scenes of the "troubles" of Northern Ireland. Families allowed this French visitor into their homes; nor was he a stranger to their pubs. Domestic spaces of memory and leisure transmit to the viewer a sense of what the Northern Irish, Catholic and Protestant, maintain with affection in their private lives. On the other hand, the scarred neighborhoods and public streets of Belfast strike us as places where matter itself is afflicted. One picks up the sinister interplay between the interior communities and the failure of the larger, external community. Outside the home, in the urban setting, the camera records real desolation. Large sections of Belfast of course resemble decayed working-class and industrial pre-cincts. But they go further than that. They look like no-man's-lands, flanked by closed doors. When groups appear, their activity is dis-torted—so that children's play is a premonition of war, not to mention the way adults do real battle with each other. And there are too many funerals.

Belfast funerals, as Peress sees them, fall into two categories: mil-itary and elegiac. Certainly he was given access to the former so as to further news of Catholic resistance in Protestant Northern Ireland to the outside world. When comrades of the fallen one wear ski masks, and the guard of honor shoots off its pistols, resistance and death are shown to feed on each other. Another martyr joins ranks with those who have preceded him and those to come. Peress's position is au-thorized as someone who might do the Catholics good—a publicist

Gilles Peress, *Martin McGuinnes at the funeral of a volunteer,* 1984. Courtesy Magnum.

of their sacrifice. But there are several occasions when the mourners troop out behind the hearse, and it is as if instead of being elevated to the status of a hero in a struggle, the lost human life is remembered for what it was. Here, it would have been appropriate for the photographer to be tactful, which he is, without any decrease of invention. Something is made to intervene in the picture foreground—a hedge or the moldering statue of a sleeping cherub—so that the survivors are cut off, in a zone we're unable to reach. For its part, the militant funeral demanded spectator proximity, but was meant to be a ritual of tribal vengeance. The photographer was with the participants, but not of them. It's the other way around in the civic funeral. There, a physical barrier or an oblique view only reinforces an effect of emotional solidarity with the event. This kind of framing realizes itself as a lonely view that is extended, perhaps out of its own introspection, into the grief of its subjects.

Over the years, a number of Peress's Irish photographs have appeared in periodicals, and have therefore contributed to normal journalistic flow. But I think that though in the aggregate they are motivated by

Gilles Peress, *The first snow, Belfast*, 1981. Courtesy Magnum.

journalism, they are also removed from it. His curiosity becomes almost narcissistic and is crafted for its own sake, far in excess of its genre function. This imagery overflows with, and opens up precipitous ideas about space, yielding an endless repertoire of dislocations. For example, a narrative business may be squeezed off laterally to one side of the frame, as if the photographic regard had chased off in the wrong direction. A viewer is alerted to the eruptive character of the action in perceiving how the picture has been nervously constructed. Just as often, there are implications of pressure in the depth of the shot, as when projectiles are hurled from foreplane to back, or vice versa. This is not just ground that is covered, but territory that is violated, with the result that the very depiction of space is inevitably caught up in politics.

Almost as if to socialize this issue, a particular kind of questioning face appears in these photographs. It belongs to someone who wonders why Peress is there and what he's up to. This entirely pictorial phenomenon—having to do with sightlines—reflects the displeased consciousness of subjects being observed, while it simultaneously locates

the point of observation. A text can rarely convey the discomfort of such micro-exchanges, which necessarily include the viewer. Peress's record is made volatile by them as he moves through charged scenes. In Iran, people looked back with a general suspicion. In Ireland, the faces are more modulated because Peress himself is playing a greater number of roles. If his subjects there had recognized him as an artist, would they have behaved differently? And if we sensed in these pictures their deep journalistic mission, would we think them any the less expressive?

This essay appeared in *Parkett* 15 (1988).

Picturing the Killing Fields

*That blasted Pole {Conrad} makes me green with envy
because he writes literature when he's trying to write journalism
and I write journalism when I'm trying to write literature.*
GRAHAM GREENE

B Y AND LARGE, artists aren't widely heard of in our culture unless their work is priced off the charts or they're censured for sexy subjects. War photographers don't typically enter the news unless they get shot. Hearing of such deaths, we may feel momentarily shocked, as if we had been impudently denied our natural right to reportage from dangerous areas. Recently, though, a few photojournalists have emerged into the limelight on their own, without having paid the final price. This or that phase of recent history has even become associated with their view of it, to curious effect. Some of them, indeed, are no longer nameless and faceless drudges who bring back the pix but figures illuminated by the media or even occasionally by film or fiction. Here they are viewed as lions of photojournalism, a profession they practice on a level to be equated with art. We know about Capa and Bourke-White and W. Eugene Smith, full-dress biographies of whom have recently been published. It is improbable that their counterparts today, photographers such as James Nachtwey and Alex Webb, will receive the same treatment, for they are far more diffident characters. But they also display a more willful, knowing—and troublesome—relationship to art.

We are pretty definite about what we tolerate in such matters. Photographic and TV journalists are constrained by their responsibility to their subjects. Because of the documentary power of these mediums, which confirms rather than merely alludes to an episode seen, one

thinks of them as forms of actual witness—often in zones where peoples struggle and life is lost. Let aggressive scenes be photographed harshly or discreetly: the one mode is as acceptable as the other, provided the visual record isn't overmastered by anything so inappropriate as a personal sensibility. For that would add, to the shock that is originally elicited, an esthetic pleasure that would be embarrassing to acknowledge. Many photographers of violence have possessed style and even a vision, but kept in bounds by their grim topics. When those boundaries are transgressed by an artistic consciousness—as if estheticism had superseded human values—we're presented with a dilemma that bears on our moral understanding and our perception of history.

While I don't remember a film since Haskell Wexler's *Medium Cool* of 1969 that deals seriously with the moral quandaries of TV cameramen, two movies of the past decade have treated the political dilemmas of war photographers. Enhanced public awareness of the medium over the last ten years does not in itself explain why such figures have been singled out as protagonists. But it's fair to say that the photojournalist threatens to supplant the soldier as romantic hero in today's popular depictions of war. In these films, the photojournalist is converted before our eyes into a man of breathtaking action and ambivalent activism. *Under Fire* (1983) and *Salvador* (1986) background the grotesque U.S. penetration into Central America, exposing our obtuse—and complicit—national media coverage of it. While hardly artists, the photographer-heroes are initially shown as monstrously self-centered—the next best thing. Further, they are career fetishists, and their careers have made them crazy.

How else can one account for people who enter freely into firefights, not to participate in moments of viciousness but to record them? Celebrated prototypes such as Robert Capa, Eugene Smith, and David Douglas Duncan were hard-bitten idealists who at least felt themselves on the virtuous side of the hostilities they photographed. The films' heroes, on the other hand, are burdened by their knowledge of being identified with the wrong side, the oppressive party, in a civil conflict. In Somoza's Nicaragua, the magazine photographer portrayed by Nick Nolte in *Under Fire* is at first totally unthinking and naive about politics, compared to his savvy counterpart, James Woods's free-lancer in Salvador. Their occupational craziness seems foolhardy and yet also

praiseworthy, for it betokens a form of eventual redemption. In fact, the very extremity of their involvement becomes a necessary trial by fire from which they emerge more humanely tempered.

In recent Hollywood lore, the figure of an unsavory, almost demented outcast is often portrayed as the lone dissident within an unresponsive and alien system. Though sometimes paired with a buddy, he's a maverick, repelled by teamwork and contemptuous toward the rule of law. Within this antiauthoritarian framework, we find tight-lipped, murderous vigilantes like the heroes of the *Death Wish* and *Dirty Harry* series. The films about photojournalists in Latin America have taken this violent fantasy and have fused it with a gentler myth of the concerned photographer, with the further twist of inserting him into a reconstruction of actual historical events. This winning formula plays upon our dread of conspiracies in high places and our horror of social disintegration. With their hysterical texturing, all these films, from *Dirty Harry* to *Under Fire,* appear to me as cultural products of an imperial state that perceives itself in evident decline. We yearn to have the old order or a swifter justice restored to us.

In the liberal version of this story, the hero undergoes a character change, unlike his homicidal opposite number in *Death Wish* and *Dirty Harry,* and emerges as a sadder and more caring person, able to question the value of his past work though still motivated by a hustler psychology. As he blunders into even less coherent societies than his own, he loses hope of personal impact and doubts even his ability to picture events in accord with his painfully won conscience.

Like other Western films fascinated with Latin America, such as *Aguirre, Fitzcarraldo,* and *Walker,* these two movies featuring war photographers tell the story of a white-skinned interloper obsessed by a doomed project. Whatever it had been before, his reason is disabled by the enigma and savagery of the jungle. Of course, the gringo-centric viewpoint of these films assures the incomprehension of a reality that is their nominal subject.

Our fiction, too, has dealt with this theme. In Philip Caputo's *DelCorso's Gallery* (1983), the Vietnam war photographer DelCorso commits himself to a realism in which mystery has no place, especially the grainy kind of photographic mystery practiced by his famous and hated mentor, P. X. Dunlop. The "gallery" of the title refers to a cache of

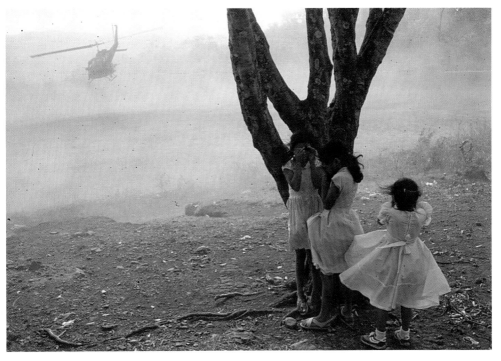

James Nachtwey, *San Luis de la Reina,* El Salvador, 1984,
from the series "Deeds of War." Courtesy Magnum.

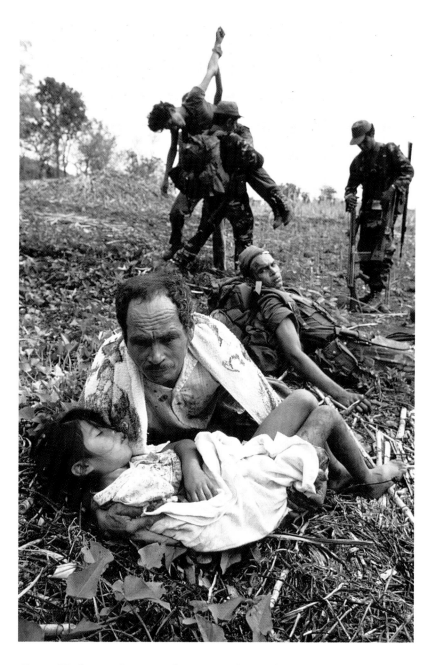

James Nachtwey, *San Miguel Province,* El Salvador, 1984,
from the series "Deeds of War." Courtesy Magnum.

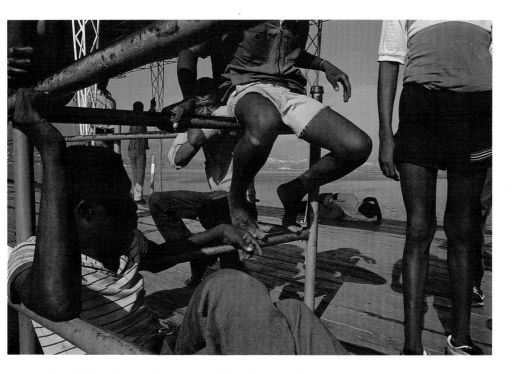

Alex Webb, *Port-au-Prince,* 1986-88. Courtesy Magnum.

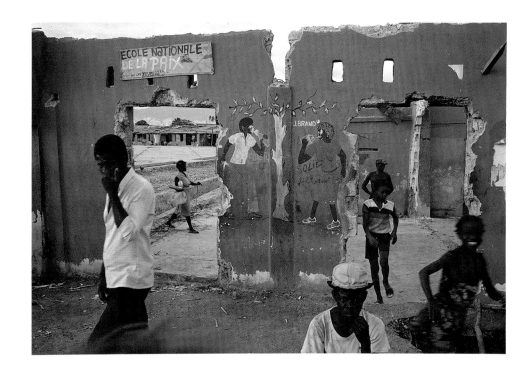

Alex Webb, *Port-au-Prince, Haiti,* 1986. Courtesy Magnum.

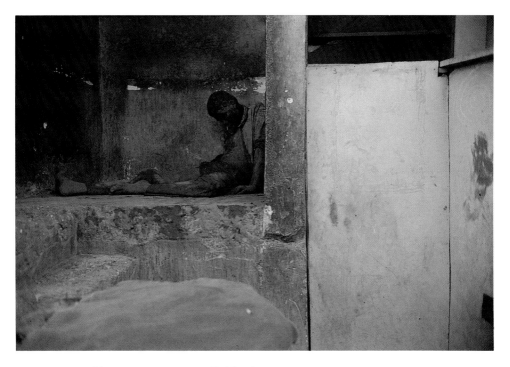

Alex Webb, *Port-au-Prince, Killed by the Army,* 1987. Courtesy Magnum.

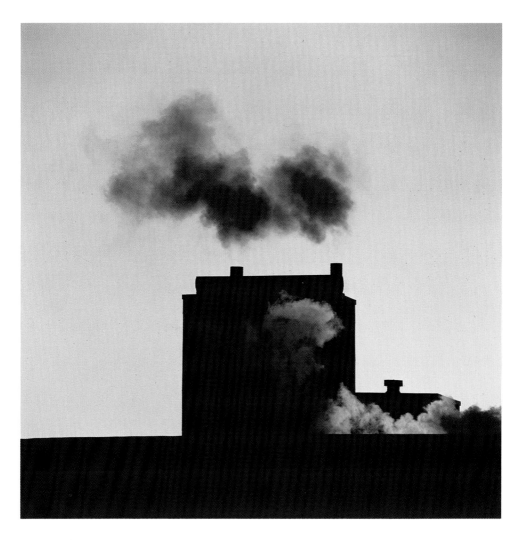

John Pfahl, *Goodyear #5, Niagara Falls, New York,* 1989, from the series "Smoke." Ektacolor plus print. Courtesy National Museum of American Art, Smithsonian Institution.

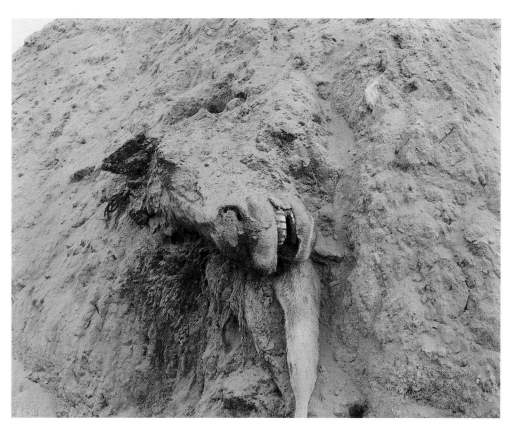

Richard Misrach, *Dead Animals #327,* 1987, Ektacolor plus print.
Courtesy National Museum of American Art, Smithsonian Institution.

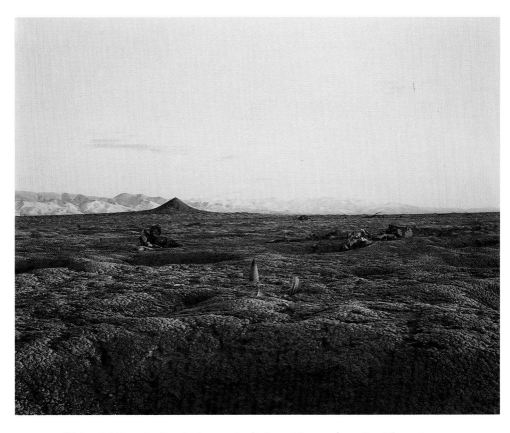

Richard Misrach, *Bomb, destroyed vehicle and lone rock,* 1987, Ektacolor plus print. Courtesy National Museum of American Art, Smithsonian Institution.

photos DelCorso has taken of the most bestial, and therefore unpublishable, mutilations. He possesses traits similar to those of his movie colleagues—an incurable restlessness and a highly flammable personality—but here these characteristics are illuminated by a more articulate doubt about the efficacy of photographs as history and as expression. Condemning tasteful war reportage as hiding the abominable truth of Vietnam from the public, DelCorso nevertheless feels himself to be an artist in his own right—albeit one who strives to be as offensive as possible. His aim is to achieve a photographic effect that would transfigure and yet accurately describe his most appalling experiences.

This ill-educated journalist, of blue-collar origin, has a class animus against the American power brokers of the war. In Cambodia, he photographed a Chicano kid, wounded in the groin, alongside "freaks with their long hair and peace symbols; a grunt with a prick tattooed on his arm . . . taking a smoke break with a stick of Red; a sergeant looting a temple, grinning. . . ." These shots, together with some that show bald old generals eating lobster thermidor, he sells to *Life* and the *New York Times Magazine* (though they would be unlikely to have published them, as the novel claims). Because of his attempt to analyze what happened to our underclass in the Vietnam conflict, let alone the damage done to the Vietnamese, DelCorso is furiously chastised by his old mentor (possibly modeled on David Douglas Duncan) for his cynicism and his prostitution to the supposedly left-wing (!) editors of these publications.

But it is callousness for which DelCorso most blames himself and from which he needs to be redeemed. He shares the same risks as the soldiers, which gives him some moral parity with them. And he has the same survivor's guilt as those who randomly come through the fight. Capa's law—"if it isn't close, it isn't true"—impels him on to the agony and terror he sees written on the face of a wounded ARVN soldier during the fall of Saigon. Under fire himself, he exposes this subject on film, calculatedly, with an almost erotic instinct. Later, in printing the image, the photographer perceives that it inadvertently records the moment of a fatal hit from shrapnel, and that he has an excruciating kill shot with "none of the dignity that mitigated Capa's *Death of a Loyalist Soldier.*" DelCorso reckons that it may be sublime but also fears it is pornographic.

There comes home to him the terrible thought of professional ob-

servers of bad scenes: that what they imagine as the worst and most admonishing of reports, others would appreciate as pictorial effect or even as art. He feels himself in excessive accord with the demands of editors for sensational material and is driven yet sickened by his compliance with them. By what right does he profit, if not in money then in fame, from that poor soldier's death? Is the public actually informed or merely pandered to by such harrowing imagery? Caputo's novel acknowledges the counsel of Philip Jones Griffith and Donald Mc-Cullin, two war photographers with an animus against the unconcerned and protected readership at home, which has little idea of what is endured at the front. DelCorso considers himself justified by a kind of "corrective aggression" toward the public, but he also has to realize that his hair-raising faithfulness to an atrocious moment, for which he risks life and limb, lacks any conventional news value. Significantly, he has no patience for captioning his pictures, since dry words fail to illuminate a convulsive reality. Rather than pursuing history, he wants to administer a shock to the uninvolved, hoping that their response will somehow enter history. His means of doing so will be a picture of one individual's fate, through which it is meant that we see a larger significance: the failure of U.S. foreign policy and the fall of a corrupt order.

I cite this fictional offering not only because it recalls photographs we have already seen, but also because it represents the triumph of a symbolic reading over a realist intent. Photographs such as DelCorso's are thought to exceed the reach of discourse, since they appear to crystallize the pathos of human suffering in visual terms alone. Unlike film and TV, only photographs combine the (obviously partial) act of witness with a sometimes iconic power of condensation. This dual potential of photographs—to offer hard information fused with symbolic content—is unique in media. TV's fluid kinesthesia has no stamina next to photography's indicativeness and consultability. The symbolic needs of various publics are especially revealed by the photographic icons they choose—pictures that often have an air of fatality about them, regardless of the actual circumstances they memorialize. And the tragic flavor of such images comes to have a mytho-historical value for successive viewers, as if they, too, recognized this to be a promise of photography itself.

Outstanding moments of photographic imagery tend to be elegiac in character, with a moral content embodied in the spectacle of or the resistance to human loss. Even major scenes of victory seldom match images that resonate defiance or call for solicitude and regret. As Dorothea Lange's *Migrant Mother* concentrates those sentiments for the first half of our century, images like Korda's portrait of the beret-clad *Che Guevara Guerillero* has broadcast them for the second half. And these are but two among the thousands of photographic martyrs regularly produced by the daily turn of events. In the face of the endless Passion play of our epoch, the photojournalist's shutter is released time and again in the hope of hitting a jackpot of moral imprint and iconic memory.

Yet a news photograph is one of journalism's most perishable items. Ever in danger of being scooped or discarded, its purely topical value decays instantly if it's not published. Much has been written lately about the need to comprehend photographs on the basis of their first-time context, yet the majority of journalistic photographs are initially lost in a sea of competing images, and the lasting impress of the few that survive is determined through later, shifting contexts. So as to draw retroactive attention, the imagery is published in the permanent form of books. We might even describe the moment during which general culture comes to reckon with these images not as their afterlife but as the beginning of their real, effective life. At that stage where its immediate news value has long since evaporated, the photographer repossesses the visual material in his or her own name.

In 1947, the Magnum agency was founded on the principle of the photographers' personal ownership and copyright of their images. Since then, the agency's members have led in producing photojournalism that speaks in the first-person singular and has a place beyond the pages of a magazine. Far from weakening, this attitude has generally deepened the photographer's investment in the story. One strain of Magnum work—let's say Capa's—has always dealt with subject as archetypal vignette or climax, maintaining legibility in strictly narrative terms. But other Magnum photographers, following the lead, say, of Henri Cartier-Bresson, have more and more treated subject as parenthesis, packing multiple episodes within a single frame that may scramble story content but increase psychological texture. Indeed, the

"story" in such cases is often defined by the sort of marginal visual incident that no editor could predict or require. Dan Hofstader writes of Cartier-Bresson's pictures that you are amazed to ask not only "How can this be so?" but "How can this be so while that is also so?" The anarchic simultaneity of this kind of visual thinking ultimately places itself at odds with text, where ideas tend to move in ordered succession.

Extrapolated in books, the work of such Magnum photographers as Gilles Peress, Eugene Richards, or Sebastiao Salgado may still recall outsized magazine layout, but it is also freed from the nearby company of copy or ads and sequenced according to authorial design. If a book is devoted to one subject, the effect of a unified theme is intensified; if it consists of a medley of topics, the photographer's reportorial role is often atomized. In either case, the resulting gain in pictorial emphasis and impact is offset by the danger that the historical realities depicted may be processed as merely a phase in some photographer's career. Nevertheless, as they distill their vision in its own terms, photojournalists augment and outflank the schematic concerns of the media, announce a personal act of witness, and assert a liberal ethos that atrophied elsewhere in the U.S. press of the eighties.

Two stunning but very different books have recently been brought out by Magnum photographers. James Nachtwey and Alex Webb are steeped in the contradictions of their genre and the ethical complexities of their trade. Each has also evolved a color palette that gives to the painful tone of his work a voluptuous accent.

Since he has been awarded the Robert Capa Gold Medal three times, we're left in no doubt of Nachtwey's lineage. His book *Deeds of War* (Thames and Hudson, 1989), introduced by the novelist Robert Stone, anthologizes desperate moments from a carousel of assignments in Lebanon, Nicaragua, Northern Ireland, the Philippines, Israel, Sudan, Afghanistan, etc. Where death is meted out at short notice during blood feuds and civil wars; where guerrillas or anti-insurgent forces are active in the wilds; where firebombs are thrown by hooded youngsters and campesinos are interrogated by army patrols; where graves are dug, bodies uncovered, and families mourn—there Nachtwey is likely to be found . . . with a clean view. He describes lives that are being threatened or have just been taken, and he excels in depicting

the choreography of grief. His charnel spectacle, much of it unpresentable on TV, is Goya-esque in subject but not in the clear luminosity of its style.

The effect sears as much as it chills. In the majority of his images, a nerve-racking intimacy with barbarous conduct or events is objectified by the photographer's pictorial intelligence. We never find any blur in his work or any sign of hurry. His deliberate, transparent, and selfless approach makes his images, centered yet radiantly detailed throughout, all the more harrowing for the viewer. Further still, their tingling, clinical manner of observance and the brutal scenes of action are at ferocious odds with each other. It is as if a Pre-Raphaelite had visited the slaughterhouse.

A line by Graham Greene, describing a cockfight in *The Lawless Roads,* evokes the sensory presence of a Nachtwey photo: "It was a matter of seconds and then the beaten bird was lifted up and held downward, until blood came out of the beak, pouring in a thin black stream as if out of a funnel." Here the pitilessness of the contest is enhanced by the vigor and precision of the way it's described. More than realism, however, is involved in this drive to visualize suffering flesh. For in making us see as vividly as possible, it also causes us to reflect—on those who are sacrificed for reasons that the image alone can never fully explain.

I use the word *sacrifice,* mindful of its religious aura, not only because Graham Greene was reporting on the 1930s Mexican repression of Catholics, but because James Nachtwey's photographs sometimes recall certain motifs of Catholic iconography—the Deposition from the Cross (embodied by a wounded contra) or, in another example, the Entombment of Christ (recalled by the funeral of a Tamil fisherman). This photographer has no trouble recasting his players according to his and our knowledge of a sacred drama. But the significance of the torment is not clarified, only exalted by the spiritual reference. Nachtwey is ambiguous, indeed, when it comes to moral questions closer at hand. He takes pictures at the time of a rise in the blight of religious fundamentalism, and the appalling strife it causes is crystallized through his lens with a disturbingly neutral clarity. In introducing *Deeds of War,* Robert Stone remarks that "the religious dimension and its reverence for martyrdom no longer sustain us in the West, but the por-

trayal of suffering humanity has never lost its moral dimension." Yet if Nachtwey constantly alludes to this moral issue—the meaning of the suffering he portrays—he seems never fully to be engaged by it.

Whatever Nachtwey's politics, they are masked by a stringent professionalism. The vehemence and passion of battle, even the force of ideology, seem, in his eyes, to be the products of nature rather than society. For that reason, it is difficult to imagine him subscribing to Capa's hope to be put out of business by the end of war. Lacking stakes in any combat, Nachtwey wants only to render its effects as brilliantly as he can (using the monumentality of W. Eugene Smith augmented with strong color). He teaches that suffering is not so much cruel as indiscriminate and endless, a lesson that decreases its meaning. He can be accused of a narrow focus and an unreflective temper. Certainly he is a secular artist who exploits spiritual metaphors, regardless of their pertinence—Nachtwey's awareness of what contras do does not stop him from giving them a noble mien at prayer.

Yet for all his calculated symbolism, he deals with actual tragedies and profoundly existential themes. A man in Belfast splashes a burning truck with a pail of water. It is just a microsecond in which the sparkle and lace of the flung water is suspended against a pall of white smoke. But it is enough to see that he will wet himself more than the blaze— and that a protest against destruction is ludicrous. Three little Salvadoran girls shield their faces from the dust kicked up by a helicopter evacuating wounded soldiery. The delicate pink and lilac of the girls' saint's-day dresses contrasts with the vengeful insect of a machine, as the concept of innocence contrasts with evil. Nachtwey's readings strike us not just in their simplicity but in the way simplicity epitomizes a continuous discrepancy of forces. All the same, the individual clarities of his messages in *Deeds of War* are interspersed in thematic clusters that blur their potential import.

The book opens with scenes of fighting, moves on to the recuperation of bodies, observes civilian casualties and trauma, and proceeds to the relation of Church and military, religious events, funerals, memorials, scenes of hunger, and ultimately the training of kids or young soldiers in warfare. This last section is remarkable. Only after his treatment of the effects of aggression does the photographer depict its causes, yet even here the topic is thought of as more a natural than a social

process. Everyone is braced or knocked down by the ideologies of hate, which are as irresistible as the force of the elements.

No one picture can better indict our Latin American policy than the one here of a U.S. military advisor in El Salvador exercising in a room decorated with hunting rifles and Playboy centerfolds. We're free to feel the same about the shot of the Israeli yeshiva student studying next to his faithful assault rifle. Incongruous as they seem, nothing is discordant about such pictures, for they describe ingrained behavior. All of Nachtwey's photographs in the book are as incisive as these, and many are as weighted, but none of them are pointed . . . because they are extracted from his scrupulous, extended photographic analyses conducted in the field and homogenized here in a gallery of epic moments.

If Nachtwey's book represents a triumph of the parts over the whole, Alex Webb's does the opposite. *Under a Grudging Sun* owes at least part of its coherence to the facts that it stems from repeated forays to one place—Haiti Libéré 1986–88—and that its imagery was intended from the start to be exhibited in book form. Along with his earlier book *Hot Light/Half-Made Worlds,* 1986 (both published by Thames and Hudson), this one is pervaded by the overarching experience of heat—a heat that not so much enervates as oppresses. People sweat in these pictures, tempers flare and colors ripen with gorgeous indecency. The hyberbolic effect of all this upon one's senses transforms an apparent reportage into a mournful diary of estrangement within the tropical place. Rather than follow through on any story, Webb saturates his work with mood. His scenes are visualized through jagged shadows that camouflage and often obscure the smoldering humanity within them. (He exposes for the light, not the shadows.) This virulence of contrast seems to exacerbate a social malaise. Though shown with darting eyes and in nervous movement, people mainly mark time on this parched island. There are too many of them for the little work there is to do. Webb thinks of the picture as a field whose energies reach out to every perimeter, and he thinks of himself as an organism embroiled in—not detached from—those energies.

This is a far cry from selfless objectivity. Despite his presence at some historical events, his attitude yields scarcely any "hard news."

Photojournalists are supposed to be voyeurs, but Webb's intimacy with his subject seems unrelenting and excessively privileged, as if he'd gotten under the very skin of woe. Who would deny his view that extreme privation and disenfranchisement produce a galled state of mind, which can be manifested in photographs? The disjointed space, the harsh, surprising patterns, the very abandonment of the Haitians under the sun, express this consciousness. Each photograph embroiders upon such a theme, and together they give to it a kind of crescendo. Webb was deeply affected by the chromatics of the Brazilian photographer Miguel Rio Branco. He learned collage/Surrealist structure from the early Cartier-Bresson and employs it now in a calculated move away from the Frenchman's later, more reportorial work. With only a "vague interest on the part of a few magazines," this American returned to a tortured society, assigned only by his own compulsion. In the process, he deprofessionalized his genre so as to lend to it a depth—particularly an emotional depth—that it usually lacks.

Webb has been attacked for contributing to a "Third World mystique." The critic Esther Parada sees his earlier work (of *Hot Light/Half-Made Worlds*) as "continuing a tradition manifest daily on the front page of the *New York Times* where Third World citizens, shown as 'the people' or an ANONYMOUS MOB—chaotic, violent, irrational—are often in contrast to identified individuals in the developed world: well-groomed and reasonable in crisis."[1] Certainly photojournalists are emissaries from the communications chanceries of the West, whose managers wear suits and ties, and our "cool" rulers are undeniably responsible for supporting brutality and causing bloodshed in "hot" lands. But it's precisely this detachment of both conscience and affect from information that Webb protests in his own field. We are too familiar with the photographic portrayal of conflict in the manner only of a job that may be poorly or brilliantly performed. *Under a Grudging Sun* breaks that manner open. One doesn't feel in Webb's pictures any "fatalistic pessimism as to the possibilities of change, whether societal or personal," a complaint that Parada could have leveled with far more justice against journeyman practitioners. For it's not just that Webb treats Haiti Libéré as an eruptive zone, but that his visual style is unquiet as well.

He came back to the island for the fourth time in March 1986,

just after the Duvalier dynasty fell. Never had he seen Haitians speaking on the streets and feeling free enough, as they did now, to talk to him about what the future might bring. His book nevertheless turns horrid as it begins to chronicle the repressions and massacres of the November 1987 elections, when the army reasserted its control and foreclosed that future. Just as his Magnum colleague Susan Meiselas had been an initially inadvertent documenter of the Sandinista rise to power, Webb became the poet of crushed hopes following Haiti's revolutionary episode. Suddenly, the lattices of shadow he observes become metaphorical prisons for the betrayed and defeated. Their funeral marches and demonstrations rend the air with shrieks we do not hear. The photographer does not spare himself (or us) the guilt of feeling protected within slowed cars as their windows are pounded by the dispossessed. Any sense of a larger history can only emerge from his personal circumstances as he lives them at each moment, jostled in a crowd, as a conspicuous stranger, a helpless onlooker, above all as one who acts under some physical pressure and often has to steal a quick glimpse. In these fretted views, Alex Webb also indulges to the extreme his taste for color accents widely scattered yet piquantly echoed, so that the esthetic scaffolding matches the psychic tension of his work.

The eye doesn't know where to settle in these profuse photographs, laden with visual excitements that distract from narrative or are in the "wrong" place. A seductive pink blob in a bluish picture steals the scene, to the detriment of a corpse—a man killed by the army—slumped in an alcove above. These two elements are not of equal importance to the mind, but as Webb includes them both in the field of the picture, he reflects something intrinsic to the field of action. For this poorest of peoples spruce their houses, streets, signs, and vehicles with gaily painted borders and fringes, as if in perpetual celebration of some event that never happened. Because it's one of the few instinctive reliefs that can be afforded in a severely restricted life, Haitian decorative culture is essential, not frivolous. Webb's pleasure in the dissonance of phenomena is a more factual and certainly a tougher response to Haiti than would be any artifice of symbolism or complaisance of sentiment. In *Port-au-Prince, Cité Soleil,* the contrast between the punctured blue wall and the unexpected depths revealed through it, the charm of painted figures and the grace of real ones,

orchestrates a range of ironies into a powerful whole. The human poignance of the scene asserts itself exactly through this pictorial form, just as it does in Cartier-Bresson's great Spanish pictures of the thirties.

Alex Webb has said that he was partly inspired to visit Haiti by having read Graham Greene's *The Comedians*. For his part, Nachtwey opens his book with an epigraph from Conrad's *Heart of Darkness*. These literary sources are revealing ones. Both writers are among the most "visual" in twentieth-century English letters, and both are novelists of extreme critical disillusionment dealing with imperialist themes.

Conrad, as we know, saw in the torment of the jungle an evil so horrible that blacks must be supposed to participate in it as well as the whites who annihilated them. As for Greene, he gives the impression that we are always in moral arrears for our inevitable misdeeds. At the end of *The Comedians,* a priest sermonizes: "The Church condemns violence, but it condemns indifference more harshly. Violence can be the expression of love, indifference never. One is an imperfection of charity, the other the perfection of egoism." I don't know if Greene's black priest would have approved of Nachtwey's denial of ego in luminous service to an oppressive media system. But surely Webb's egoism is not indifferent, as the priest imagined it would have to be in the absence of faith. Both photographers have resorted to art as a means of reconciling their expressive ambition with their documentary métier. In that sense, they've gone the opposite way from the novelists, who alluded to autobiographical experience in order to intensify their fictive grip on the throat of the imperial myth.

Nachtwey shows himself to be a spectacular popular artist with a grueling subject matter. But Webb is a much more challenging artist, one who does not sacrifice the anguish of his witnessing to the modernism of his form. He probably sees little hope of continuing any relationship with the magazine world. In its lonely distinction, his work has nowhere social to go except outside the rigidified genre of photojournalism and into books of an ambiguous and troubling cast.

Perhaps a new category needs to be established to define such hybrid pictures as Webb's and those of a few other photographers at Magnum. As something to look at, as something to incite feeling, these images outdistance any photography to be seen in American galleries of the eighties. But if they are not so much in an artistic limbo, they are in

a media limbo. Here is imagery still very much in search of an audience. Ordinary photojournalism's most positive social role is to expose those moments when governments hope to get away with killing their people in the dark. Dissident photojournalism more actively sides with popular forces against illegitimate rule, until such time as their nationalism becomes repressive. Gilles Peress's photo survey of the Khomeini takeover portrays a historical moment when both these things happened at once, and his pioneering book *Telex/Iran* (1983) discovered the form to reveal precisely that double-edged sense of its subject.

For nationalism has shown itself to be just as much a retrograde as a liberationist force, one now drawing world politics in its tide. As the old Soviet and U.S. empires collapse, a nationalist dynamic assumes a fresh importance within their spheres of influence and even within their own borders. Rather than on Third World peripheries, where nationalism has long festered, photojournalists will find themselves drawn to the interior precincts of the one-time superpowers, where the ethnic, linguistic, sexual, and religious conflicts of the nineties will be played out.

As a novelist, Greene chronicled the demise of the British empire and he anticipated the failure of ours, whose rottenness is seconded in more literary detail by Caputo and Stone. The interest of all these writers in images reflects their need to describe experience in the most concrete terms of their own subjectivity. Reciprocally, Nachtwey's and Webb's allusions to Greene and Conrad suggest a need to give a discursive charge to their pictorial work. Photojournalism will undoubtedly give a formulated account of events to come. But only as an art that is simultaneously a passionate act of witness will it do these events proper justice, making evident the dissension of subjects not only closer to the viewer's home ground but within all our psyches as well.

Notes

1. Esther Parada, "A Knife, A Camera, A Book of Myths. Thoughts on Cutting and Keeping Images," lecture presented at the Friends of Photography 20th Anniversary Symposium. Carmel, California, May 29–31, 1987.

This essay appeared in *Art in America* (June 1990).

Bad News from Epic Landscapes

N RECENT years, an admonishing view has emerged in an ordinarily bland genre: the photography of nature. One glance at the field tells us that ecological concerns, understandably enough at this historical point, have infiltrated the medium. How can they be expressed effectively? How can they be responded to? What do they tell us about our culture?

As a craft, nature photography is specialized, requiring particular tools. Only a big view camera, for instance, has the range to thrust deep into a landscape, restoring to a picture surface remote detail that a smaller instrument would interpret only as tone. In a grand horizon one expects both texture and tone, or rather texture *within* tone. A large-format print allows a panorama to be backed up by what seems to be an endless reserve of data. This discriminative power is just as well, for the scene is likely to be devoid of a main incident. What we generally have in landscape photography is a kind of micro-nutrition—based on diffuse vegetarian ingredients—that compensates for a lack of psychological narrative and a visual center.

Such a peaceful, almost comatose state of affairs has recently been ruffled by a wave of activism. Pictorially, the chief but also misleading forebear of this would be the French *paysage moralisé*, a landscape genre which, either by reflecting our passions or inducing some philosophical meditation on life, drives home a moral. We do not just contemplate the goodness of the place but find in it an object lesson derived from its pictorial appearance. About Nicolas Poussin's *Et in Arcadia Ego*

(ca. 1640, Louvre, Paris), a famous moralized landscape, the poet Théophile Gautier wrote, "The picture of the Shepherds of Arcady expresses with a naive melancholy the brevity of life and awakens among the young shepherds and the girl who look at the tomb they have found, the forgotten idea of death."[1] Arcadia, the ideal of the pastoral tradition, here represents that strangely lovely moment when figures in a landscape uncover evidence of an ancient happiness and a witness to our mortal destiny. Gautier could call this a "naive" melancholy because he lived in the already stressed-out, coal-blackened nineteenth century.

In a postpastoral version of that melancholy, the picture of nature today may testify to the damage men have done to their environment, a damage possibly so extreme as to hasten human and animal fate. With both the earlier moralizing tradition and the current instance of it, landscape is conceived as an artifact of culture. But unlike its predecessor, the present culture leaves new traces of disorder and anomaly within the old landscape construct. We glimpse a prelude to a future that once was inconceivable but now may not even be remote: the irrevocable extinction of certain living things. The pastoral tradition had been expressive in its awareness of the natural cycle in which death and birth replace each other. Now, instead of discovering the ephemerality of sensate life in an enduring scene of beauty, the viewer must face the fragility of the scene itself—a tableau of repulsive contingencies that do not strike us as either culture or nature.

This ambiguity, though it has quite a literary and pictorial background, is the product of something we are just beginning to recognize. Artists have always liked to depict fringes, blurred borders, and vague terrains. They may have thought of them as truly mysterious regions or unregarded banalities, but in either case the prevalence of such scenes impresses them now. In some of today's landscape photography, dubious surroundings reflect a kind of unthoughtful contemporary experience. Everything runs into everything else in a manner that exhausts anyone's power of discerning cause and effect. Put differently, a sifting occurs whereby territories come to seem palpably other than—often subtly the opposite of—what they had been. Without being to any human advantage (though activated by humans), phenomena migrate to the wrong place, as do toxic gases that escape

into the air. Observing such unlikely fusions, we perceive what in information theory would be called noise and what in common terms is spoken of as dirt.

"Wrongness" on this level is obviously a relative measure. It implies a contrast to what organisms want or where they need to be to maintain the conditions, systems, and functions of life. The contrast summons up what we fear: interference to patterns of natural replenishment. Here, "wrongness" is a more difficult notion to understand than, say, *incongruity*—things going inappropriately together—a state of affairs that often describes heterogeneous arrangements, natural or cultural. Surrealism has given us a taste for some of these phenomena, which can offer surprise and therefore new information. But generally speaking, the incongruous has no fatality about it. We are accustomed to the depiction of American townscapes or rural scenes with mildly clashing features. But we do not think of them as "wrong" in the same way that symptoms indicate something is wrong to doctors. This symptomatology has become a subject of some recent American landscape photographs.

In theory, one way to observe that subject is via aerial camera or one traveling in space. Recent NASA photography of one of Neptune's moons revealed inexplicable markings that have nonplussed science. These phenomena may have originated in events that were singular or even abnormal but were hardly unnatural. On earth, categories that define natural or unnatural exist for us as products of our own culture. Even so, at some altitude, it is still often difficult to separate human-made from natural conditions in the biosphere. For example, after many years of photographing the earth from planes, Swiss scientist Georg Gerster published the results in a book called *Grand Design* (1976). He was able to show a phenomenon like red tide in a Japanese bay without attributing it to human interference, as was obvious in his images of aluminum poisoning of Australian trees or oil and tar residues along the Ivory Coast. While the view from above certainly revealed a very dynamic and fragile ecosystem, it did not deflect Gerster from stating that "man's dilemma—to change nature or adapt himself to it—is insoluble. . . . It is Man's earth. . . . The right of codetermination for wild animals? Partnership with all creatures? . . . Fashionable models all, but foolish ones."[2]

Gerster did not then question our priority as a species, but our

understanding now begins to suggest that partnership with animals is an enlightened rather than a foolish idea. Yet one would be hard-pressed to read this just from the perspective of aerial photography, for the wrong spots, when they exist and are interpretable, are also coded by distance. Either specialized knowledge or explanatory texts are needed to disclose such a pathology, like that possessed by a doctor incriminating an otherwise nondescript white area in an X-ray.

A young photographer, David Taverner Hanson, has brought to his aerial photography a decidedly clinical tone that depends on a kind of color coding. He has flown repeatedly over the Montana Power plant at Colstrip and has picked out alien presences there: chemical deposits left from operations and mine tailings that show up as strident dyes draining into sandy, torn ground. Though these acidic hues immediately tell us that something is amiss, they are in themselves no more than splotches in an abstract topography, reminiscent of illustrations in fractal geometrics. We have to appreciate the sensory impression as an outcome of processes reported in the mineralogical analyses with which Hanson sometimes accompanies his pictures. Their moralizing is inevitably ex post facto. These delicately or weirdly colored photographs may have an impact, but it is delayed and finally dissociated from its cause. Such imagery works as an act of certain witness, at a remove that disconnects us from the actual hazards it describes, even as it uniquely situates them. The greater the visual perspective, the more it requires a narrative—for example, the history of a company's failure to observe safety regulations—to account for the jumbled photographic spectacle. In the end, narrative tells the main story, of which the pictures are but an elegant, puzzlelike confirmation.

On the ground, the photographer may face or actually choose the problem of being too close to the wrongness of an environment and therefore resist a narrative reading. It seems unlikely that the internationally known Lewis Baltz conducted himself that way except in long-term recoil against the prevailing sentimental or heroic genres of landscape. His two large projects along these lines are *Park City*, showing a Nevada ski resort in a stage of slipshod construction (1978–79), and *Candlestick Point*, the quintessential semiurban, indeterminate, trashed, American open ground near San Francisco (1988). Though his landscape is more tractable and the abuse of it by no means as grave as Hanson's, Baltz proves to be the more pessimistic artist. The

topographical view, after all, is an attempt to map and therefore delineate earth features within a span of time and space. Topography's depiction is a pragmatic enterprise designed to inform us of differentials on our ground surface. But Baltz's precise closeups—even his horizons—are dis-informing, not only because they are nondescript but because they evince no interest in distinguishing one spiritless view, or nonview, from another. Except to notice their interchangeability, Baltz is pictorially indifferent to the events that created the dishevelment that seems to obsess him in a low-grade way, just as a virus drags on in an organism.

Baltz makes redundancy a principle in his photographic campaigns. Tumbleweeds, crabgrass, rusted automobile parts, snap-top beer cans, the impressions left by tracked vehicles: these proliferate in images that cover the same polemical point over and over again. His camera can never drink in enough unsightly chaff, never slake a thirst for debris and rubble. This omnivorous gaze—monotonous and impassive in its spread and reiterated in serial clusters of black-and-white photographs always printed the same size—seems entirely disproportionate to the interest of its subject. In the thirties, Farm Security Administration photographs sometimes depicted automobile graveyards in rural areas; in the sixties a whole school of photographers fancied urban bushes. Baltz's program, mingling nature and culture, is different. It lacks elegy, and however deliberate, it is devoid of formalism, for he collects his dismal frames as if to show a world, perhaps *the* world, unrelieved of our forgetfulness. The sole way to drive home that prospect—of an environment consisting only of dirt—is to exclude from the visual field anything that is finished and cared for, or untouched by humans.

He leaves us to feel that this work is less worthy of being looked at than necessary to contemplate. Here are bad pictures invested with a strange psychological interest. Like ecologically minded photographers, he lets the implications sink in; unlike them, he does not suggest the value of preserving any land nor does he urge reformation of our ways. If he had any moral hopefulness, he'd have to show his denatured bits as blemish or wound and therefore as still exceptional zones that can be brought back to a state that accommodates us. In short, he'd have to convey a notion of the attractive, or at least what constitutes environmental health. It is the absence of any sign attractive

Lewis Baltz, *Between West Sidewinder Drive and State Highway 248 looking southwest,* #6 from "Park City." Courtesy Galerie Michele Chomette, Paris.

to us as social animals within an ordinary landscape of our own negligent making that distinguishes Baltz's art and gives it a terrible neutrality.

By "terrible" I mean the feeling imparted to relatively accessible vistas of a kind of ground zero, where everything resembles a mockup. Baltz shows sharply etched and summarily fabricated presences, such as unfinished condominiums, as if they were awaiting some unspeakable test. Not enough ecological hope lies in any of this material for us to interpret it as a depiction of earthly casualty or misfortune. To the contrary, the blightedness out there (which he seems to have internalized) is a given, something that preceded the photographer and will long succeed him.

On the other hand, to viewers of politically accented landscape, attraction is a very convoluted issue. Strictly speaking, whether the land seems comely or not is secondary to whether it needs to be detoxified. A conservational urgency must precede and often marginalizes an esthetic response (otherwise social priorities would be undermined by the vagaries of taste). Still, if we do not experience some

keen loss of pleasure in the wastage of the region, we are less motivated to urge measures to reclaim it. We transfer our sensitivity to injured flesh to our sense of a damaged land, provided the damage can be made evident. In these matters, the empathetic consideration is more powerful than the chemical, but less relevant to political change.

Still, merely to single out affecting landscape does not generate a very searching case for its preservation. Despite the Sierra Club's popular use of such images, which makes us want to hold on to things, gorgeous scenes hardly illumine the real jeopardy to the environment. As for Edenic nature, whether in calendar or ad, it purveys a strong cliché content, cloying rather than seductive. Far from apprising us of the dilemma of pollution, the tourist or consumer propaganda that utilizes such images tends to exploit and worsen it. Landscape photographers who want to make a statement about the deadening of the environment find that their own medium puts them into a quandary. They must steel themselves against ingratiation while somehow affirming the value of their abused subject.

In strictly *documentary* imagery, this quandary is beside the point. The act of bearing witness justifies itself quite simply as it points out such evidence as the oil-smeared wings of an egret or the balding effects of acid rain in the Black Forest. We need such witness as a palpable indictment of accident or malpractice. Nevertheless, as soon as it localizes examples of wrongness, documentary is exhausted of further meaning. It does not satisfy those who, in addition to their search for a record, look for the sounding of an attitude.

In contrast, there is a kind of picture that alerts us to the ways we ourselves remember, reflect upon, and forecast our changing situation. No matter how often we hear of media documentary as an editorial, even as propaganda, we perceive it as a disembodied product, without any investment of the photographer's individual consciousness. Of course the image doesn't need that consciousness to make an impact upon viewers, as might the impersonal depiction of a crime that seems to implicate us all. The sight of it may or may not spur us to action, but it does not raise in us any awareness of how we ourselves process evidence. All photographs mediate reality, but instead of displaying a corporate perspective or ideological dogma external to our beings, some of them—the ones considered here—extend to us an individual regard similar to our own.

When the subject is nature, the regard tends to be solitary. Landscape seems to call upon us to be intimate with ourselves, as if to awaken in us pleasures, memories, or hopes that are not yet acculturated. The meaning of landscape is arguably bound up with an appeal to the illusion that within each of us lies something unshareable and not yet socialized. This is partly because of the ineffability of ungrasped sensation perceived in the far reaches of land under open air and partly because it still pleases North Americans to fantasize about nature not as culture and therefore not as a communal experience. Of course we know very well that the reserve into which we place our ideas of nature is a cultural reserve. But perhaps alone among the developed nations, we can still imagine our actual contact with nature to extend past that reserve, as if there were a frontier we hadn't yet transgressed. One photographer who knowingly works within that conflict between the imagined and the transgressed is Robert Adams.

Off the freeway near Colton, California, Adams climbed an eroded hillock. Fumes, haze, and effluents halate the otherwise graphically silhouetted black-and-white tones of photographs such as this and others he made for his book *Los Angeles Spring.* While the effects are redundant, the compositions are individually realized, each of them variants in an expanding poetic search. What Adams achieves is a poetry of depredation. In an era of landscape color, the black and white strikes a memorial note, and a curious mournfulness pervades scenes of an otherwise humdrum brutality. It's not that Adams appears to think tenderly of these undeserving views, but that in capturing them as moments of lonely experience he projects them back into a nineteenth-century landscape tradition and perceives their horizons as seemingly deserted now as they were then. A weariness of view fuses with the freshness of radiant seeing, as if Robert Frank's vision of a fifties America had blended with the imagery of Carleton Watkins's post-Civil War Yosemite. Adams shows withered eucalyptus trees, abandoned orange groves, and bulldozed, broken stretches of earth. Having earned his attention, they stay in mind as naturalized forms, lost to a process symbolized by the road or developers' trails.[3]

In the introduction to *The American Space: Meaning in Nineteenth-Century Landscape Photography,* Adams writes, "Physically much of the land [the West] is almost as empty as it was when Jackson and Timothy O'Sullivan photographed there, but the beauty of the space—the sense

that everything in it is alive and valuable—is gone." Adams considers the nineteenth-century photographers privileged because the clean skies they saw could illustrate the "opening verses of Genesis about light's part in giving form to the void."[4] Their cameras could take their fill of scenes that are now obscured or faded out by an amorphous whiteness against which the reminiscent photographer now has to struggle to describe depth.

In *Los Angeles Spring,* that description and the conventionally nostalgic desire that went with it is foiled, leaving us to judge only unkempt things in the foreground. Deep space is equated with a past we cannot restore. Consequently, these recent images evoke a regret about the wealth of information steamed out in the light. They are comparative pictures. They imaginatively comprehend a span of events in which affection for nature must be misplaced if it is to have any object at all.

On the other hand, it is possible to reposition one's attitude and get enthusiastic over a new though sinister beauty. The ambiguous shallow space of Adams's southern California becomes very declarative in John Pfahl's *Smoke* series, begun in 1988. By using a telephoto lens, Pfahl flattens the billowing, polychromed emissions from factory smokestacks. The subjects are tightly framed and very definitely brought within optical range, but at the cost of disturbing the viewer's intuitively physical relationship to their space. The telephoto's seeming intimacy is undermined by its neutralizing of vantage; we can neither establish the locale nor gauge the actual depth of the sighting. Quite aside from being the only way Pfahl could have depicted such a noxious phenomenon without choking, he clearly uses his telephoto lens to invite us in, suspend us in some unmoored place, and then disquiet us, over and over, by a study of atmosphere ecstatically befouled. During his long career, he has kept us aware of the surface of the image at the expense of its illusive depth (by disposing lines within the scene that read as two-dimensional geometric figures on the picture plane), and he has refused to ground the viewer's perspective by any kind of introductory ledge. Everything that appears in his work is perceived as if from an indefinite mental space of our own. Yet, in the end, the spectacle of the roseate benzene cloud, visualized in the melted colors of a kind of pastoral sublime, overwhelms our understanding of its evil. This work is too deliberately ingratiating to be

Robert Adams, *La Loma Hills, Colton, California*, 1983. Courtesy Robert Adams.

critical, even if a critical comment—a record of dirty clouds—defines its reason for being.

Perhaps the flaw in such a project as the *Smoke* series is its need to avoid a condemnation of the obvious. Despite having been enveloped once in benzene vapor, all the photographer has to say—all his irony will allow him to say—about such miasmas is that they're beautiful. We, the victims of such stupendous pollution, are reduced to applauding his artfulness in depicting it! Further, these clouds momentarily take heroic shapes; they belong to a stereotypical genre that celebrates the productivity of factories. Who could be blamed for imagining that Pfahl approved of it? At this particular historical moment the *Smoke* series could only be conceived in the United States, when, the general standard of living just beginning to show signs of decline, ecological

Robert Adams, *On Signal Hill overlooking Long Beach, California*, 1983. Courtesy Robert Adams.

consciousness is afoot yet significant environmental measures are defeated. Pfahl's blend of luxuriant estheticism and alienated space has never proved so hollow as when it handles real debasement of the environment.

Yet it was never easy to visualize that danger. Photographers have had an aerial/abstract go at it; they have also adopted an affectless nihilism toward it. Some of them have waxed nostalgic or have been perversely engaging about our common peril. We grant them their expressive resonance. Just the same, at each turn they depended too much on their viewers to contribute their own moral earnestness to the scenography. The diffuse appearances of the terrain—whatever the state in which they were found—do not of themselves strike us with any urgency. We have been schooled to *contemplate* a pictured landscape far more than to protest loudly in common cause to rescue the screwed-

up territory it may show. We feel that landscape is "there" for us, and if for any reason we are given country that puts us off, we turn elsewhere. Arcadia, even a sad Arcadia, was inviting. But how are we to be aroused by a spectacle we reject: an American wilderness we ourselves have done in?

That kind of panorama in the West has been addressed by Richard Misrach with increasing vividness throughout the 1980s. To begin, he offers a totally convincing sense of place—the Mohave, the California inlands, the Nevada deserts, over which he has roamed repeatedly. His moment of perception is always the present, gritted in by sandy ochres and limned by sage green, mauve, and blond hues often merging into an exquisite bleached depth, though sometimes reddened by dusk or fires. Misrach lives such moments to their sensory brim without standing on any ceremony. He gives us the feeling that what happens out there in the nominal wild happens for him and to him quite in advance of being filtered through any memory of art.

Other photographers have just as keenly possessed the land through their pictures, disclosing refuges we thought were scarce. There is something enterprising, even sporting, and yet a little sad about their project, for they bring back appetizing views as if they were trophies. Misrach works the flip side of this mode: he camps out in what passes for the remote desert only to show our unexpected hand in it everywhere. He's a specialist in transmitting drab, and finally bad, news from epic landscapes.

In 1983, as twilight gathered at Lake Havasu City, Arizona, Misrach evoked the distant twin arches of McDonald's as a precious beacon in the desert. This was a sensuous epilogue to work done in the 1970s by a group of photographers that included Robert Adams, Lewis Baltz, Joe Deal, and Frank Gohlke, who showed the West as a Pop landscape in an important exhibition called "The New Topographics." Their theme, suburban development as an unexpected vernacular, disgruntled a number of viewers who were put off by the works' cool, noncommittal style. Actually, matters would not have been improved had the photographers been judgmental, for it was their very choice of such material that provoked. How eye-worthy were the ranch-style houses at the end of a new road, with their lonely tree sprigs, or the mobile-home parks and RV camps, satellite towns at some dry outskirt? Here art reckoned with the decentering caused by a shift in

population to the Sunbelt. Arrangements for those middle-class folk who were passing through or who had retired had a provisional look about them—and that look was captured by the New Topographics. But the photographers concentrated so much on an atrophy of community that they didn't deal with its consequences to the land. Now, in every case their work has darkened in mood as it has explored that land. In Misrach's book *Desert Cantos,* that mood has come to flower.[5]

From the first, one gleans Misrach's intense interest in the desert as, of all things, a social phenomenon. His romanticism may have initially brought him there, but his realism takes over at the actual site. He writes, "One only needs to stand outside a 7–11 at Indio with a cherry slurpy, or dangle one's legs in a Palm Springs pool in the 105° early morning sun to know what is desert."[6] As the title *Desert Cantos* suggests, however, he transmits his realism back into a poetic framework that has Dante-esque overtones. Each of the cantos, his photographic chapters, develops a topic: *The Highway, The Inhabitants, Survival, The Event, The Flood,* and so on. Drawn in by the rocky forms and velvety tones, our normal attachments to things as they are near and distant tend to be reversed. Tiny remnants left by passersby or abandoned works are scattered everywhere and nowhere within awesome perspectives. The boxcars of a long Santa Fe freight train are reduced to lapidary points of scarlet and gray way off in a plain of olive scrub. In one canto, *The Event,* the same endless horizon suddenly takes on a narrative interest, for it tells of the arrival of the space shuttle at Edwards Air Force Base and of the people, colored silhouettes on a blinding flat, who are awaiting it. The future—a dot in the sky—is about to descend into this immemorial place. Or is it the Second Coming these cowhands, army personnel, and sightseers are about to witness? Biblical parallels are certainly a part of Misrach's overview of his desert campaign. His notion of *The Flood* is filled out by the Salton Sea, an utterly still body of water that has inundated telephone poles and swamped a gas station and a kiddy slide. Such limpid scenes have an eerie, unforced beauty that whispers to us of retribution. And he concludes with *The Fires,* vegetation burnoffs, often uncontrolled in their sweep, which he photographed at such close range as to almost make us feel their scorch.

For all their ominousness, however, these crackling vistas are not yet infernal, as are a later group Misrach calls *The Pit,* and his latest

book, the even quieter *Bravo 20: The Bombing of the American West.*[7] The Pit acts as a dirge to thousands of livestock that died of unexplained or unexamined causes and were thrown into remote Nevada dumps. Their hooves and hides protrude from the silt like so much refuse. The burnoffs provided a startling new subject for Misrach's photography; his dead animal pictures amount to a scathing political exposure. Yet both subjects are treated with a caressive regard that is eloquently incongruous. A tension is set up between the magnitude of the description, the physical presence of large prints, and the dread of their subjects—disgorged, as it seems, into our own space, from which we are not meant to escape. Hitherto, his attitude toward the desert was one of almost anthropological curiosity, and we were cast as wayfarers there with our guide, who saw with real opulence. Presently, he maintains his vision and takes us into a holocaust.

Misrach was not the first to discover the devastation wrought at Bravo 20, the United States Navy's bombing range in Nevada, nor the first to learn that it had all been illegal for more than twenty years. The worst kinds of violence had been committed there, to the deafening accompaniment of supersonic jets. He happened upon the place in his travels, joined the activists who had come in to resist the military, and made his reflective pictures of the scenery. They show a cratered landscape, barren of all but the most stubborn plant life, yet littered with thousands of bombs and shells. These photographs inadvertently recall Roger Fenton's pictures over a 140 years ago of the Crimean battlefields, strewn with cannonballs that resemble the feces of some obscene metal bird. But Bravo 20's ready-made quality as a moralized landscape lies in the fact that it is not a battlefield but a practice zone. Misrach has no trouble in revealing how a macho culture has literally vomited all over the very same environment that in yesteryear it had held up as the territory of its heroic aggressions. Because they show the results of the United States military purposefully at work rather than just one of its accidental by-products, Bravo 20's wastes are even more demonstrative than those pitiable animals brought down by chemical or radioactive taint.

The economy of the tacky developments out in the western drylands—the dreck—is deeply entwined with our militarism. The people of Fallon, Nevada, though terrorized by the noise, were loath to protest the armed forces' usurpation of their nearby ground because it brought

revenue into their town. It seems as if we have extreme difficulty either in adapting ourselves to nature or protecting it from us. In speculating along these lines, Misrach has never argued for anything so radical as removing people from the land. But he has proposed that Bravo 20 be turned into a national park as the country's first environmental memorial. Sightseeing routes within it would be called "Devastation Drive" and "Boardwalk of the Bombs"—apt names for a horizon that deserves to be considered prodigiously wrong.

Notes

1. Théophile Gautier, *Guide to the Louvre,* quoted in Frank Jewett Mather, Jr., *Western European Painting of the Renaissance* (New York: Tudor, 1948), p. 746.

2. Georg Gerster, *Grand Design* (London: Paddington Press, 1976), pp. 17–18.

3. *Los Angeles Spring: Photographs by Robert Adams* (New York: Aperture Foundation, 1986).

4. *The American Space: Meaning in Nineteenth-Century Landscape Photography,* with introduction by Robert Adams (Middletown, Conn.: Wesleyan University Press, 1983), p. 3.

5. Richard Misrach, *Desert Cantos* (Albuquerque: University of New Mexico Press, 1987).

6. Ibid., p. 96.

7. Richard Misrach, *Bravo 20: The Bombing of the American West* (Baltimore: Johns Hopkins University Press, 1990).

This essay appeared in *American Art* 5, nos. 1–2 (Winter/Spring 1991).

Anselm Kiefer's Books

Glum sky: my mind masquerading as the firmament.
E. M. CIORAN

ANY WRITERS on Anselm Kiefer's art speak of its melancholy tone but fail to notice its depressive spirit. A distinction exists between a judgment, or at least a sense, that the world is sad and the involuntarily dejected state of mind in which his art seems to be grounded. To be sure, a sorrowful attitude and an abused feeling may be compatible with each other, but they are not necessarily convergent. The chronic depressive either feels threatened or suffers from an awareness of lowered possibilities, an inner dwindling of potential and resource. Gripped by the malaise, his personality may be inconsolable, though not so much in grief as frustration. In artistic terms, such a note of incapacity, of being hemmed-in or deprived, is often expressed by a pervasive grayness. Images are de-colorized, made wan, morose, and null, as if their very complexion has been sucked out of them. Though his art is invested to its very marrow with this mood, Kiefer also reacts against it by spritzing the surface of his paintings with the dirt and sediment of the earth itself, combined with exclamatory strokes and sibylline messages. Some depressives are apathetic; this one is robust, learned, quite often refined, and grandiose.

His luxuriously extended metaphors of detachment and panorama, fertilized by various myths, barely conceal a uniform, downbeat self-involvement. Yet Kiefer's ideal moment of perception is always retrospective, as if to escape the vacuity of our present, which has no character except in the shadow of a terrible and sublime past. At the same time, his art is his way of working himself out of despondency

to the happiness of involvement with palpable matter. Depressive visions, like those of Gerhard Richter and the Bechers, with their endless photographic categories of obsolete or dead tech, often adopt the guise of Minimalists, but Kiefer has an Expressionist sensibility. The former, who only allot a single subject to each frame, proceed from one immobilized point to another, while the attention of the latter hardly seems to rest in multilayered subjects. Still, they all have in common their monochrome proclivities, their fixation on the bruteness of materials, and their accent of disenchantment.

They had come of age in a divided country, where World War II defeat and prostration occurred before their time, yet obviously lingered as a kind of psychic wound in the national consciousness. So much had the West German economy recovered that it led the increasingly affluent European community. But the material wealth and consumerist life overlay a disquiet that was probed by German artists at the same time as they often fell victim to it. Their cultural burden, of the utmost ferociousness, was not yet—and perhaps never could be—resolved in moral memory. Who knew to what extent the historic evil of Nazi times could be regenerated in those around them and in themselves? By contrast, in the United States, the most enterprising artists found their central mythology in the popular media, whose transmissions offered commanding themes in a huckster's paradise. What America meant to our artists, what it stood for, was bound up in the seductive absurdities of our commercial culture. Some of this was derisively reflected in Sigmar Polke's short-lived "Capitalist Realism." But it was only during the last half of the Cold War, when the Germans turned inward, searching for their true identity, that they sickened interestingly. Kiefer, born in 1945, was among those who lingered intermittently in the historical memory of the Third Reich. His mentor Joseph Beuys had actually been through it all, as a fighter pilot in World War II, and the gray felts used in the installations and performances of this messianic figure were meant to recall the material with which sympathetic Ukrainian peasants had once wrapped his body, first greased with fat, to save him from the cold.

Kiefer, the painter, is neither as avant-garde nor as humanist as the older artist. Expressionists usually internalize a will to power, but Kiefer distances himself at the same time as he conceptually associates

with it. His world is one in which the exercise of power has ceased to be an active process, but is at least recalled in the ruins of what had once been its symbols. The protagonist of the Expressionist pictorial theater is the agonized self, opened out in a kind of endless, exasperated "now." Instead of protagonists, there are only such things as a frivolous palette or ominous leaden wings, hovering in Kiefer's stages, burnt-out halls, or trampled fields. With him, the theme of spiritual vanity is linked with a dreary emptiness of the land, a spectacle from which the artist, himself, is absent. His brushstrokes do not afflict phenomena with the painter's supposed emotion, but seem to batter his architectural subjects and forest scenes, to show how they've weathered frightfully in some temporal dimension outside of linear time. Whenever the subject involves deities, such as Osiris and Isis, this treatment ennobles rather than debases. Here is a chill Expressionism, in which a pessimistic consciousness acts upon its themes with increasing sympathy.

What's surprising is the job Kiefer assigns to photography in this painterly scheme of things. There can be no doubt that he identifies himself as a painter, as well as no question that photography plays a core role in his art, and has done so since his beginnings in 1968–69. Other painters have moonlighted with the camera medium or relied on it heavily; Kiefer makes it indispensable to how he sees. We come across photographs most often in his idiosyncratic, almost uneventful, unbelievably heavy books where they're featured on almost every page, as if to make wordless novels or false diaries. Two recent publications allow us to survey this output in detail: *Anselm Kiefer: The High Priestess,* with an essay by Arman Zweite (New York, Harry N. Abrams, 1989), and *The Books of Anselm Kiefer,* edited by Gotz Adriani (New York, George A. Braziller, 1991).

Sometimes Kiefer's book images masquerade as documentation in albums or archives. Certainly many of his paintings started as photographs, later slathered over with translucent acrylic washes and silt. The ubiquity of photographic images in his art looks at first anomalous, because their slightness contrasts too much with heavy substance, and, above all, because their historical record seems to be at odds with his visionary program. But Kiefer sees to it that photographs articulate his concerns the more he puts them under external stress. Nothing is more obvious than the difference between a pictorial system that de-

Anselm Kiefer, *Zweimstromland,* 1969, from *The High Priestess.* Courtesy Harry N. Abrams, Inc., New York.

scribes through the tracing of light and one that evokes through the mark of paint, in a field adulterated by clods of earth. While this difference is certainly emphasized in the flat and rough surface qualities of the two media, it is more importantly obscured by the ashen or chancred tonality they are both made to share . . . and the analogical work they perform together. For Kiefer suggests an almost elemental continuum in which his varied imaginings take place.

He's sensitive to their mineral substrata, so that the deposits of silver in the matte photos and the unreflective surfaces of crumpled lead pages appear to be cognates. Quartz, calcium, salt, and carbon seem to exchange their attributes in art often preoccupied with kabbalistic or alchemical mystagogy. He reminds us that depiction only realizes itself through the materials of the earth, sometimes influenced by the gases of the sky. It would also appear that the damages of fire and water have had their way with the human artifact, abandoned to ordinary neglect and the indifferent patina of nature. Vertical, milky rivulets, for example, blemish Kiefer's photographs, as if they were

Anselm Kiefer, *Exodus*, 1984, lead shellac on charred photographic paper on board (27¹/₂ × 39¹/₂ in.). Courtesy Marian Goodman Gallery, New York.

the residue of inadvertent light leaks or chemical spills. And the artist pretends that he is unaccountable for such variant effects, that there is little or nothing he can do to prevent an overall slow ferment of his work. As the pages of the book called *Lilith's Daughter* (1990) are turned, some powder inevitably falls from their loose crusts.

For that matter, his interest in the instabilities of chemical development anticipates the fading of the photographic image. He revels in the wrinkling of paper mounts and sloppy fixing, along with wrong duration and strength of toning—"mistakes" that guarantee the impermanence of his results. The images will oxidize and the metals corrode into a beautiful mulch. An artist who deals with such process would ordinarily be working with a romantic overview, but here the activity is literal, the intent self-destructive, and the attitude passive. The mechanical, impersonal rendering of the photograph is likened to the fortuitous, surface accretions of natural forces that overwhelm touch—the executive touch of the artist. So, instead of contemplating phenomena, he would give us to understand that his art has been

eroded by influences occurring on indefinable schedules beyond his control.

We are familiar with found objects; these are lost images. They're treated as remnants of culture, abandoned in some ancient and unconscious moment. When we encounter dolls' dresses or strands of hair pressed into the unleavened pages, they appear as lifeless survivors of a bygone age, and therefore as pathetic specimens. The same goes for the photographs, except that when they peek out from beneath the schmutz, they have value as witness of an even more archaic rubble, a remote industrial order that has come to grief. Quarries, water-filled bathtubs, abandoned brickworks, pebbled graves of railroad tracks, the artist's own studio: these are the apparently wintry subjects in Kiefer's catalogue of ruins. Each is configured through an ache of solitude natural to him, toned with a grudging light and a singular pallor.

Among other things, the photographs' debilitated optical qualities mandate their collectible status. For Kiefer assumes the role of the collector, in love with chaff that he folds endlessly in books that conclude, if they do at all, with only a darker, more overgrown and rank version of their opening. Some collectors are motivated more by an idea of inventory than an exclusiveness of material. True to that spirit, Kiefer's books are additive and indiscriminate in their sampling. There is no more principle of local selection in them than there is a power of organization in individual pages. Drifting throughout is a certain atmosphere of alienation, which he prizes. Too symbolic to be narrative in any sequence, too casual to be aligned in any series, the books compile textures that are interchangeable and formless.

Just the same, the photographs provide specific interior points of view, more effective for being marooned in the surrounding chaos. Kiefer favors a look down upon something, but not from so high that it affords a perspective. In this, he has precedents in some of the horizonless Bauhaus photographs, just as his encyclopedia of loneliness recalls Atget. The artist seems to have visualized for our own era Walter Benjamin's hunch that Atget's streets are scenes from a crime. Unpredictable areas of focus keep the pictorial field alive, as if the eye, as it browses, must be conscious of the momentariness and anxieties of its gaze. The smooth, recessive surface is there, but seems to create new roughage and disordered grittiness in the mind. With their

Anselm Kiefer, *Zweimstromland,* 1989, from *The High Priestess.* Courtesy Harry N. Abrams, Inc., New York.

scarce patches of detail, realized throughout by a kind of lunar tonality, these photographs nourish a feeling of real oppression. One is intimately sequestered within this netherworld that has gone to seed. At the same time, though it is a dismal place, it is also a fabricated one, refreshing in its contrast with the chaotic, insensate environment that surrounds it.

No photographer has been as emphatic as Kiefer in "humiliating" his pictures; in fact, he's at some extreme edge in showing his disrespect for them as objects. Yet he displays an intrinsically photographic understanding of what the camera, and darkroom processing, can do—in unruly circumstances. His most exquisite effects stem from this dualistic view. In one of the more than 200 lead books now placed on the shelves of *The High Priestess/Zweistromland* (1985–), a shot of fluffy clouds, a mile beneath the vantage, is mounted on treated lead that has been amorphously stained. The viewer is struck by the suavity with which the transcription of the far and the presence of the near are likened to each other. Though it's a humble means, which must

compensate for the indifference of Kieter's drawing, photography furthers his cause because of its tendency to equivocate. It's not just that he gravitates toward neurotic space, he also cultivates the narrative misdirections that can be brought off by photographs.

So, Kiefer is quite capable of retracting what he evidently asserts, as when, in *Operation Sea Lion* (1975), he starts with shots of waters labeled Dunkerque, Ostend, etc., and then shows a model of a warship on a bathtub sea. The artist designs his scenario—nominally Hitler's plan to invade England—to suggest that its subject is inconsequential and toylike. But if he intended to sass a megalomaniac history, his humorless temper and elegiac mood suggest almost the exact opposite. Kiefer is said to admire Albrecht Altdorfer's *Alexanderschlact* (1529), depicting a battle whose combatants are reduced to antlike size. Instead of following a Mannerist vision in which the force of arms is made to look puny when compared with the grandeur of nature, *Operation Sea Lion* pits farce against pathos, with no coherent result.

By now, it should be clear that Kiefer is hostage to his funerary tone. Whether the so-called subjects are actually evoked through his dirgelike accent is almost fortuitous, for regardless of story, it is his only note, and it is constantly sounded. Kiefer's atmospherics carry everything before them, and no legend or title deflects the content of his work from his already determined, mournful emotional outlook. Sometimes, in fact, theme and motif are wrenchingly at odds with that outlook. Rejobbed into a painting called *The Red Sea,* the Sea Lion bathtub, even though filled with blood, fails to express the biblical wrath of the narrative, and even more, denigrates what was apparently meant to be terrible. When he depicts the Byzantine *Iconoclastic Controversy* as a combat between German World War II model tanks, fighting over a clay palette, he does not seem to be aware that the whole silly performance is out of tune with the dolorous atmosphere. A historical dispute between the party of the word and the party of the image is relevant to his own conflicts, but in practice he always sacrifices the discursive to the figurative, while aspiring to a textual allusion that is almost cosmic. Yet at the same time he trivializes, as if to score against, events or ideas memorialized by his style and blown up to an awesome size. Kiefer's pride in painting, symbolized by the flying palette, and the defeat of the Third Reich: both

these disparate themes are steeped in the piety of his now inappropriate depression.

To gain a better idea of this muddle, consider the French artist Christian Boltanski who has treated the subject of the Holocaust by means of photographs within filelike or archival installations. These bureaucratic shrines, illuminated by clerical lamps, erected to the memories of lost families and nameless children, seem to us tragic in their very circumspection. The genocidal acts of the Nazis are not even whispered of, and yet Boltanski's emphasis on indexical framing as a formal agent confronts us with their magnitude. One comes away from his works charged with the artist's reverence for life.

In comparison, Kiefer's reveries can achieve a certain poignance, but they lack this kind of moral beauty. And this is because his attitude toward power is entirely skewed. His dominant metaphor excludes everything but regret at the passing of power, even when power—frequently—was evil. True authority is out of his reach, which apparently makes him hanker after it all the more. Meanwhile, there is no reserve in his art with which to regard the victims of oppression with any kind of specificity. On the contrary, when the structures of power are eclipsed by the passage of time, his art gives the sense that we are inevitably diminished. In such a context, what is he really trying to say about the defeat of the Roman legions under Varus by Arminius the German, in the Teutoberg forest? Here, an imperialist state was harshly checked by a native tribe and given a foretaste of its eventual demise, an occurrence later marked as a heroic remembrance in German culture, particularly as it grew more nationalist. Kiefer's textual jibes at that Wagnerian culture are hollow, and his conceivable sympathy with Rome—an older kind of Reich—would be simply . . . weird. Much has been written in praise of the political ambiguity of Kiefer's work, even his assumption of guilt for crimes committed before he was born, but in choosing politically explosive subjects he demonstrates that he has no political point of view, only a wish to resonate his art with a shiver of historical violence.

That limited goal accords with Kiefer's depressive psychology. He cloaks it in his art with a guise of terminal weariness, expanded to Leviathan scale. There can be little depth in such a project, regardless of the obscurities that have fed happy erudites. Their literature would

have us believe in a mind of great scope, philosophically gifted. Yet the pretense of it is not fatal to Kiefer's strength, which is a diffident and enduring poetry. It's not so much that his universal archaeology is glib, but rather that it's off key within his own work. He has no ear for history, certainly no moral insight into it, but he possesses an eye capable of making the finest distinctions, whose irrationality is enhanced by their elegance. Not by chance, he is at his best in his books, where he's at his most intimate, most in touch with his private self. The role played by photographs in that intimacy is crucial, since they furnish him with a view of the world outside the self. It is a world cast into silence, a quietude from which he derives—improbably but necessarily—the energy to continue.

This essay appeared in *Print Collector's Newsletter* 23, no. 1 (March–April 1992).

City of Crowds, City of Ruins

But why are people so interested in ruins, unless there is a
need to destroy an aesthetic order which has been dominant heretofore.
Erotic energy aims at exciting cold violence.
So long as this passion exists, ruins will exist all around you.
ARATA ISOZAKI, 1988

O F ALL THE words we have to describe the thing: mob, throng, mass, horde, or swarm, each with its own inflections, the most social is the term *crowd*. After it decisively manifested itself as a revolutionary force, 200 years ago, the crowd in enlarged mercantile cities tended to be perceived as a phenomenon of spectacle. That perception, nowhere more available to a roving eye now than in economically expansionist Japan, was first borne in to many in Western Europe during the nineteenth century. An individual like Baudelaire could stroll the streets of Paris, entertained by the rhythms and manners of the endless passersby. Immersed within them, he nevertheless adopted an outside view, a singular viewpoint, which, since then, has been picked up by speakers in novels and by photographers beyond count. They have transformed the spectacle into an allegory of modern consciousness, equivocal and potentially frightening in its scope. Though huge urban gatherings might look benign, an urgency can suddenly well up in them as to overwhelm a stranger, or make states tremble. I well remember being swept about in a moment like that in July 1982, in Rome's Piazza del Popolo, on a sunny afternoon, unnaturally quiet at one instant, erupting into a frenzy the next.

The Italians had apparently done something cataclysmic: they had won the World Cup soccer championship. If they had landed on the moon or discovered the key to immortality, the mood would not have been more euphoric—but I did not share it. My lot was that of amazed and swallowed up spectator with a camera. Though hardly lonely, I

sensed myself as vastly outnumbered. Pictures of crowds united by one spontaneous emotion tend to have that effect, for their witness is understood to work in a separate psychological zone, necessarily detached from the crowd in order to capture its mood. One gets that feeling from Weegee's crowds at Coney Island and from William Klein's expressionist up-front views of clamor across the world. Whether the spectacle is panoramic or thrust open at close quarters, the photographers are there to observe, not to participate. Their awareness of their isolation can give to their work a characteristic selfconsciousness. So we viewers, whom they represent, are often distanced from the energy of their photographs, as a theater audience is distanced from an onstage actor.

Klein went to Japan and was influential there in the sixties. But his photographs of Japanese crowds differ significantly from those of native photographers. In that country, the components of mass are not implied as separately volatile, nor is the crowd an aggregate of temporary individual impulses. Rather, the Japanese crowd has a life of its own, homogeneous in its will even if bumpy in texture. The pictorial view is likely to be sweeping, decorative, or epic, and the mass of people gives the impression of being internally regulated according to laws of movement, interval, gravity, and surge that shape a given space. Individuals have very little importance in that space, with which the photographers are habituated. A viewer assumes that the image maker is either at one with what is seen, or perhaps just neutral about it, and so there is no outsider consciousness, no dialectic between active and passive roles, theatricalized by the picture as a discovery within pressurized circumstances.

With all that, such pictures can be remarkably fraught. An overhead night shot of a collision between riot police and banner-waving demonstrators, taken by a *Mainichi* newspaper photographer in 1960, highlights the serpentine human-wave tactics with which the two sides press against each other in a sea of bodies. The picture is about ideological containment during a moment when leftist groups united against Prime Minister Nobusuke Kishi's extension of the U.S.-Japan Security Treaty. Since the doings of such groups were given little coverage by the Japanese press, the image's meaning to a general public would have been contingent on the fact that radicals are among the few groups singled out for real punishment in that consensual

Haruo Tomiyama, *Tolerance (Shinjuku Station, Chuo Line)*, 1965.

culture. Their destabilizing element sought leverage within a met-
ropolitan traffic that photographers have repeatedly depicted as diffuse
but heavy, and that crops up in joyless perspectives as an outright
cliché of the Japanese scene. What is Haruo Tomiyama's fish-eye view
(from above) of squished passengers in a car at the Shinjuko Station
(1965) if not a comment (optically distorted) on the hyperdensity of
citizens within insufficient space? He calls this uncomfortable picture
Tolerance, a state coerced by the overtight arrangements under which
people live. Severe physical constraint obviously accounts for highly
concentrated grouping, but more than that, it leads the Japanese eye
to view the crowd not as an agent of history, or as an enjoyable
spectacle, but as a relentless condition of existence.

The sixties were conducive to this kind of subject, but it continues
on in the late seventies/early eighties work of Hiromi Tsuchida, in a
series on crowds called "Counting Grains of Sand." City dwellers on
vacation, in a marathon, or at some public event, micro-units all, are
packed in and unable to maneuver. The theme was absent from the
tepid pictorialism of the years before World War II, but is plentifully

illustrated after it, if the several shows devoted to Japanese photography at Paris's *"Mois de la Photo"* in November 1990, were any evidence. In their historical account, and in other sources as well, one sees the charred rubble of cities, repatriated troops, lines at soup kitchens, and clusters of frowsy street urchins in the aftermath of 1945. Much later, the salarymen, the white-collar masses, flood the place. People work in coordinated teams, they walk down corridors in single file, they even kiss in a kind of chorus. These dye-stamped forms of public behavior are depicted without hint of satire. The sense is given that Japan proliferates even communities of monks, or classes of pregnant mothers, by means of assembly lines. For the photographers emphasize social process as a mechanical conveyance through which standardized units are multiplied. And their pictures manifest a taste for quantification, such that Tsuchida's use of the word *counting* is symptomatic of a widespread pictorial outlook. A shortage of space alone would hardly have produced this sense of ordered repetition. Rather, the photographers want to reveal how people belong or relate to their social environments, and to disclose the interchangeable parts, in any milieu, of which the cultural whole consists: a system that can only be implemented through pronounced communal constraints. Karel van Wolferen writes, "Japanese are treated by their school system and their superiors in the way a landscape gardener treats a hedge; protruding bits of the personality are regularly snipped off."[1]

On no account should this famously productive and overwhelmingly high-tech urban workplace be thought of as the setting for a modern state on the Western model. The controls that photographs make apparent have a history preceding the modern city. And when release from the binding civic order is tolerated, it has an origin that is as ritual as the control is traditional. Consider an electrifying photograph taken by Takahiro Ono, *Naked Festival of Saidaiji Temple, Okayama Prefecture,* 1953 (also attributed to Horace Bristol).

Here is a bursting crowd of men, hundreds by the look of them, naked but for their loincloths, some of whom slip or jump from a balcony in the temple's courtyard onto a mass of their fellows, protecting themselves from the impact of the falling bodies by their outstretched arms. Some of the males, already dropped down, are literally staggering over endless hands or shoulders. The heat must have been intense, the din uproarious, the footing scanty, and who

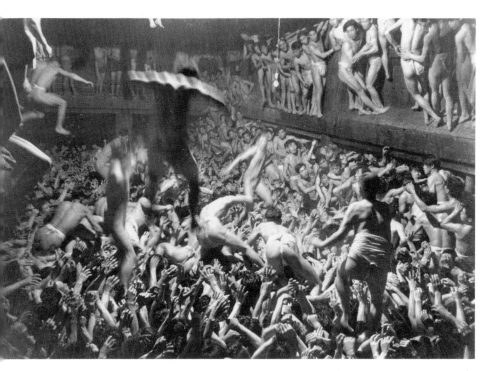

Takahiro Ono, *Naked Festival of Saidaiji Temple, Okayama Prefecture*, 1953. Also attributed to Horace Bristol, *Honshu, Japan*, 1946.

could breathe in that gorged sweatbox? Such is the jam of writhing people that the scene appears deranged beyond measure, implosive. One thinks of our painted Last Judgments, or of an infernal tableau by Bosch, with its nightmare pandemonium. Their compression forces these men into hivelike congress with each other, bone and shank and elbow and buttock jutting or heaving into flesh. At the same time, none of them is physically capable of yielding an inch in the mutual shove to which they all must contribute. A light from a bare bulb shines down into the temple's darkness from above, where dangling feet suggest still another tier of bedeviled figures about to plunge into the human chaos beneath. What is more, the perception of the photographer, the one man madly doing something else—perhaps clandestinely—is as kinetic as the scene itself, since it is caught up by the tumult in which it must have been engulfed.

As they stuffed themselves inward, none of the men respected the limited capacity of their enclosure. Originally they might have been an open and now they are a closed crowd, willfully contained in a

kind of humongous locker room. Yet what looks like a disaster climaxes a deliberate program. In his book *Crowds and Power,* Elias Canetti writes,

> There is nothing that man fears more than the touch of the unknown. He wants to see what is reaching towards him, and to be able to recognize or at least classify it. . . . It is only in a crowd that man can become free of this fear . . . so that he no longer notices who it is that presses against him. . . . Ideally, all are equal there; no distinctions count, not even that of sex. The man pressed against him is the same as himself. . . . This is . . . why a crowd seeks to close in on itself: it wants to rid each individual as completely as possible of the fear of being touched.[2]

If Canetti is on the right track, then the claustrophile reflex of the Japanese men acts as a bonding agent. Though it deindividuates them, the closeness of their quarters also unites them—here, in the most hypertensive way. The dread I feel as a Western observer of this incredible entanglement—which entails a loss of unique identities in a huge collective—is therefore an unwarranted projection upon its meaning for the Japanese. Canetti wrote of crowds in general; to follow his argument, this particular group would epitomize the annihilation of personal territory and of ego as a closure that protects against fear of . . . human difference. Or rather, at this particular moment of extreme intimacy, the homogeneous mass affirms its very freedom from difference.

The photograph depicts an esoteric Buddhist festival of the Shingon sect conducted annually in a village harvest celebration. If it resembles an orgy it also manifests a discipline, close in spirit to rites of initiation. At the same time as such things went on in the country, in the city, by contrast, corporate recruits were taught how to bow 15, 20, or 25 degrees, according to the rank of those they met. From such rigid social boundaries, fixed hierarchies, and formalized behavior there issue outlets into the netherworld of carnival, theater, love hotels, strip joints, hostess bars, porn flicks, and other institutions catering to male eros. Japanese photography has had a field day depicting these pursuits, whose coquettish or violent routines reflect ongoing themes of popular culture.

Ian Buruma speaks of how hard it is to be alone in Japan, of "a general horror of loneliness. . . . The answer seems to be the anonymity

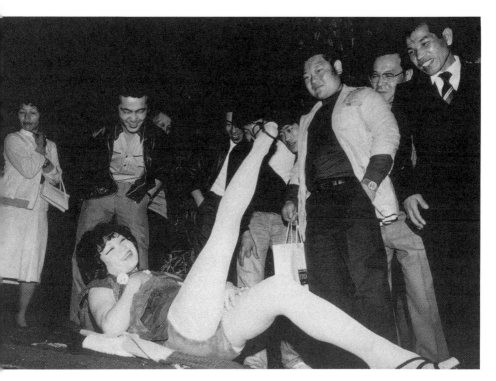

Masatoshi Naito, *Slightly drunken gay*, 1981.

of the crowd. People are soothed by being with others without having actually to communicate with them: hence the thousands of expressionless faces. . . . Hence, also, the fantasy of the anonymous rapist."[3] Occasional photographs—Shoji Ueda's small boy jumping on a dune, of 1948, or a beetlelike man in a swimming pool by Kikuji Kawada, from 1978—characterize unwanted openness of space around a figure as a kind of limbo. But there is another, more frequent loner, a woman loner in a male crowd. She appears before us as the object of the men's gaze, often as a nude modeling for their cameras, or as a stripper. The photographers of these pictures delight in the contrast between the one and the many, and clearly their interest in the woman's exhibition or plight is added to that of their subjects. Often the vantage is near the woman but not associated with her, so as to make the group's behavior and the odd one out a joint spectacle for the viewer. As if to sum up the whole period, the photograph chosen for the cover of the mammoth history of modern Japanese photography from 1945 to 1970 produced by the Japanese photographers' association, the Nichon

Shashinka Kyokai, and published by Heibonsha in 1977, is a street scene by Haruo Tomiyama that belongs to this type. One can easily cite other, raunchy examples of it by well-known photographers such as Shomei Tomatsu, Masatoshi Naito, and Moriyama Daido. In their work, indisputably, the men subjects are in the presence of difference, which fascinates them and which they deride.

Outside Japan, comparable vignettes have been made of the single female amidst leering males. But what those pictures and their Japanese counterparts say of their respective cultural milieux is different. For one thing, in Rome—I'm thinking of Ruth Orkin's famous 1955 picture of the American girl there—the passage of the woman created a ripple of macho, unself-conscious interest. A Japanese photographer like Naito makes something far more sordid of the theme, where the woman—or, possibly in this case, a female impersonator—is certainly on show for the drunken men who have gathered around, in a nervous, laughing twitter illumined by the camera's flash. The American girl was estranged from the male culture into which she had wandered. The smiling Japanese would more likely have been estranged—if at all—as an actor from an audience. So we reckon with transient qualities of solitude, one imposed, one invited—one that invokes sympathy and the other that the photographer seems to disdain. Naito's picture is lively enough, and cold. It belongs in a context where women are popularly typecast into two roles: whore or mother. In neither guise is there ever demonstrated any concern for the possibility of their sadness or vulnerability. The whore is a cast-off personage. As for the mother, Buruma reports on a remarkable husband-and-wife show on television in which runaway wives are publicly "bullied into resuming [their] miserable existence in the home."[4]

Speaking of other media, Jared Taylor writes, "Whether or not Japan is a primarily visual culture, as some Japanese argue, sex comic plots and other pornography often suggest seeing rather than doing. Even more explicit are voyeurs' handbooks that describe the best techniques for spying on women and photographing them unawares."[5] These remarks imply that Japanese society, unlike ours, is in the end more self-repressive than licentious, despite the gruesomeness and cruelty of much of its popular media. The more those media pander to a visual appetite for the erotically sensational, on a pervasive scale, impossible to ignore, the more they imply that the crowd is well

stocked with men for whom seeing compensates for doing. In nude photography sessions, their voyeurism operates in concert . . . and just as the Japanese habit of touring foreign countries in close-knit groups, the better to carry their ethos with them in unfamiliar territory, is often noted, so here they conduct conspicuous group tours of the female body. The act of seeing is institutionalized, so that the private thoroughly penetrates the public sphere—and the boundaries between the two become confused. An emphasis on seeing can't help but stress a consciousness of the distance between the object and the subject. This distance can be traversed only by a gaze, even as it stimulates the appetite of touch. Certainly the more expressive Japanese photographers have been involved with this appetite, and have inevitably gravitated toward scenes of sanctioned or hired touching, i.e., debauchery where the pictures are.

But the unspontaneous debauchery they give us has something forced about it. When it was not outright staged, this effect may be due to lurid graphic contrasts, compositional imbalances, and caricatured faces—in other words, stylistic choices. To these must be added printing techniques that deepen a nocturnal atmosphere. When combined with a taste for obscurity and blur, the images project a sleazy life apparently caught on the fly by one of its denizens. Memories of some Western photography—possibly William Klein, as I mentioned before—mingle with the pressure-cooker scenarios of Kabuki drama and grotesque effects exploited by Japanese film. We are not far removed from an impression of hysteria—but it is a kind of polemical hysteria. For example, Shomei Tomatsu's passionate subjectivity—in scenes of litter and anomie—calls attention to itself as a forceful protest against everything that is impassively seen or politely uncentered in the image world around it. Whatever his project, this man, who insists on madly doing something else, is not involved in documentary.

Tomatsu's acknowledgment of his own stakes in the act of seeing, which marked him off in the professional environment as early as the fifties, exerts an undeniable moral power, the more so as he has long been concerned with the national trauma of the war, the way it had of scarring flesh and ruining cities. Their rebirth would have been a thing to celebrate, but it had not taken a form that he could pictorially accept. A Japanese writer, Shunji Ito, thinks it too easy to say that

Tomatsu's gesture represents a kind of "revolt against the modernization, the rationalization and the excessive mechanization of the urban space."[6] Rather, Tomatsu's memorial and therefore conservative role has been to keep alive the reality of a troubled past. That reality is perceived introspectively, in the recovery of a disoriented space within a vertigo of shadows.

The misused or abandoned sites that Tomatsu photographs appear struck down not by poverty—as if he were making some political statement—but by despair, a mental state that brands his work with the hard loneliness of one who works outside a group. The desolate environment that reflects his alienation in society, and his query into his own psyche, have literary exemplars in Japan. I think, for instance, of the heroes of Shusaku Endo's *Scandal* (1988) and Kobo Abe's *The Ruined Map* (1967), two novels whose portrayals of the city resemble Tomatsu's. The protagonists restlessly cruise the streets, inveigled into these labyrinths by the mysteries of alter egos who outwit and humiliate them. Endo's distinguished novelist, a faithful married man, has a double who ostentatiously frequents the Tokyo porn shows. Abe's detective descends into the gang world in search of a missing husband whose personality he gradually absorbs into his own. This type of plot is concerned not just with a fancied loss of status, serious as that would be in Japanese culture. Rather, the men justly fear they are in the process of losing something more vital than class: a sense of their own identity. Abe's character approves the statement "No good hunter pursues his quarry too far. Rather he puts himself in his quarry's place as he looks for the path of flight; by pursuing himself he corners his quarry."[7]

A sense is given of these characters as hollowed out, their consciousness increasingly baffled and troubled by its lack of self-awareness. Narrative momentum hitches on the possibility of their achieving a view of the actual content of their lives. By no means is this theme exclusive to Japanese art, but it achieves a specific poignance there. Since the culture loudly announces the priority of loyalty (*giri*) over compassion (*ninjo*), an archetypal conflict is set up, favorable to dramatic presentation. In the popular media, the conflict tends to be treated sentimentally (tearjerker plays or movies being rated from one to three handkerchiefs), and in the serious arts it turns into an existential puzzle.

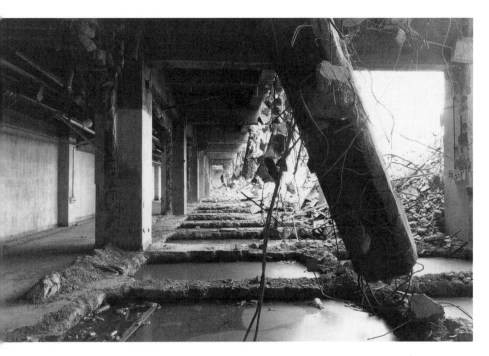

Ryuji Miyamoto, *Tokyo Metropolitan Gymnasium swimming pool*, 1987.

The problem of the Japanese photographer is to uncover improb-
abilities in an environment where rules are everywhere standardized
to make behavior predictable, when not actually ritualized. As we're
endlessly told, social signs and stimuli can proliferate in Japan quite
happily without calling for any unprogrammed personal display. Some-
how the idea of an interior self, more consequential than the decorous
player, sounds vaguely quixotic in that country. If the *"Mois de la
photo"* were our guide, we would think that the typical photographic
genre that deals with "selves," portraiture, was absent from the postwar
record. It was as if there were no portraits that the Japanese curators
could take seriously, or even as if portraiture had not been entertained
as a possibility for art. We were presented, instead, with a number
of categorical sets—the crowd and the loner, containment and open-
ness, ritual and release—that all involve parallel oppositions. Yet they
are not seen dialectically, that is, as subjects that are changed by the
view of a photographer, an integral self, who is in turn affected by
what is seen. Their styles may alter as fashionably as any others', but
what I miss too often in Japanese photographers is another sort of

change: the workings of an interactive principle between photographer and environment that breaks open the mold of received impressions.

This may explain why the broken mold itself, the ruin, has fascinated some of the more adventurous among them. Here, after all, quite literally, is an opportunity to get past the social facade. A ruin is a sad thing, perforated and undone. It lays open the distinction between surface and interior, and allows us to consider these two essential physical aspects of the structure simultaneously. It is also a spectacle showing how they have come to a grief that cannot fail to have its emotional repercussions. How often that spectacle must conflict with the presence in Tokyo, over so many years, of things being constructed. When so pictured in a photographic campaign, it must look as if history is being run backward.

Tomatsu has found the ruin a fertile zone for his mental cruising, and Ryuji Miyamoto has seconded him resoundingly. The younger man establishes himself within the dark skeletons of racecourses, movie houses, municipal swimming pools, prisons—places where there were once crowds—such that one fancies one still hears their roar. For him, the wrecker's ball sounds a funeral knell, and the city is a graveyard of once active structures. It is all seen very calmly, the dust settled in. Though the place is still evidently being pulled down, we look into it during an intermission of the violence. Cracked windows sprout everywhere, toilets have been uprooted from the plumbing, tie-rods dangle from the armpits of concrete joists. As for the floors, one can hardly step over their hairy mounds of rubble, filth, and junk.

The intimacy of such prospects that reveal the bodily functions of the building, sent all askew, borders almost on the indecent. We trace them into their furrows, as none of their inhabitants or visitors could have followed them. And yet Miyamoto's outlook is elegiac. We are inside; the blinding light coming in halates the few remaining upright supports. For that reason, the fate of the building weighs in more heavily upon us. It is ceasing to be recognizable before our eyes. It assumes fantastic shapes in its agony. The process of disassembly, with all its accidents and anomalous turns, is beautiful. Miyamoto titles the 1988 book in which he has collected this lovely imagery *Architectural Apocalypse*. He goes out to other cities besides the Japanese, to London, Berlin, Hong Kong, carrying that same vision with him. Everywhere he finds solid victims of obscure demolitions. We can

easily imagine him in Baghdad or Basra. Here is a self-knowing art and a fin-de-siècle mind, demonically attuned to our historical moment.

Notes

1. Karel van Wolferen, *The Enigma of Japanese Power* (New York: Vintage Books, 1990), p. 23.

2. Elias Canetti, *Crowds and Power* (New York: Seabury Press, 1978), pp. 15–16.

3. Ian Buruma, *Behind the Mask* (New York: Pantheon Books, 1984), p. 67.

4. Ibid., p. 42.

5. Jared Taylor, *Shadows of the Rising Sun: A Critical View of the "Japanese Miracle"* (New York: Quill, 1983), p. 192.

6. Shunji Ito, "Dans les ruines: Essai sur Shomei Tomatsu," *La Recherche Photographique: Japon* 9, Paris (October 1990): 45.

7. Kobo Abe, *The Ruined Map* (New York: Perigee Books, 1980), p. 176.

This essay appeared in *Artforum* (May 1991).

Conjuring

Alternate Worlds

Thomas, *Taste Shown Actual Size* (original in color). Courtesy S. B. Thomas, Inc.

Photographs

THE IMAGES THAT GIVE YOU
MORE THAN YOU EXPECTED TO SEE
AND LESS THAN YOU NEED TO KNOW

I N T H E New York City subways, currently, one sees an advertising placard that can offer interesting intellectual problems. It features a color photograph of one half of a lightly browned English muffin, from which a bite has been taken. The diameter of the muffin, produced by Thomas's, is about that of a large pizza. Underneath, a legend reads: "Taste shown actual size."

It's easy to imagine what Roland Barthes would have made of this phenomenon. Earlier in his career he would have analyzed it in terms of signifier and signified, and at the end of his life he would have dismissed the muffin image as one that belongs only to the domain of the *studium*. It would have lacked a *punctum* altogether. Nor is it difficult to suppose how Marxists would have worked over the poor muffin. One can almost hear their jeremiads against commodity fetishism and the consumer culture, ignited by the image of the bread. Now, I must confess to my radical colleagues that while Thomas's is not my favorite muffin. I did find the picture mouth-watering. And I thought the text rather clever, for a message of its kind. But what really struck me was the fact that the message said that the image showed something—"taste shown actual size"—whereas the image showed something else.

Of course, when it comes to photographs in media, this kind of standoff is the rule rather than the exception. Texts are forever pointing out that viewers should consider the content of the photographic frame to be larger, or at least more extensive than what is locally visible. By texts—just to define my term—I mean not only legend, caption,

label, but also implied message or any appeal that can be or has been translated into discursive language. Clearly, the established function or rhetoric of a photograph supplies visual allusion to a general "text." From a visual image that presents only a part of a thing, the whole of a meaning may be deduced.

But in the muffin ad, a part was subtracted—the bite—and with it, a sample, presumably, of an attribute of the pictorial subject. Let me raise a question or two about this "taking away." Who did it, for example, and does it matter? Literally speaking, an unknown person—that is, someone unknown to the viewer; and, no, it doesn't matter. But metaphorically speaking, the biter is me, the one who looks. I am assumed to have taken a bite out of the content, so to speak, and am encouraged to go at it again. So this simple picture of an object, isolated on a white ground, could not be more direct, and more intimate in its directness, for it's implied that I have ingested the substance of the thing depicted.

Now, there are strong objections to the idea that the taste was "in" the muffin, but there are even stronger ones to the thought that the taste was in the photograph. A modernist might furnish a bitten photograph, to demonstrate awareness of the image as only a material, paper artifice. Modernists are always deflating our illusions for the sake of their illusions. For the time being, though, I am a subway passenger, responding to or rather reflecting about a visual stimulus. But is it really all that visual, or even primarily visual? Couldn't a case be made for saying that the operative content of the photo, though taken in by the eye, is appropriately received on the tongue?

As long as it excites my salivary glands, the picture is doing its job. It will apparently be neutered if asked to perform any other work. One can see here an argument that information theorists would fondly make, as well as an example of what behavioral psychologists would denote as a conditioning experience.

In their purely functional view of the matter, the picture's reason for being was to act as a cause to produce a mechanical effect upon the appetite of the viewer. Not only is the viewer made entirely reactive, in a prepared way, but the viewer's perceptions are instrumentally reduced and dissociated from any life, any affect, beyond the visceral.

As you can see, I am imagining variant but congruent texts to accompany the one that has been stated. For the words are very specific: "Taste shown actual size." Considered from a logical point of view, this is completely irrational and ridiculous. Everyone knows that a sensory effect cannot be shown, but only experienced. And it certainly has no size, as if it were possible for a grownup to confuse a sensation with a thing. But my literal approach to a metaphorical statement is itself ridiculous. The ad agency only meant that eating the product would be highly enjoyable. So much could be said in words alone, and this would surely have been true if the ad came over the radio. The role of the image does not so much provide "proof" of a verbal claim, but rather triggers memory of past tastes. The image is intended to go some way to confirm a concept—tastiness—and as such it means to be correlative, subordinate to a nonvisual goal. Though it's fabricated to very specific commercial standards, the photograph operates in a vague way. It's like a magic talisman which is valued materially for the static place it holds in a dynamic mental construct.

But there's no reason why we're obliged to honor that construct when looking at the pictorial object. It need hardly be pointed out that we're more than tongues in this life, more than consumers. Who is to deny our freedom to choose whether to keep within the perceived textual control of the image sponsor, or to stray from it into freshened possibilities of our own control?

Please don't think that I am overlooking the original reading, which singles out one response to the picture as obviously appropriate while all others are theoretically excluded. Anyone would be within his/her rights to question my mental competence if I were to say that the muffin picture was a profaned reference to the Eucharist. One would feel the same way about the baseball batter, to use Neil Postman's example, who stepped up to the plate and remarked to the umpire: "Father, forgive me for I have sinned." There is such a thing as being aware of the semantic environment one is in. Suppose, however, that I notice not only that the image is a commercial food picture, but that I announce that it belongs to the category of still life. This will perhaps not be disputed, not be considered absurd, but eyebrows may still be raised. After all, to call it still life is to imply that the muffin picture might be taken seriously—as art.

Let us admit that art is an entirely different ball game. For one thing, the objects of our *artistic* regard are thought to be intellectually dignified, a quality the muffin photograph lacks. Anyone familiar with photographic studies, or who gives the matter any reflection, knows, however, that photographs are constantly rejobbed or recycled, taken from their initial utilitarian contexts and displaced into aesthetic ones. Photographic culture is especially prone to this kind of conceptual circuiting: the metamorphosis of humble, magical objects into more presumptuous but still magical icons. That kind of valorization, as they say, goes on all the time, but never, so far as I know, for a sitting, incumbent ad. This implies that one of the difficulties we have in accepting commercial as artistic photographs is resolved by time. When sufficient time has passed (and this may be a very brief period), the original, mundane purpose looks defeated. That is, it no longer solicits in the way it was conceived. It's essential to our artistic appropriation of a commercial photograph that the image appear dated, nontopical, juiceless and dysfunctional. For then, in that disenfranchised state we no longer feel that our contact with the image opens us to the "cheap", live manipulations of its text. The picture is like a stone from a dead planet whose strangeness is appreciated as a souvenir of another world, a remote, alien dominion, which attracts us because we can no longer relate to it. So then—but this we already knew—displacement in time confers a once-missing dignity upon certain images.

Do we have any idea how particular we are in these matters? Just as a taste is not activated until chemical information is nervously transduced from someone's hyper-individual mouth and throat receptors to that person's brain, so art meanings are not perceived except as inputs which can only be taken by thoroughly specialized yet generally orthodox social predispositions. The word *still life* implies a syntactical visual order or symbolic value imposed upon inanimate subjects, just as the word *landscape* does the same for nature's chaotic features. By the use of these culturally laden art terms, "still life," "landscape," we refer not only to intelligible pictorial modes or genres, and categories of seeing, but to the sense we have that aspects of the surrounding world are ready for us. Of course, the state of readiness—things shown off presentably—is mainly a sign that acknowledges our human need for them to be that way. Often I think this is the tau-

tological basis for what we call representation. We represent what we simultaneously project, having already altered much of the world to show our mark. That is, we solipsistically recognize in our visual representations clear traces that human beings have been at or have influenced the locale to which the projection ideally takes us.

I will not argue that the first telecasts, and stills made of them from the space vehicle on Mars, lacked ideality in that projective sense—for we have our canons of science fiction—but I will say that Mars lacked conviction as landscape. That place had never known us, nor was it in the least presentable. And the intimate pictures that came back from this world of profound otherness introduced us to a beautiful dread. The displacement in space, which they witnessed, was fully the equivalent of any displacement in time and just as compelling. But more important than the shivery attraction of such things—the desire stirred up to connect across an unfathomable opening—the pictures eluded social captions. It's true that they were immediately appropriated by scientific texts. But in the scrutiny of those extraterrestrial forms, the eye interested in the material constituents of the scene and the eye awed by the sheer phenomena of the planetary surface were united in early wonder. It might be said that all optical receptors were doing well enough, but that they let in data that outflanked preceding mental constructs.

What happens in the outcome of such a situation, of such emphatic visuality, interests us keenly because it is thought to be quite rare. The impact of these pictures, with so much that was inchoate in them, was implacable and concussive. The self-confirming aspects of social projection—for science is definitely a social undertaking—were stunned by material disclosure. During the interval before anyone recovered from that blow, representation was understood to have taken a new step in the history of images. But I think there's a serious problem awaiting anyone who would like to propose photographs themselves as capable of taking that step. For, whatever else they are, I'm pretty sure that photographs are *not,* inherently, representations.

We are on safer ground if we claim only that a photograph depicts. After all, it is the product of an intelligent system, the aim of which is to realize pictures. A photograph cannot be imagined apart from its pictorial attributes, i.e., its frame, its flat, two-dimensional surface, its monocular viewpoint, and so on. At the same time, it is not the

sort of picture that "serves to express, designate, stand for, or denote, as a word (or) symbol . . . does"—that is, it doesn't primarily do the kind of thing the dictionary says it ought to do if it were to represent. Of course I realize that this statement flies in the face of common sense, a faculty I deeply respect. In particular, it denies the overt, representational uses to which photographic pictures are ordinarily put—of which the muffin picture was an example.

But this use refers to the social matrix and work program into which the image is easily inserted; it does not speak at all of its physical genesis. Within that brief, senseless moment of light exposure, any representational *aim,* as we know it, is annihilated. It blacks out subliminally, like the blink in the viewfinder of a single lens reflex camera, caused by the upward swinging mirror when the shutter is released. During that infinitesimal coma, time out from intelligent purpose, the photographic act accomplishes itself. There is never any such *ontological gap* between the conscious planning, execution, and the showing of hand-made pictures. Representation of observed or imagined possibilities guides them, *in*-forms them at every step of the way. Improvised or premeditated, marks are sensitively inscribed on a surface, coded in place, and then more or less decoded by interested viewers in one long continuum of psycho-social maneuvers. Inevitable disparities in our cultures, historical experience, and temperament obscure that code, at times, and may complicate or fluster any evocation of deeper meaning. But what we see literally in a *photograph,* as everyone agrees, lacks just such an *informing* code. Beyond stating that it registers the light that came in onto the film, I cannot say that this oblivious, machine-fabricated image represents anything—however legible or even highly meaningful its contents might be. There is no argument to the picture. *By itself,* it cannot stand for anything or speak on behalf of or against what it depicts. The subject is helplessly there, presented merely, and replete with its own momentary appearance.

This is intolerable, a spectacularly useless way to consider the medium. And yet anyone, like myself, who wishes to uncover the terms of photographic observance occasionally catches sight of mechanical vision in all its brute triviality. But I cannot hold on to it for very long. How often have I started up in minor panic at the sheer vagrant, superfluous, and irrelevant abundance of photographic description before photographic culture took over, directed me, and erased what I

felt! Enough of the memory of it lingers, though, to make me consider that the least visible thing about a photograph evolves out of what it shows! I mean the kind of material phenomena that could not be prevented from being there, as compared with what is highlighted through the social business of the image. In the example of the Martian horizon, the two strata of display, gratuitous and indicated, are exceptionally fused, and therein lies the fascination of such a picture. It offers a visual torrent, whose texture of inconsequent, atomized odds and ends is impossible to overlook because of its shock as a first sighting. In fact, the total newness of the material spectacle (to our eyes), is the real point, the real subject.

But the case of the heavenly body furnishes only a graphic example of what is utterly normal—yet underexamined—in photographic definition. The torrent I spoke of prevails everywhere, even in vistas as common as the backyard or, for that matter, the muffin. Aren't its endless hills and ridges, its pockmarks and crevasses, the counterparts of those on Mars, even if written much smaller?

Muffin makers encourage us to open the product with a fork rather than a knife, for the roughness of the surface that animates the tongue will enhance flavor. I am a critic who tends to forksplit my objects. I like, if at all possible, to keep tabs on their tactility—mainly because this implicit photographic roughness is most often denied by appreciators or critics whose smoothing operations leave much out of the photographic experience. But such a divisive stand shouldn't be understood simply as a preference for a minority argument. In one sense there is a long artistic tradition behind its typical artistic reckonings, stemming from Leonardo's famous grease-stained wall, on through Alexander Cozen's inkblot landscape drawings, right on to the psychic automatism of Breton's Surrealism. Artists have been off and on again haunted by the incipient suggestiveness of chance markings, deposits on surfaces that came to be through natural influence rather than conscious human control. But the masters wanted to rationalize the look of such stimuli so as to enliven and perhaps outwit their learned, pictorial schemes.

The Surrealists lauded certain photographic imagery because of that reserve in it beyond the reach of conscious editing. It was very much that same capacity in photos that earned them Baudelaire's contempt for leaving nothing to the imagination. To him, photography was the

apotheosis of the material. It was to be spurned as such, or at least relegated to a merely useful role, such as copying art. He had no sympathy for what I want to call the fractal complexity of the photographic image.

Leaving aside the open question of what is imaginative in any one philosophic case or not, let me illustrate this problem of infrastructure by an example of perception. Claes Oldenburg has a pencil and casein wash drawing of Swedish *KnackeBrod* or ryekrisp, seen in plan view. Only a few of the object's craters have been delineated, and then only sketchily, whereas others remain in a state of still lesser completion. Looking at them, my mind fills them in, by virtue of a recognition that might be called the etcetera syndrome (as conceived through Oldenburg's style). No need to waste further marks, the artist seems to say, on what has adequately been implied. But a photograph is bereft of such implication. Rather than a drawing's concision and elegance, it describes with a surfeit that is also unlabored. Though they are crucially affected by uneven circumstances of light and placement and overlap, though some of them may well be ill-defined because unfocussed or in shadow, the objects in the photographic field are depicted with an impartiality of attention, characteristic of a mechanical instrument's limitations and possibilities.

I may not have the patience to follow through nor clearly remember all the details that are revealed. In fact, I am very likely not to, because my human vision, as contrasted with that of the photograph, is nervous and pre-emptive. Oldenburg has written: "A work of art is a debased understanding of a magic object." By that token, a photograph might be a copious understanding of a perceptual summary.

On its two-dimensional plane, a photograph replenishes data that confirm appearances, but at a threshold broader than needed to judge what they are. In its almost endless discrimination of features, the photograph has obviously never heard of distinguishing marks. That's why the contents of such an image can be simultaneously familiar, or very plausible, and uncanny. Baudelaire could not have foreseen an enigma of the material world—that the closer we come to it by means of photographic depiction, the more alien and disorienting it becomes. (Under the influence of abstract painting, this, too, I am sorry to say, has become an all-too-familiar approach to the unreasonable, and hence a cliché in its own right.) But we do not have to lose ourselves in

microscopic approach patterns to apprehend the sometimes subtle, sometimes gross difference between the nominal identity of things, and the way they look under varying photographic circumstances. It would be hard to deny that after 150 years, we've developed a yen for that kind of difference. But it's nevertheless the job of photographic culture in its official, institutional, corporate, commercial, scientific, and civic branches, to keep the garden-variety disclosures of the medium to a minimum, to keep them as undistracting as possible.

For all that we may generally know *what* we're looking at, still if not through this minimizing stricture, how are we to know why we are looking at it, or asked to look? The roughage of photographic vision conveys through optical means a traction, as it were, with our remembrance of quiddity. That is why it is valued, by every public user, large and small. Yet this typical proliferation of surface events, lacking any idea of where to stop, performs inefficiently as a transmitter of messages. All genres out there in the media curtail visual surfeit by declaring their territory and restricting their gestures. And yet the world has a way of extraneously leaking in, in trivial or conspicuous violation of the image's social program. For the medium has a kind of ontological generosity that tends to profane its own schematic genres.

In observing that potential at work, I am not making any type of judgment, as if it were a question of preferring so-called unmediated to programmed imagery. Since we already mediate complexly through our eyes, let alone a machine like a camera, and every other artificial sensor, the dream of unprocessed seeing is without foundation—a figment. But I want to counter the emphasis that our criticism and our historical studies place upon mediating filters as a key that opens up photographic content. A directive is not necessarily a delivering mechanism. As the fashion goes, the mediating filters are all conceived to be *ideological,* and that very word suggests how analysis built upon it depreciates the figural experience of the work. The interest of image makers and sponsors certainly conditions but does not inevitably account for what is to be gotten from the pictures. Do they, for instance, carry out their assigned intentions, subvert or exaggerate them, do they even make sense or are they likely to affect different viewers differently at different times; are they nondescript or significant examples of their kind? One will never know unless one asks. To reduce

and level-out media pictures as only visual exemplars of promotion, control, or propaganda, is to ignore their visual texture, and to construe them only as texts. Texts being present, in fact, texts being cardinal, we can be spared the picture.

Now, when the picture conforms entirely to the critique of ideology, the critique substantiates itself, but at the cost of calling into question the reason why there needed to be a picture to do this. The discourse assumes its object to be solely discursive in its own tendentious manner. There issues a strange kind of narcissistic reading, which projects itself in order to reflect itself, and can do nothing more than to treat of pictures that it holds in contempt. Contemptible photographs mirror contemptuous analysis. In this scheme of things, this textolatry, the figurative has no choice but simply to null out. Though it fails to perceive any such outcome, the critique of mediation turns into an exercise in resentment. Any quality or phrasing of an image that calls to our speculation, fantasy, fear, or desire—that is, to our normally irrational traits—is described as manipulative and repressive. It's very easy to understand that this obvious protest against the market and institutional powers that disseminate photographic culture has another, undeclared target: the allure of the medium itself, which serves only to intensify iconographic "sins." For media criticism conspicuously takes no interest in, nor is it even dialectical enough, to distinguish the volatility of the image from its program, or better, what the image actually shows from what is purported it tells.

What do they want, these generally Marxist iconoclasts who call themselves students of the pictorial? From the evidence of much current work comes some general answers. They want images to explain historical cause and effect, or at least point to them; they want material truthfulness of observation, untainted by ruling class bias or anyone's merely personal sensibility. And they are disappointed because it doesn't work out that way. Photographs not measuring up to a true exposure of class relations, or that perpetrate the inequality of those relations—such photographs are fallen objects. Evidently, they are corrupted by their sensuous appeal, but more importantly, they are invalidated by their misrepresentations. Braving all experience of what an image is, the demand is for "objectivity"—and that, of course, makes those who voice or imply such a demand, iconoclasts.

For a photograph can never lie unless it is required to tell the truth. After all, this object is generated through a system of picturing, of showing, not of telling. One can certainly draw incorrect inferences about what a photograph samples, but only by contributing or having been supplied a text that is later contradicted by another text, or another picture with its text. In that event, it's realized, as Mark Twain said, "You can't depend on your eyes when your imagination is out of focus."

Since photographs most often come to us bound by text, the idea that they tell us something is perhaps an understandable but still elementary mistake. They can definitely affect the way we feel or think about the real state of affairs they picture—and of which they provide a direct trace—but they cannot tell us how it happened, nor what we're looking at, nor where the "what" has gone—without names being named and stories told. Unlike a painting's, the appearances in a photograph do bear an explicit, physically connected relationship to actuality, but it's an actuality that later changed, and was not the same before. We do not come to a painting in order to gain knowledge but to be gripped by metaphor that has no temporal duration. In contrast, a photograph does present us with a certain knowledge— that which was visually the case—for, let's say, $1/125$th of a second. I will admit that it is very hard for our instincts to recognize what this limit means, no matter how much our minds understand it. For it faces us with the most drastic, fortuitous curtailment of showing: this minute instant of time and not any other. Whittled down by its own temporal slightness, photographic content lacks any real stamina, a fact we often compensate for by giving the photographic effect an illegitimate longevity.

By way of illustrating this, I want to cite two famous images in the history of the twentieth century. Outstanding examples of pictures with fixed meanings, they have only recently been undermined by the publication of other pictures of the same subjects by the same photographers, taken within minutes of each other. Alfred Eisenstaedt came upon Joseph Goebbels while on assignment in Geneva, 1933. Hitler's Minister of Propaganda is shown seated outdoors in a chair, flanked by courtly attendants, and looking quizzically in the direction of the photographer. The other instance is a picture by Robert Capa,

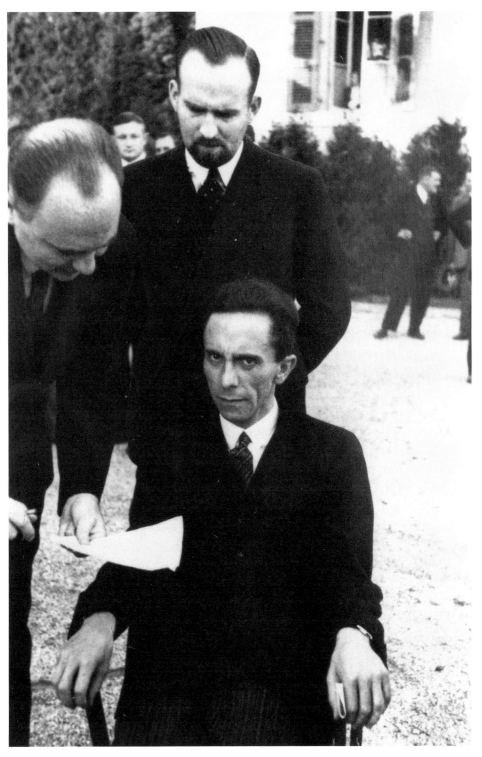

Alfred Eisenstaedt, *Dr. Joseph Goebbels*, 1933.

often titled *Chartres, 1944.* It shows a crowd of people surging through a street toward the photographer, though many of them are looking smilingly, to our right, at a young woman with shaved head, eyes downcast, holding a baby and accompanied by police.

Eisenstaedt writes, next to the Goebbels picture: "Suddenly he spotted me and I snapped him. . . . Here are the eyes of hate. Was I an enemy?" I will not doubt that it was reasonable of Eisenstaedt to think so. His recall of the occasion, as a little Jewish photographer who approached a powerful Nazi, has inflected the subsequent history of this image. The thing to notice, though, is that one of the most common, fleeting expressions in the history of modern photography—that which comes over the face at the perception of an intruder with a camera—has in this case imprinted itself upon the mind of our century as a look of pure malignancy.

As for the even more celebrated Capa photograph, one of its captions has read: "Followed by jeers and marked by her shaven head, a woman collaborator is paraded through the streets of Chartres following its capture by Allied troops." The panoramic sweep of this caption implies a much wider-angled regard for historical narrative than the episode commented upon by Eisenstaedt. Though for that reason presented as a relatively unengaged outsider to this moment of French retribution, Capa is still understood as aligned with those who triumphed in the historical struggle of the war. That is, his picture would be unthinkable as a document provided by one of the Axis troops. But if I indicate the obvious fact that a political position is established by the physical placement of the camera, at a critical moment in time, the moral impact of the photograph has been more expansive and shaded. For in the picture's instant of record there would appear a figure, a loner in the crowd, who is simultaneously a martyr and a culprit. To be more exact, while the text remains neutral on this question, the image itself turns around by isolating the helplessness and punishment of a mother and child within the mass of townspeople. So, the very distance of the viewpoint, which emphasizes the misery of the protagonists while failing to identify with the smiling tormentors, has given rise to an idea of Capa's humane and liberal consciousness.

I used to buy Eisenstaedt's line about Goebbels. If, in fact, I speak in the past tense, it's not because the evil reputation of the Nazis has somehow decayed. Rather, the photographer now gives us, fifty years

later, a far less pointed even amiable image of this villainous character. Eisenstaedt says: "He smiles, but not at me. He was looking at someone to my left." In this little drama, the subject smiled before that contact with the photographer which produced the picture we know. Neither party had yet been clued by an adversarial context, so that Goebbels's inimical reputation and transitory charm do not match. That possibility should not surprise, for as Hazlitt said of enemies that disarm us: "If you come into a room where a man is, you find, in general, that he has a nose upon his face."

Far more shocking, however, is the discovery that prior to the crowd picture, Capa photographed the same woman, among others like her, close-up, scowling, formally framed before what now functions as the official camera of an Allied photographer. There can be no mistake about the text of such an image, based on experience of similar pictures. A social sentence has been meted out to these subjects, of which the picture itself is a *direct outcome.*

If it were to have the content intended by the occasion, the photograph should present itself as a kind of institutional record describing what had temporarily been done to the women to mark their disgrace. We viewers become the equivalent of the townspeople in the slightly later picture, that is, we are assigned the role of those who consider themselves rightful in their judgment. Since the subjects had no choice but to sit for their portraits under these harrowing circumstances, it can reasonably be assumed that the photographer accepted the coerciveness of his position. Instead of picturing power relations, as he did in his very celebrated picture, Capa here memorably embodies them, in a very declarative way.

I referred before to the world that extraneously leaks into a photograph's apparent social program, by which I meant the degree of physical information caught within the frame in excess of the narrative needs of the image. From the Eisenstaedt and Capa examples, it's evident that the fortuitous *timing* of exposure can pressure or alter the text that has been accorded to a photographic effort. In fact, their unsuitability to circulated texts may account for the long time we had to wait for the arrival of these old pictures. This is particularly noticeable in the Capa pair, where the photographer plays almost antithetical, successive roles in visualizing one theme. I must Insist on

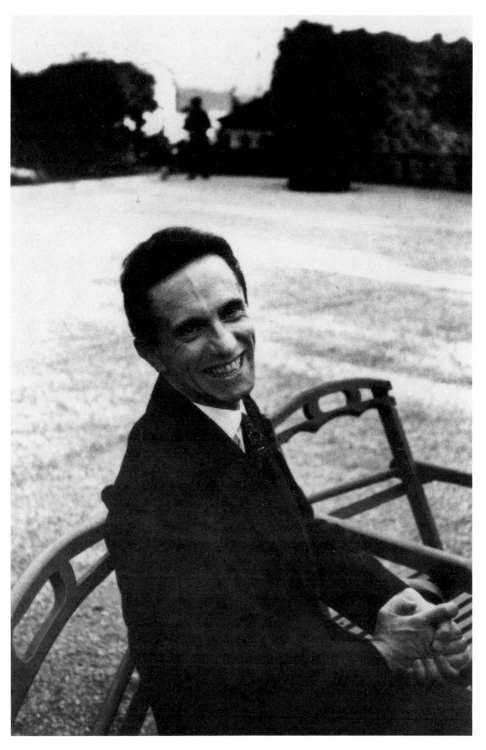

Alfred Eisenstaedt, *Dr. Joseph Goebbels,* 1933.

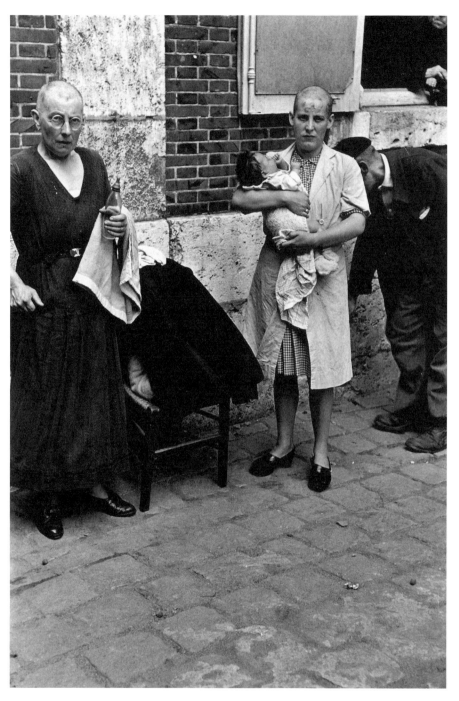

Robert Capa, *Chartres, 18 August 1944*. Courtesy Magnum.

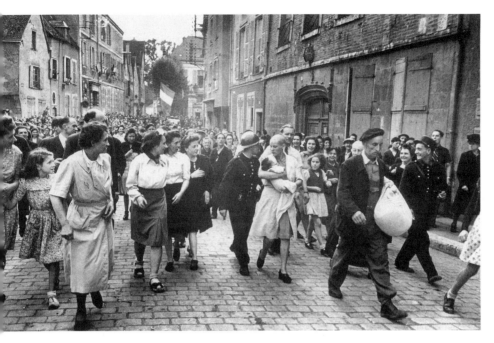

Robert Capa, *Chartres, 18 August 1944*. Courtesy Magnum.

this idea of role differential because it crops up so frequently in photography as to seem indigenous to it.

When Jacques-Louis David conceived of different dramatic moments and groupings for the work that went into and was finally distilled for *The Oath of the Horatii*, he conjured various dramatic perspectives but maintained the same authorial presence and control. It was still David, still that one mind calculating optional shaping of material. But in photography, the person with the camera, or rather, the picture that results when the camera is fired, can be an option of the material.

And as that option is realized through timing, we have to acknowledge that the temporal is obviously a crucial element that enters into social transactions of photographs and that gives roles to all parties, from one minute to the next, as if the same personnel were in successively related, but different plays. A parallel is suggested between the unexpected input of material data and the unscheduled temporal access to a photographic subject. But, of course, there is no real schedule, just opportunity, sought after or come upon.

If I am right, then the potential of photography for unsettling or eroding textual control is derived from interventions into life that are

betrayed through the lens. When that betrayal insinuates itself, we can make it more visible by turning off the sound track.

I would like to conclude these sketchy remarks with a few brief points about the position of art in a medium so well adapted to the uses of knowledge, commerce, and entertainment. Many of us recognize artistic photography when we see it, but can give no coherent idea of what it looks like. Questions of style—the pictures can be in any style—and questions, even, of "feel" are beside the point. Given my concerns here, I would rather indicate a technical criterion to approach this particularly subjective problem.

Artistically involved or self-conscious photography is likely to be brewed in a scene where the figural and the textual components of the imagery are initially found in great contention. The key work is that which puts textual statement in considerable doubt, or sends us in a hurry to discover or engage with new text. That is, available textual control does not seem adequate to stabilize the various figural aspects of the image. They may seem underdetermined or—what is very much an equivalent—too open to random conjecture. It's entirely possible for such deficiencies to be stratified into aesthetic schemes, so that weak or overly competing signals contribute to a network of recognized obscurities. In that case, meaning is claimed for images that can very well lack, and are sometimes even known to lack, significance. No, the real issue has to do with how imagemakers *freely,* that is, to their own limits at specific historical, material, and cultural points, assess the phenomena of the outer world and intensify them through systemic means. The fresher had been their encounter with that world, the less I correspondingly know what to say. A truly speechless condition is an early intimation of art.

One would have thought that the critique of ideologies would applaud the artistic aspiration in photography. After all, doesn't art still represent for us the enhancement of our resources through the redefinition of their freedom of activity? The artistic impulse should then be considered as an ally in the protest against corporate mediation. But it is precisely here that the criticism brands the art as reprehensible. Let us set aside the puritanical instinct which stigmatizes the art at that moment it gratifies any appetite. And let us not be impressed by the accusation that art, in photography, is fetishized as a luxury

item. Personal photographers, at least, have no market and therefore no motive to produce items that can be identified as luxury, or that are significant as physical property. Finally, though, let us heed carefully the judgment that there can be an ideology of freedom that is no more disinterested than any other repressive doctrine—that "freedom" itself is the official byword of a repressive society.

All of us know of people who have made that last comment a grotesque reality: that is, connoisseurs, curators, historians, pundits, who reserve for art a transcendent, asocial role, removed from history, and which is neither indebted to nor reflects any material conditions nor personal limitations. I call this "The Amadeus Complex"—a wretched thing that is a profound source of complaint. In that it removes a human creation from the very rich matrix of circumstance and compromise from which it stems, this complex estranges us from that which would nourish us. Peter Shaffer's Salieri, listening to Mozart's music, and in the experience of it rent with feelings of impotence and rage at a God that bestowed a divine, inexplicable gift on another, this Salieri is no fit representative of our attitude toward art.

I hope, rather, that I have already indicated how traditional art attitudes run particularly afoul of what I called the fractal complexity of the photograph. Art models, derived from painting, have no way of coping with it, and are no more prone to see it than Marxist determinism, with its blindered, textual bias. Both perspectives tend to deny the material disclosures and temporal revelations that could not altogether have been intended. By all means let us be quickened, if need be, by the manner in which texts are precipitated for photographic images, but let us also learn from what happens in those images themselves. For it sometimes occurs that they liberate us from texts, despite themselves. Information from the world leaks into artistic dreams, riots with them very nicely, and it can also undermine commercial drives. The energy of art is lively and fulfilling because it tends to be hospitable to that which cannot be foreseen—that which photography itself unreflectively brings off. The mistake of our two models of photographic interpretation, Marxist and aesthetic, is to expect either too much "responsibility" from the camera image, or not enough materiality. As a writer, I am obviously in the business of constructing texts, and as a critic, my concern is the interpretation

of visual images. So, I can hardly applaud an image which successfully resists any attempt on my part to give it a plausible reading. It is just that when I have to look as carefully as I read, that my reading becomes a discovery. And that is as it should be.

This essay appeared in *Photographic Insight* (Fall 1987). It is a slightly revised version of the keynote address given at the meeting of the American Society for Aesthetics, eastern division, at the Rochester Institute of Technology on March 20, 1987.

The Etherealized Figure and the Dream of Wisdom

THERE EXISTS a photograph of Richard Nixon, on tour in a crowd, coming toward us, shaking hands with someone in line while looking at his watch. One caption described the scene in part as "President Nixon, hand in one place, mind in another." And the text went on to speak of him as "caught with his sincerity down."[1] As a revelation of a questionable public performance, this picture, taken by Horst Faas, won a World Press photo contest. Rarely has it been given to a photographer to show as graphically as here what phoniness actually looks like. But there's a deeper message in this picture than political or social exposure, a message that has to do with time itself.

We, at least in the West, constantly worry about time and are dominated by it. It enlarges itself for us whenever we perceive an unexpected delay in our schedule. We are wound up in our purposes and are reluctant to consider the mesh of time in which they must uncoil. Let there be a greater duration than we expect in getting from one point to another, and time seems to have slowed. Let there be too many activities for the interval allotted, and time seems to have speeded. The elasticity of time is felt very differently by those who have been on an exotic trip, compared to those who have stayed home during the same period. The more centered and directed, the more an individual feels pressured by the temporal. Its passage is sometimes measured disagreeably, as in one's consciousness of the clicks of a taxi meter or the cost of a long-distance call. As the minutes go emphat-

ically by, anticipation is stranded in the sense of not having made enough progress or reached a goal.

Music plays upon these suspended moods about time, coloring them with its modulations and harmonies. By music's standards, Nixon's state was a dissonant one. He was at everyday cross-purposes with himself—being in one place and reflecting on another. But, as far as the music of *photography* is concerned, Horst Faas was completely in tune. He found himself at the right locale and moment, with the right frame of mind when an unscripted gesture usurped an official event. As there are endless variations of muscle tone, so there are also those of social tone, to which this picture bears witness. It works through the contrast between the split-second opportunism of the photographer and the distraction of the subject; between the one who knew how to seize the moment and the one who was ephemerally undone by it. And the question that remains, which I want to take up, is: Where does such a contrast put the viewer?

Obviously, we have our itineraries as individual viewers no less than as socialized beings. Photojournalism addresses itself to the second of these viewer roles. But, unusually for his genre, Faas would seem to have scored a point against the routines of journalism and the interests of his subject. In fact, the "point" is not something that actually existed out there but is fashioned in our minds. For ideological reasons of our own, the Nixon picture will be reckoned gratuitous or insightful, though in neither case does the picture itself argue a judgment. Even though we see the gauche presidential gesture, it's unclear if anyone in the photograph itself was aware of it, except subliminally. For one thing, no one of the crowd had our present front-row sightlines. But more important, the act did not occur in the guise we perceive it—congealed in time and illusive space. The photographer did not instigate the scene, which would have had no trouble occurring without him. Yet his picture manifests the activity for us as no other record could. We've come to trust the spectacles bruited by such images, even though they would accord very little with our bodily experience had we played a role in them. For we would have been "in time" with the proceedings, swamped by all their confusing, unedited features, instead of outside of it all . . . outside their time.

When photographs are looked at, they are expected to be "comprehensive," that is, to furnish more visual particulars than could have

been noticed in the flesh. Who would deny that the pictures themselves are equipped to furnish such factual dividends by virtue of their mechanical ability to stop time? It's as if everything that was going to fuse into another appearance, or simply vanish past the margin, instead piled up right into the stoppage. One has to imagine the time barrier or snare almost as if it were a physical impediment literally arresting things, luminous phenomena, so that they emerge out of memory or supposition into a permanent "now," where they are at our disposal and can be studied. Of all known visual media, only still photography catches sensations on the wing in this peculiar way: decisively braked, denied any further change or possible destination. In an obvious sense, to have indefinite time or recurring chance to scrutinize something increases the likelihood that it will yield information. Image stasis promotes data output.

It goes without saying that the immobilized subject is fixed precisely in space. It has been brought to a pictorial halt exactly where we see it, and at no other locale. But its fixity is a peculiarly open condition. Where can the thing actually be said to be, except in relation to other things around it? And how can we talk about relative situation, unless by how objects relate to the perimeters of the photograph's field? But the field, in turn, is a questionable area, since it literally didn't exist before the matter that is visualized within it. Suppose you are looking through the viewfinder of a camera at an activity. Until you release the shutter and light is exposed on film, you are dealing with a rectangular opening, a framing device, a viewing potential only, and not a field. The latter only materializes after development, with the subsequent appearance of a print or transparency.

A photograph, with its two-dimensional surface, is the inert, flattened light trace of certain external maneuvers that once occurred. In order to understand the visual experience of the picture, it's appropriate, therefore, to speculate about the processes that brought it about—of which the image is a kind of residue. Often, subject and photographer were more or less perceptibly on the move, and the pictorial field is a sign of the contact they had at a definite point, planned or not, conscious or not. We can say that each of the parties was within range of the other, and this range, whether specified as opening or closing, expresses the spatiality of the scene.

But all along I've been obliged to use other, temporal, references

to describe the photographic act, words like *until, after, before* . . . light had been exposed on film. A search is conducted through the viewfinder. But that process is unknowable except as photographic fields document moments of their own genesis within that search. By the easiest of shading, terminology that conjured up ideas of placement begins to phrase hypotheses about time. It comes naturally (or at least is convenient) to language about photography that metaphors about time and space should seem virtually interchangeable.

A good way to show that kind of transition is to consider the photographic picturing of a live activity which is usually established at close call to the camera and which generally favors the immobility of the subject: a formal portrait. Here, the accent comes down on physiognomic changes that are quite insignificant as markers in space. The search through the viewfinder is internalized, since it is at the service of a psychic interaction whose medium is an unfolding or a convergence of inner states through durations of time. Subject and photographer implicitly clock each other, without any guarantee that the beat they declare will be in unison. A portrait is their joint product, a study in mood that has been tensed, for better or worse, by mutual awareness of a short deadline.

Mood inflects the moment, but, just the same, a viewer cannot say So-and-so felt such-and-such "then." When can the mood, supposing it's even identifiable, be said to have actually taken hold? (I was about to say "taken place.") Accompanying text might be so kind as to give us the year, but rarely will it go so far as to supply the day or the hour. A moment's thought explains why this is so. The occasion of the portrait is defined as a performance within which pictured incidents are detached from each other, without any tendency to summon up a passage in the subject's life. We are not accustomed to take even a suite of images from the same sitting as any kind of narrative of real comportment. They are each of them in a temporal niche, variants on the possibility of a character—so it's meaningless to ask which of them came before and which came after any other one, as if the answer would make any difference to the perception of the subject. Though it evidently occurred at a definite historic moment, the pose itself occupies no ordained position as part of a discrete sequence. As for the "sitter," who certainly pre- and postdated the sitting, this personage is a larger concept than the "subject," who is defined only at

the instant of exposure. Despite being fixed for us, the portrait appearance swims about, unmoored in the sea of the person's singularity.

Something about this usage of the word *subject,* in application to photography, sounds as evasive or rather as provisional as the medium's treatment of time and space. Clearly, much depends on what limits are drawn around that which we are given or desire to see. A human being in a portrait session is a psychic enormity of which we can get only a surface glimpse. But what about a fired bullet as it tears through an apple which is just beginning to erupt with entrance and exit wounds? Harold Edgerton, the great pioneer of strobe light, has provided just such a photograph, and its prettiness stems in large part from a virtually definitive treatment of its subject—all the more as the subject was hitherto invisible.

By subject, here, I am not referring either to the bullet or the apple—common enough objects—but to what the former does to the latter. Or, as Dr. Edgerton himself put it when illustrating a lecture with this image: "How to Make Applesauce at MIT." With the titles for other photographs of comparable violence (for example, *Cutting the Card Quickly* and *Death of a Lightbulb*), this scientist could also afford to be jocular (in his very American way), since he had already been extraordinarily precise. After all, the ignition and duration of exposures, along with the intensity of the light and the area of the frame, had to be infallibly coordinated to depict what happens when a soft object is pierced by a hard one traveling at 2,800 feet per second.

It matters that the event could only be captured whole on film at less than a millionth of a second of exposure. J. B. Priestley remarks on how our time sense is flustered by the thought of such unimaginably tiny durations: ". . . if we demand that any idea of Time should include all . . . things so far outside our scale, from Andromeda to a proton, I believe that we shall begin in confusion . . . and soon end in chaos and madness."[2] Priestley was intuiting the ferocity of events acted out on a time scale not perceived or remembered by the human body, and he was cautioning us about them. Edgerton's killing subject didn't occur in a time scale palpable to us, just as certain very high frequency sounds can't be heard by human ears. But still, Edgerton's event appears before us in such hallucinatory intimacy, described in such tactile detail, that it seems the bullet in flight is as touchable as the apple! So, the amiable, even voluptuous presence of the red-yellow

fruit, an object in our "time and space," is violated by an entirely alien presence, on trajectory through inhuman time. And they both coexist—effect and instantaneous cause, impossible as it had been to see them thus together—for no other reason than to show themselves in this mad, crystalline light.

The apparitional gleam of Edgerton's photographs issued from entirely rationalized, even homely objectives. Strobe is a visualizing technique ideally suited to the production of sequential imagery with diagrammatic implications, since the ultrarapid multiple flash catches succeeding positions of a moving body—a pole-vaulter, a diver—on one negative. The body does make a kind of staggered progress, but only, as it seems, at the photographer's sweet time. He is pleased to confer upon the accelerated object enchanting—because radical—step-by-step delays, ideally allowing each to be compared with the others. From an electromechanical point of view, the Edgerton project has an awesome finesse. From a conceptual vantage, though, it's extremely simple, if not slightly obtuse. Let the following argument from Henri Bergson stand as a critique. Bergson was countering the paradox attributed to the ancient philosopher Zeno which stated that the flight of an arrow is marked by a sequence of positions at any one of which the object is immobile.

> . . . With these successive states, perceived from without as real and no longer as potential immobilities, you will never reconstitute movement. Call them *qualities, forms, positions,* or *intentions,* . . . multiply the number of them . . . let the interval between two consecutive states be infinitely small: before the intervening movement you will always experience the disappointment of the child who tries by clapping his hands together to crush the smoke.[3]

And Bergson goes on:

> The movement slips through the interval, because every attempt to reconstitute change out of states implies the absurd proposition that movement is made of immobilities.[4]

Of course we recognize in the immobilities illuminated by strobe the same absurd state of affairs as in Zeno's propositions. Whether Ed-

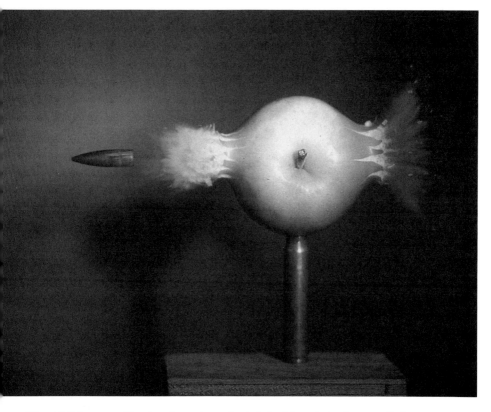

Harold Edgerton, *Shooting the apple,* 1964 (original in color). Courtesy Palm Press, Inc.

gerton's Zeno-esque bias is the inevitable one, to which everything in photography tends (and is therefore not a bias but a norm), or whether photography tells us that all sense of becoming is internal and continuous, is a question that has been debated, not by the scientists but by explicit artists in the medium. Rather than omnisciently clap their hands they tend to fan the smoke.

I have been speaking from a slightly technical viewpoint, but this has only been a way to approach the emotional resonance of space-time mysteries in photography. For the physics of such phenomena is but the inverse of a certain poetry. Edgerton could always be counted on to hatch extra configurations out of thin air and to juggle them gracefully in space. But this is knowingly contrary to our larger sense of a world where the odds are against the retention of energy, and where

events escape and are lost from our control. What of the vanishing of the things we know, and of the consciousness that can be bewitched by that dwindling down? To live within any flow of perceptions is to be impressed by the degrees to which they spread out and get away. As a medium, photography unquestionably acts to store up and hold impressions for later use. Now, however, I want to consider those artists who notice its flaws of retention and acknowledge them as part of an expressive program.

Take, as an example, certain forays in self-portraiture. Here is a genre where the image is understood to be a function of divided consciousness. The subject of the photograph and the one who fashions it, being the same, find that they cannot be in two places at once, and they somehow want to overcome that gap. (I am reminded of a clever ad for travel by Concorde supersonic jet, whose legend reads: "For those who have already arrived!") The self-portraitist looks into a mirror, as did the Canadian artist Michael Snow, or gestures nervously during the countdown by timer, as did Lucas Samaras, Dieter Appelt, Mary Beth Edelson, and Francesca Woodman. What we see are faces or sometimes only blurred bodies, trying to image themselves—as if being behind and in front of the camera, directing and performing, were, in fact, carried on at the same point. The self-portrait is a fantasy of transubstantiation, since the external guise and the inner self-regard of the person at that moment are ideally fused by the photographic act.

One doesn't know whether to respond to Michael Snow's Polaroid-and-mirror piece *Authorization* (1969) as a passive or an engaged exercise on this theme. At first, the work looks schematic, a dry, chronological history of its own genesis. The artist began by taking a photograph of himself and camera, directly facing a mirror. He then repeated the shot, having glued the first one on the mirror in a rectangular zone that he had framed by masking tape. This procedure removed one quadrant (upper left) of the space available for self-depiction. Snow then reiterated the identical step two more times, progressively crowding out his own presence by photographs of himself doing it. Still, we do not think this is a work of committed self-effacement because every time he deletes his reflection Snow comes back again as a "secondary" image. A fifth picture, stuck up in the mirror's corner, portrays the other four and completes the series. Up

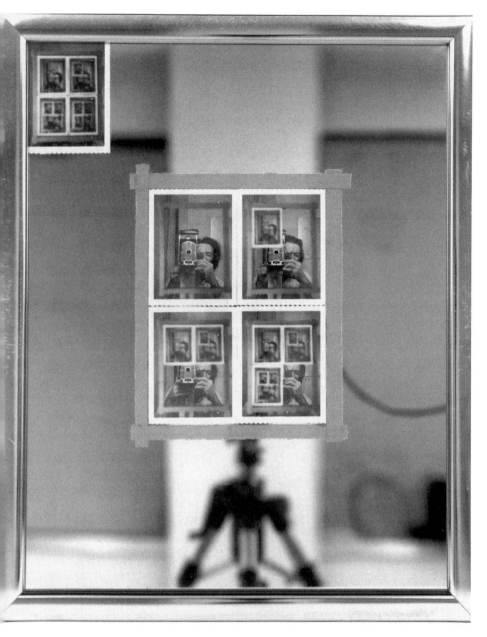

Michael Snow, *Authorization/Autorisation*, 1969. Courtesy National Gallery of
Canada.

to this point, the work can be enjoyed as an ironic comment on any number of things: the banality of the Fotomat pose, a mania for Polaroid replication, or modernism's tetchiness about picture planes. As for Snow's contrast between decreasing "original" and increasing copies, it seems witty enough and rational, by virtue of its clear stages.

But on second thought, the artist's thrust seems darker because of the evident dissolution of his image. It will not have escaped the viewer that a real conflict exists here between focus and out of focus, and that the latter wins. Not only does the fellow get smaller—in decreased partitions—but he becomes dimmer and blurrier until, in the fifth Polaroid, he really can't be made out at all. The truth is that he had to choose between opposed possibilities of the system he was using, and it could only have been a sacrificial choice. He had either to maintain focus on the mirror's surface, where the photographs were, or on his own reflection further into the mirror's illusive depth. The fact that he was loyal to the depth metaphorically sealed his fate. And the fact that he calls the whole reductive effort *Authorization* betokens some of the rue and melancholy of consciousness as it contemplates itself. Snow, after all, is the author who authorizes his disappearance from the scene.

Such a thought-through set piece appears to us now as characteristic of literalist art ideas of the 1960s. In its deliberate entanglement of the process of adding with that of subtracting content from the field, Snow's gesture recalls Jasper Johns's art earlier in that period. With a handling that was demonstrably a sequence of equal steps, none more emphatic or expressive than the next, Johns built up a lumpy surface of waxen marks on which it was made clear that the later ones had no choice but to carpet the earlier ones. If they reacted against this mechanistic approach, seventies artists and photographers—often they interchanged their traditional materials—retained the pessimism of its outlook. The artist's ego was equated with the mortality of the body, and there runs through much of this later work a shudder, as if at the thought that every breathing moment brought one closer to oblivion. In the last fifteen years, a mental alarm of this general kind underlies fantasies of intolerable stress, of levitation and dying falls, of the body resting in suspended animation—a beautiful coma—and of afterlives or rebirths, organic or even earthy in their origin. Still, with reference to individual awareness, the time span of the picture

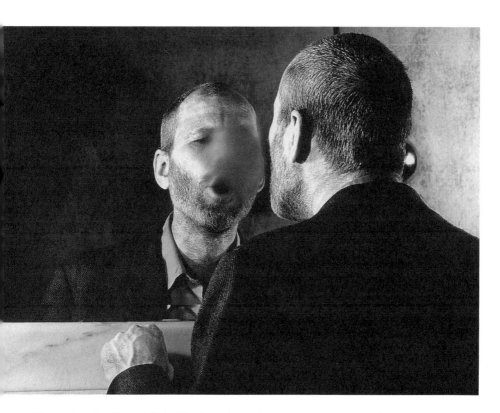

Dieter Appelt, *Der Fleck Aufdem Spiegel,* 1978. Courtesy Galerie Rudolf Kicken, Berlin.

broadens out, sometimes symbolically and always with sensuous result, to draw in the spectator as a companion to the reverie of the artist.

When Dieter Appelt exhaled upon a mirror, the softness of the optical change is communicated as an effect of which we do not see the cause. An open mouth, and then the vague steam that clouds part of the man's mirrored face: these are in dialogue with each other. But they don't comprise the actual subject of the image. Rather, it's impossible not to recall that traditional moment when a mirror was placed near the lips of a person thought to have died. That which condenses—produces vapor, has some kind of pneumatic energy, subtle in its bloom—would signify a life within. Photography here catches the effect of it.

That Appelt more often considers himself in extremis, or beyond the veil of the sensate, is an impression brought out in the main body of his photographs, or rather, his body as reexplored incessantly by

his photographs. The iconography he summons up in this one figure contributes its own accent to a Germanic artistic culture which includes the orgiastic, bloody performances of Herman Nitze, the retarded stranger in the films of Werner Herzog, the messianism of Joseph Beuys, and the spastic photographic capers of Arnulf Rainer. Appelt is a great one for showing himself as a disinterred victim, caked with clay, fibrous, and thoroughly dehydrated. The reference is to a time that stretches way into the past, perhaps into prehistory, of which this pictured cadaver is a remnant.

Of course, one is encouraged to intuit the antiquity of the object by the effect upon it of seemingly natural decay over a long duration. However, since we cannot expect Appelt to go so far in the pursuit of his artistic goal as to commit suicide, some of his corpselike impersonations are suspiciously healthy! The artist cannot allude to his death except as a conscious and living activity—or, in *Monte Isola,* as a rather elaborate and obvious bit of playacting. So much the better for our peace of mind, but also for the poetics at work upon us through Appelt's vision.

Here, the dramaturgy explicitly refers to such things as the petrified victims unearthed at Pompeii or the Danish bog people, of which we always remark that they are so *lifelike.* Overtaken by sudden extinction and then preserved with miraculous freshness, they are like presences that come back to us still instinct with energy over a great divide. Photographs of them never fail to arouse a certain pathos that is also mixed with a sense of the uncanny. One thinks of such subjects as contradictions in terms—as once-living statues. Many of them seem to have died before any knowledge of their deaths had been registered in their attitude. The resemblance between this state of affairs and photography is eerie.

During the seventies, we saw a heightened interest in still photography on the part of many artists. The problem addressed by a fair number of them was what to do with the strange inertness and weight of figures that had been deprived of their buoyancy in time by the photographic act. If they were sculptors or painters, artists were habituated to the purely static character of imagery, and if they were performance people, they knew about the tremors of representation in the sinews of their own bodies. The photo medium offered itself as

new territory, flexible and indeterminate in its operations. It attracted some temporary and some longer-term defectors from art practice who were clearly intrigued by the challenge of restoring to a photographed being a sense of lightness and real motion. Not surprisingly, they associated the kinetic activity of the figure with intense and immediate experience. So the issue was how to take advantage of the instantaneous character of photographic depiction without being saddled by its testimony of the past and, therefore, its historical value.

Only in the phenomena of the dance, and then chiefly in its more delicate numbers, have there appeared figures as fleet-footed as were now sporadically seen in new art photography. Before any of these quickened players were recorded on film, something of their gestural repertory had already been visualized in the 1960s work of Ralph Eugene Meatyard, a Kentucky photographer who invoked an aura of obscure ritual within the theme of children's games. His young subjects may indeed be shown at rest or in settled enough positions, but their heads have abruptly turned or they are flapping their wings. It is hard to tell whether they have pricked up their ears at some untoward signal off-camera, or if the machine has misfired just as they had started up in new action. One reads the figure, or sometimes only an area of it, as a point of soft, luminous vibration in a dark stillness, responsive to an unknown prior event as a tuning fork is to a gentle blow.

Francesca Woodman, herself scarcely more than a child when she undertook a photographic soliloquy on her own person, liquified the body still further, throughout its limbs and reaches. Allegorical and Hellenic fragrances are imported into the homely rooms she uses as backdrops for her silky gambits. (The fact that the walls are often cracked and paint peels from them is probably an inadvertent reprise of Meatyard's work.) Woodman mimes the nude caryatid, the nymph, the bacchante, like a one-girl chorus, as if possessed by their ancient missions. One photograph shows her kneeling on a mirror resting on a bare wooden floor. She appears to have bent down to press her hand on and to gaze into the mirror while the camera's shutter was open, and the move had made indistinct all but her knees and fingers.

The mirror plays a key role in much self-portraiture, and here its junction with the figure must be deliberately reminiscent of the Narcissus myth. Woodman's variants on this story orient the whole mood

Ralph Eugene Meatyard, *Untitled,* 1960. Courtesy Walker Art Center, Minneapolis.

of her art. A youth falls in love with his own image reflected in a pool and then wastes away in a longing and desire impossible to satisfy because his object is himself. The nymph Echo loved Narcissus and could have snapped him out of his problematical state, but she herself had a difficulty, being incapable of saying anything but the last words she had heard. Because Woodman is depicted entwined with door frames or vitrines, her physical activity is hindered by that which encases or would impede it. There's no question that she's in a whirl

Francesca Woodmann, *Untitled, Providence*, 1975–76. Courtesy Shedhalle, Zurich.

or wispy flight, impelled by some urgency, as it seems, that is flustered and droops. The extent to which Woodman suggests intensities of personal displacement is remarkable, for the idea of relinquishment, escape, or release from the corporeal permeates her art, almost as an index of the way her body is melted in light. In Jean Cocteau's film *Orpheus,* the hero, obsessed by the loss of his beloved wife, Eurydice, finds that a mirror is the gateway to that netherworld where she has disappeared. When he reaches out to touch the glass, it dimples and

trembles, giving way to him as water does when entered. Woodman's work assumes a quest for another such medium, through which human passage is perceived as slower and yet freer from gravity than in the air we know.

I hope these remarks about iconography have not seemed to digress from the topic of time in the photographic medium. For I believe a connection exists between a kind of pictorial protest against the solidity of things, which looks forward to their incipient change of state, and the viewer's own sense of the moment. Despite their appreciable differences in program and sensibility, the artists I've just mentioned, and many others, have this one policy in common: they tend to etherealize the figure. The figural dissolve is meant to signify a somehow live transit at the *viewer's* moment of contact with the image, rather than when the transit must have been, at that past moment when it was recorded. It's crucial to insist on this contrast of time zones because the aesthetic of the artists is thoroughly embroiled in it.

How can such an insubstantial and really illusory matter be talked about? Ordinary language shows the way, as, for example, in Mary Beth Edelson's *Raising Firebird Energy,* where it would be quite natural to say that "something moved." The statement recognizes the motion as anomalous. Everything else in the picture has been put on hold but for this one, weirdly exempted thing. The studies Edelson did along these lines suggest a motion that occurred *after* the picture was taken and is therefore, to say the least, suspect. Just as we settle into the peaceful and assuring immobility of the landscape and, of course, the paralysis of photography, the eye catches a flicker, a fluttering shadow, which gainsays the status of the picture itself. With such a blemish, it dawns on the viewer that not everything in the field is available for scrutiny.

If it were a matter of the camera having been jolted, then all the appearances would seem to have streaked or to have been sideswiped by a shift of viewing position. Unlike the lens, the eye does continually scan its objects in order to supplement the minute information given in any one glance. But the scanning takes place so fluidly that the breaks within it are no more remembered or even experienced than the involuntary blinks of the eye. The jolted photograph does not necessarily imply anything about movement "out there" on the ho-

Mary Beth Edelson, *Cliff Hanger*, Montauk, Long Island, 1978 (triptych).

rizon. It transcribes a movement of the machine/perceiver. Since such a picture enacts the scan itself, we don't make out (stabilize) any of the contents. They seem to have taken leave of their erstwhile positions, but it's merely the shock of the camera's departure that comes through, with a horrible vertigo memorialized by the photograph itself.

In contrast, the Edelson photos develop a situation favorable to the leavetaking of only one element, while all the others are restrained. The procedure is very selective. Regarded simply by the effect it produces, that element strikes us as very alien, even more bizarre in

presence than the touchability of Edgerton's bullet in flight. I referred
to that object earlier as traveling in inhuman time. Edelson's specters,
on the other hand, seem to be rising outside photographic time, in a
malignant soufflé. Though they reside in the photograph, they don't
appear to be part of it, and the two are no more to be reconciled with
each other than Bergson with Zeno.

However, one obviously doesn't use the same language to evoke the
effect, as one does to reason through and analyze the cause, of a
phenomenon. A logician's eyebrow would surely have been raised at

the proposal that a feature in a photographic frame is not visualized at the same time as the other features. (We're not talking about collage fields or manipulated prints or double exposures, where temporal heterogeneity is fabricated from different sources.) If we deal with one untampered negative, with one exposure, then we should have one discrete temporal instant represented by the photograph. My metaphor of an impression that had been smoked out a posteriori from frozen pictorial surroundings makes no sense logically, however it may suggest a bodily empathy with a photographic process. But the metaphor

does nevertheless indicate something about the mechanical explanation for the blurred figure.

This motif is by no means unusual in photography nor even a mysterious thing. A more or less wavering passage emerges when the length of the exposure is the same or exceeds the time taken to do the action photographed. Thus, if my one-second handwave (goodbye) is recorded by a one-second photographic exposure, the different hand transitions in space will have had enough time to imprint on the negative an integral, if ragged, back-and-forth swoosh. Or, to put this in reverse, the exposure will have been too slow (or long) to have discriminated the agent from the act. From this follows, just as definitely, the contrary: the shorter (that is, quicker) the exposure, the more likely is the resultant image to fix the agent, or visually separate it from what it did. It would be appropriate to speak of the hand as caught in the act. The interval in time, represented by the picture, is too small for the act to have completed itself. In such a scenario, the choice is between the more or less clear rendering of an incomplete event or the more or less illegible depiction of a filled-out episode.

Behind either of these mechanical determinations there are also cultural innuendos. The history of photography shows that clarity of finish has been the dominant and therefore desired image state, regardless of the cost to narrative understanding of short-term deeds, let alone longer ones. We have to accommodate ourselves to the fact that in our photo culture, the word *subject* functions as a verbal shortcut to designate that which the image did not grasp. Cultural priority, on the contrary, is given to the thing, the physical entity, and the one-at-a-time consideration of objects, even as they are shown simultaneously. This is the case with the miraculous Edgerton, where the bullet shoots through the apple. What is remarkable about that image is that, against extreme odds, it hits on both possibilities, totality of description and completeness of subject. In general, Western photography is an exercise in quantification, through ever greater resolving power in time and space. One should connect the obviously acquisitive thrust of the image campaign with the diminution of exposure times, brought about through a tide of late nineteenth-century inventiveness and scientific curiosity.

Whatever else was implied by this trend, it was predicated on the physical distance and mental detachment of the spectator from pictorial

appearances, the better to conceptualize the information they contained. In contrast, the medium does furnish an alternate set of possibilities, one that stresses psychosomatic engagement with the picture content, fullness of subject, and immersion in the temporal activity of a scene. The spectator is invited into it as one who can give him or herself over to the qualitative aspects of visual experience, realized through dilated photographic exposure. One can almost call this an absorptive form of picture-making, because the camera's field and the eye's glance seem to exhibit some of the same nervous traits of perception, the same restlessness, the same loss of peripheral acuity. Above all, substance itself becomes volatile because it's ambiguous—certain surfaces or volumes or passages are unpredictably spelled out less than others. And, as a result, the field is perceived as if generated upon contact, as if events are imminent, everything coming on at once and some of it discarded or redefined in the process of negotiating oneself through space. So great is the illusive proximity of the figurations that there appears no time to conceptualize anything. The events occur before one has a chance to sort them out. This, of course, would resemble the experience we have of cinema, except—crucially—that the photograph does not augment nor supplement incidents through time.

At the extreme of such a tendency, relishing a literal up-for-grabs spritz of objects across the field, are some very large photographic sequences by Bernhard Blume, such as *Magischer Determinismus* (1976). It's impossible to distinguish the variables in this project, whose ploys included furniture toss, irrelevant shutter speeds, and camera flip. One would have to look far afield to find as much an antithesis of Edgerton's maniacal control as Blume's delirious pandemonium. There's no proper moment of depiction, no single instant when the object of interest comes into view or is made visible. On the contrary inanimate things can be counted on to misbehave spatially, as if the kitchenware, for example, obeyed absurd laws opposite to the ones that keep things down and in their determined places. Blume would have us believe that the very schedule of moving bodies has been sent into disarray. Effects cause effects. Instead of grazing, two objects in midair stick together in wonderful illustration of an asinine physics. Edgerton's world, in which we believe, is a setting for high-speed impact during which shapes are distorted in proportion to the violence of their collision. For every action, said Newton, there is an equal and opposite

reaction. This German artist in contrast tells us that nothing is "equal" and implies that the symmetries imaged by science are the delusions of reason completely marginal to our real dilemmas of perception. The magnetism of these dilemmas is the artistic subject.

A hundred years ago there had not been such a chasm in the exploration of photographic time. In fact, the two tendencies of which I speak had a common pedigree at a moment when the scientific and artistic cultures of the West were in far greater communication than they are now. Everyone had understood that the photograph acted as a memorial record; it now looked as if the camera could be used as a prosthetic device, as if to replace the human eye and to visualize phenomena that were not within its power to observe. One aspect of this prosthesis or extended mechanical capacity was brought out in the work of Eadweard Muybridge. His studies in *Animal Locomotion,* published in 1887, successively decomposed the fluid movements of living bodies in sequentially related frames. Here was the one-image-at-a-time analytic syndrome gathering coherence through the linear aggregation of the frames (twenty-four in two horizontal tiers of twelve). As for his colleague, the French physiologist Etienne-Jules Marey, a comparable impulse to explore the rhythms and pulses of motion had led to a more synthetic project. Marey's chronophotography not only utilized very fast exposures but bunched them in the same field so that they were variously superimposed. One had to become newly literate in this kind of simultaneity by above all keeping in mind the onward flow of the figure. It wasn't to be imagined that the same bicyclist's body (or part of it) appeared in two different places at once but rather that one witnessed, howbeit in stilled form, the actual displacements of the same body at different points through time. This was certainly a more dynamic concept than Muybridge's. Instead of building up separate images into the one construct Marey injected several temporal intervals into the one image.

From our perspective, it is possible to see what were the critical limits to these time-space explorations of bodily movement. Whether analytic or synthetic, the pictorial program was conditioned by the peculiar economy of still photography, namely that it stored temporal events that could not be relayed in real time. Though clearly a capital gain, the dynamic impression was not a liquid asset. If one wanted to pursue the direction opened up by Marey, it could only be done at

increasing cost to the information that his special camera gun had been devised to record in the first place. When Marey accented the pattern character of the pictorial flow, he emphasized the aesthetic pleasure to be gotten from what were still presumed to be diagrammatic exercises. Measured by what he ostensibly wanted to do with it, the medium of still photography was recalcitrant. He had opted for a course halfway between the ponderous linearity of Muybridge and the frameless, fluid "recomposition" of the cinema, i.e., an actually moving, and therefore temporal, photographic medium.

In Marey's work one finds lapsed contours or discreet smears; in the work of the Futurist photographers, the Bragaglia brothers, the pictorial effects go further into emotive froths that had been primarily decorative, melodic, and abstract when first elaborated by the French scientist. Influenced by theories of empathy and the techno-euphoria of the pre-First World War era, the photodynamics of the Bragaglias, with their bravura phrasing, were caught up with the kinesthetic aura of motion. In one photograph, a cellist saws away, certainly to demonstrate what cellists do, while multiple or extended exposures would graph something of his process. Having noted that, however, the viewer comes from the image with the feeling that the visual swaths were also meant to evoke the sound of the instrument itself. Such images show that the static imprint of concerted movements through time created "interferences" that were appreciated for their own sake. Agent and act, neither wholly differentiated, crossed through each other, producing a kind of visual noise.

Here, at least in embryo, were the visual principles that were to be articulated in the 1970s work of the photographers of the etherealized figure, such as Woodman and Edelson. As soon as they're considered together, however, their differences of conceptual as well as historical and expressive outlook assert themselves. One hardly needs to pause at the "sonic" contrasts, for the later American imagery is decidedly quietist in mood. There steals through this work a much more intimate and private sense of the naked human body than in those earlier studies, where nakedness was simply a prerequisite for the clarity needed to demonstrate the flexings of anatomy in space. Muybridge's classic questions—What muscles were involved? What positions were taken?—were obscured in Futurism, though it, too, had a quasi-scientific rationale. The Futurists operated within the

gravitational field of "experimentation." A glance at Alvin Langdon Coburn's 1916 portrait of Ezra Pound (whose Vorticism was an English alternative to Futurism) reveals that empirical spirit at work as it superimposes three Pounds, at three different scales, and, by implication, three distances from the camera. Spearheaded by the aggressive flanges of his repeated shirt collar, the subject seems either to have rapidly advanced or backed away, in either case with equal momentum. No doubt the "vibrations" that have been set off, as if in the wake of that activity, could also have symbolized the mental power of the celebrated avantgardist.

Contrarily, it's the drainage of such power from the face of a cultural icon of our time that Duane Michals shows in his triple portrait of Andy Warhol (1973). The countenance of Warhol vaporizes before our eyes, the result of progressively longer exposures of his shaken head. Warhol, one might say, is blown out, like a match. If his fixated or horrified grimace in the first portrait is any sign, the worst of it is that the subject seems aghast at what is about to happen.

When I asked Michals about this work, he said that while he was well acquainted with Warhol, absolutely no one could have known him. "Warhol was not there." That impression went beyond the famous recessiveness and cipherlike qualities of his being. Warhol simply lacked knowability, as if this were an attribute one could do without. He appeared to Michals as a contradiction in terms, an absentee presence. A perception of this kind, radically expanded—that we are not present in our own flesh, that reality is a dream, that death and life are reversible states—keys Duane Michals's narrative photo-sequences. All of them evolve out of, and sometimes revolve around, the phenomena of moving bodies, truly ineffable now in their lightness. *The Spirit Leaves the Body* (1968) demonstrates its title with a concision that Edgerton might envy, if that engineer could ever conceive things without their "heavy" physical behavior or in undefined states. From the stretched-out naked body of a man on a bed, there emerges in Michals's sequence a shadowy, double-exposed man who sits up, stands, and then walks out of the frame, presumably into the viewer's space, leaving the tableau exactly as it was at the start. One winds up at the beginning, a situation interchangeable, indeed indistinguishable from the end. But everything has been altered in the attitude of the receptive viewer, now puzzling the distinction between X, who could have been

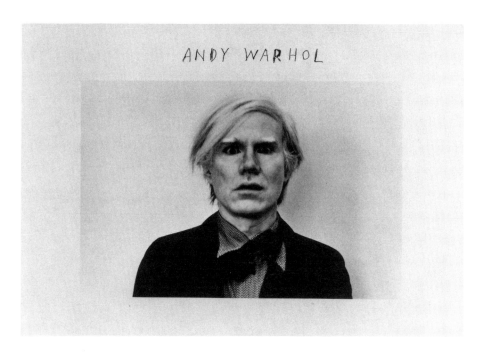

Duane Michals, *Andy Warhol,* 1973 (triptych). Courtesy Walker Art Center, Minneapolis.

sleeping or posing, and X's weighted body, an object only. Michals has written, "Everything is going; yes, even you must go. Right now you are going. Right now!" And: "We must touch each other to stay human. Touch is the only thing that can save us." And: "I am compulsive in my preoccupation with death. In some way I am preparing myself for my own death. Yet if someone would put a gun in my stomach, I would pee in my pants. All my metaphysical speculations would get wet!"[5]

However occasionally nebulous his imagery, an artist who can make such remarks is not lost in the clouds. Compelled to touch each other, in the affective as well as the physical sense, his characters have to reassure themselves that things are as they look. The sight of the creatures and objects around us is all very well, but it is touch that accredits them. Like Thomas who, in his doubt, reached out to feel the risen Christ, these people fear that their desire for solidity may not be found in reason. Their hands are in one place, and their minds are in another. With every poetic resource at his disposal (and that includes text), Michals wants to transfer that dualism of consciousness to viewers, as they, too, confront the uncertainty of being. Just as in

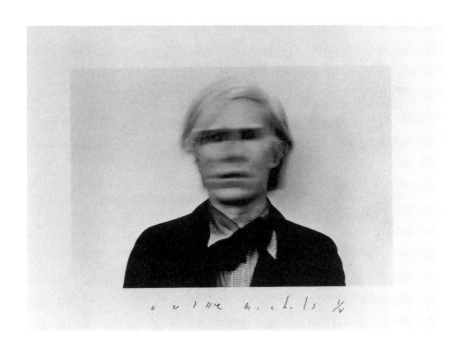

"Andy Warhol" Michals ½

language he makes the abstract concrete (i.e., "wet speculations"), so in his pictures the intangible materializes—but to what effect? If it were exclusively a matter of feeling, the actual sight of death, incarnated by an old man who comes for the old lady, would cause dismay. But in Michals's world there is hardly any arrival without a departure, and departures are an affront to *reason* because they remind us of our mortality. Every thing or creature that escapes touch puts reality in question, a dilemma that is treated here with a softening of contour and darkening of tone that is extraordinarily tender. People can even eat each other or strike from behind, but they don't seem to make contact with anything but rumpled shadows. As we look, the knowledge of the apparent physical violence conflicts with the impression of immateriality. Finally, the contents of the tableaux seem to be locked in a spell, and if that is so, it can only be the spell of photography.

One might speak of it as the enchantment of the disappeared contour. Velocity, as recorded by slow exposure on film, though it will register only change or becoming, is regarded by Michals as a form of eventual extinction. His characters are sometimes dissolved in light or enveloped in darkness, which allows them to slip away under

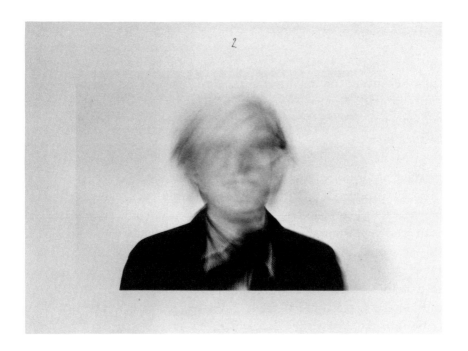

external cover. Mainly, though, they take a powder into their own tonal activity. They settle in or lift off in a flash or a torrent of such tones, as does the old lady when crossed by death. As seen elsewhere, by photographers, the progress of figures is viewed as an extendable event—and why not?—but in Michals's work their passage is visualized as an attrition, hastened by the doubt of onlookers both within and outside the frame, who are encouraged to think of perceptual reality as in short supply. There is no way for us to touch the people depicted in the photograph or reach out to them, across the time and space which separate us. The wonder of it is that they themselves seem to be aware of the same frustration, for their every energy strives to overcome it. Each time action is taken, a bodily zone is visibly aerated, and since the figures were originally discrete, their stock of substance is exhaustible. To move, in Michals's world is to be depleted.

This is a particularly horrendous deficit because it is inseparable from or even more, is an outcome of, a main human function. I am reminded of a dilemma in the historical genesis of photography itself. Every time William Henry Fox Talbot, the calotype's inventor, re-examined his earliest "photogenic drawings," that is, re-exposed them

to light, they darkened. He had not yet found a way of stopping the light sensitivity of the silver nitrate with which he had coated the paper ground. Repeated eye contact with the image had an Orphean consequence: one could not look without the object of sight receding further into the void.

In Michals's case, photography has been understood very well as a product of an immaterial agent that was artificially conserved. He is quite prepared to admit that what is brought back, conserved, does not necessarily have to resemble what we see, or could have seen. The man who walks out the door is "alive," but the man who comes back in that same door, and who is now a blur, is alleged to be "dead". How can it be denied that the blur itself is a new impression never seen before except in photography? Photographers are students of movement, apprenticed to light as their only teacher. The man who came into the room, the "dead" man, has arrived.

It doesn't disturb Michals that this arrival is a photographic chimera, and that it does not establish anything more than an aberrant deposit of light. This artist, who has been so frequently and rightly accused of a literary bent, here emphasizes his adherence to a purely optical potential of his medium. Entirely within character, he argues that since appearances themselves are questionable, he is entitled to make free with them. Far from acknowledging any category of *normal* perception, he insists that what the eye sees and what the lens views are equally arbitrary versions of what is beyond them. The door opens and the door closes, but as far as Michals is concerned, it might just as well be a revolving door.

To the extent that they're successful, Michals's metaphors depend for their appeal on a kind of symbolism that equates certain characteristics of photographic description with our physiological empathies. For example: the way we identify our sense of life with substance that has inner motility, or the way we perceive time as an awakening to the "pulse" of events. The photographic image brings us close to these feeling-states, but because close, still achingly removed from them. It had always been like this, but few practitioners have reflected upon such irrevocable distance as their expressive base. The subjects of Michals's work appear to be reaching out merely into their own delirium, panic, or unfulfillable desire, so that they're inevitably revealed

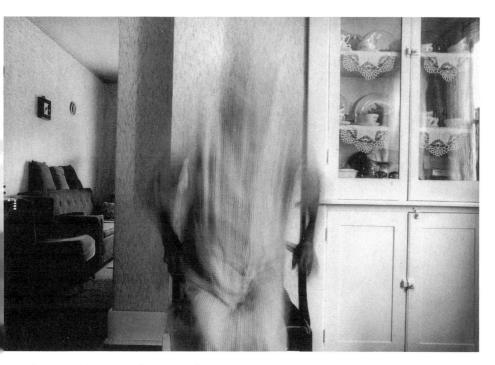

Duane Michals, *Death Comes to the Old Lady*, 1969.

as narcissists or as onanists, aroused at the discovery that they are their own objects.

In Michals's hands, Narcissus is a fable of paternity, in which the beautiful youth, looking into the mirrored surface, turns into the aging artist who dreams the youth's reflection as his unborn son. There have been many images of time's passing in visual art, but this implicitly homosexual one is among the most beautiful. All of Michals's art is illuminated by the premise that like seeks out like, a short step to the thought that consciousness projects only its own images. Despite their flailings, many of his characters, humbled or degraded when they transgress with their appetite, are only too happy if they can return to their fantasy. They can only be affected, in short, by what they have already conjured. Beyond the confines of their room, often within that room when strangers enter, they lose their bearings. They retreat, as in *Private Acts* (1973), to a meditation on past and present in which the word *then* is triumphantly equated with the word *now*. And this miraculous occurrence takes place, Michals suggests, when

we encounter *that which had been* as a moment of our current experience; that is, when we look into a photograph.

Borne along by the continuum in which we find ourselves, and of which life knows so little, we're oriented by the forms around us, though they are not bound in by any field and though they are in constant change. Try as some of them may to zip past the viewfinder, we have the means to track a few of them down. If the phenomena out there don't know their place we will establish it for them. As soon as that happens, the frame ceases to be a moot enclosure and is changed into a zone of potential meaning.

The transitory sweep of lived experience leaves an undertow that photographers wish to bring to a visible surface. At first they could only conceive of a metric approach to the problem of representing the elapse of time through the movement of forms. Gradually that method of report broke down into styles of dark evocation. In retrospect, the metamorphosis can seem the product of a pessimistic strain in recent culture, maybe even despair. But this would be to overlook our own physical limitations.

The reference points in this study are our eyes and brains, the camera apparatus, and the outer world, that is, natural and artificial sensors and their objects. The sensors do not at all yield the same kind of data, nor work within the same durations of time. Neither kind of sensor is commensurate with the other nor with what they take in. Our perceptual equipment is too impatient to apprehend the ratio of the apple's decay, for instance, and yet not acute enough to locate the bullet's course through time. Photography is a tool that is seductive because of its apparent sharpening of our viewing capacity, so that by its use we think that we can "catch up" to that which has gone by too fast. But a photograph can also be exposed much more slowly than at the rate at which we perceive activities. In which case, it's often considered to have muffed its chance to gain a sighting. Of course photographs are not outcomes of our perception at all but merely record the way *they* have ingested light. Human egocentrism, if it were still fresh to these things, should be taken aback at photographic images snapped at quite alien rates of exposure.

Like the space shuttle or rocket nose cones that have to reenter the earth's atmosphere at exact angles, so we discern movement only within

a very tight time slot. If it dawdles too much, the speed of certain active bodies, like an hour hand, will fail to make an impression on us, and if they exceed a slow velocity such bodies will be rendered invisible, as is a spinning propeller. Time, in the latter situation, "evens out"; we can't even guess how much of it is involved to complete any separate event nor even what that event might be. Since it's not biologically engendered, the photograph has no instinct to carry on its work nor to contain events; it merely cuts into time, the continuum, in a peculiar way, and with that act, supposing that it is done with real dispatch or true sluggishness (to our mind's eye), a consciousness of temporal "extremes" is brought within public range as never before.

At either end represented by those extremes there seems to be a wish fulfillment expressive of our conflicted drives. We expend energy developing high-speed photographic systems in order to further our understanding of the physical environment and, of course, to control it. This is a dream of power, even of eventual omniscience. The information input will be recycled back as manipulative output. But for those who regard photographs as a means to increase their emotional knowledge, the time cuts represent a psychic adventure. *And this is more a dream of wisdom than of power.* The vanishing presence and the etherealized figure, insofar as they are conceived by artists, are phenomena that we think we see and don't see at the same time. The process that brings them into two-dimensional open space is not one spurred by Faustian acquisitiveness but is kindled by a desire for anomaly and allegation. As it simultaneously dissolves and leaves some trace of itself, the figure comes to seem like an alter ego of our condition. It depends on what the viewer wants from the photopicture: to peer into it as at the things of the world, perhaps using the image to sublimate the will to possess; or to look into those sacramental tones to see where our limits have been and to prepare us for the end of our game.

Notes

1. Harold Evans, ed., *Pictures on a Page* (New York: Holt, Rinehart and Winston, 1978), p. 106.

2. J. B. Priestley, *Man and Time* (New York: Dell, 1968), p. 52.

3. Henri Bergson, *Creative Evolution,* trans. Arthur Mitchell (New York: Modern Library, 1944), p. 334.

4. Ibid., p. 335.

5. Duane Michals, *Real Dream: Photo Stories* (Danbury, N.H.: Addison House, 1976), p. 5.

This essay appeared in the book *Vanishing Presence* (Minneapolis and New York: Walker Art Center and Rizzoli, 1989).

The Dream Mill in the History of Photography

HOLLYWOOD FILM stills have an obvious importance as a collective index of social values, but few writers have studied the peculiar evocations they offer as photographs in their own right. From 1927 on, for instance, they established a separate category, different from photographs of plays which they otherwise resembled closely. Of no other pictorial medium, aside from the movies themselves, could it be said that the people depicted were already known by their voices as well as their gestures and walk.

Viewers could now bring their memory of sound to the associations that resonated from the glossy pictures in the theater lobby. One had only to look at the icon of Garbo or Grant or Bogart to anticipate their familiar vocal presence. Their voices were blended with their visual style, the one as much an entertainment trademark as the other. During the era of the silent films, the public could only fantasize about the utterance of the eerily quiet stars. Stills, though immobile, were therefore on a level with the movies themselves, mute and given to physiognomic overemphasis to dramatize narrative concerns. With the advent of sound, the stills—for all that they supplied just as much information as before—were at a disadvantage when contrasted with the plenitude of script and music that orchestrated the visual product they advertised. They were comparatively less articulate than their predecessors in the early silent days, but they became more of a tease. Producers knew very well that filmgoers would contribute imaginative possibilities of which the reductive photographs could only hint.

Many American photographs of ordinary life in the 1940s showed people listening to the radio—a discursive transmission in which voices come to us without faces. By the next decade, the "golden age" of radio was supplanted by the "golden age" of television. The photos that dealt with radio had to do with family. They pictured how the instrument knitted members of one, and by implication all such groups together in a common ritual. Some photographs that treated TV in the 1950s, such as by Robert Frank and Dan Weiner, were more involved with the technology of artifice—how display and spectacle were managed for distant audiences. In its then awkward live performances, television recapitulated that first uncertain stage in which the silent film struggled to define itself within the gravitational field of the legitimate theater. If it had nothing yet of the technical suavity of the movies, nor the sweep of Cinerama, the TV screen nevertheless rapidly joined forces with all those media that socialized the American populace. Definitely included in this roster were the big magazines such as *Life* and *Look,* whose photo essays often reported on Hollywood for the mass public. They all brought forth idealized images, not to say outright, self-regarding myths, of who we were, and broadcast them with characteristically overwrought style to the rest of the world. Film stills had a significant, but also a most equivocal place in this media environment.

To begin with, they belong to that large set of images whose contents had no function or even existence except to be photographed. We can group them with certain advertising photographs whose material power of comprehension contrasts with the ephemerality of the mood they try to elicit. For instance, the satisfaction of smoking. The similarity between elaborate production conditions in the film and the commercial studio hardly needs to be stressed. Especially were they aligned in their common use of glamorous lighting. But the storytelling role of the still far exceeds that of the commercial photo; it demands singular expositional qualities of the image. Further, the still doesn't purport to be a setup in its own right, with its own textual boundaries, but derives unclearly from a larger artifact. Nominally, what we see in a still depicts a reality, but is in fact some kind of gloss on a separate and completed representation—the movie itself. Until Cindy Sherman alienated the genre for her own alarmed artistic purposes, no one had heard of a film still generated independently of a movie. As with

bombastic previews or trailers, the image's whole point derived from its presumed saturation by the finished product. That is why we consulted such pictures during the "golden age" of stills. They could not compete with the schematic luridness of full color movie posters, but they imparted some of the actual texture and flavor of the thing we wanted to see. Previews often give a distorted, inflamed, or un-balanced impression of a film's contents, through a sampling of phys-ical action only. Stills, contrarily, could only give emblematic value to action, and therefore necessarily underplay the kinetic impact of the film.

In retrospect, it perhaps doesn't matter that we were often mistaken about the origin of the still in the realized fiction of the movie. Or misremember the cues given by the pictures themselves. Certainly there were a fair number of cast portraits among the stills in the theater lobby. To go through public collections of film stills is to view alternate re-enactments of a scene, and from angles other than the one that came to be known. Occasionally, too, a mimeographed note will speak of a shot as one within a numbered continuity layout, evidently a worked-up story board of an episode in photographic form. I have also seen variant clusters of studio photographs that attempt to stereotype a character through lighting. Such were the none-too-successful but naively charming studies of Virginia Mayo as a floozy in William Wyler's *The Best Years of Our Lives* (1946). In contrast with the de-pressing wholesomeness of the other players, she was enveloped in an extravagant chiaroscuro in order to symbolize her sinful frivolity. From such diverse, in-process functions, which check or second guess a scenario, evolved a stylized imagery that had unstable relation to its sources. But it was credible to prepared audiences who were looking, finally, not for accuracy of contact, but evocation of atmosphere.

Whatever it led us to expect, the still photograph nevertheless failed to deliver. It's not simply that its allusions were so discontinuous and piecemeal. The foretaste it gave us of the film was inevitably random when judged by the memory we took away from the theater. Even now, it remains a puzzle as to how distributors imagined that the emphases retailed in the stills would correspond to the outline of the film plot. Singly or even in a group, stills offered very few opportunities for narrative highlight. One thing, certainly, can be noted: the staple of dramaturgy in these pictures is conversation, and the meaningful

glances that ricochet among its participants. As a result, viewers were motivated by their appetite for text as much as or even more than by their desire to see. The ellipsis and hiatus of dialogue were almost painful to contemplate. So the stills chronically whispered of event outside the frame, of material that was absent.

But they could never convert that absence into pathos. Photographs continually reacquaint us with pathos because they literally extrapolate from time and space, appearances of the past that are forever irrecoverable except in memory. There is always something precious about them in this respect, and they age well. But film stills do not age attractively in this way because they are marooned between the historicity of record and the fiction of the set. The deliberate or unforeseen poignance of simple observation is beyond them. Rather, they purvey an innocent, and, as time goes on, a grating devotion to the insufficiency of their own deceits. All the dramatic juice is drained out of them as actors pose under stressful demands and hot lights. Weirdly enough, the film still is at the same time over-determined and understated—by which I mean that its rhetoric quickly came to seem inexpressive. Even on its premiere, once its invitation was accepted, the picture was immediately exhausted of interest. We can very possibly be fond of stills, of course, when we love the film from which they stem. And as we return to them in that mood, they can give us extra dividends of information. So, for example, it is now possible to reconfirm exactly what kind of violent photographs Hitchcock fancied to be the work of his hero, the photojournalist Jeff (James Stewart), in *Rear Window*. Beyond their use as a simple aide-memoire, film stills can also be enjoyed for their often sensational pretenses, and therefore, as particularly ripe instances of camp sensibility.

But their significance for us now exceeds whatever value they may have as the degraded kitsch or outdated flummery of a bygone era. In fact, to speak of them on this level is to do them a disservice. If one shifts from their psycho-dynamics and reinserts them into the history of photography, where they do their work as a distinct type of image, they straightaway take on their proper importance. This is not to put aside the sentiments they individually inspired, or their visual qualities, but rather to see such aspects of the stills in the cultural context of image production overall. Even in their satellite status to the movies, their presence as sometimes only cryptic footnotes, what was there to

compete with stills as a massive archive of American attitudes, manners, data, and dreams on a national level? Think of the great patrons of American photography in the twentieth century: Condé Nast with his fashion empire, Henry Luce and his publications, *Time, Life, Fortune,* the Farm Security Administration photographs of the depression, sponsored by the Roosevelt government, the Esso Oil commission, *National Geographic,* and so on. Mighty as were these campaigns, they never had the scope nor the impact of Hollywood film stills in the coverage of our mores. A hypertense mimicry mingled with a relentless fictionalization of American lifestyles in these Hollywood photographs, with an effect that was as stupendous at home as it was consequential abroad.

Native viewers assimilated the content of this imagery with the greatest of ease because they were familiar with its visual dialect and its situations. No one had to be introduced to the local bullies figured in *Bad Day at Black Rock,* directed by John Sturges in 1955. Such characters were fixtures in several thematically related films, and could well have accorded with the experience of an impressive number of filmgoers. Here was a movie that updated the classic Western and fused it with a noire murder mystery. Its wounded, World War II veteran was threatened by civilian thugs in a menaced town. Sturges's film recalls George Stevens's *Shane,* two years earlier, and it anticipates *First Blood,* featuring Sylvester Stallone's Rambo, more than twenty years later. American heroes had fought to save the world for "democracy," and now, at home, they were challenged by brutish elements whom they singlehandedly combatted with real ferocity, obviously outside the law. These paradoxical continuities of our narcissism and guilt did not have to be restricted to American subject matter to be in the native grain. The popularity, during the 1950s, of Hollywood films dealing with the life of Jesus or the prime of the Roman Empire gave an American tilt to representations of world history, and also speaks to the Pax Americana effected by the Cold War presidents. Film stills were at the forefront of assistance to this gigantic cultural aggrandizement.

Features of their operation, in fact, resemble propaganda, one of whose requirements is ubiquity of transmission. Here, Hollywood, from the first, was extremely privileged. When the studios owned most of the theaters, they were guaranteed free round-the-clock ex-

hibition of their publicity photographs. The fan magazines and other media amplified image output and furthered their distribution. It helped that all this took place during an era of expanding technology and absorbent markets, which contributed decisive momentum to the onslaught of films heralded by the stills.

Since the fall of Communism in Europe, the geopolitical implications of our popular culture have been particularly revealed. Without actual intent or government censorship—though certainly affected by sexual taboos and economic restraints—the movies proclaimed to a deprived world the abundance of goods available in our system, along with the dazzling options of a free people. Nothing could have been more seductive, especially given the fact that Hollywood dominated foreign distribution. Even in the 1930s, the heroic peasant or worker of the Soviet cinema was totally outclassed by Astaire and Rogers, as they captivated an international public. Pop cult won out entirely over Proletkult in the drawn-out cultural clash of the superpowers. From an ideological standpoint, the beauty of the Hollywood movie in exporting American values lies in its obvious "lightness" as an entertainment product. Unlike actual propaganda, the make-believe of entertainment could not be held to account, either by any political cause or obligation to fact. All the more could Hollywood culture spread essential truths about American people, deeply invested in their own fantasies. There could be no doubt of the profound contradictions of these fantasies—for example, those that showed American power manias and moral insecurities to be reflections of each other. What, after all, did it mean to be asked to sympathize both with the Roman tribune and the early Christian martyr, historical opponents yet also erstwhile movie friends or even lovers? Hollywood film manifested the conflict between the desired and the principled course of action—a Victorian paradigm—only to confuse or reconcile them unconvincingly in its fictions. Naturally, stills could no more than hint at this tense content, for they were more iconic than narrative. But in the conflict between the logic of their own invention and their references to the real world, they paralleled the fascinating difficulties of the movies.

Looking at these images, one finds a consistent preference for hard edges over soft focus, and rare is the lighted plane ill-defined within the depth of field. It is a style appropriate to the operating theater, clinical, rigged for utterly precise disclosure of channeled or masked-

off material. The meticulous description of objects seems almost to give an inventory of props that ordinarily escape the viewers' gaze in the swim of the movie. In fact, the ponderous, dissociated view camera stills purvey a nineteenth-century aesthetic of scrutiny quite at odds with the quickness of the modern cinematic pan or track shot. But at the same time, the highly crafted syntax of light increasingly takes over the role played by excessive body language in the older, stage-influenced silent films. This histrionic lighting (for example, the heist scene in *Asphalt Jungle*) would be just as obvious as the earlier, strenuous acting style, except that we can't hold on to it in the films as we do in the stills. (For a long time, it would have been as inconceivable to have dispensed with such gaffing techniques as it would be unthinkable for men of the period to leave their homes without their hats.) So, we have an obsessive detailing and centered design, whose realist premise is countered by a turgid luminism.

But the artifices of this pictorial style were not confined to the film set. Just as they were derived from earlier moments of photographic tradition, they also had their effect on contemporary practice. In constructing the scenography, sometimes even the mood of a movie, studio planners needed visual sources of historical information, and they were glad to find it in documentary photography. *Gone with the Wind,* a case in point, certainly owes something to George Barnard's photographs of Sherman's campaign in Civil War Georgia. The general relation between the film still and the movie is self-evident, but the dialectic between the still and photographs in other genres reveals something equally enlightening about American visual culture. In both instances, of course, the still is faithful to scenes already represented, by models at each side of its professional horizon. That is what makes film stills objects of interest to postmodernists who concern themselves with simulacra, facsimile, and image appropriation.

The torrent of research that often informs such pictures was necessary because they *allude* to and *recall* rather than witness scenes of which they otherwise give an indexical trace. John Ford's *Grapes of Wrath* (1940), was certainly constructed with a very attentive eye given to Dorothea Lange's FSA photographs, and to Horace Bristol's, of migrant farm laborers in California camps. When the latter's work was published in *Life* to illustrate the historical accuracy of Ford's film, it was as an acknowledgment of the movie's power to sway public sentiment,

an effect certainly greater even than John Steinbeck's best-selling book, let alone the actual photographic testimony of the depression itself. Consulting the stills today, I notice their remarkable charade of Lange's arresting images, but also "errors" such as a wretched farm woman's perfect coiffure, and the cleanest jeans on dusty people. Visually, the film was a tribute to the work of photographic investigators who first brought the plight of the migrants to national attention. But, for the true squalor of the subject to sink in, there needed to be a little greasepaint in the grime.

While the cinematic treatment of story was the source of the movies' appeal, the stills tell us of an equally forceful taste for explicit description of immobilized things and figures, an indigenous trait in American visual culture. But the description, alone, was symbolically inert. It had to be given heroic, or at least expressive profiles and depths, no matter how little they corresponded to the surprises of optical perception itself. On behalf of that perception, the modernist Moholy-Nagy complained of hyper-finish in American photography as early as the 1920s.

The finish had deep roots in the photography of the last century, but it flourishes equally well in ours. With a now characteristically romantic posture, one sees it in the work of Edward Steichen, Ansel Adams, Eugene Smith, and even in the brilliant cartoons of Weegee. A stilted version of it also appears in commercial studio work of the 1940s and 1950s, such as Ralph Bartholomew's, and O. Winston Link's epic homage to the last steam engines. With the exception of Weegee, who reported on the New York underworld, they all implied that an American dream would prevail. This was the era of American happiness poses, the age of Wrigley Spearmint gum, and toothy film musicals. Regardless of differences in their style, these photographers exhibit a theatrical sensibility kindred with that in the movie studio, where actual experience is portrayed at several removes. They gave to the genre of the still a certain kind of outside credence, but they may also have possibly taken unconscious lessons from it. Incalculable in their influence as guides to behavior, Hollywood stills have had a tremendous impact in depicting the whole world as a stage.

This essay appeared in *Film Stills: Emotions Made in Hollywood* (Museum für Gestaltung, Zurich), 1993.

David Levinthal, *Modern Romance,* 1985. Courtesy Laurence
Miller Gallery.

Bruce Charlesworth, #44 from "Man and Nature," 1989, Cibachrome print, 40 x 40 in. Courtesy Jayne H. Baum Gallery, New York.

Sandy Skoglund, *The Green House,* 1990, Cibachrome print, 50 x 70 in.
Courtesy Janet Borden, New York.

Patrick Nagatani and Andree Tracy, *Trinitite Tempest,* 1988, Polaroid
24 x 20 in. Polacolor print. Courtesy Jayne H. Baum Gallery, New York.

Hapless Figures in an Artificial Storm

The friends who met here and embraced are gone,
Each to his own mistake.
W.H. AUDEN

TOWARD THE end of our twentieth century, in a bleak
public atmosphere of unremitting entertainment, many vis-
ual artists see themselves as locked in unequal combat with
the smiling media. During its modern past, art has had to
slip out from the grasp of decayed and repressive structures. It has
pried open the grip of the salon or the academy, and of other, more
recent state-sponsored cultural controls that have uncertainly contin-
ued to the present day, loosening in such traditional sites as Russia
but tightening here. Simultaneously, artists have had to compete for
social status within an explosive outreach of communications that
almost literally atomizes all personal statement. Distanced by aug-
mented technical systems, daunted by the massive publics accessed
through satellite, artists have been hard put to treat of any subjects
not already trivialized by the Western media. Like certain jeans pre-
shrunk for sale, their world seems composed of spectacle that has been
preexhausted of content.

If one happens to be an emergent artist of reformist temper, what
is to be done to confront this environment? To speak out beyond his
or her historical confinement has been a repeated mission of the con-
cerned artist, and it has never been more quizzical than at this con-
temporary moment, which thoroughly inundates political critique in
a confused space. An artistic signal is a specially privileged and also—
to the extent that it's highly professionalized—an abstruse utterance.
One might try to enter the indifferent systems where art escapes notice,
unless it fetches wild prices. Or, more often, one takes a safer route

into an intensive art enclave that is sometimes perceived as a tainted context. Lacking impact upon the larger world, except when their work is judged obscene or blasphemous, artists also feel in danger of running aground in the shallowness of meaning in which the media swim. There is no sense, anymore, of an appropriate audience. During the Reagan years, the once confident dream of artistic power can be said to have waned, and with it, the prestige of the Modernist avant-gardes. Somehow the line between protesting and reflecting the status quo, in the galleries, has been blurred. It has become increasingly difficult for an elite culture to take a stand outside its own tradition of cultivated ambiguity, or the host culture's amorphous passivity. This is a serious dilemma, and one must sympathize with anyone entangled in its net.

As for the media begotten for and by the host culture, they can't, of course, be located at distinct points because they are pervasive, ingested as indiscriminately as the polluted air we breathe. At the same time that they become ultraslick in their presentation, they are inherently discordant in their messages. Mark Crispin Miller, repeating a plaint already voiced in the seventies, writes:

> Is it possible that no contrast, however violent, could jolt TV's overseasoned audience, for whom discontinuity, disjointedness are themselves the norm; a spectacle that no stark images could shatter, because it comes already shattered. TV ceaselessly disrupts itself . . . as a strategy to keep the viewer semihypnotized. Through its monotonous aesthetic of incessant change, TV may make actual change unrecognizable, offering, in every quiet living room, a cool parody of the Heraclitean fire.[1]

Given a TV atmosphere where presidents exchange greetings with apparently off-camera but actually nonexistent audiences, and where reporters harass a subject about his or her reaction to a pressure that they themselves have created, we are schooled to detach cause from effect, or, rather, to see around us only a contagion of effects. Miller observes about advertising that, like propaganda, it wants to "startle its beholders without really being noticed by them."[2] To do justice to these phenomena, especially their psychological impress, I would speak in oxymorons, of such states as . . . riveted noninvolvement.

Who would take the trouble to expose the countless unexplained gaps and illogicalities in any TV story, since only its tedious excitement counts? Is an event represented because it has consequence, or is consequence limited to the representation? And what about the events that aren't filmed? Because it is backed by multiple sponsors, affected by ratings, vulnerable to special interests, managed by corporate heads, and, above all, subject to its own formalized and proliferating conventions, broadcast narrative appears as a puree of artifice, of simulated activities that are interchangeable. In such charades, social reality is consumed by arbitrary and stereotyped images accompanied by judgmental texts.

What opportunities and also what treacheries lie in store for any artist who would make this state of affairs a central theme! We are familiar, since John Heartfield's photomontages, with the goal of laying open the distinction between what is officially and what is subliminally transmitted in public media. To intervene, agitate, displace, ironize: these are among the methods that would introduce a principled critique of media culture's indefinite cynicism. At the same time, it has to be noted that the visceral and symbolic tools of public propaganda are simply more amplified and nerve-tingling versions of those employed by artists. How does one make clear that one is *commenting upon* the estranging effect and inauthenticity of the media when the project itself is to estrange viewers from their fondly regarded media culture?

These are matters of artistic exposition; they require that the subject be so framed as to imply the artist's moral and conceptual distance from it. The Pop artists effected such a frame by accentuating the element of burlesque, deflating kitsch sources by a riotous exaggeration of their syntax. Much of these artists' imagery of hard sell was flavored by the sense of a world in enthusiastic disintegration. Pop's process was an enjoyable one that yielded sensuous dividends. As a measure of how things have changed twenty years later, pleasure is only likely to appear in today's media-conscious art as a contraband element dissolving within a mood of sophisticated defeatism. Far from being a configuration of signs, as the Pop artists imaged it, the outer environment is now declared to be a layering of programs that cannot be framed from a distance because they provide the frame in which we stand. It has become an intellectual cliché of the eighties for our

cultural theorists or professors to speak of the mediation of sense data through an indefinite series of electronic filters as an effect that has made us vicarious even to ourselves. By this line of reasoning, memory, information, witness, indeed all sensory input from public event and culture are seen as digitized and pixilated illusions. Though we have unprecedented flexibility, convenience, and transparency in the commerce of our images, contemporary theory, and the photography-based art that reflects it, insist that the forces that generate such phenomena are malign. It is not a matter of being ill-served, but of being deadened. Nowadays, to follow the argument, we are mere functions of our images. It is supposedly impossible for us to project any understanding of the world outside what has already been represented for us. We are indentured to shadows. As Vilém Flusser puts it, "Man forgets that he produces images in order to find his way in the world; he now tries to find his way in images. . . . Imagination has become hallucination."[3]

If symbols had indeed virtually replaced objects, and if programmed scripts had usurped spontaneous behavior and actual events, then we could have no discernible relationship to a reality. All the more effectively because they are immaterial, the new codes of representation would have produced a closure upon us. Within such an image prophylaxis, human psychology would dry up from within, and feelings would be codified in robotic exchange. An artist convinced that such is the case is also convinced that impotence is our social lot, and illusion our natural state. Nonpictorial or iconoclastic arts have an easier time avoiding the political impasse implied by such a belief. Hans Haacke's texts and Jenny Holzer's homeless statements, flashing in dotted characters, further a political awareness undeflected by pictorial blandishments. As they stand clear of imagery, they exempt us from its illusory control. We come to painting, on the other hand, expecting the proposal of alternate worlds of metaphor and hypothesis; painting can visualize what happens in the media, but at an inevitable physical remove. Its distance from its subjects is inherent in its rendering.

In retrospect, it now seems predictable that artists could visualize their disenchantment with mass image culture only within its own territory of photographic forms. Like a fish that has been hooked out of the water to gasp and flip about in the air, photographic imagery has been plucked out of the media, estranged by artists in the limbo of its own artifice. Despite everything we know about the subjectivity

inherent in the framing of photographs, and about the orchestration of photographs by powerful interests, we still come to them expecting them to confirm and verify, in their flattened form, the world that we perceive. Many new photo-artists have paid lip service to that credibility in order to exploit it for their own ends. Counting on our recognition of photographs as technical and mechanically produced images, embedded in the media, these artists indulge the most painterly means. They have chosen the ontological base of one medium, but adopt the expressive aims of another. As a rhetorical maneuver, this one has a long history behind it. Now, however, the interest arises out of a dangerous flirtation between the bad faith and false statements of commercial forms and the freely created content of artistic forms . . . on the same ground.

The easiest method of consummating this affair is to invest the photographic medium with a variety of antirealist esthetics. Accordingly, the route taken by a number of current photo-artists has been to lessen the energy levels, dim the contrasts, and weaken the states of definition in ordinary photographic parlance. The atmosphere in their works has thickened almost viscously, and the tonal values have become murky. The intense local colors do not "breathe." It is hard to identify any source of illumination. Any cluster of these works will immediately distinguish itself by a monotonous dankness. Vaguely translucent barriers seem to have been placed between the objects depicted and the surface of the print, and the light seems barely to have sieved through to selected passages in the dark fields. If it is asked why such artists as Stephen Frailey, David Levinthal, Allan McCollum, and Laurie Simmons occlude and densify the frame, the answer is most likely to be that commercial photo culture, their stalking horse, favors accessibility of display and transparency of effect.

The most recent case made for work like this was in an expensive show curated by Joshua P. Smith at Washington's National Museum of American Art last summer—"The Photography of Invention."[4] Heavily framed, outsized in scale, elaborately processed, these works produced an effect at once turgid and lugubrious. Smith remarks that the exhibitors produce nontraditional photography (currently at the fore in our galleries) and are at the same time unaware of the history of their medium—without noticing that they couldn't be knowingly "nontraditional" if they were ignorant of their background. Leaving

aside the oddness of an argument that praises artists for being uninformed, one sees that Smith has also misread them if he thinks they are inventive. For it is precisely the jobbed and hackneyed content of their subjects that apparently fascinates them. "Inventive," in this context, means reliance on any number of elderly hybrid techniques (such as multiple exposure) or new ones (such as printing on steel) that effectively cancel the dominant "purism" (Smith) of straight or documentary photography. One wonders how an observational stance can be "purist" if it accepts the material circumstantiality of the world, the violent, endless fortuitousness of things, as subject. (Try to tell a war photographer that he is a "purist.") In modern-art talk, purism signifies the exact opposite—either a reduction of all appearances to a schematic order, or, less commonly, affirmation of a medium's limits. By this measure, the photo-artists are expansionist in process but reductive (purist) in content. They deflect their gaze from the external world, as if sensitively affronted by its realities, but they do not retreat inward—they do not discover any depth within their individual vision.

Admittedly, to ask such a thing would be to impose an inappropriate demand upon them, for they are unfriendly to the individualist canon of authorship, or to the phenomenon of aura, as it has sustained the work of their elders. Sherrie Levine's framed rephotographs of Walker Evans images were of course meant to undermine not only the prestige of prints made from original or copy negatives, but the value of an artist's way of seeing; they argue that the esteem enjoyed by certain images is arbitrary, and can be cheapened. Many of the photo-artists—not all—hold that the human interior functions only as a receptacle stuffed with media deceits. These photographers never feel more at home in what they do than when their work targets something stale and hollow among easy prey in the image landscape around us. Richard Prince, for example, says that "sometimes I think all my work got sent away for. . . . It seems to me that trying to present something believable might be *asking too much*."[5] At first this sounds like Francis Picabia's remark that one must change one's convictions as often as one's shirts. But Prince is not such a dandy. He's casually assured that convictions aren't possible.

Since the photo-artists are generally about replacement of the vague dubiousness of public imagery with a dubiousness decidedly more acute, the question of their artistic distance from their subjects is basic

to an understanding of their project. Two things we notice as conspicuous by their absence in such distancing are parody and wit. Do not ask Victor Burgin or Clegg and Guttmann to lighten up their sententious tone. Their takeoffs of hack imagery are very seriously intended. How far we are from the playfulness of camp, which implied an affectionate intelligence acting upon the motif from the outside. Photo-artists, contrarily, offer us a puritanical embrace of comparable material, so as to emphasize a now rather abstract quality of fiction. They are enemies of snap, or incisiveness of any kind, and if their work pretends to send any message, it is usually blander, more wooden, than when it might originally have appeared. Some of them have taken it into their heads that a beguiling image is insidious because it heightens an illusion of truth—so the correct step is to debase the illusion.

We're familiar with traditions in art and photography that have fastened on humble or nondescript subjects the better to make us see them freshly, through an exhilaration of form or concentration of gaze (from Monet to Lewis Baltz). Here, in contrast, synthetic motifs are ostentatiously diluted with the hope of introducing a new lowering of experience. Though the removal of visual nutrients may once have been didactic, it works more practically now as a stylistic mark. Hal Foster has suggested a prototype for such negativism in the work of the painters David Salle and Thomas Lawson, who "contrive an art that plays on our faith in art to cast doubt on the 'truth' mediated by it, a 'dead' painting that saps conviction in painting, that undermines its own claim to truth, authenticity, consent."[6] By a kind of customized anesthesia, the photo-artists numb the vibrancy of their sources as if to establish a distance beneath and *within* the depiction.

More specifically, that distancing operates on three, sometimes interconnecting levels: images are mutated, figures are objectified, and symbolism is rendered inert. All these practices are proposed as varieties of pictorial dysfunction, as if viruses had migrated into a computer network. Nancy Burson, for example, has long been interested in the resources of computer-generated imagery in averaging (mutating) the faces of public personalities or different racial types into new, nerveless amalgams. These smudgy distillates no longer represent flesh, and are certainly deprived of their media currency. The artist perhaps takes a swipe at the iconic value of overcirculated faces, like George

Bush's, but not against the stereotype itself—she brings off the sanding of contours, the blending of differences, with a dispiriting bravura. It's as if she were intimating that no one can properly "tune in" anymore, or find the right command, a feature that is also evident in Robert Heinecken's crossbreeding of television anchor people, who smile on without knowing that he has afflicted them with some indeterminate form of lupus or leprosy.

As for objectification, it is the common coin of photo-artist imagery, immediately manifest, say, in the substitution of toy dolls for people as actors in chintzy minidramas. Laurie Simmons, an artist known for such usage, states that "the danger of photographing real people is simple literalism."[7] One would have thought that the metaphor of toys was a much more literal—and limiting—device for the dramatic representation of human behavior than the mysterious presence of real persons. But the fact remains that *depreciation* of affect is everywhere perceived as an ideal among artists who nevertheless look with understandable coldness upon the media's *exploitation* of affect. Instead of countering such phenomena, however, they invite unfavorable comparison with their models, as Levinthal does when he alludes to John Ford movies with toy cowboys, or pastiches Edward Hopper in the series "Modern Romance," 1984–85, where "lonely," faceless dolls are photographed from video monitors. Joshua Smith, the curator of "The Photography of Invention," misreads such outlooks as Levinthal's when he comments that in them is mourned "the loss of authenticity, shared experience, history, etc.,"[8] as if we were dealing with resurgent humanists who simply couldn't help the minimalism in which they were invested. On no account should the esthetics of objectification be interpreted as regretful. And it is not simply regret that is ruled out; psychological interaction is also stunted.

The photo-artists' view of the world is lorded over by depicted objects, among which are sometimes stationed thinglike people. It is true that in their earlier work Cindy Sherman and Eileen Cowin depicted tense romantic situations, with real players who pretended to have a history and a future. But Sherman has gradually added strange plastic parts to her body, and now tends to show us only dead fingers peeking from chaff and muck. As for Cowin's actors, they have shrunk to miniatures in black fields. Even those late eighties photo-artists who are still concerned with figural action, such as Bruce Charlesworth,

Nic Nicosia, Sandy Skoglund, or Patrick Nagatani and Andrée Tracey, make sure that it is especially congealed. Skoglund and Nagatani and Tracey drive home their point by guying objects with string, or apparently spraying them among hapless figures in artificial storms.

When we consider portraiture, we see that it, too, has attained extremes of impassivity in the art of Thomas Ruff and Neil Winokur. Nothing disturbs the serene, sensuous transparency of their description, certainly not the wrinkle of a brow or a thought in the head. Though they may be given their individual names, the sitters in these pictures are visualized as only interchangeable pawns of an artist's style. Winokur flanks his subjects by separate photographs of objects with apparent biographical interest, yet the human being is photographed in the same iconic spirit as the belongings—they are all of equal status. Toys or ventriloquist's dummies are simulated people in small scale; in the portraiture of the photo-artists, we see real people represented with an emphatic vacancy of expression.

The impetus of the objectifying glance obviously takes a wide variety of forms, with the one common element that given a choice, the artist will prefer immobile presences to sentient human behavior in depicting social relations. Modern art, particularly in its mechanistic phases, offers precedents for this development. But it is more likely that the photo-artists are inspired to their new prodigies of fermentation by the remorseless enthusiasm of faces in the *media.* They had officially taken their stand against narrative charades in the media that everyone recognizes as only display setups. The next obvious move was to reduce the narrative display to still life.

There remains the question of ordering the elements or units within the allocated space. Instead of choosing grid or sequence, the photo-artists often prefer the rebus, a puzzlelike matrix of scattered signs, images, and words. In page spreads, newspaper layouts, the incessant lamination of commercials and features on television, and even the endless roll of data columns on computer screens, the matrix presses onward. The proximity of disjunct materials on the same surface or within an allotted interval reflects shared usage of finite space; we graze within these storage areas, fetch what we want, and turn the page or switch the channel. As is well known, Modernists from the Cubists on to Robert Rauschenberg have been visually attracted to rebuslike forms, and have made them melodious. For a number of

photo-artists, however, there is no information-storage area that is not also a field of perpetual disconnections. They have contaminated the artistic and empirical attitudes toward the rebus so that its deployment of images can mean anything, and therefore nothing in particular. Sarah Charlesworth, for example, has explored the possibilities of a layout of few units in which trivial readings are multiplied by indifferent options. The rebus no longer functions as a puzzle (though it's hypercryptic), and it doesn't look good, but at least it now labors conspicuously as a strategy to amplify the distance between concept and motif.

Were they to have led to a critique of corporate image culture, or had they achieved a poetic resonance, these strategies were worth following. Indeed, one of the theorists from mission control implies that much recent work is involved in a critique of past and present art practice: Abigail Solomon-Godeau writes that such practice "specifically addresses the conditions of commodification and fetishization that enfold and inform art production."[9] (The remark refers to imagery by Sarah Charlesworth, Louise Lawler, Prince, and James Welling, among others.) It is hard to know what practitioners can do about this thankless market process. By and large, the theme has been dropped from current photoart.

No, the real predicament stems from the way art internalizes the pathologies of the media within an independent context that only makes sense if they are turned upon themselves. The media are essentially amoral; lacking respect for individual integrity, they objectify their subjects, with a particular weight that continues to bear down heavily on women. So where, for example, is the consciousness of women artists who *enhance* the objectifying stare in their work, as if it imposed no penalties on subjects or viewers of either gender? It won't do to argue that the stare brings home the malevolence of our image culture. (The intended art audience would hardly be edified by what it already knows.) In too many instances, the hand that is thought to point to a cultural deficiency is the thing looked at, not the deficiency. Faced with the overwhelming popular impact and high production values of the mass media, artists have taken precisely the wrong move by rendering their own work ineffective, presumably in contention with what it mimics. Whatever the aim of the internalized

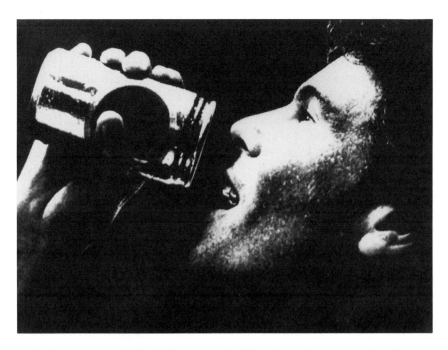

Richard Prince, *Untitled (refreshment)*, 1982, Ektacolor print, 20 × 24 in. Courtesy Barbara Gladstone Gallery, New York.

distancing system, it breaks down. The effect achieved is at the artist's expense, not the media's.

All that happens, in fact, is that physical filters are added to the theatrical filters already in place. It is difficult to understand this as anything but a reflection of the artists' own esoteric passivity and devitalization. The slackness of their project, in fact, opens up the question of whether they are aligned with the media, by imaginative default. The token Marxism in their theory evaporates in their practice. We have to reckon with a pseudo, not a real, artistic distance from the commercial content; and instead of an unmasking, we are offered only a coarsening of illusion. That is why this art frequently oppresses us without challenging us. Much of it perhaps deliberately gives the impression of wanting to fulfill Jean Baudrillard's pronouncement that "if the entire cycle of any act or event is envisaged in a system where linear continuity and dialectical polarity no longer exist, in a field *unhinged by simulation,* then all determination evaporates."[10] With their unearned skepticism and a languid metaphysics, photo-artists are zeal-

ous to determine nothing. They have souped up photography without retaining its credence, and they have imitated painting without achieving its sensuous presence or its pictorial freedom.

Curators often promote this kind of work as relevant to our era because symptomatic of a widespread malaise. This is like saying that cynicism should be endorsed because so many people are afflicted by it. Luckily, a few corrosive minds among the photo-artists demonstrate an activist temper that turns media material around within an inflammatory context. The early art of Barbara Kruger, for example, stands out from that of the raging sheep around her. Rarely since Heartfield has advertising or reportage been so aromatic of conspiracy as when she gets her hands on it. The same applies to Dennis Adams, who blows up still photos on Duratrans (illuminated by fluorescent) of such subjects as the Rosenbergs, South African blacks at an antiapartheid funeral, and Nazi regalia. He usurps sites usually given over to commercial signage in locales likely to be frequented by hostile publics.

In a similar spirit, the team of Elizabeth Sisco, David Avalos, Lewis Hock, and Deborah Small has used funding from the San Diego Municipal Arts Council, obtained through tourist revenue (a hotel bed tax), to indict their city's tourist image. Last April, moving about town on the ad placards of regular buses was to be seen their message: "Welcome to America's finest a) city; b) tourist plantation; c) convention center," accompanied by photographs of dark-skinned hands washing dishes and cuffed behind backs. This sort of presence is inappropriate to boosterism but conducive to the memory of inequities at unprepared moments. Instead of infecting the image with some sort of pictorial disease, such art provides correction to the double standards that are a disease of the society. It assumes that artists and viewers live in the same historical continuum. Using rebuslike forms that offer genuine puzzles, or appropriating press material in rephotographed guise, Kruger and Adams inject a palpable aggression into familiar techniques. They are unhesitatingly clear about the need to be effective and to hit hard. Elsewhere, viewer response may be treated as a matter of indifference, and the artists are alien. Here, we feel that they are on our side, oddly enough because they imply that we are worth shaking up.

But the turbulence is also mysterious. As it sometimes indicates a specific reference, it also has a generic import. There's no telling where and when these artists will strike again, undermining the public hype

with a guerrilla abruptness. And in that prospect, with exemplary tension, their pictures keep us alert to the world of awful consequence—the real storms—beyond their frames.

Notes

1. Mark Crispin Miller, *Boxed In: The Culture of TV* (Evanston: Northwestern University Press, 1988), pp. 13–14.

2. Ibid., p. 11.

3. Vilem Flusser, *Towards a Philosophy of Photography* (Gottingen: European Photography, 1984), p. 7.

4. With a catalogue of the same title, essay by Joshua Smith, introduction by Merry A. Foresta (Washington, D.C.: National Museum of American Art, and Cambridge, Mass.: MIT Press, 1989). The exhibition ran from 28 April to 10 December 1989.

5. Richard Prince, "An Interview by David Robbins," *Aperture* 100 (Fall 1985): 9.

6. Hal Foster, *Recodings: Art, Spectacle, Cultural Politics* (Seattle: Bay Press, 1987), p. 52.

7. Laurie Simmons, quoted in *Fabrications: Staged, Altered, and Appropriated Photographs,* by Anne H. Hoy (New York: Abbeville Press, 1987), p. 47.

8. Smith, p. 15.

9. Abigail Solomon-Godeau, "Photography After Art Photography," in *Art After Modernism: Rethinking Representation,* edited by Brian Wallis (New York: New Museum of Contemporary Art, and Boston: David Godline, 1984), p. 80.

10. Jean Baudrillard, "The Precession of Simulacra," in Wallis, p. 264.

This essay appeared in *Artforum* (November 1989).

The Digital Worm in the Photograph of the Apple

A S IT HAS spilled out from specialist into popular literature over the last five years, notice of an expanding arc in our visual culture has turned eyes and triggered fears. I refer specifically to the effect of the computer upon the practice of photography, an event that influences our consciousness of the world mediated by images. A century and a half ago, painting was shocked by photography's advent. In the interval, which continues, the camera became the dominant tool of visual record and memory across the globe. Today, photography itself is literally electrified by the arrival of pictures that may appear identical and even be used, but do not work the same way. They present new opportunities that are certainly helpful in science, and maybe positive in art. But they have hit an insidious snag in communications. There, images partly or wholly generated through computer can do real mischief to our reliance upon the information they disclose.

The continuous tones of the analogue photograph are achieved through the exposure to light of silver salt grains coated on film. Results from such an activity bear what has been called an indexical or trace-like relation to external appearances or stimuli. Without such an inseminating cause, there could be no effect we could call a photographic image. For some time now, however, such photographic appearances can be broken down into tiny elements, pixels, each assigned a tone value according to a binary *digital* code implemented by a computer. A photographic print is the result of a kind of luminous copulation with a negative; by contrast, a print-out from a digitally

generated computer screen image, even one that reproduces a photo, is like a clone asexually derived and perfectly synthesized from electronic pulses.

Although prints can interpret a negative quite variously, it itself was permanently configured when light hit its silver grains. Determined by initial impact from a light source, the tonal data contained in a negative are not only defined but closed off in their particular placement in historical time and space. One simply can't update the subject in a photograph . . . a ludicrous thought! On the other hand, though they may seem equivalents of silver grains on film or paper, pixels built from electronic signals are redistributable in ways the grains never could be. A viewer's implied physical perspective on the subject is therefore a function of this distributive process and is rendered nominal. The same applies to a digitized picture's account of historical circumstances in time. One may now encounter a replica of a photograph, whose visual particulars have been electronically modified from whatever photographic source without seam or blemish. Pixels configure a visual product which the picture manipulator in a room, all along or eventually, *decides* is to be seen. Whatever its erstwhile origins in time and space, they're mooted in the reupholstered image. Since pixels lack temporal specificity, the pictures they create have no necessary terminus in the past, even as their pliancy allows them to be reshaped in the future. (Or seemingly to foretell the future, as in computer imaging techniques used to age someone's appearance.)

Distinctions between process and completion, in vivo and in vitro states of the picture (at least on a monitor screen), are neutralized by this structural openness. If we were to liken this scenario to a text, there would be no original draft from which a finished version derives, nor even a manuscript upon which work had been indicated. Instead, we would have only one or more of an indefinite number of essentially optional textual variants that could be presented. In such a maze of endless, possible metamorphoses, what is the relatedness of this new kind of digitized picture to the physical events it shows?

The answer to that must be tied up to what we mean by the verb *witness,* which I think is at the crux of the difference between the two pictorial systems. My dictionary defines witness thus: "to see or know

by personal presence and perception . . . to be present at an occurrence . . . to testify to; give or afford evidence of." With photography, the noun *witness* must refer to the presence of a viewing agent, in this case a camera by itself or operated by a photographer, at a scene. I don't speak of the accuracy or wholeness of this agent's account, but only of proximity of a sensor to something, even at ranges out of view to the human eye. Regardless of how they're mediated, blips on a radar screen or in a picture produced through an electron microscope can give a kind of testimonial report of their subject. (In its assumption of "personal" presence, my dictionary reveals that it was prepared before our computer age.) We define photographic witness here by induced visual contact, a decisive criterion when compared with a circumstantial measure, the optical resemblance of the image to the actual thing contacted. Indeed, photography can and has charted phenomena, unseeable but for the special capacity it may have for detecting them.

On this level, computers *assist* photography in bearing unprecedented witness. They automate flash, exposures, and focus. And they can measure and translate into photographic terms the results of sensors and scans sensitive to nonvisible light wave-lengths. With awesome speed, they compile, read, calculate, and sample from the data the sensors have detected, but it is arguable that they, themselves, perform the activity of detection. They do transmit into their particular visual form material that has been drawn in by other means. Nothing is more typical of current technique than the corporate linkage of computers with those means—as in radio telescopy. Characteristically, one code is altered and made visually accessible in another.

I can imagine it being said that a comparable activity is involved in the human act of seeing. Light energy is taken in through the pupil, projected on the retina and transmitted through the optic nerve, where it is inverted and processed in visual form by the brain/computer. The electronic process I have been discussing is maybe suggestive of this organic one. Can we go further? The apparatus that receives and the device that processes are indispensable though discontinuous components of one organized system. Diversified performances are exponentially expanded in integrated circuits. In the sense that computer functions are modeled on brain operations, the intended change we see in the work of the machine is from a servo-electronic to an administrative role in perception.

The heightened power of our artificial intelligence systems reflects a Western culture fascinated with simulacra and replicants. True enough, this syndrome stems from a drive for efficiency. We've become habituated to see much of our manual labor automated by machines, and now we look forward to having them handle unprecedented intensities of our thought.

From the beginning, this hope had also been extended to the qualities of our experience. Photography must be considered as a provision of visual experience—in the form of witness—that we most often could not have obtained and retained for ourselves. However, as photographs "advance" to the next step, digitized images, they're no longer exclusively channeled to witness our human or natural situation. On the contrary, whether acknowledged or not, some of them come to us as electronically contrived visual material, of whatever origin, that look as if they *were witnessed* . . . through photography.

Most everyone who writes on this new, ambiguous phenomenon considers it to be a big deal, and I agree. If certainly not a clean break with our past visual culture, computer-generated imagery bids to undermine it. Between the two media, the way has been opened wide to talk about a difference in kind, not just degree. But here our criticism has fudged the issue because of a philosophical animus that is also politically blindered.

Since the late seventies, we have been deluged with a medley of protests against claims that photography can act as a witness and therefore tell any sort of truth. For instance, we're told that the glimpses afforded by the medium were too relative and fugitive to establish meanings. Though a representational form, it had no narrative depth because it could not explain cause and effect. More recently, it has been assumed that all representation was fiction, and that reality could not be perceived except as represented. Much of the cultural theory of the eighties was centered on the assurance that there was no "thereness" beyond representation, that what we perceived was only an illusory imprint of what we and others projected. This relentless disparagement and these escalated denials of our—not just photography's—ability to ascertain anything, have become intellectual commonplaces of the day. From Susan Sontag and Roland Barthes (though they affirmed the photographic trace), right on to the full range of the Neo-Marxists, structuralists, and deconstructionists, so

often antagonistic to each other in method, so united in their recoil from the photographic medium, a mutual theme emphasized the guile and interested, banal duplicity, the mere shadow play of the photographic genres.

Such are the wages of postmodernism, a theoretical critique that supposedly attacks but has become fascinated with the inauthentic. Because they are necessarily mediated, their subjects sieved through distorting filters of language and tone, texts and images must be misleading. We apprehend only what they have screened, and their perspective acts simply as points of reference *within* the network of fabrications in which we are all caught. Photographs are only perceived to allude to manifest states of affairs; in no way do they actually trace them. And even their latent content can have only ephemeral import in drifting introversions of flawed consciousness. In this iconophobic view, writes Suzanne Seed,

> the sin of Adam was not so much eating the apple as evolving from an immersed, preconscious existence to climb the apple tree and gain a perspective view. Thus perspective view becomes the original sin, the West becomes Adam, media become fallen modes of expression, and alienation a punishment for their use. Photography, which cannot help but give us a perspective view, is currently chosen by this myth to play the role of the snake.[1]

For practical purposes, let me define "authentic" as something that really has the source professed or implied. As for "mediation," it is the complex of activity that affects an impression as it reaches us. Now, if one denies the authenticity of the photographic trace, it seems to me that one denies what a photograph is, and no longer has anything to say about it. (Elsewhere I've argued that the photographic trace cannot be a representation in itself, but is rather made to perform a representational role.[2] Similarly, if one complains about mediation, one simply voices a protest against a necessary feature of our being, since even our bodily senses, our eyes, for instance, mediate the outside world. The fact that we live within a spectrum of mediated distances from the objects of our regard hardly implies their nonexistence . . . or the impossibility of confirming their existence. Rather, it suggests the varieties of intimacy in our experience of things. But the totalizing

bias of our criticism refuses to deal with the integrity of fragments or the evidence of circumstances, which we synthesize to form our ideas about the world. (What disclosures are or aren't permitted by circumstances is certainly an issue, as in, for example, a court of law. But that truth can only be conveyed through a regard or record of circumstances is not an issue.) Our theory, though, is inflated by a romantic-idealistic fantasy of some absolute truth, which photography will never satisfy because of its limited perspective. Here is a critique that depreciates partial viewpoint, something which is built into any statement, and which thickens, locates, and limits it. Instead of analyzing the misuse of power in image culture, case by case, such wholesale skepticism floats in a cloud of authoritarian resentment all its own.

Theories of photography that cannot survive an ordinary reality test are not worth very much. As they treat the impact of digitized "photography," however, they're worth even less. In their disparagement of photography's credibility, writers have inadvertently diminished the novelty of pixels. If both media are inherently fictive, how can there be a computer *revolution?* The fictive being the norm, one is reduced to speaking only about a comparatively more facile or more convenient means to create an illusion through improved technology. This is a trivial way to approach a most critical turn of events. From the first, photographs could be manipulated in the darkroom and retouched in the print; later, they could be airbrushed. There is some possibility of tactile change and considerable latitude in tonal shift. But what is any of this cosmetic dabbing—even when not detected—to compare with a form of potentially explosive cell division that reflects a principle of growth? If anything's natural about digitized images, it must be this principle, which enables revisions of space, placement, shape, scale, contour, light, vantage, and so on.

At the moment, the indexical picture competes with its digitized alter ego, an image that has no certificate in light. Freed from a nominal dependence on the negative, the digitized image also forfeits the authority of the negative. Though straight photography will retain its place because of its unique forms of witness, satisfying deep human and social requirements, it has now become host to an uncanny parasite that can inflect and replace sources with endless, indeterminate mutants. Those who are incredulous about the veracity of photography should also reject this new, thoroughly suspect, and equivocal phase

of image culture. On the contrary, they tend to approve anything that reinforces their chronic disbelief, and so they give up any dialectical understanding of what we are looking at.

Who can doubt that there has been a gradual loss of presence in the historical depiction of the real environment? Though photographs on paper supports are still obviously around, as we adjust to the new image reserves fewer of us expect to conduct our business or be entertained with the thought of holding pictures in our hands or of dealing with pictures that take up space in our personal environment. Movies, slides, and analogue television might now be viewed as dematerialized forerunners of an era dominated off stage by the lunar illuminations of the computer screen. When "turned off," they retreat into abstract recesses where they hibernate in unrecognizable codes. A prodigious traffic in screen images advances far ahead of—will maybe even replace—much of the need for hard copy. It is the instant continuity and metamorphosis of images that matters now, the indefinite play of combinations in possible orders. At the touch of a few keys, picture meaning can be instantly changed in flash floods of new contexts. The term "interactive" long ago ceased being a buzzword and refers to an increasingly extended valence of our relation to picture and data systems.

In order to fit into them, the image itself had to be repackaged as a transitory and bodiless construct. We grow accustomed to fabricated gestures within ill-defined spaces, of an uncertain, nebulous composition. An incessant, almost subliminal carbonation ruffles all edges in the video pictorial field. Some time ago, users became habituated to the only provisional status of this new depiction. Open in this most progressive phase to random inputs, and with no final integrity, an alterable set of pictures is summoned to furnish references or saturate people with diversions in home-delivered networks. To the extent a public is acclimated to this general softening and instability, this fishy and unverifiable character of the images in the visual surround, photographs themselves will look resistant in their hardness. When I speak of softness, therefore, I don't necessarily mean even descriptive imprecision—HDTV, for instance, is emphatically descriptive—but lack of substance.

In an important sense, the kineticism of our popular visual media compensates for the insubstantiality of their base. The first movie, by Auguste and Louis Lumière, was of an arriving train that seemed to screech right into the viewers' laps, and cinéastes have kept us jumping ever since. American commercial television intensifies this kineticism of movies, which, already for many years standard fare on the smaller screen, have demonstrably been influenced by television itself. Within its restricted field, and with its characteristically briefer cuts, feature TV administers a rippling broadside of visual jolts to the nervous system, as if to make up for its actual puniness as a material stimulus.

MTV, the latest model of this state of affairs, bombards us with the most delirious and arbitrary splices . . . so that the apparent continuity of the music track stands apart from the incessant mincing of vantages and spaces. We are taken along by a helpless, disconnected, and thrilling mobility, and spun about with the collision of light beams and the impact of bodies. One never knows how the same performers get from one scene to another without skipping a beat of their song, anymore than one can figure out how flesh is stretched by computer-generated special effects in demo films like *Terminator 2*.

As far as depiction goes, this is the era of multiple creaturely existence in the same body, and of different bodies in an alien space. The scenario of action is presented as an ensemble of disparities that are coordinated rhythmically rather than narratively. Kinetic dividends are enhanced precisely because of the estrangement that results from such unearthly effects. In the electronically carnivorous space that now extends in all directions, the integrity of things is maintained only as an aura. Viewers are implied as being no place and everywhere, all at once. How would the great early modernists Boccioni and Eisenstein have responded to techniques that at the mere graze of a keyboard or movement of a mouse, outdistance their laboriously wrought interpenetration of forms and their film montage? What happened routinely at the Zoetrope studio made the silkscreen transferred images of Rauschenberg look like the Bayeux tapestry. Of course the technical obsolescence of Modernism implies nothing about the enduring artistic worth of its more visionary productions. It's just that when the vision is actually installed as a factor in the everyday viewing environment, it ceases to be a metaphor of a world transcended by technique and becomes an outright conditioner of perceived reality.

As now borne home to us, this media state is experienced as a zone in which things are degravitized and bodies are made newly permeable to foreign matter, on an impersonal, malignant course of its own. No surface can be counted on to protect an interior. Something odd is being done to our sense of the opacity, density, and volume of things and people in the world. More than that, the complete gamut of editing, pretaping, scanning, and mixing, activated by computer means, disorients us in a space which seems to exist only as a field for violent (violating) episode.

"Anyone who's ever seen a mega-violent film with an audience", writes J. Hoberman, "knows that audiences laugh at violence in the movies. This seems to be a peculiarly American trait. Foreigners always comment on it," and then he remarks that "you could take this back to Mack Sennett."[3] In Sennett's time, the most grievous damage is meted out to our fellow creatures who, instead of being mown down pop up again fresh in purpose and whole in body. We're free to enjoy such antisocial mayhem because there's no moral cost nor even psychological calculation to the pleasure it affords. *When animated cartoons later both schematized and exaggerated slapstick, they unknowingly prepared our culture for the space depicted in the computer age.* It's taken for granted that characters in either mode can and will get anywhere at lightening speed, independent of drag, traction or distance.

Many of the breakthroughs that launched this electronic triumph over space have been spurred by U.S. military contract. This fact maybe helps to explain their percussive usage in the entertainment media. The graphic cruelty of the one expresses kinship with the diagrammatic violence of the other. It is sufficient to think only of warheads fitted with video cameras, whose trajectories were later broadcast on CNN, to get the picture. The lenses scanning hostile territory in both fields have come to seem optically predatory, as if nothing existed within their purview but targets. We're brought ultra-near to gross *fictions,* while reciprocally distanced from unspeakable realities, where loss of life has to be inferred from the whitening of a screen.

But such breakthroughs have their wonders, as well, and sometimes the media dwell on them—in science fiction especially. One film illustrates this quite spectacularly, with ambivalent reference to photography: *Until the End of the World,* by the German director Wim Wenders, released in 1992. In this narrative, the eventual object of

chase is a small camera, for whose possession the C.I.A. would not hesitate to kill.

The machine had been invented by an eye doctor so that family pictures could be "seen" by his wife, blind since her childhood! Strapped on the viewer's head, the camera records what that person perceives, members of a clan, along with the electrical and biochemical activity involved in the act of visual perception. Computers had been programmed to digitize this information so that it can be later decoded and translated into "images" internally visualized by the blind subject. Additionally, what happens in her mind is transmitted back into pictures that can be monitored by other viewers on large screens.

Here is a timely conceit pertinent to the medium of photography, about to achieve a new level where it will be able to "observe" content that has no physical existence and that even bypasses the ocular core of sighting. In the process, a camera tickles notions about telekinesis. Reportedly, devices can now isolate and locate visual perception as it takes place in the human brain. But though they can show the activation of brain cells, they cannot as yet inscribe the iconic side of memory and dream, the accomplishment of which becomes a kind of gorgeous epiphany of the scientist at the end of Wenders's film. As we know photography to be largely a voyeurist enterprise, this must be its ideal goal: to give access to someone's inner reveries.

"If a blind man asked me," wrote Joseph Joubert, 'What is light?' I would answer: 'What makes us see.'—'What is seeing?'—It is to have an idea of what is before our eyes without having to think about it."[4] So as to release his blind wife from the necessary bondage of thought, only, a man invents a super camera. I can conceive this film as an allegorical homage to the record of photography. The medium brings light from the past, solacing memory, confirming existences. That is why photographs are treated as the images of choice for the retention of appearances, ordinary or improbable. These pictures speak to virtually global publics, making references they trust, and in a visual language they share. No wonder such photographic prestige is taken advantage of and used as a cover by new visual forms, in pursuit of invisible quarries.

We use words to evoke images in our minds, and in fact, a scholarly cliché regards language as a surrogate pictorialism. From hieroglyphics to Wenders's light show, images, for their part, signify thoughts or

stories. But Wenders's movie breaks open this dialectic and reveals a chasm. However they may have been stimulated by external events, the dreams of the eye doctor aren't located in the outer world. We cannot have a photograph of them, only a kind of image that is *said* to represent them. To think that technological progress will allow us to *document* what can only be imagined is to go over an edge. It's to conceive that mental activities can actually be revealed by light energy, as if a mysterious psychic event were like a bone or an organ that would show up on an x-ray. *Until the End of the World* is a romantic fantasy that occurs at the end of our century. (The scene is set in 1999.) It tells of a longing to be done with distinctions between exterior and interior, connotation and denotation, and finally, word and image, in one, great, out-of-body crescendo.

Plainly, this ecstatic spectacle is cued by corporate mediation, more concerned with how messages are received than with their point of origin—which can be fabricated; or with speed of transport—which is essentially instant. There may come a time when a public is apt to forget the idea that messages and images, in order to be authentic, have to come from somewhere "else," that is, from where they originate. They don't so much travel as manifest themselves to us, when activated by an instrument aptly called a remote control. Everything is waiting for us and all we do is unblock the channels of entrance to a deciphered world of unknown scope. But around the bend comes another form of mediation for those less passively inclined, a form called "virtual reality."

In this new mediation, the viewer is placed in a theater of self-contained events with which he or she appears to interact. At first, the form was devised conventionally enough for technical use before being readied as an entertainment option. Detached cockpits simulate the landing of jets for pilot trainees. Typically, the viewers' way wends through events in time and space as if the way itself were part of their continuum. Now, with a kind of combined camera and screening device, like a headset cradled over the eyes, one can be playfully blindered within another "virtual reality," a crypto-space in which a pseudo-actor, oneself, locomotes among various meta-presences, affecting them "here" and "there," while being completely dissociated from real surroundings.

In brief, models are devised to see how reflexes can be studied and

altered in advance of actual contact with situations. We're dealing with sophisticated dry runs, contingency plans that project certain eventualities that have a bright future in new arenas of learning techniques and perceptual gamesmanship. Subjects interact with their own responses, or fancied consequences of them. Behind this whole modular enterprise is implied an ideal: the most perfected because the most expeditious form of mediating something (now almost in "sight"), is auto-suggestion. "Our connection with the real world," writes Marvin Minsky, "is very thin and our connection with the artificial world is going to be more intimate and satisfying than anything that came before."[5]

Though this sounds quite speculative, in view of the hardness that dominates most people's lives, there can be little doubt that our visual culture has entered a phase where fancy and fact are fused in undecidable ways. I don't argue against the oncoming image world generated by the computer on the basis of any kind of purist thesis about the uniqueness of a *medium*. For in the act of learning anything, we inevitably crossbreed data. Modernism and postmodernism are nothing if not hybrid in the application of their techniques. "What a dull world this would be," said Heywood Broun, "if every imaginative maker of legends was stigmatized as a liar." Dull, indeed! In order to survive, we need to conjure and symbolize as well as describe and report. Photographs have often been understood to do both, simultaneously. But what a horrible world this would be if legend making should be deliberately camouflaged as journalism. Just as we've been introduced to new pliancies of space and time, so we have strange, new *categorical* hybrids, docudramas, reality effects, and infotainments, genre shifts no one asked to contribute to our political confusion.

Distinctions in categories are obvious prerequisites for maneuvering in the world. If truth in advertising, for instance, be unattainable, at least advertising should not be proposed as something else . . . editorial comment. (In the same way, creation myth must not be mistaken for science, nor holocaust revisionism, history.) Computer-altered images, in whole or even in part, have about as much truth value as steel engravings that flourished in the newspaper before halftone photography was introduced.[6] It follows that they can't be allowed the hubris of passing for reportage, whose visual standards have been

defined by photography. These are conflicts of instrumental interest, but more than that, obscurities potentially fatal to our need to know, and to judge on the basis of what we know.

I shouldn't run on. A social or media historian would have more to tell us about how such matters come about than a critic of photography. But I do notice a deficiency in photographic criticism, linked to social problems. For unclear reasons, we find it much harder to talk of pictures, and things pictured, with the openness and sensuous responsiveness that we can bring to phenomena seen directly. The difficulty is revealed in a tendency within the literature to favor conceptual or background rather than perceptual aspects of pictorial experience. Writers lean, not so much toward what is shown, but rather toward what their minds imagine a picture shows. Instead of interpretive and/or descriptive, I'd say we have more of a projective literature about pictures. Electronic imagery may very well be ontologically strange or factually dubious, but at least a language already exists with which to treat it, a language that feels at home in a text-saturated world, without presence(s), where cyberspace has a blind date with phone sex.

As a writer, I hardly wish to belittle the mental component of vision. But as a writer on *photography,* I have to reckon with the way the medium challenges the descriptive capacity of words, by virtue of what it uniquely shows. We are attracted by our obvious empathy for the material content of the photographic image, into the field of phenomena that outreaches our power to imagine them. This is the lure that must have driven the inventors of the medium. What they gave us was a trace of lived moments of people generally other than ourselves, with whom we nevertheless share a common fate. They carry on in an external world of varying substance and surface to which the picture is literally accountable. The palpable distance in space and time which separates viewers from subjects, immobilized in the frame, reminds us of the obstacles to our connection, and, therefore, the reality around us. To talk about this distance, observantly, is to stretch the mind.

It's worthwhile to reflect on what digital imagery contributes to this problem because what happens to our values as a society is signaled and reflected by what happens to the way we picture society. Serious modification in one of these terms—social beliefs or depictive sys-

tems—affects the other. Any influence upon public information that depreciates or compromises the act of witness, particularly from a concealed structural mechanism . . . is politically retrograde in the extreme. For tainted evidence—in future, perhaps even the suspicion of that taint—deprives us of evidence that now records the misdeeds of the powerful and the cruel. The information empire plays with image manipulation at great peril to us all, for who can doubt that we're dependent on the credibility of the empire? It can be no accident that at the onset of this digitized age, the eighties, the American political process visibly began to disintegrate, absorbed into images rightfully understood by many citizens as having no substance. What a paradox that developments at our furthest technological edge should induce a fictive latency into pictures characteristic of the moment *before* the invention of photography! Call the digitized image a revolution in media, if you will, but don't, for one moment, think it as radical as the one in 1839, unmatched in excitement, and with whose implications we still struggle.

1992–93

Notes

1. Suzanne Seed: *The Viewless Womb: A Hidden Agenda,* in Daniel Younger, ed. Multiple Views, University of New Mexico Press, 1991, p. 387–407.

2. Max Kozloff: *Photographs: The Images That Give You More Than You Expected to See and Less Than You Need to Know,* Photographic Insight, Fall 1987 (see pp. 238–39 in this book).

3. J. Hoberman: in Special Section "Shoot to Thrill," The Village Voice, December 1, 1992, p. 55.

4. The Notebooks of Joseph Joubert, Paul Auster, ed. Northpoint Press, 1983, p. 67.

5. Quoted by Timothy Druckery: *Electronic Representation: Imaging Beyond Photography,* in Camerawork, Spring/Summer 1993, p. 4.

6. By "truth value," I mean a picture's or an utterance's high degree of accountability to external states of affairs, based on extreme, checkable particularity of description. The picture's effective content may not be much changed by trivial alterings of detail, but its truth value will.